FRA ANGELICO

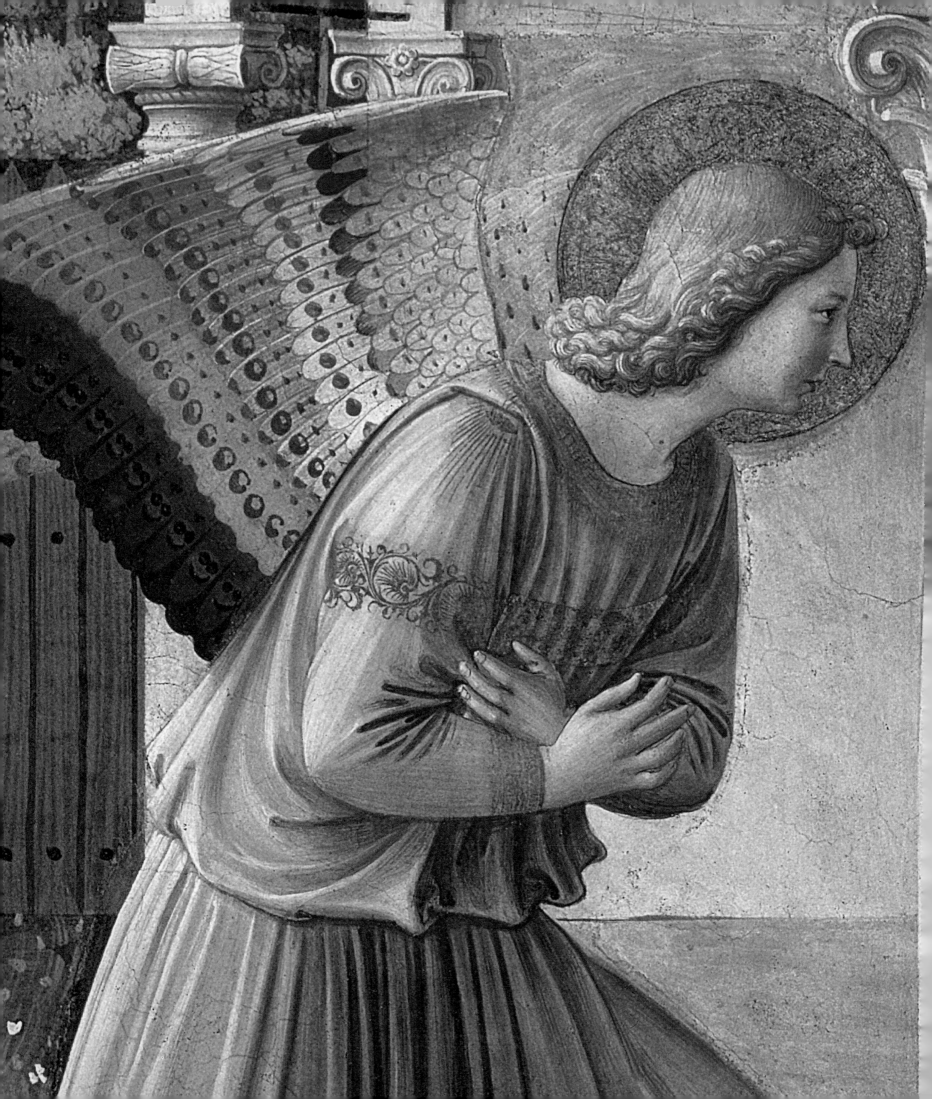

Diane Cole Ahl

FRA ANGELICO

Phaidon Press Limited
Regent's Wharf
All Saints Street
London N1 9PA

Phaidon Press Inc.
180 Varick Street
New York, NY 10014

www.phaidon.com

First published 2008

© 2008 Phaidon Press Limited

ISBN 978 0 7148 4830 3

A CIP catalogue record for this book
is available from the British Library

Typeset in Miller
Designed by BLOK
Printed in China

Frontispiece:
Detail of *Annunciation* (see 97)

Diane Cole Ahl is the Arthur J. '55 and Barbara S. Rothkopf
Professor of Art History at Lafayette College, PA. She holds
a Ph.D. from the University of Virginia and a BA from Sarah
Lawrence College, and has received many grants and awards
for teaching and scholarship. She is the author of *Benozzo
Gozzoli*, editor of *The Cambridge Companion to Masaccio* and
*Leonardo da Vinci's Sforza Monument Horse: The Art and the
Engineering*, and co-editor of *Confraternities and the Visual
Arts in Renaissance Italy: Ritual, Spectacle, Image*.

Introduction
The Angelic Friar

1
Lorenzo Gelati, *Fra Angelico in the Refectory of San Domenico*, c.1879
Oil on canvas; 55 × 69 cm
(21⅝ × 27⅛ in)
Palazzo Pitti, Florence

In the late nineteenth century, Lorenzo Gelati portrayed Fra Angelico (*c*.1390/95–1455) as Giorgio Vasari had immortalized him in the *Lives of the Most Illustrious Painters, Sculptors and Architects* (1568), the first published history of Italian Renaissance art (1). With palette in hand and head lowered in prayer, the pious Angelico is shown kneeling before his fresco of the crucified Christ in the convent of San Domenico di Fiesole, where he was a friar. Beholding the image is a fellow Dominican, perhaps Antoninus Pierozzi of Florence (1389–1459), the brilliant theologian, social thinker and prior of San Domenico during the early 1420s, when the artist took holy vows. Gelati's painting was inspired by Vasari's evocative description of the devout friar, who 'never took up his brush without saying a prayer or painted the Crucifix without tears streaming down his cheeks'. Dedicating his life to the service of God, the friar painted altarpieces, frescos and manuscripts of supreme beauty for nearly four decades. In homage to his piety, he was remembered by his Order as *Angelicus pictor* (Angelic painter), inspiring the name by which he still is called today. Gelati's painting, however, is less an illustration of Vasari's imaginatively poetic text than a melancholy meditation upon it, as is evident from its many anachronisms. Bales of straw, planks of wood and empty kegs fill the vacant refectory where the community of friars had gathered in the distant past. The fresco itself, once the inspiration of their prayers, is enclosed in shutters with broken boards. In 1879, it had been removed from the wall and installed in the Louvre (2). Half-hidden in the gloom and sitting with paintbrush in hand, Gelati portrayed himself gazing upon these phantoms, mourning the passing of the artist and the age of faith. For Gelati, as for so many in his era and previous centuries, Angelico was regarded as a venerable mystic, the last exponent of the waning Middle Ages.

Through the mid-twentieth century, most scholars reprised Vasari's view of Angelico. They supposed that the friar was born in 1387, as Vasari had indicated in the *Lives,* and consequently viewed him as a late medieval master. They incorrectly believed that he took holy orders in 1407, two years after the zealous, conservative reformer, Blessed Giovanni Dominici (1356–1420), founded the friary of San Domenico di Fiesole. They then assumed that he spent the next decade in exile with Dominici, who was persecuted for his religious and political beliefs. Since the dates of only two of Angelico's works were known, scholars found it difficult to trace his origins and the sequence of his development. And while some critics, most notably Roberto Longhi and Mario Salmi, perceived Angelico's greatness as an innovator, the majority shared the opinion of John Pope-Hennessy, who characterized him as a reactionary faithful to his 'own intransigent ideal of reformed religious art'. All of this changed in 1955, the 500th anniversary of Angelico's death.

The quincentenary marked a turning point in our understanding of Angelico. A major exhibition in Rome and Florence displayed together for the first time numerous paintings, drawings and manuscript illuminations by the master. With so many original works before their eyes, scholars were compelled to reassess the artist's development and contributions. The prevalent conception of the master as a still-medieval artist could no longer be sustained. Mario Salmi, organizer of the exhibition, concluded that Angelico had emerged from the late medieval ambience of his formation to become a true *homo novus* – a new man – and a prime exponent of the Renaissance, an opinion that Pope-Hennessy and other scholars eventually came to share.

Of equal importance, the Dominican historian Stefano Orlandi and the archivist Werner Cohn published several new documents that corrected long-held beliefs about Angelico's career. In a series

2
*Crucifixion, c.*1440
Fresco; 435 × 260 cm (171 × 102 in)
Musée du Louvre, Paris

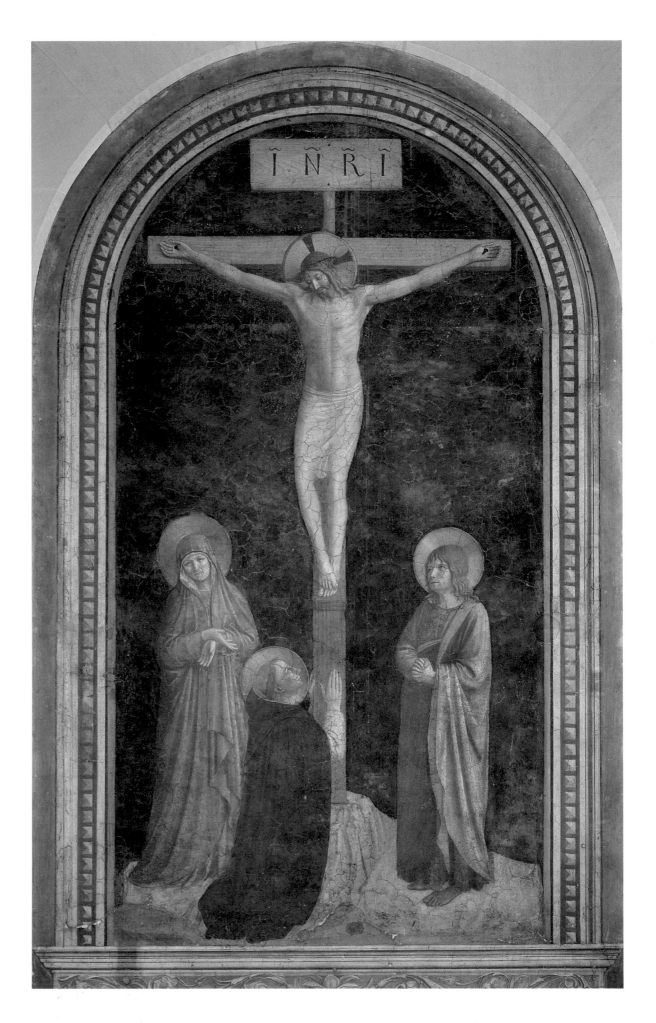

3
Raphael, *Fra Angelico*,
detail of the *Disputà* (152), 1508–11
Fresco
Stanza della Segnatura,
Vatican Palace, Rome

of dramatic discoveries, it was proposed that the painter was born around 1400 rather than 1387. Orlandi proved the inaccuracy of an entry in a chronicle from San Domenico di Fiesole that seemed to establish Angelico's novitiate in 1407. Composed from fragmentary records about sixty years after the painter's death, the notation was judged unreliable. Cohn discovered that Angelico's activity as an artist preceded his religious vocation, and proved that he was living as a lay painter named Guido di Piero in Florence in 1417, when he joined the religious confraternity of San Niccolò di Bari. In 1418, while still a lay painter, he was paid for an important altarpiece in the Florentine church of Santo Stefano al Ponte. These documents indicated without a doubt that Guido di Piero had established himself as an artist before he became a friar.

Subsequently published documents identified firm dates in his career and recorded his prolific activity during the 1420s and 1430s, about which virtually nothing had been known. These findings proved that between 1418/20 and 1423, Angelico rejected secular life to enter the convent of San Domenico di Fiesole, known for its strict observance of the Dominican Rule (Raphael portrayed him in his habit almost a century later; see 3). His spirituality was shaped by Antoninus of Florence rather than by Giovanni Dominici, as had long been believed. Angelico's prolific activity as a painter was demonstrated by other documents related to commissions for his own convent as well as for other churches. These archival discoveries necessitated a reappraisal of his development. Previously, Angelico was deemed a late Gothic painter, one of a generation of artists born in the mid-to-late 1300s, whose uptilted space, linear figures and interpretation of traditional themes were rooted in the medieval past. Instead, the newly-found documents indicated that the friar was in fact and in spirit a contemporary of Masaccio (1401–28), whose innovative naturalism and convincing portrayal of space and perspective transformed the course of Florentine painting. More significantly, these documents established the dates of several key works. They indicated that Angelico, already active in the second decade of the fifteenth century, was the major painter in Florence from the mid-1420s through the early 1440s. For the first time, his chronology and role in the development of Renaissance art could begin to be knowledgeably assessed.

The quincentenary of Angelico's death was over fifty years ago. Many discoveries since then have further expanded our understanding of the friar and his art. Over the last few decades, conservators have restored his frescos in the convent of San Marco, the Chapel of Nicholas V in the Vatican Palace and the Chapel of San Brizio in Orvieto Cathedral, as well as several of his panel paintings. Their efforts have revealed the chromatic brilliance of his works and new data about his technique, reaffirming his mastery as a painter. Scholars have explored many aspects of his art, from its origins within the rich visual and iconographic traditions of sacred painting to its remarkable innovations. Studies of his associates and collaborators, including Battista di Biagio Sanguigni (1393–1451), Zanobi Strozzi (1412–68) and Benozzo Gozzoli (c.1420–97), have challenged traditional attributions and established the prolific activity of his workshop, especially in the realm of manuscript illumination. In 2005–6, an exhibition devoted to Angelico at the Metropolitan Museum of Art, New York challenged a number of assumptions about his works and chronology. Placing the artist's earliest paintings around 1411, several proposals were quite provocative and renewed discussion of Angelico's oeuvre.

While art historians have made important contributions to our understanding of Angelico as a painter, theologians, especially those of his own Order, have illuminated his spirituality as a Dominican. On 3 October 1982, Pope John Paul II formally beatified Fra Angelico, praising the 'nearly divine beauty of his painted images' and the 'sanctity of his life'. To celebrate this joyous occasion, numerous commemorative publications were issued, including testimonials and texts from the friar's contemporaries and later authors, catalogues of his paintings and their inscriptions, and essays on his spirituality. They demonstrated the unequivocal centrality of the friar's religious vocation to his art and his profound knowledge of sacred theology. Dominican scholars underscored how deeply the Order's teachings informed virtually every aspect of his paintings. More significantly, they identified specific writings by the Order's saints and theologians – Thomas Aquinas, Catherine of Siena, Giovanni Dominici, Antoninus of Florence – that clarify his work from the perspectives of Dominican thought. As their research has demonstrated so compellingly, the art of Angelico must be seen as 'painted preaching' in obedience to the Dominican Constitutions that mandated a life spent in the service of God.

In writing this book, I have incorporated a range of approaches. My intention has been to place the paintings of Angelico within Renaissance visual, historical and religious culture. He lived in a period of strenuous religious reform, humanist inquiry, political uncertainty and economic decline. His career intersected with the activity of other early Renaissance masters – Lorenzo Monaco (1370/5–c.1424/5), Masaccio, Lorenzo Ghiberti (1378–1455), Donatello (1386/7–1466), Michelozzo di Bartolommeo (1396–1472), Benozzo Gozzoli – whose contributions complemented his own. From the very beginning, the friar's works, while being deeply rooted in tradition, introduced extraordinary innovations in iconography, style and technique. They responded to the demands of his clientele, who ranged from members of religious congregations and confraternities to such powerful men as Nicholas V, the first humanist pope, and Cosimo de' Medici, the wealthy ruler of Florence and the city's greatest patron of art. While many scholars have seen the friar's works exclusively as expressions of Dominican piety, I believe that Angelico responded to the unique demands of every commission. His paintings reflect a cognizance of the devotional and visual culture of each site, an understanding of sacred decorum and an awareness of the diverse audiences in whom they were intended to inspire piety.

Angelico was one of the most prolific masters of his day, painting quickly and with great facility. Despite the loss of several key works, among them three major commissions in Rome, an exceptional number of his paintings do survive. Some are works of which the provenance and patronage are unknown, due in part to the dismemberment and sale of many altarpieces following the suppression of churches and monasteries by the Italian government in the nineteenth century. While such works help trace his development as a painter, they are inherently less valuable to our understanding of Angelico's response to his clientele than those paintings for which the patrons and original location are known.

In this book, I have chosen to focus primarily on the works with certain provenance in order to explore the circumstances that inspired their creation. Although I have devoted extensive research to recovering the history and chronology of Angelico's commissions, the sequence of his works is largely a matter of conjecture, since few are documented. To signify that most of these dates are approximate, they are preceded by a 'c.' (circa). Ultimately, I believe that speculations on attribution and dating may be less important than appreciating the history, meaning and extraordinary beauty of the images themselves. They reveal the spiritual aspirations of those who commissioned them and the mysteries of salvation as envisioned by the friar.

1
Magnificence and Splendour, Poverty and War
The Florence of Fra Angelico

4
Luca Signorelli, *Self-portrait and Portrait of Fra Angelico* (right), detail of *The Preaching and Rule of the Antichrist* (120), 1499–1504
Fresco
Chapel of San Brizio, Orvieto
Cathedral, Orvieto

Previous page
Detail of *Madonna and Child*, from *San Domenico di Fiesole Altarpiece* (19)

Around 1404, Leonardo Bruni – scholar, author and, later, chancellor of Florence – composed his *Panegyric of the City of Florence*. This patriotic manifesto was written two years after the despotic Giangaleazzo Visconti of Milan, conqueror of northern and central Italy, succumbed to the plague just as he was about to invade Florence. Bruni extolled the bravery of the citizens who had resisted invasion and praised the city for its love of liberty, its noble people and its imposing architecture. Writing the *Panegyric* in the glorious aftermath of victory, Bruni invoked Florence as Rome's heir and proclaimed it a city of 'magnificence and splendour'. Bruni's image of Florence was shared by several humanists, those intellectuals who studied the literary and philosophical legacy of ancient Greece and Rome. Goro Dati – a wealthy merchant and author, whose *History of Florence* spanned events from 1388 to 1406 – identified the city as a patron of peace and lauded its institutions as so righteous that the saints were inspired to protect it from harm. In 1427, the historian Poggio Bracciolini idealistically wrote that Florentines undertook 'war for the protection of liberty'. Such humanist rhetoric, however, could not veil a reality that was unremittingly harsh.

The Italy that Fra Angelico knew was entirely different from the country of today, unified only in 1870, and the region ruled by the emperors of ancient Rome, who imposed a common language and government on the people inhabiting its territories in the first to fifth centuries. Angelico's Italy had inherited a legacy of virtually constant warfare that began with the fall of the Roman Empire (*c*.476 AD) and continued in the rivalry between the heirs of Charlemagne (742–814 AD) and the Church, which had territorial as well as spiritual power. The German imperial dynasty, centred in Prague during Angelico's lifetime, ruled what was called the Holy Roman Empire; these territories comprised most of northern Europe and the northern-most territories of the Italian peninsula. The pope ruled from Rome, claiming jurisdiction over much of central and northern Italy. Although the pope was officially head of the Church, his authority in worldly affairs was challenged constantly, not only by the emperor, but by the cardinals, often members of noble Roman families, who coveted his power and often conspired against him. In 1309, the papal court sought refuge in Avignon, where the popes would live in exile for nearly eight decades. To restore Rome as the centre of the papacy, Pope Gregory XI (reigned 1370–8) returned there before his death in 1378. Within months, the cardinals regretted their choice of his successor and elected a rival pope, who ruled simultaneously. From 1378 until 1417, two or more popes ruled at the same time, each claiming to be the true heir to Saint Peter. This chaotic period, called the Great Schism (also known as the Western Schism), was finally healed with the election of Martin V (reigned 1417–31).

Throughout Angelico's lifetime, there was no single mode of government. Florence, Siena, Lucca, Venice and Genoa were republics that forbade the rule of lords. Eligible male citizens – primarily members of major guilds – were selected by lot and theoretically served brief terms. By contrast, southern Italy, known as the Kingdom of the Two Sicilies, was ruled from Naples by monarchs, while dukes governed Milan. Within these cities, local

leaders with ever-changing loyalties conspired to extend their holdings through political intrigue and violence. So it was in the opening years of the fifteenth century, when the tyrannical rulers of Milan and Naples sought, and narrowly failed, to invade Florence.

Although the Italian Renaissance is often portrayed as a golden age of culture and learning, the Florence of Angelico was besieged by poverty, war, political ambition and plague. To preserve its liberty, the city fought innumerable battles at the cost of countless lives. Between 1411 and 1414, the ruthless dictator Ladislaus of Naples repeatedly threatened to invade Florence, provoking more bloodshed. Only his providential death by bubonic plague saved the city. In 1420, Filippo Maria, the son of Giangaleazzo Visconti, returned to conquer Florence, beginning a war that would last until the 1440s. To subsidize the army, Florentines were subjected to crushing taxes that destabilized the economy and further impoverished the poor. Writing a history of Florence during his own imprisonment for bankruptcy, the humanist Giovanni Cavalcanti observed that, 'because of taxes, and the result of wars, the wealth of Florence shifts from the weak to the powerful citizens'. Although Florence was a republic, the city's government was, in fact, an oligarchy. A small number of men, sons of powerful families and members of major trade guilds, were eligible for election. Political enemies faced exile, imprisonment or death. The devastating Black Death, which had reduced the city's population by almost two-thirds during the second half of the fourteenth century, was an ever-present threat or reality. Throughout Angelico's lifetime, onslaughts of plague killed thousands of citizens. By 1427, the population of Florence had declined to under 40,000 – one-third that of a century earlier. Many existed in poverty, hunger and despair, relieved only by faith. This was the age in which Angelico lived, and the city in which he became an artist and, later, a Dominican friar (4).

No document records the date of Angelico's birth. The year of 1387 proposed by Vasari in the *Lives* cannot be corroborated and is generally presumed to be inaccurate. It is now believed that Angelico was born sometime in the last decade of the fourteenth century. He was named Guido di Piero and came from the central Mugello valley of Tuscany near Vicchio, a small village located in the Val di Sieve, about 32 kilometres (20 miles) to the north of Florence. Nothing is known about the economic circumstances of his family, the name of his mother, or the profession of his father, Piero di Gino. Many of those living in the Mugello were poor, illiterate peasants who farmed the land and whose children continued their parents' way of life. This was not likely to have been the case with Angelico's father, who must have been a man of some means. Evidently he could afford to send Angelico and his brother Benedetto to school before they went to Florence for further education in their professions. Family ties were extremely close in the late fourteenth century, and the lives of the siblings were deeply intertwined. Angelico was probably the older of the two, becoming a painter in the second decade of the century and entering the convent of San Domenico di Fiesole between 1418/20 and 1423. Benedetto, who became a scribe, was not ordained at San Domenico until 1429. Until death, the brothers devoted their lives to their faith. They had a sister, Checca, whose grandson, Giovanni d'Antonio, became a painter. In 1447, Giovanni accompanied Angelico to Rome and Orvieto. After Angelico's death, he worked with the master's closest associate, Benozzo Gozzoli.

As the merchant Giovanni Morelli described it in Angelico's day, the Mugello Valley was 'the most beautiful area' of the Florentine countryside. The Apennine Mountains and undulating hills enclosed lush, green pastures and thick forests of beech, oak, cypress, pine and chestnut that would inspire the landscapes in Angelico's paintings. Shimmering rivers and streams descended from the mountains, providing fresh water for livestock and irrigating fields from which crops were harvested two or three times a year. Although some wealthy Florentines, including the Medici family, owned villas in the Mugello, most of the people who lived in this region were farmers. They raised the animals that provided cheese and meat consumed by Florentines and they tilled the soil that provided the city with abundant supplies of grain, olives and fruit. Giovanni Morelli idealized his portrayal of the area from which his own family came, taking special care to emphasize the great piety of its inhabitants.

Governed by Florentine magistrates with ancestral homes on its rolling hills, the towns and villages of the Mugello were allied closely with the urban centre in other significant ways. Teachers from Florence taught the small number of boys who would pursue trade or commerce in 'abacus schools' (so-named for the abacus that was used in simple calculations). Students generally were comprised of the privileged quarter or third of the town's male children. This select group of youths began school around the age of six or seven. They learned mathematics and were taught to read and write. Their primers included prayers, stories of vice and virtue, selections from the Bible and accounts of saints' lives that would reinforce their faith. Some children in abacus schools also learned Latin, although this was rare. Angelico may well have been among this elite group. It is probable that he knew Latin when he began his novitiate, since the Dominican Order, renowned for the erudition of its friars, required the memorization of all the texts required for its ceremonies and rituals – prayers, psalms, chants and liturgies – in Latin, the language of the Church. The same presumably was true of his brother Benedetto, whose profession as a scribe as well as a Dominican friar obliged him to have a thorough knowledge of Latin.

By the time Angelico completed his education, he was probably between twelve and fifteen years old, the typical age for a youth to finish abacus school. He is likely to have begun his apprenticeship as a painter at this time. The date of his departure from the Mugello is unknown. It may have occurred as early as 1410/12, since by October 1417 he was already practising as a painter. In leaving this land of fields and forests for Florence, Guido di Piero was following in the footsteps of many other artists born in this region, including the most famous fourteenth-century Florentine painter, Giotto (1267/75–1337).

The city that Angelico saw on his arrival was entirely medieval. The brilliant sculptor, architect and urban planner Arnolfo di Cambio had conceived Florence's most prominent sites in the

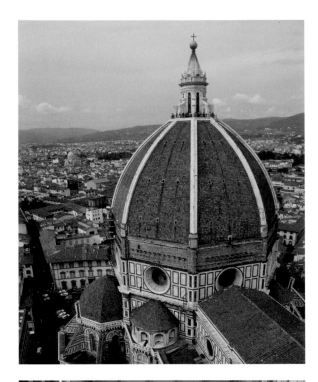

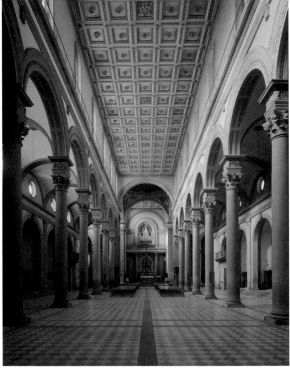

5
Filippo Brunelleschi, Dome, Florence
Cathedral, begun 1420, completed
1436

6
Filippo Brunelleschi, Nave of
San Lorenzo, Florence, begun 1419

7 Opposite
The Death of Saint Peter Martyr, detail
of the *Saint Peter Martyr Triptych*
(45), documented in 1429
Tempera and gold on panel;
137 × 168 cm (54 × 66⅛ in)
Museo di San Marco, Florence

late thirteenth century. He designed the ring of massive walls
that surrounded and protected Florence from invasion as well
as several of its major sacred and civic sites. These included the
Cathedral, which was the centre of religious life; the fortress-like
Palazzo della Signoria (later called the Palazzo Vecchio), which
housed the city's magistrates; the church of the Badia (Abbey)
of the Benedictine monks; the church of Santa Croce, where the
followers of Saint Francis of Assisi established their church and
convent; and the original loggia of Orsanmichele (later destroyed
by fire and rebuilt), which served as a communal granary, guild
hall and religious sanctuary. Arnolfo's architecture was built in the
Tuscan Gothic idiom, with thick stone walls supporting vaulted
roofs and conveying the ideology of power, both secular and sacred.
Surrounding these buildings were winding streets crowded with
the stone towers of the wealthy alongside the hovels of the poor.
The streets were clamorous with the noises of the marketplace, the
wooden wheels of heavy carts, the harangues of citizens arguing in
front of the Palazzo della Signoria. Florence was divided by the
Arno River, its lifeblood, which provided water for drinking,
bathing, transport and the milling of grain. Along its banks, poor
labourers toiled to wash and dye the wool that would be woven into
cloth, the most important product exported by the city's merchants.
Four bridges spanned the river at strategic points, serving as
places of public gathering and commerce. Crossing the river at its
narrowest point, the city's oldest bridge, the Ponte Vecchio, led
directly to the Via Por San Maria, the location of the great banking
houses that were a major source of the city's prosperity.

As important as Florence was as an economic centre, it was
also perceived as a city favoured by God. Goro Dati's *History of
Florence* proclaimed that the populace was governed by the Lord,
the Virgin Mary and John the Baptist, patron of the city, who
bestowed virtues and rewards upon its citizens. At its heart was
the Cathedral, dedicated to Santa Maria del Fiore – Saint Mary
of the Flower – simultaneously honouring the Virgin and the city
itself, the symbol of which was the lily. Infants were baptized in the
Baptistery that faced the Cathedral, simultaneously joining the
community of God's faithful and the populace of Florence. Within
the city, clergy celebrated morning and evening Mass at more than
one hundred churches, ministering to the spiritual needs of rich
and poor alike. Members of religious confraternities – organizations
of pious lay people and sometimes clergy – promoted devotion and
charity. Many in the confraternity imitated the example of Christ
through rituals of self-flagellation, fasting and prayer, and on
holy days, they joined processions of clergy through the city to sing
hymns of praise and perform acts of penance in public view.

The last years of the fourteenth century saw the inauguration
of a rigorous reform movement within many religious orders that
intensified in the opening decades of the fifteenth century. This
movement, known as the Observance, redressed the decline in
austerity and discipline that had corrupted the orders in the years
following the first outbreak of the Black Death (1348). It mandated
a return to the original constitutions of these congregations. For
the Dominicans and Franciscans – both mendicant orders, in which
the friars were forbidden to own property – this meant a renewal
of their commitment to strict poverty and their mission to preach,
educate and minister charity to the populace. In Florence, the
churches of the mendicants – most notably the Dominican church
of Santa Maria Novella and the Franciscan church of Santa Croce –
officially were supported by the city, which understood the crucial
role of preachers in urban life. The emphasis on poverty and public
preaching distinguished the mendicants from such monastic orders

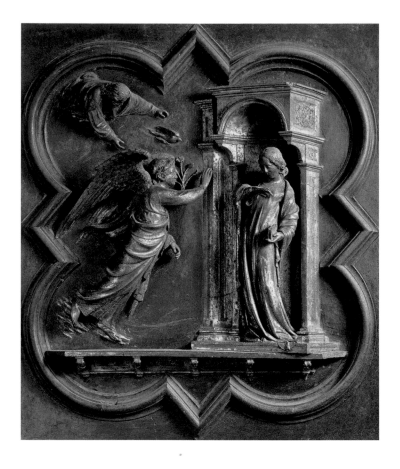

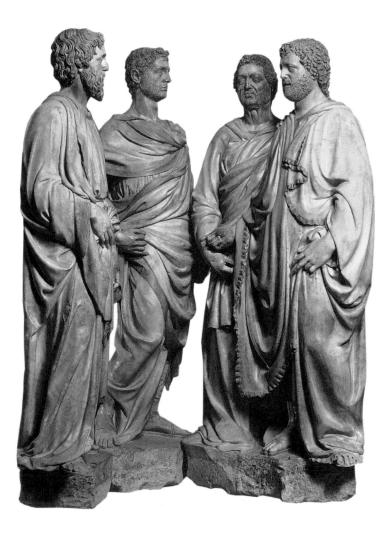

as the Benedictines. The Florentine Benedictines secluded themselves from the world within the walls of the Badia, a vast, self-sufficient complex of buildings, devoting themselves to lives of solitude and prayer rather than public ministry.

The Observant movement profoundly affected the Dominican Order throughout the lifetime of Angelico. In late 1405, Giovanni Dominici, who had been a friar at Santa Maria Novella, founded the Observant convent of San Domenico on the slopes of the hills of Fiesole, outside Florence, where Angelico and his brother later became friars. Sermons by the Observant Dominican preacher, Manfredi da Vercelli, delivered in the piazza of Santa Maria Novella between 1419 and 1423, urged the populace to devote themselves to God by uniting their work with lives of prayer. Leonardo Dati, Master General of the Dominicans between 1414 and 1425, advocated reform of the Order in sermons and treatises. Renowned for his eloquence and erudition as a preacher, he was prior at Santa Maria Novella before Angelico became a Dominican and may have influenced his decision to profess as an Observant friar.

The culture of Angelico's Florence was oral and intensely visual. Within the churches or the open piazzas in front of them, friars would set up pulpits to preach to the populace. In the opening years of the fifteenth century, Giovanni Dominici and Manfredi da Vercelli implored their listeners to repent for their own sins and for those of the city by returning to Christ. In so doing, they honoured the mission of their Order, which was devoted specifically to preaching, as well as the memory of such eloquent Dominicans as Saint Peter Martyr (1205–52), murdered by the very heretics he had hoped to convert (7). Whether preaching within the city's churches or in its piazzas, friars would illustrate their sermons by reference to the images that the devout knew well. Frescos, altarpieces, stained glass windows, processional banners, street tabernacles and sculpture portrayed the lessons of Christian faith for an audience that was largely illiterate.

Angelico's arrival in Florence coincided with the introduction of some remarkable innovations in architecture. In 1418, the sculptor and architect Filippo Brunelleschi (1377–1446), newly returned from Rome, entered the competition to construct the great dome for Arnolfo's Cathedral (5). This *tour de force* of engineering inaugurated the programme of building by the architect who inspired the city's evolution from medieval to Renaissance. Brunelleschi rejected the soaring height, pointed arches, massive piers, cluttered interiors and stained glass windows characteristic of late medieval architecture. In their stead, he constructed edifices in which the lucidly mathematical proportions, round-headed arches and hemispherical domes recalled those found in the ancient buildings that he had studied in Rome. In the year following the announcement of the competition for the Cathedral's dome, Brunelleschi began the reconstruction of San Lorenzo, one of the city's most venerable churches (6). The interior is rigorously geometric. The aisles, exactly half the width of the nave, are cubes of space supported by slender, grey stone columns. Grey stone trim unites the columns to the round-headed arches of the nave. The white stucco walls reflect the light from precisely aligned circular and arched windows that repeat the curvature of the arches below. San Lorenzo has been described as the first Renaissance church in Florence, expressing Brunelleschi's interpretation of Roman architectural principles.

Even before Brunelleschi began the construction of the Cathedral's dome and the church of San Lorenzo, the city's appearance was being transformed by sculpture. In 1403, the young and virtually unknown goldsmith Lorenzo Ghiberti defeated

Brunelleschi and others to win a major commission from the international wool merchants' guild, the Calimala, to make the bronze doors for the Baptistery, located directly in front of the Cathedral. Executed slowly and meticulously over the next two decades, the reliefs of the gilt bronze doors interpreted scenes from Christ's life with fluid grace and dramatic movement, together with Ghiberti's own detailed observations of space, nature and human behaviour. The primary source of his inspiration was sculpture from the late fourteenth century, reflecting the style known as late Gothic, seen in art from Tuscany to north of the Alps. The *Annunciation* epitomizes the influence of the late Gothic style on Ghiberti in the slender proportions of the elegantly turning figures, the rhythmically curving lines of the flowing drapery and such finely wrought details as the individually rendered feathers of the angel's wings (8). Other scenes reveal Ghiberti's study of ancient Roman sculpture, as in the nude, muscular torso of Jesus in the *Flagellation* and *Crucifixion*, and his awareness of Roman architecture.

As Angelico walked through the streets, he could observe the slowly unfolding drama of the city's transformation. During the first twenty years of the fifteenth century, numerous lifesize and larger than lifesize statues in marble and bronze were commissioned for sacred sites throughout Florence. The old sculptors who had controlled the workshop of the Cathedral were replaced by a new generation intent on innovation. The rising masters included Donatello, who apprenticed with Ghiberti, and Nanni di Banco (*c*.1380/5–1421), who was trained in the Cathedral workshop. In 1408, the young sculptors began to carve statues of seated Evangelists for the façade of the Cathedral, elongating the torsos and deeply undercutting the folds of drapery to compensate for the distance from which the figures would be seen (10). Donatello's monumental statues for the Bell Tower of the Cathedral further explored the implications of these discoveries with their forceful postures, boldly carved drapery and intensely characterized expressions. The city's guilds that controlled commerce and labour practices and wielded political influence were also important patrons of the arts. In response to an edict passed by the Florentine government, they began to fill the niches of Orsanmichele, located on the street that connected the Palazzo della Signoria to the Cathedral, with statues of their patron saints that were larger than lifesize. Over the next two decades, sculptors would produce figures of increasing realism and psychological penetration inspired by study of ancient Roman sculpture. From Nanni di Banco's *Four Crowned Martyrs* (9), which translated the appearance and spirit of Roman statues of emperors and orators with archaeological accuracy, to Donatello's *Saint Louis of Toulouse*, whose voluminous drapery of fire-gilt bronze gleamed in the sun, the statues set new standards for monumental sculpture. Such works are truly Renaissance statues, reviving the appearance and spirit of ancient sculpture.

In contrast to the architecture and sculpture, the paintings that Angelico saw preserved the rich visual legacy of the past. In the early years of the century, tradition rather than innovation was valued by the devout. Instead of being regarded as outmoded, holy icons in two of the city's oldest churches – Santa Maria Maggiore and Santa Maria del Carmine – were venerated as ancient images brought from the Holy Land, through which conversions and healings were performed and victories in battle assured. In the oratory of Orsanmichele, a miracle-working image of the Madonna, itself a replica of a much-venerated painting destroyed by fire in 1304, was the object of fervent devotion, for it had inherited the ability of the original to cure infertility and blindness. Another wondrous image, a thirteenth-century mural of the Annunciation

8 Opposite, top
Lorenzo Ghiberti, *Annunciation*, from North Doors, before 1407
Gilded bronze; 52 × 45 cm (20½ × 17¾ in)
Baptistery, Florence

9 Opposite, bottom
Nanni di Banco, *Four Crowned Martyrs*, *c*.1416
Marble; 185 cm (72⅞ in) high
Museo di Orsanmichele, Florence

10
Donatello, *Saint John the Evangelist*, completed 1415
Marble; 210 cm (82⅝ in) high
Museo dell'Opera del Duomo, Florence

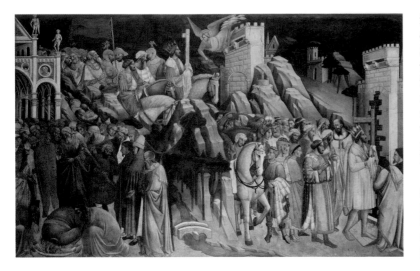

11
Agnolo Gaddi, *The Triumph of Heraclius*, from *The Legend of the True Cross*, 1388–93
Fresco
Choir, Santa Croce, Florence

12
Lorenzo di Niccolò, *Coronation of the Virgin*, 1402
Tempera and gold on panel;
208 × 261 cm (81⅞ × 102¾ in)
San Domenico, Cortona

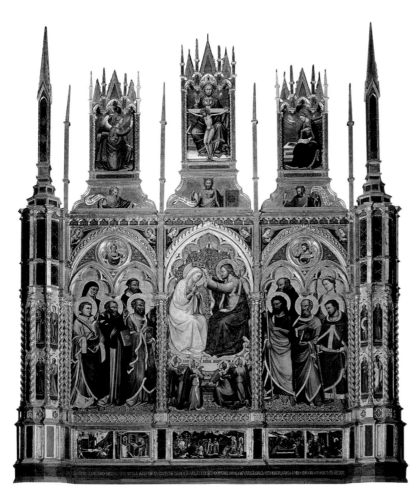

in the church of Santissima Annunziata, believed to have been completed by an angel, was copied for several of the city's churches. Such replicas paid homage to the original images and extended their charisma to these sites. These holy works, so profoundly rooted in the past, shaped the age's conception of the sacred. In a similar manner, older frescos or altarpieces might be eventually renewed or replaced when chapels changed ownership, but rarely because they were deemed outmoded. In fact, the very antiquity of these older paintings attested the venerable history and continuity of a family's lineage that was so greatly esteemed by contemporaries.

The training of artists in the workshop system contributed greatly to perpetuating the artistic traditions of the past. Often painters were taught by their fathers and, as a consequence, inherited the visual legacy of the previous generation. Such was the case with Agnolo Gaddi (recorded 1369–96), the dominant master in Florentine painting during the last few decades of the 1300s. Agnolo was taught by his father Taddeo Gaddi (1300–66), who in turn was a student of Giotto, revered as the greatest master of fourteenth-century painting in Florence. Agnolo's frescos of the *Legend of the True Cross* (11) are located in the choir of the church of Santa Croce, near the chapel painted by his father and adjacent to two chapels by Giotto, attesting the continuation of Giotto's legacy within the church. The narrative is multi-episodic, with numerous groups of figures clustered in the foreground and others placed within the landscape. So crowded, profusely detailed and anecdotal are the brightly painted scenes that individual figures and separate episodes can scarcely be distinguished. Without transition or middle ground, mountainous landscapes and the lofty walls of cities rise high behind the figures. Space does not recede in convincing perspective, but is tilted up so that every episode might be seen. Like that of his father, Taddeo, Agnolo's art, especially his interest in multi-episodic narration and deep space, emerged from the traditions established by Giotto's late works. Indeed, Agnolo's own pupil, the painter Cennino Cennini, paid homage to Giotto's legacy in his own works as well as in the dedication of his tract, *The Painter's Handbook (Il Libro dell'Arte)*. *The Painter's Handbook* appears to have been commissioned by the Florentine painters' guild in around 1390 and reflected prevalent aesthetic sensibilities. Revealingly, it is dedicated to God, an array of saints, and 'in reverence of Giotto, of Taddeo, and of Agnolo'.

When Angelico arrived in Florence, he beheld many of the same images that Agnolo had regarded in his youth on the walls and altars of the city's churches. The masters whose earliest works were executed in the last decades of the fourteenth century still dominated painting. Many of these artists, like Agnolo, were trained by their fathers, and are characterized as late Gothic because they carried the traditions of the previous generation into the early fifteenth century. Among them were Lorenzo di Niccolò (recorded 1391–1411), who studied with his father, Niccolò di Pietro Gerini, and Bicci di Lorenzo (1373–1452), son of the prolific Lorenzo di Bicci (c.1350–1427?). The *Coronation of the Virgin*, painted by Lorenzo di Niccolò for the church of San Marco in 1402 (12), closely reprises the altarpiece that he executed in collaboration with his father and Spinello Aretino for the church of Santa Felicita only a year earlier (14). It paraphrases the crowded composition of the earlier altarpiece, in which figures are closely clustered, and the space of the central panel is tilted up. Bicci di Lorenzo similarly perpetuated the sensibility of his father's era in the *Stia Triptych* (13), dated around the time of Angelico's arrival in Florence. The central panel seems inspired by the miraculous image in Santissima Annunziata, and the overlapping saints resemble those of Agnolo

Gaddi in their massive drapery, the linear drawing of their contours and their placid features. The crowded space and slanting perspective of the Virgin's room and throne typify the inconsistent rendering of perspective that prevailed in Florence at the time when Angelico received his training.

The leading master when Angelico came to Florence was Lorenzo Monaco, whose altarpieces, frescos and choir books filled many of the city's churches. Although the identity of Angelico's teacher is not recorded in any historical source, most scholars now believe that he was trained in the workshop of Lorenzo. This supposition is based primarily on an analysis of Angelico's early paintings, which demonstrate significant analogies in technique and style to works painted by Lorenzo in the first two decades of the century. Angelico shared the master's distinctive palette, unequalled in subtlety by any other artist of the day, in which colours are brilliant and myriad in hue, highlighted by thinly brushed filaments of white. The graceful, slightly elongated proportions of the figures in Angelico's early works, the luminous modelling of their drapery and their soft, delicate facial features closely resemble those of Lorenzo, and seem to have been inspired directly by his example. Angelico's residence near the monastery of Santa Maria degli Angeli, outside the walls of which Lorenzo established his shop, also is suggestive, since it was the practice of artists and apprentices to settle in the neighbourhood in which they had been trained. Angelico's association in 1417 with Battista di Biagio Sanguigni, a manuscript illuminator closely affiliated with Lorenzo's shop, provides yet another link between the two.

From the 1390s until his death in the mid-1420s, Lorenzo directed the most important and prolific school of manuscript illumination and panel painting in Florence. It was located just outside the walls of Santa Maria degli Angeli, a monastery of the Camaldolese Order. The Order was founded by Saint Romuald in the solitude of the Apennine Mountains, and was renowned for its mystical piety, austerity and eremitical isolation from the world. When Santa Maria degli Angeli was established in Florence in 1295, the monks were committed to pursuing lives of prayer, poverty and solitude within an urban setting. But by the end of the fourteenth century, the monastery had accumulated considerable wealth and possessions, which compromised their discipline. Encouraged by Giovanni Dominici, who wrote his anti-humanist treatise *Lucula Noctis* (1405) at the urging of its monks, Santa Maria degli Angeli sought to restore the ideals that originally had inspired its foundation. The activity of Lorenzo coincided with this period of spiritual renewal. In the opening years of the fifteenth century, Santa Maria degli Angeli became an important centre for reform and biblical scholarship. As Dominici implored in *Lucula Noctis*, only by study of scripture would the 'true poetry of wisdom' be revealed. Indeed, the monastery's prior, the brilliant scholar Ambrogio Traversari (1386–1439), devoted himself to translating sacred texts from Greek, Latin and Hebrew into Italian to recover the origins of Christian faith.

Lorenzo may have been trained as a painter before he took his vows as a monk. He became a deacon in 1396, but then left the cloister to take over a workshop of painters and manuscript illuminators. The growing shop was then moved adjacent to the walls of the monastery in order to respect the solitude of the monks. Continuing a tradition that began at Santa Maria degli Angeli in the mid-fourteenth century, the workshop was comprised of painters and manuscript illuminators. Scribes practised their craft within the walls of the monastery, where a scriptorium had long been established, but often illuminations were subcontracted

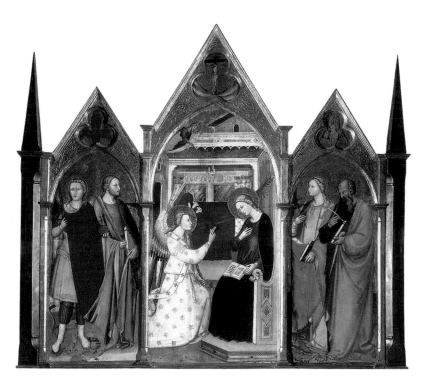

13
Bicci di Lorenzo, *Stia Triptych*, 1414
Tempera and gold on panel;
180 × 160 cm (70⅞ × 63 in)
Santa Maria Assunta, Stia

14
Spinello Aretino, Niccolò di Pietro
Gerini and Lorenzo di Niccolò,
Coronation of the Virgin, 1401
Tempera and gold on panel;
275 × 278 cm (108¼ × 109½ in)
Accademia, Florence

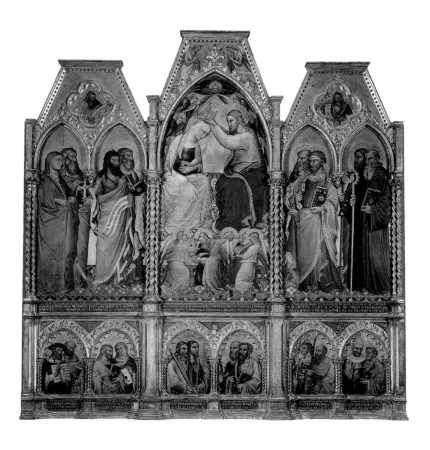

15
Lorenzo Monaco, *Coronation of the Virgin*, 1414
Tempera and gold on panel (modern frame); 450 × 350 cm (177⅛ × 137¾ in)
Galleria degli Uffizi, Florence

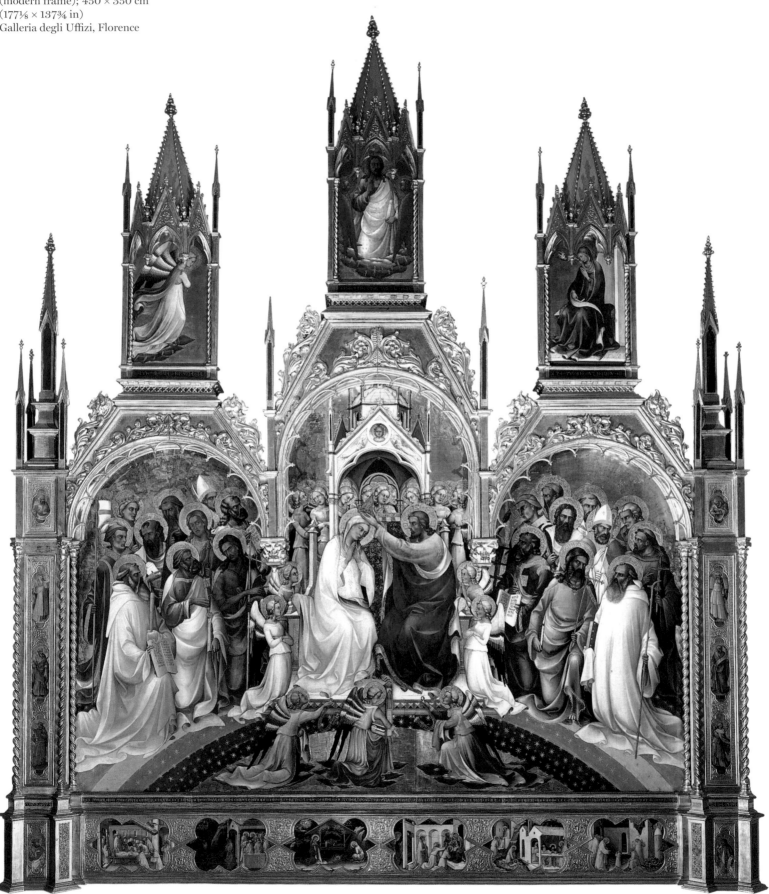

to lay painters. The workshop specialized in producing the large, illuminated choir books that Camaldolese monks used in chanting their liturgy (17). Eventually, choir books were produced for other religious orders and churches throughout Tuscany. The miniatures decorating these choir books not only illustrated narrative events and themes described in the accompanying liturgy, but served as mnemonic devices, helping the monks to remember the complicated texts. The preparation of these books was extremely costly, labour-intensive and time-consuming. It often involved the collaboration of several artists over many years or even decades to paint the illuminations for a single volume. Through their engagement in this process, apprentices would have been exposed to the style and techniques of diverse artists. At the same time, Lorenzo sought to impose a uniform style on the works produced under his supervision.

The workshop of Lorenzo Monaco was distinguished from the enterprises maintained by most lay painters. Santa Maria degli Angeli was located in the parish of San Michele Visdomini, where several artists also lived and worked. Lofty walls enclosed the monastery, isolating it from the distractions of the everyday world, although Camaldolese monks collaborated with lay painters and apprentices. Working together, they produced a range of devotional objects that included not only the choir books for which they were best known, but also monumental frescos and altarpieces. In so doing, the monks exposed their lay collaborators to the spirituality of the Order. In fact, the shop of Lorenzo was the only one in Florence in the early years of the fifteenth century known to have been directed by a monk. The spiritual ambience of the workshop must have been unique for this very reason.

Angelico is likely to have begun his apprenticeship as early as 1410 or 1412, most probably under the aegis of Lorenzo Monaco. This was precisely the time that Lorenzo and his shop were beginning to paint the *Coronation of the Virgin* for the high altar of Santa Maria degli Angeli (15). The inscription on its elaborate gold frame ascribes the altarpiece to Lorenzo, 'a monk of this Order, and his [associates]'. It attests the Order's devotion to the Virgin, to whom Santa Maria degli Angeli was dedicated. The inscription further commemorates the installation of the *Coronation* on the altar in February 1414. The altarpiece displays the luminosity, glowing colours and expressive figures that are found in Angelico's earliest paintings.

The *Coronation of the Virgin* is Lorenzo's masterpiece. Concentric rings of saints and angels rhythmically encircle the Virgin and Christ, who are enthroned beneath a Gothic tabernacle. Elongated, curving lines describe the contours of the holy figures, whose yearning postures, impassioned gestures and intense faces express their piety. Sinuous drapery dramatically envelops their bodies, the edges of the deep, metallic folds radiant with light. The chromatic brilliance of the *Coronation* is extraordinary. The painting glows with myriad hues and variations of colour: the star-studded rings of the heavens range from pale azure to deepest lapis lazuli; the Virgin and the kneeling founders of the Camaldolese Order are robed with shimmering white drapery; and the saints wear luminous red, yellow and green mantles. Transparent filaments of white paint are brushed lightly over the drapery of some of the figures to enhance the chromatic radiance. The small-scale narratives that comprise the predella (the painted panels at the base of the altarpiece) would best be viewed by the worshipper while kneeling. Lucid compositions devoid of extraneous detail direct the beholder's attention. In the *Nativity*, for example, the roof of the manger, receding in perspective, fits precisely within

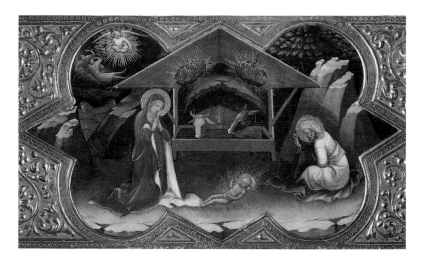

16
Lorenzo Monaco, *Nativity*, predella panel of *Coronation of the Virgin* (15)
Tempera and gold on panel
(modern frame)
Galleria degli Uffizi, Florence

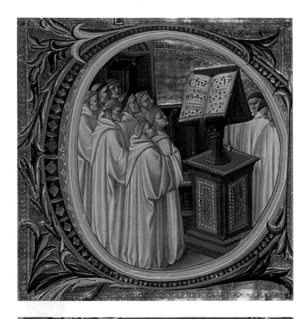

17
Attributed to Zanobi Strozzi,
Camaldolese Friars in Choir, fol. 41v,
from *Corale 3 (Diurno Domenicale 3)*,
*c.*1450–5
Tempera on parchment
Biblioteca Medicea Laurenziana,
Florence

18
Attributed to Zanobi Strozzi,
*The Dance of King David before the Ark
of the Covenant*, fol. 57v, from *Corale 3
(Diurno Domenicale 3)*, *c.*1450–5
Tempera on parchment
Biblioteca Medicea Laurenziana,
Florence

the angle of the frame to focus attention on the infant Jesus (16).
The prophets of the pilasters, like those in the choir books
illuminated by the workshop, are endowed with extraordinary
movement. Their dramatically turned postures and wind-filled
drapery convey the fiery words of their apocalyptic prophecies,
which foretell the coming of the Messiah and the resurrection
of the dead.

Theologians regarded the Coronation of the Virgin as the
culminating event in Mary's existence, when she passed from
this life to reign beside her son as Queen of Heaven. Accordingly,
depictions of this theme were often splendidly framed, as
demonstrated by the altarpieces painted in the first years of the
century (see 12, 14). A comparison of these works suggests how
greatly the *Coronation of the Virgin* for Santa Maria degli Angeli
surpasses them in variety and magnificence. In Lorenzo's altarpiece
the celestial setting, so distinctively portrayed by the arches of
the starry blue heavens, and the profusion of saints and angels,
the latter garbed in radiant white mantles like those worn by the
Camaldolese monks themselves, reflect the dedication of the church
and monastery to the Virgin of the Angels. Christ and the Virgin
are seated on a throne inspired by the tabernacle enshrining the
miraculous image in Orsanmichele, evoking the charisma
of that work. The brilliance of the colours, so luminous and varied
in contrast to the earlier altarpieces, and the abundance of gold
surrounding the figures and in the frame, convey the aura of
majesty. The beauty of the *Coronation* inspired commissions from
Lorenzo well into the 1420s, including a close imitation for
a Camaldolese church on the outskirts of Florence. The workshop
responded to this demand by painting devotional works that
were based on prototypes in the master's repertoire. The most
popular themes included the Madonna of Humility, the Crucifixion
and silhouetted crucifixes that were displayed on altars or carried
in religious and civic processions.

A range of individual styles may be distinguished in these
collaborative paintings, although they share the exquisite
craftsmanship, luminous palette, sinuous line and expressive faces
with small, finely drawn features that are hallmarks of the master's
style. The presence of these very features in paintings by Angelico
seems to confirm that Lorenzo was his teacher. It is perhaps among
the many images by the shop that one might seek to identify the
first works of Angelico, but despite suggesting the probability of his
training and origins and the stimulus for his earliest works, his
direct participation cannot be identified with assurance in any one
of them. The same is true of the choral books produced in Lorenzo
Monaco's shop. At one time, several miniatures in a choir book,
the *Corale 3* (begun in 1409), were ascribed to Angelico, but critical
opinion has changed. Although *The Dance of King David before
the Ark of the Covenant* seemed to suggest the expressive grace of
the young Angelico, the strongly shadowed modelling, opaque
colours and elongated facial features instead suggest the execution
of Zanobi Strozzi, one of his later associates (18).

If Angelico indeed received his education as an artist under
Lorenzo Monaco, he would have observed the organization of

a workshop that included those devoted to the religious life as well as lay artists. This experience would have served him well when he began his own workshop in San Domenico di Fiesole, similarly composed of friars and secular painters. It may have been through Lorenzo that Angelico became acquainted with the painter Battista di Biagio Sanguigni. Although Battista is known primarily as a manuscript illuminator, recent research has identified him as the Master of 1419, the artist who painted an altarpiece in 1419 for the chapel of the prominent Giugni family for their parish church in the Mugello. This work and other devotional panels reveal his probable origins in Lorenzo's workshop, as seen, for example, in the Ackland *Madonna of Humility* (20), a studious reiteration of a Madonna by Lorenzo Monaco's shop (21).

On 31 October (the vigil of All Saints Day) in 1417, 'Battista di Biagio Sanguigni, miniaturist' sponsored Angelico – 'Guido di Piero, painter of the parish of San Michele Visdomini' – for entrance into the religious confraternity of San Niccolò di Bari, to which he himself belonged. At this point, Angelico had achieved his independence as a painter and was living in the neighbourhood around Santa Maria degli Angeli, where Battista also resided. The confraternity, one of two in Florence dedicated to Saint Nicholas of Bari, was founded in the church of Santa Maria del Carmine as a flagellant society of the strictest discipline. It was comprised of twenty men, primarily Carmelite friars, although the Dominican Giovanni Dominici was accepted as a member in 1408. While this ardent reformer was almost certainly living in Rome when Angelico joined, his membership and the involvement of Carmelite friars signal the exceptional spiritual rigour of this penitential society, which also performed acts of charity within the city. As well as Angelico, two more of the lay brethren who joined the confraternity became friars, one an Augustinian and the other an Observant Franciscan.

Of the many confraternities associated with the Carmine, San Niccolò was the only one with a private oratory in the church. Located in the crypt below the high altar, the oratory was frescoed with scenes from the Passion of Christ that inspired the penitential rituals of the brethren. Primary among these was weekly self-flagellation, through which the members ritually recreated the tortures inflicted upon Jesus in an effort to expiate their sins and those of the city. On Good Friday, the members mimetically recreated the Passion, weeping and embracing the confraternity's crucifix while carrying it in a torchlight procession for 'burial' before the altar of the oratory. Penitential piety among the laity was on the rise in fifteenth-century Florence, but the discipline practised at San Niccolò was exceptionally severe. Angelico's membership in a flagellant confraternity dominated by clerics signified an intense and evolving piety that led to his vocation as a Dominican friar.

By the time he entered the confraternity of San Niccolò, Angelico had begun to establish himself professionally. In January and February 1418, he received payments for a now-lost altarpiece for the Gherardini Chapel in Santo Stefano al Ponte. The church, located near the Ponte Vecchio, was built on the site of the ancestral home of the Gherardini family, whose dead had been buried in its

19
Madonna and Child, detail from
San Domenico Altarpiece (33),
*c.*1422–3, as modernized by Lorenzo
di Credi in 1501
Tempera and gold on panel
San Domenico, Fiesole

20
Attributed to Battista di Biagio
Sanguigni (formerly known as
the Master of 1419), *Madonna
of Humility*, c.1420–5
Tempera and gold on panel;
116.4 × 54 cm (45⅞ × 21¼ in)
Ackland Art Museum, University
of North Carolina, Chapel Hill,
Ackland Fund 80.34.1

cloister since the early fourteenth century. The decoration of the chapel was administered by the officers of Orsanmichele, the façade of which was then being adorned with monumental statues by Ghiberti, Donatello and Nanni di Banco, the most advanced masters of the day. The officers previously had commissioned Ambrogio di Baldese to fresco the walls of the chapel, and Giovanni dal Ponte to paint the altar frontal. Although their works for the chapel, like Angelico's altarpiece, have not survived, these painters were trained in the late fourteenth century and represented a previous moment in the history of Florentine art. Conceivably, the officers of Orsanmichele, who had seen the innovative, life-like sculpture enliven the façade of their oratory, might well have chosen to commission the chapel's most important adornment from Angelico, who represented a rising generation. They also may have known Angelico through Lorenzo Monaco, who was the chaplain of Orsanmichele as late as 1412. Although no documents for earlier works by the young master have yet been found, he must have achieved some prominence to have received this commission. The loss of the altarpiece is one of many obstacles that complicate the reconstruction of his chronology in the decade before his first surviving documented work, the *Saint Peter Martyr Triptych* (see 7, 45 and 46), for which an overdue payment was expected in 1429.

Generally it has been assumed that the origins of Angelico cannot be recovered. Many scholars have dated his earliest known works in the early to mid-1420s, apparently believing that those from the previous decade have all been lost. Consequently, a great number of paintings have been placed in the 1420s, notwithstanding the diverse influences and styles that they collectively reflect. It seems likely, however, that several were executed before this decade, for they interpret themes associated with Lorenzo Monaco in a style and sensibility closely related to that of the master. They may be attributed to Angelico because of their analogies to paintings from the 1420s known to be by him, including the altarpieces that he painted for the church of his own convent. His colours are distinctive in their range and luminosity, dominated by deeply saturated crimsons and roses, pale blues and lime greens highlighted with pale yellow. The proportions of the figures are graceful, slender and elongated, and drapery flows over the body in deep folds and calligraphic lines. The features of the Virgin and angels are delicately modelled and delineated, with fleshy eyelids, narrow noses and small mouths. Figures are arranged in a rhythmic, varied manner, creating visual harmony even in symmetrical compositions. While they suggest Angelico's training by Lorenzo, they also reveal his innovations in portraying traditional themes. His earliest paintings demonstrate his emergence as an independent personality from the time when he completed the lost altarpiece for the Gherardini Chapel until his entrance as a novice in San Domenico di Fiesole.

A crucial work for understanding this early moment is the St Petersburg *Madonna of Humility* (22), a devotional painting of unknown provenance (now displayed in a modern frame). The theme of the Madonna of Humility originated in the mid-fourteenth century and surged in popularity through the first few decades of

21
Workshop of Lorenzo Monaco,
*Madonna of Humility, c.*1418
Tempera and gold on panel;
112 × 66.5 cm (44 × 26⅛ in)
Nelson-Atkins Museum of Art,
Kansas City, MO

the fifteenth century. It was portrayed time and again by Lorenzo
Monaco and his workshop. It shows the Virgin, humbly seated on
the ground instead of majestically enthroned, tenderly holding
the infant Jesus on her lap. It foretells the Lamentation, when the
Virgin sits on the ground to cradle her dead son in her lap, presenting
to the worshipper his sacrifice to redeem the sins of humankind.
The allusion to the Saviour's fate is made explicit in the predella
below several paintings of this theme, as seen in a *Madonna
of Humility* by Lorenzo's shop from around 1418 (21). In the centre
of the predella, the dead Christ is shown in his sepulchre.

If indeed Angelico was taught by Lorenzo, he may have
participated in creating the many variations of the Madonna of
Humility theme produced by the shop. Among them are paintings
in which a pair of angels, kneeling or in flight, pay homage to the
Virgin and Child, as they do in this panel. Lute-playing angels
kneel before them, evoking the solemn melodies of sacred music.
The lily-filled vase between them recalls the Annunciation and
innumerable epithets to Mary as the sacred vessel filled with Christ,
the Word of God incarnate. Although the Virgin is seated humbly
on the ground, the luxuriousness of the gold-embossed tapestry
and cushion and her crimson gown, patterned with gold, portray
her as Queen of Heaven, as she was acclaimed in songs and
the liturgy.

The attribution of this *Madonna* to Angelico is substantiated
by a comparison with the central panel of the *San Domenico
di Fiesole Altarpiece* (19), painted in the early 1420s for the church
of the convent where he took his vows. (The altarpiece will be
discussed at length in Chapter Two.) In both works, the slender
proportions, averted profile, sidelong glance and delicately drawn
features of the Virgin and the softly modelled anatomy of the lively
infant reveal Angelico's origins in the shop of Lorenzo Monaco,
as do the luminous colours and calligraphic drapery, especially the
mantle of the Virgin, with its bright, contrasting lining. The
Madonna of Humility seems to precede the altarpiece by several
years. Angelico's conception of perspective is less advanced than
in the Fiesole altarpiece, where the receding tiles of the floor and
arms of the throne convey the illusion of depth. His notion of space
is related to that of the past, as suggested by a comparison to
the *Coronation of the Virgin* altarpieces associated with Lorenzo
di Niccolò (see 12, 14). The Virgin is seated atop a gold-embossed
tapestry that rises around her instead of receding in depth. As
was traditional, the Child's halo is flat, not foreshortened as in
the altarpiece.

The *Madonna of Humility* merges elements from several
paintings by Lorenzo and his shop, but they are suffused with a
distinctive sensibility. The flying angels at first seem virtual mirrors
of the Archangel Gabriel from the pinnacle of Lorenzo's *Coronation
of the Virgin* (see 15), as do the kneeling ones, also adapted from
the *Coronation*. At the same time, they are fully integrated into the
composition, forming a rhythmic frame around the Virgin and Child.
The airborne angels, their garments lifted by a heavenly breeze
and their wings poised in flight, and the music-making ones who
gaze upwards, move with fluid grace. The poignancy of the image

22
*Madonna of Humility, c.*1418
Tempera and gold on panel;
80 × 51 cm (31½ × 20 in)
Hermitage, St Petersburg

23

Madonna of Humility, c.1419
Tempera and gold on panel;
102 × 58 cm (40⅛ × 22⅞ in)
Museo Nazionale di San Matteo,
Pisa

is magnified further by the depiction of the Child lying nude on the lap of the Virgin, covered only by her veil, which, it was believed, became his shroud.

The precocious development of Angelico's sensibility is apparent in the Pisa *Madonna of Humility* (23). It formed the central panel of a dismembered altarpiece and is enclosed in its original frame. The coats of arms painted on the frame are those of the couple who commissioned it. The only legible arms, those of the wife, belong to an illustrious Florentine family, the Giugni, suggesting the prestige of this commission. The family traced its ancestral roots to the Mugello, where in 1419 Battista di Biagio Sanguigni had painted an altarpiece for the family chapel in their parish church. The Giugni donated funds to the friars of Santa Maria degli Angeli, a connection that, in light of Angelico's proposed association with Lorenzo Monaco, may be relevant to this commission. Although the original location of the *Madonna of Humility* is unknown, Angelico's patronage by so prominent a family indicates the professional stature he had achieved at this time.

The Pisa *Madonna of Humility* was inspired by the paintings of this theme by Lorenzo Monaco and his shop, as revealed by a comparison with the Kansas City *Madonna* (see 21). In both, the elongated proportions of the seated Virgin are enhanced by the curve of the mantle that flows below her waist, revealing the graceful lines of her ungirt, patterned gown. The Virgins have similar features, with almond-shaped eyes, narrow noses and small mouths, although those of Angelico's Virgin are more softly modelled. Finely incised against the gold ground on the panel, the rays emanating from the Madonna are found only exceptionally in representations of this theme. To the fifteenth-century worshipper, the rays would have conveyed myriad associations. Because the Holy Spirit is painted above the Virgin, they may allude to the moment of the Annunciation, when the Word of God was 'made flesh'. Rays of light are also attributes of the Virgin as the 'woman clothed with the sun' who portends the Apocalypse, as described in the Book of Revelation. The roundel of Christ in the frame supports this interpretation. Blessing the faithful, he proffers an open book inscribed with the Alpha and Omega. In the Book of Revelation, the Lord announces the Last Judgement by proclaiming, 'I am the Alpha and the Omega, the beginning and the end'. Imparting the aura of divine majesty, the rays surrounding the Virgin and Child augment the apocalyptic and devotional associations of the image.

The painting is larger than the St Petersburg *Madonna of Humility* (see 22) and is more austere in conception. While retaining the gold-embossed tapestry on which the Virgin sits, it excludes the vase of flowers in favour of the roses, symbolic of Mary's purity, held by the Child, and omits the angels symmetrically framing the holy figures. The gaze of the Madonna does not directly meet that of the beholder, but is slightly averted, suggesting her private contemplation of Jesus's fate. The playful infant reaching towards his mother has been replaced by a child whose expression is sombre and whose movement is restrained by the Virgin's transparent veil. The foreshortening of his halo and lowered head as well as the angle of his body suggest that Christ is turning towards the kneeling worshipper in compassionate response to prayer.

The solemn piety of the Pisa *Madonna of Humility* (see 23) is translated affectively in the *Crucifixion with the Virgin, John the Evangelist and Mary Magdalene* (26). Nothing is known about its patronage or provenance, but its size suggests that it was a private devotional panel. Until relatively recently, the painting was ascribed to the School of Lorenzo Monaco. The attribution initially seems supported by analogies to several works by the

24
Lorenzo Ghiberti, *The Sacrifice of Isaac*, 1401–3
Gilded bronze; 53 × 44 cm
(20⅞ × 17⅜ in)
Museo Nazionale del Bargello, Florence

25
Lorenzo Monaco, *Crucifixion*,
*c.*1405–10
Tempera and gold on panel;
50 × 26.5 cm (19⅝ × 10½ in)
Accademia, Florence

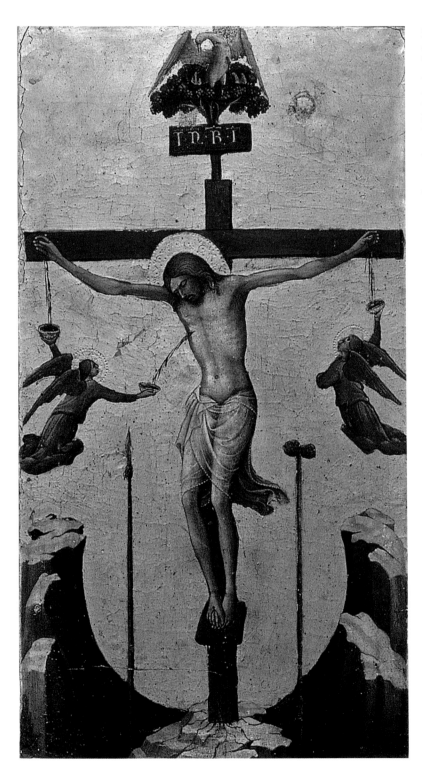

master and his shop, including silhouetted crucifixes as well as devotional and processional panels of the crucified Christ (25). The slender anatomy of Jesus, the taut contours shadowed against the gold ground and the windblown loincloth are related closely to those in the Accademia *Crucifixion*, as is the foreshortening of his head, lowered in death. Above the Cross, the pelican feeding her young with the bleeding flesh of her breast symbolizes the sacrifice of Jesus, whose body and blood are mystically present in the consecrated Eucharist. The graceful, flying angels trailing clouds confirm the origins of the painting in the circle of Lorenzo Monaco. Although the *Crucifixion* emerges from traditions preserved by Lorenzo, its sensibility suggests Angelico's authorship.

While derived from Lorenzo's portrayals of the Crucifixion, this interpretation is stylistically and notionally different, corroborating the attribution to Angelico. The anatomy of Jesus is not defined by line, but modelled in subtly graduated light and shadow to suggest its musculature and volume. The body's weight is conveyed by the tension of Christ's arms and shoulders. Instead of being shown laterally, as was traditional in Lorenzo's Crucifixions, the footrest of the Cross is depicted frontally – a more challenging solution for the accurate portrayal of space – and is foreshortened to enhance its immediacy to the beholder. The neck and lifted wing of the symbolic pelican above the Cross are consistent with the perspective of the head of Christ, underscoring his Eucharistic sacrifice. While blood pours from the wounds on his hands and side, as in Lorenzo's painting, the angels do not hover below the Cross with chalices to catch Christ's blood, but devote themselves to prayer as they behold their saviour. One is portrayed at an angle, in *profil perdu*, as if he were flying behind the Cross.

The sensibility of Angelico is best expressed in the mourners below the Cross. The artist created the illusion of depth by varying the angles at which they are portrayed and through perspective. The Virgin Mary, her features and garments luminously modelled, engages the gaze of the beholder directly as she gestures towards her son. The kneeling Magdalene embraces the Cross, which she wraps with her brilliant scarlet mantle. John the Evangelist dramatically balances the women. Instead of facing forwards, as was conventional, he turns from them to gaze upon the Cross. The slope of his shoulders, prolonged by the fall of his mantle, expresses the weight of his sorrow. Lorenzo Ghiberti's competition panel of the *Sacrifice of Isaac* for the North Doors of the Florence Baptistery inspired this figure, whose profile reverses that of the foreground servant and whose features recall those of Isaac (24). The extraordinary pathos of the Evangelist, whose enraptured face is lifted to Christ, discloses an engagement that seems intensely personal. Angelico – still known as Guido di Piero – chose the name 'Giovanni' when he entered San Domenico di Fiesole, in homage, perhaps, not to the patron saint of Florence but to the Evangelist, the apostle most beloved by Christ, who witnessed the Crucifixion and whose Gospel was most divine. With eloquent piety and passion, the *Crucifixion* reveals the artist's spirituality as well as his mastery. It may have marked the decisive moment in Angelico's life when he relinquished wealth and worldly success to take holy vows.

26
*Crucifixion with the Virgin, John
the Evangelist and Mary Magdalene,*
*c.*1419–20
Tempera and gold on panel;
63.5 × 38.1 cm (25 × 12½ in)
Private collection

2
Friar John of the Friars
of San Domenico
Paintings from the 1420s

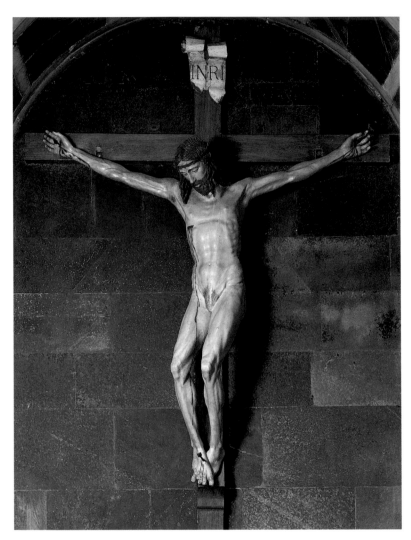

27
Filippo Brunelleschi, *Crucifix*,
c.1410–15
Polychromed wood; 170 × 170 cm
(67 × 67 in)
Santa Maria Novella, Florence

Previous page
Detail of *Madonna of Mercy with
Kneeling Friars*, fol. 156v, from
Messale 558 (40)

The convent of San Domenico di Fiesole rises along the gentle slope of a hill known in Angelico's day as Poggio di Camerata. Cypresses and poplars line the road that passes before it, leading from the city of Florence, some 6.5 kilometres (4 miles) away. In November 1405, the Dominican bishop of Fiesole, with the support of the friars of Santa Maria Novella, donated the vineyard on which the priory was built. Here, the ardent reformer Giovanni Dominici established this holy refuge 'in the name of the Lord and in Observance of the Rule of Saint Dominic'. Dominici hoped to revive the original Rule of his Order, founded two centuries earlier by Saint Dominic (1170–1221), who devoted his life to apostolic poverty, preaching and prayer. In the solitude of the hills, the brethren lived in humble quarters and practised severe forms of asceticism, including ritual self-flagellation and fasting. They committed their lives to study and meditation 'unceasingly by day and by night', as the Rule of Saint Dominic required, and prepared themselves for 'the care of souls'. Eight times a day they met for lengthy recitations of prayers, reading aloud sacred texts and chanting hymns to honour the Lord and the Virgin Mary, to whom the Order was especially dedicated. So fervent was their commitment to the Observance that the friars moved into the priory before its construction was complete.

But in 1409, the friars of San Domenico di Fiesole were forced to flee their home. They opposed the bishop of Fiesole by supporting the unpopular Pope Gregory XII (reigned 1406–9), one of two rival popes who claimed the right to rule Christendom during the final years of the Great Schism (see Chapter One). For almost a decade the friars lived in exile, seeking shelter in Dominican convents in the towns of Foligno and Cortona, where their faith was tested by plague and hunger. In 1417, with the election to the papacy of a Roman who took the name of Martin V, the schism came to an end, bringing harmony to the Church after over a century of division. The friars returned safely to Fiesole, where they were compelled to assume new responsibilities by Leonardo Dati, Master General of the Dominican Order. Dati, who resided in Santa Maria Novella, was determined to promote the Observant reform by enlarging San Domenico for training new friars. In May 1418, he persuaded a wealthy Florentine merchant, Barnaba degli Agli, to bequeath the enormous sum of 6,000 florins for the repair, expansion and adornment of San Domenico, and for the maintenance of the brethren so that 'they might continue to live in poverty in Observance of the Rule of Saint Dominic'. In a codicil to his will, Agli stipulated that construction was to begin within two years of his death. Thus the painter Guido di Piero began his life as the friar known as Fra Giovanni in the newly reconstituted Observant community.

Certainly, Angelico's joining the flagellant confraternity of San Niccolò di Bari in 1417 attested an intense faith that led, perhaps inevitably, to his religious profession. The artist might have been inspired to become a Dominican by the example of Giovanni Dominici, at one time a member of the confraternity, who was renowned for his extraordinary piety. It may have been equally relevant to the painter that Dominici, who personally illuminated manuscripts as a devotional exercise, accorded a crucial role to sacred images in promoting and enhancing faith. Indeed, the

Dominican Order itself consistently employed art to convey doctrine as the visual counterpart to its sermons, a corollary to the mission of preaching.

The Dominicans had established distinctive pictorial and iconographic traditions, as is evident in works that the faithful saw in Santa Maria Novella at the opening of the fifteenth century. Stained glass windows and paintings of the Virgin Mary commemorated the Order's dedication to her, for through the sacrifice of her son, the disobedience of Adam and Eve was believed to have been redeemed. Frescos of saints on the intrados (underside) of the ribbed vaults of the nave seem to support the church. The commitment of the friars to preaching was strengthened by the didactic frescos of Andrea da Firenze in the Chapter House (see 96) and the portraits of Dominicans in the vaults of the cloister, which extolled the luminaries of the Dominican Order. Crucifixes by Giotto and Filippo Brunelleschi (27) called to mind the Dominicans' exaltation of the Eucharist and the feast of Corpus Domini, the liturgy for which was written in 1264 by the Order's greatest theologian, Saint Thomas Aquinas (1225/27–74). Around 1425, Masaccio executed his fresco of the *Trinity* (28), a theme that resonated with theological, social and civic associations. He portrayed the Trinity – God the Father, his son Jesus and the Holy Spirit – a subject of special significance to Dominican theologians, within a mathematically structured space. All elements of the painted architecture, from the base of the columns to the curving vault, recede in perspective to a central point, creating a convincing illusion of depth.

An immediate catalyst for Angelico's religious profession may have been his engagement with Dominican spiritual culture at Santa Maria Novella. From February 1419 until early September 1420, this church was at the forefront of sacred, civic and artistic life when Pope Martin V, an avid supporter of reform, and his court took up residence in the convent of the church. Delegations of dignitaries paid their respects to the new pontiff, and preachers, among them the Observant Dominican Manfredi da Vercelli, filled the piazza in front of Santa Maria Novella with apocalyptic sermons that urged commitment to religious life. Taking advantage of the auspicious presence of the pope, the friars prepared to consecrate the church before he left for Rome. In preparation for so momentous an occasion, it seems that Angelico was asked to execute several works, which are now lost. They included a fresco of three venerated Dominicans – Dominic, Catherine of Siena and Peter Martyr – above the doors of the choir screen (also known as a rood screen), the lofty wall that separated the friars from the laity. Painting the fresco would have allowed him entrance into the choir, the most sacred space of the church. He also decorated a candelabrum, carved by 1419, with 'little stories', and painted shutters depicting the Annunciation for the church's organ, refurbished before March 1420. In all likelihood, negotiations for these commissions would have placed the artist in contact with the convent's bursar during these years, Fra Giovanni Masi. Masi was among the friars chosen by Giovanni Dominici to live in the original community of San Domenico, and might have shared

28
Masaccio, *Trinity*, c.1425
Fresco; 640 × 317 cm (252 × 124¾ in)
Santa Maria Novella, Florence

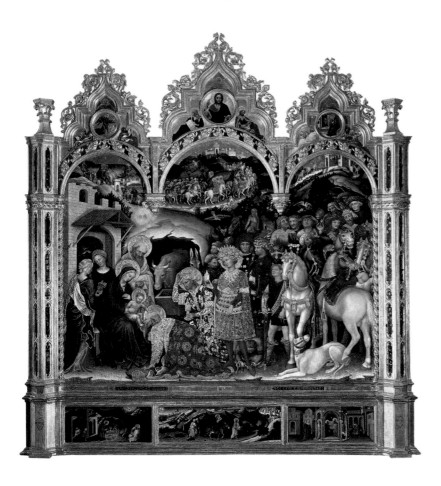

29
Gentile da Fabriano, *Adoration of the Magi*, 1423
Tempera and gold on panel; 300 × 282 cm (118⅛ × 111 in)
Galleria degli Uffizi, Florence

30 Opposite
Masaccio, *Tribute Money*, c.1425
Fresco; 255 × 598 cm (100⅜ × 235½ in)
Brancacci Chapel, Santa Maria del Carmine, Florence

his recollections of its early years with the artist. It seems almost certain that Angelico met with Leonardo Dati, whose commitment to maintaining orthodoxy may well have involved his supervision of the church's decoration. Given the involvement of Dati with securing Barnaba degli Agli's bequest for San Domenico and investment in its success, he might have personally recruited postulants for the convent, as Giovanni Dominici had done at its foundation. Angelico may well have been among them.

Angelico's novitiate coincided with years of notable innovation in Florentine painting. Although the aged Lorenzo Monaco dominated painting until his death in the mid-1420s, other artists had begun to challenge his pre-eminence even before then. In 1424, the installation of Ghiberti's North Doors for the Florence Baptistery influenced the city's art profoundly. Admired by all who passed through the piazza, the North Doors transformed how many painters interpreted narrative. Dramatic settings were created with architecture inspired by that of ancient and medieval Rome, and with naturalistic landscapes of rocky hills and trees of distinguishable species and variety (see 8, 58). Remarkable for their diverse appearance, graceful proportions, flowing drapery and beautifully curled hair, the slender figures responded through posture, gesture and expression to the events in which they participated. From monumental frescos and altarpieces to small-scale manuscript illuminations and predella panels, numerous works from the 1420s, including those by Angelico, reflect the influence of Ghiberti in their compositions, figures and drapery.

Another master who influenced Florentine painting in the 1420s was Gentile da Fabriano (*c.*1385–1427). Born in northern Italy, Gentile brought the courtly elegance and naturalism of its art to Florence, where he may have arrived in late 1420. The most famous of his works is the *Adoration of the Magi*, completed in 1423 for the chapel of the Strozzi, at that time the wealthiest family in Florence, in the church of Santa Trinita (29). Representing

a subject rarely depicted in altarpieces, the *Adoration of the Magi* was remarkable for features unprecedented in Florentine painting: luxurious textiles, glittering surfaces, rich colours and a profusion of exotic figures and animals. Gentile depicted anatomy, facial features and drapery with subtlety, graduating colours and modelling form from light to dark. The predella incorporated elements from Franco-Flemish manuscript illumination, as seen in the delicately rendered figures and the slanting walls of architecture that deepen the illusion of space in the *Adoration of the Child*. By graduating the saturation of the night-time sky from the misty horizon above the hills to the zenith, Gentile simulated atmospheric perspective as it appears in nature. Angelico responded to these innovations, especially to Gentile's description of atmospheric perspective, in his works from the middle of the decade, while several of his contemporaries imitated in their paintings the luxurious textiles worn by the Magi.

But it was Masaccio who exerted the greatest influence on Florentine painting over the course of his brief life. During a career that lasted less than a decade before his death at the age of only twenty-seven, the precocious master introduced major innovations that contrasted in almost every way to those of Gentile. They included an austere conception of narrative, with figures set in stark landscapes and framed by architecture inspired by that of Filippo Brunelleschi. Masaccio's conception of space, influenced by experiments conducted by Brunelleschi, was virtually unprecedented in painting (30). The painter constructed his settings through mathematical perspective, in which lines of architecture appear to recede consistently towards a single centric point, as in the *Trinity*, frescoed in Santa Maria Novella (see 28). The anatomy and sculptural drapery of his figures were consistently modelled in light and shadow; feelings were convincingly conveyed through gesture and expression. In the 1420s, several artists imitated paintings of the Virgin and Child that Masaccio had executed jointly with

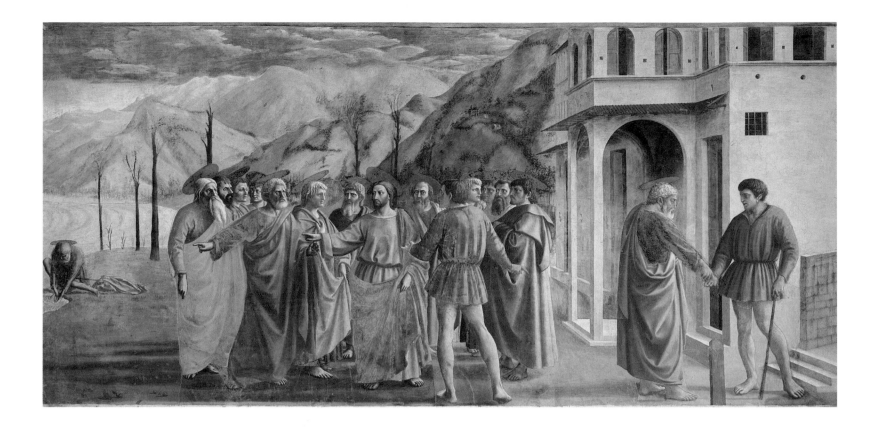

Masolino (1383/4–c.1436), with whom he frequently collaborated (31). Angelico was foremost among them, revealing a profound understanding of the master's legacy. He was well aware of innovations in Florentine visual culture even as he made his profession as a Dominican friar.

The loss of records from San Domenico makes it impossible to determine when Angelico left Florence and began the probationary two years in the solemn process of ordination. His novitiate conceivably had commenced as early as spring 1420, when rebuilding of the convent began in accord with the terms of Agli's bequest. It was certain to have taken place by late June 1423, when, as 'frate Giovanni de' frati di San Domenico da Fiesole' ('friar John of the friars of San Domenico in Fiesole'), he was paid for painting a crucifix in the hospital-church of Santa Maria Nuova. In taking the habit of the Order, Angelico relinquished the comforts of the secular world, devoting himself to austerity and complete obedience to a penitential way of life that included fasting, flagellation and regular prayer and study. The Dominican Constitutions stipulated the asceticism of the novitiate, during which the postulant was taught humility, restraint and obedience under the aegis of the convent's novice master and prior. He laid his possessions at the feet of the prior, committing himself to poverty and a communal way of life. The novice devoted himself to study, reading and reflecting upon spiritual writings that included the Bible, the *Legends of the Saints*, the *Confessions* of Saint Augustine and scriptural commentaries by great theologians. These texts shaped his spirituality, suffusing his mind with the love of wisdom and the love of God to prepare him for preaching, the primary mission of the Dominicans. He learned the distinctive liturgy and hymns of the Order. After two years of probation, he continued his preparation by studying grammar and philosophy in addition to theology, which would augment his eloquence as a preacher. At least five or six years of this intense way of life were required for his ordination as a priest, permitting him,

in the words of Saint Thomas Aquinas, 'to transmit to others' the mysteries of the Christian faith through preaching.

The Dominican Constitutions emphasized the crucial role of the novitiate in shaping the spirituality and comportment of the new friar, who would be indoctrinated completely into 'the Order's way of life' and taught 'how to behave'. During the early 1420s, when Angelico had entered the Order, the priors of San Domenico had been members of the original community established by Giovanni Dominici, and were committed to reviving his rigorous ideals. From March 1422 to June 1424, and again between 1425 and 1426, the prior of San Domenico and Angelico's superior was Antonino Pierozzi, often called Antoninus, the Latin form of his name. One of the greatest luminaries of the Dominican Order, he was canonized in 1523. The future vicar general of the Observant reform and the archbishop of Florence from 1446 until 1459, Antoninus was justly renowned as one of the most eminent thinkers of his age. For the laity, he composed popular tracts on spirituality and Christian life, several especially for women, as well as letters and sermons in Italian. For the learned, he composed historical and devotional treatises, confessors' manuals and spiritual guides in Latin that reveal his extraordinary erudition. Among them was the *Summa historialis* (*Compendium of History*), which encompassed 'the history of the Roman popes and emperors, and the schisms and the wars' from 1371 to the fall of Byzantium in 1453. It coupled factual accuracy with great empathy for the human toll taken by war and civil unrest, placing this time within the broader scope of Church history. Antoninus's most important legacy is the multi-volume *Summa theologica moralis* (*Compendium on Moral Theology*). Although he began composing it in 1440, it reflected sermons and writings as well as teachings that he had imparted to the friars during his years as prior in Fiesole and at the convent of San Marco. The *Summa theologica* provided erudite theological commentaries and addressed an encyclopedic range of religious, legal, social and

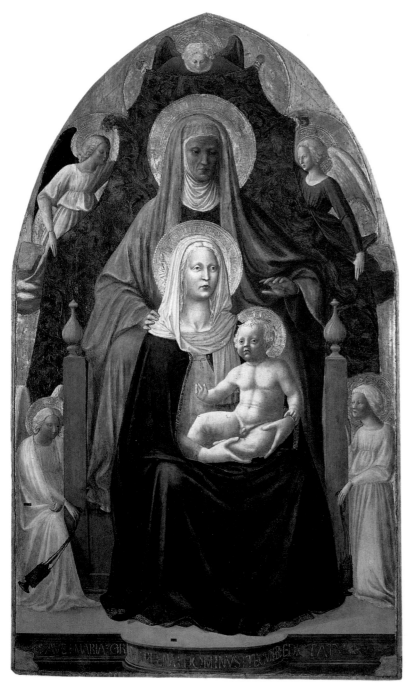

ethical issues. Numerous passages were concerned with art and the role of religious images in instilling devotion.

Antoninus shared Giovanni Dominici's belief in the efficacy of sacred art to enhance piety and convey the tenets of faith. While earlier theologians, most notably Saint Bernard of Clairvaux (1090–1153), had condemned art as a vain and impious distraction from the truths of faith, Antoninus recognized its importance in inspiring devotion. As he observed in the *Summa theologica*, images were valuable 'not in and for themselves, but because they move the worshipper beyond the representation to the object of worship'. They evoked adoration of God, his son and the saints, who 'as a result of grace or glory' served as intercessors for the faithful. Antoninus explained that holy images partook of the sacred by stimulating contemplation of higher things. An altarpiece 'of the most blessed Mary with her son in her arms', for example, inspired the faithful to 'hope for advocacy with her son for remission of our sins'. The priest himself was elevated to greater devotion as he looked upon the image. 'Looking intently at Mary' while 'handling the sacrament', he would be moved to consider how she 'made the Word flesh' in giving birth to her son. Still beholding the image, the priest was to contemplate his role in bringing forth, ever humbly, 'the Body and Blood of Christ from the substance of bread and wine'. The didactic and transformative role that Antoninus assigned to sacred art accorded with the preaching mission of the Dominican Order. While none of his writings explicitly discussed the artists who made holy images, he may have shared Giovanni Dominici's belief that the creation of sacred art in and of itself constituted a spiritual exercise.

So it was for Angelico. The three altarpieces and a splendidly illuminated choir book that he executed for the church and convent of San Domenico not only demonstrate his mastery in the 1420s but are suffused with Dominican ideals, most notably the veneration of Christ and Mary. According to the convent's chronicle (begun in 1516 but based on early documents), the altarpieces were painted 'many years before this church was consecrated' in November 1435. Their style suggests that they were executed during the 1420s. The high altarpiece, indispensable to the celebration of Mass and the worship of the friars, was completed first, followed by the *Annunciation* and the *Coronation of the Virgin*, the most mature of the works (see 163). Their subjects reflected the special devotion of the Dominicans to the Virgin, who was accorded primacy by its theologians and praised as 'our advocate' in the friars' prayers. The Order's devotion to the Virgin extended to its art. In his writing on holy images, Saint Thomas Aquinas declared that only those of the Virgin were to be venerated with *hyperdulia* – the greatest adulation – in homage to her as Mother of God. The altarpieces exalted Mary as Mother of God, virginal vessel of the Word and Queen of Heaven, crowned by her son amidst reverent saints and choirs of angels. They reveal Angelico's immersion in the Order's spirituality, his origins as a Dominican painter and his receptivity to artistic innovation during the 1420s. Although the friar resided in Fiesole, these works indicate his contacts with Florentine art.

The *San Domenico Altarpiece* was the first painting that Angelico executed for the church (33). It represents the Virgin and Child surrounded by angels and flanked by four saints: Thomas Aquinas, the Order's greatest scholar; Barnabus, patron saint of Barnaba degli Agli, benefactor of the convent, to whom the church was jointly dedicated; Dominic, founder of the Order and co-dedicatee of the church; and Peter Martyr, the Order's first martyr and most eloquent preacher. Originally conceived as a triptych, it was united into a single panel and its background repainted by the

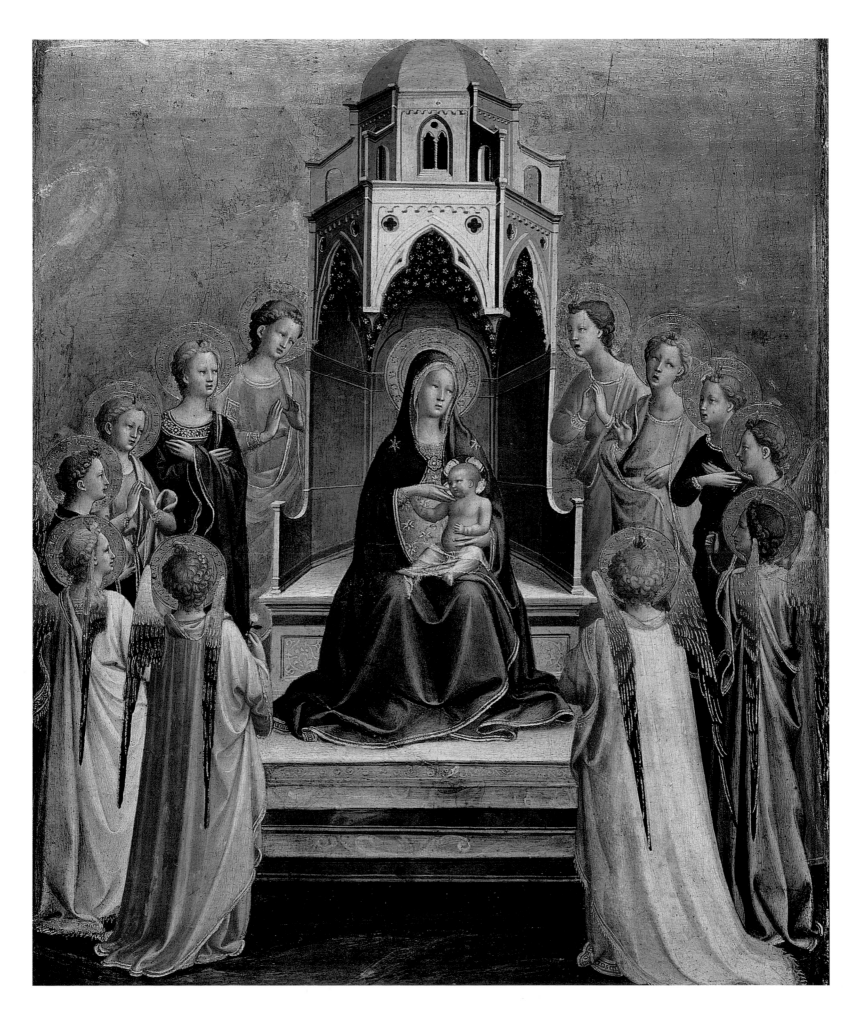

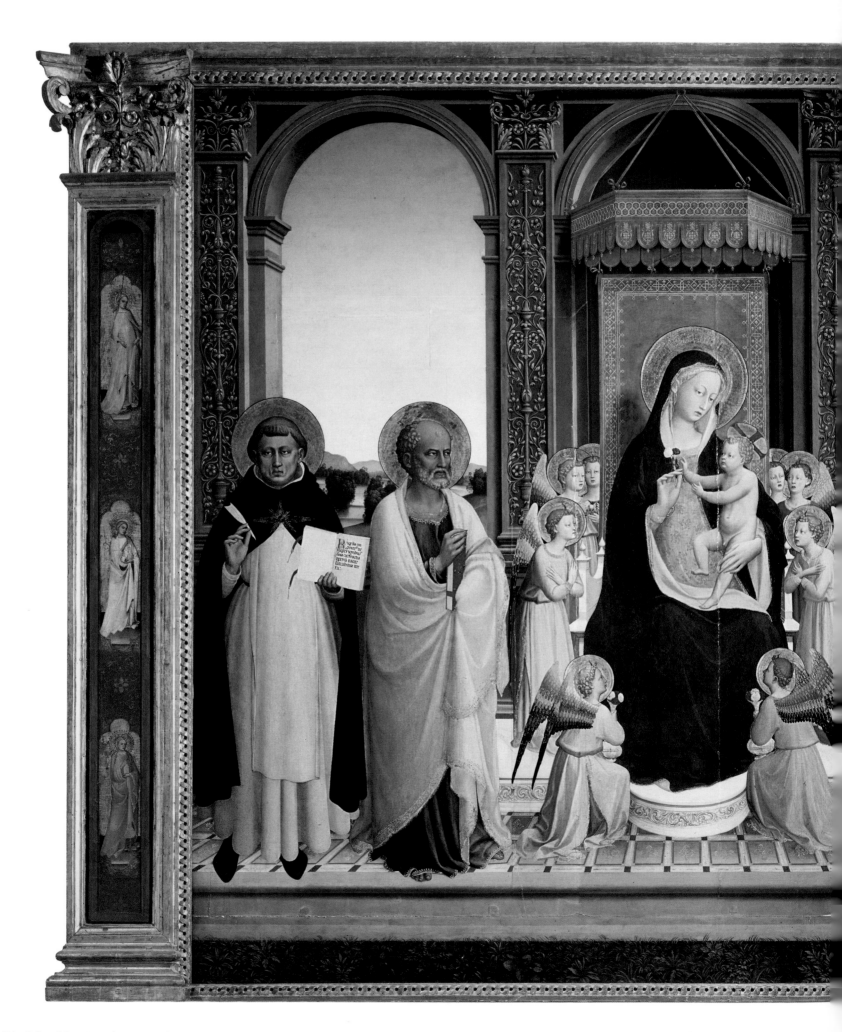

42 *Friar John of the Friars of San Domenico*

33
The Virgin and Child with Saints Thomas Aquinas, Barnabus, Dominic and Peter Martyr, known as *San Domenico Altarpiece, c.1422–3*, as modernized by Lorenzo di Credi in 1501
Tempera and gold on panel;
212 × 237 cm (83½ × 93⅜ in)
San Domenico, Fiesole

artist Lorenzo di Credi in 1501, when the church was modernized. Although Lorenzo retained the curved base below the throne and the patterned floor receding in perspective, he unified the individual, arched panels and replaced the gold background with a continuous architectural and landscape setting, increasing its height and width. He substituted a cloth of honour and canopy for the throne of the Virgin, which may have resembled the Gothic tabernacle in Angelico's nearly contemporary, small-scale *Madonna and Child with Twelve Angels* (32). Lorenzo also dismantled the frame, replacing its pilasters painted with saints and its pinnacles, which were adorned with roundels depicting the Annunciation.

It is impossible to recreate a work that was altered so dramatically. Its original appearance may be imagined from a digital reconstruction (see 164), inspired by Angelico's *Cortona Triptych* (see 76), which is still intact. Although the transformation of the altarpiece in 1501 might have been instigated by the renovation of the church itself, it may also have been an act of homage to the saints and possibly, to the friar himself. Highly venerated images were often repainted and enshrined in more modern frames. Although Lorenzo di Credi altered the background, he left the figures as they had been painted, preserving them as precious relics of Angelico's mastery.

The *San Domenico Altarpiece* adorned the high altar, located in the choir, where the friars sang hymns as they celebrated the Divine Office. A lofty choir screen separated them from the laity, who viewed the altarpiece through an opening, which may have been surmounted by a crucifix. Although the altarpiece was visible to the entire congregation, the friars alone beheld the image up close, from a literally more privileged perspective. The altarpiece evoked veneration of the Virgin and Child, enthroned and surrounded by angels, calling to mind innumerable hymns and prayers that laud Jesus as 'king and ruler of the universe' and Mary as 'queen of heaven' and 'queen of the angels'. According to Antoninus, an altarpiece served as a surrogate for their actual presence in the church. It stood in their stead 'in the sanctuary, as if in the place of the Throne of Mercy in the Holy of Holies', as the altar of God. The saints flanking the Virgin commemorated the church as a Dominican congregation and served as intermediaries through whom the faithful channelled their prayers. As Saint Thomas himself had declared, prayers directed to saints and angels were 'made efficacious' through 'their prayers and merits', transferred through them to God. As Dominicans, the friars modelled their

lives after the saints and were inspired by the illustrious spiritual and intellectual legacy of their Order. The penetrating gaze of Saint Thomas exhorted them to contemplate the words on his open book. These lines were taken from Psalm 104:13, upon which he based his inaugural address as Doctor of Theology in 1256, and they praise the goodness of the Lord: 'From thy lofty abode thou waterest the mountains; the earth is satisfied with the fruit of thy works.'

Only the friars would have been privileged to view the predella in all its detail, as they knelt before the altarpiece (34). Nearly 300 miniature angels, Old Testament prophets, New Testament saints and Dominican worthies are identified by their distinctive features, attributes and garments as well as by inscriptions. The figures turn toward the central panel, where the resurrected Jesus, resplendent in radiant white garments and emitting rays of light, ascends heavenward among throngs of angels acclaiming his majesty with music and prayer. Although there is precedent in Dominican art for the multitudes of saints and angels adoring the resurrected Christ, the predella is the most comprehensive representation known. It may illustrate the *Te Deum* – the Latin hymn of praise to God – for the feast of Corpus Domini, which was composed by Saint Thomas Aquinas to celebrate Christ's presence in the Eucharist. The *Te Deum* praises those in the heavens – choirs of cherubim and seraphim, prophets, apostles, saints and martyrs – who acclaim Jesus as 'the king of glory' who 'overcame death, and opened the kingdom of heaven for the faithful'.

The association of the feast of Corpus Domini with the Order is made explicit by the outermost panels, in which Angelico depicted twenty-four Dominicans, garbed in their distinctive black and white habits and emitting golden rays that signify their blessed state. They turn toward the central panel and behold the rising saviour with awe. Originally, a gilt tabernacle, adorned with jubilant angels and the resurrected Christ, enclosed the Host. Placed before the altarpiece, it magnified these Eucharistic associations. Aligned with the central panel of the altarpiece and predella, it was placed on the altar for veneration by the friars. The laity viewing the altarpiece from outside the choir screen could not have seen such detail nor would they have comprehended the theological subtleties of the image in the same way as the friars. Nonetheless, the text of the liturgy and the crucifix surmounting the choir screen communicated the relationship between the Mass and the altarpiece. Through Mary, the Word was made flesh; through the sacrifice of her son, salvation was procured for the faithful; through the mediating

community of saints and angels – and the Dominican friars – the prayers of humankind would be received.

The *San Domenico Altarpiece* marks a crucial point in Angelico's development as an artist. It may have been installed by 1424/5, when an altar cloth for the high altar chapel was completed. Although the slender proportions and delicate features of the Virgin and the lively Child emerged directly from the artist's paintings of the Madonna of Humility (see 22, 23), the altarpiece is more mature. In obvious response to Gentile da Fabriano, the calligraphic rhythms of the drapery reminiscent of the late Gothic style have been subdued, and the modelling of the anatomy and facial features has become softer and less linear. Significantly, the altarpiece reveals a new interest in representing space. Angelico contrived its rising perspective to appear convincing to the friars who genuflected before it. Receding tiles replace the tapestry-like floor of the earlier works, and a throne with curving arms and base substitute for the Virgin's cushion. The angels who rhythmically encircle the Virgin diminish in scale from foreground to back. Those kneeling at the foot of the throne enhance the illusion of depth, for they turn at an angle toward her, their profiles nearly hidden against their haloes. Even Jesus's halo is foreshortened in perspective – portrayed as if seen from a diagonal angle rather than frontally. These elements suggest Angelico's awareness of Masaccio's earliest known work, the *Cascia di Reggello Altarpiece* (35).

Angelico demonstrated extraordinary mastery in the altarpiece. His colours glow with radiance, revealing a myriad spectrum of hues, from the shimmering, transparent veil of the Virgin to the gowns of the angels, which range from crimson and blue to luminous rose and pale malachite highlighted with yellow. Employing a technique found almost exclusively in manuscript illumination, Angelico traced the contours of the figures with fine lines of red and brown tempera. He filled their forms with colours graduating from light to dark to suggest the volume of their bodies and garments. Drapery, especially the habits of the Order's saints, falls in deep, sculptural folds modelled in light and shadow, and faces are depicted in a subtle chiaroscuro. The distinctive appearance of the Dominicans was based on authoritative images in paintings and manuscripts. The portrait-like images in the altarpiece and predella not only conveyed the appearance of these pious individuals, but also imparted authenticity to the altarpiece, situating it artistically and historically within Dominican visual culture.

Although Angelico seems to have painted the main panels exclusively by himself, the predella suggests the collaboration of an assistant. Certainly the sublimely expressive and varied angels surrounding Christ in the central panel are by the master, but several other figures may not be. The alignment of the saints in the panel to its left is less rhythmic and continuous, and there are spaces between them. Some are painted more thickly and flatly, lacking the subtle modelling and gradations of colour that convey volume, and their expressions and gestures seem formulaic and without nuance. Such deviations in quality suggest that the master did not work alone. A possible collaborator might have been his brother Benedetto, who appears to have entered San Domenico a little later than Angelico and was ordained in 1429. It is possible that Benedetto was trained in the scriptorium of Santa Maria degli Angeli, where he became an expert scribe (see Chapter One). He may have worked with Angelico in painting these figures, inscribing the names that identify so many of them. Of equal importance, as Angelico and his collaborator depicted these devout figures while contemplating the meaning of their lives, they became immersed more thoroughly in the teachings of their faith. The same was true of the priest and friars who celebrated Mass as they prayed before the image on the high altar, privileged to behold it from so close and isolated from the laity by the choir screen.

The lay congregation of San Domenico worshipped at two chapels dedicated to the Virgin and located on the choir screen that faced the nave. Their altarpieces depicted the Annunciation and Coronation of the Virgin, commemorating Mary's role as Mother of God and Queen of Heaven, as she was praised in hymns, sermons and prayers. The chronicle of the convent indicates that the Gaddi family, descendents of the painters Taddeo Gaddi and Agnolo Gaddi (see 11), maintained at least one of them. As has been noted, the Gaddi were closely associated with the Dominican Order in the early fifteenth century, donating funds to Santa Maria Novella as well as to San Domenico. One of their members, Agnolo di Zanobi Gaddi, was also a patron of Angelico. The family coat of arms, along with that of his wife, Maddalena Niccolò Ridolfi, are painted on the *Penitent Saint Jerome*, the commission for which has been associated with their marriage in 1424 (36). This wealthy Florentine may also have commissioned the *Annunciation* for San Domenico (38). The work reflects influences suggesting its execution around the mid-1420s.

The Annunciation was of special importance to the Dominicans

34
Predella (now separated) of *The Virgin and Child with Saints Thomas Aquinas, Barnabus, Dominic and Peter Martyr*, known as *San Domenico Altarpiece* (33), c.1422–3
Tempera and gold on panel;
32 × 244 cm (12½ × 96 in)
National Gallery, London

35

Masaccio, *Cascia di Reggello*
Altarpiece, 1422
Tempera and gold on panel; central
panel: 110 × 65 cm (43¼ × 25½ in);
each side panel: 88 × 44 cm
(34⅝ × 17¼ in)
San Giovenale, Cascia di Reggello

because of their devotion to the Virgin. The Order's liturgy for the feast of the Annunciation (25 March) praised Mary as 'source of our redemption', a theme echoed in the writings and sermons of its theologians. In the *Summa theologica*, Saint Thomas Aquinas praised Mary as 'so full of grace' that 'her flesh conceived the Son of God', and identified her as the antithesis of Eve, whose disobedience led to the Fall. Antoninus imagined 'the Holy Spirit' and tongue of God 'speaking through the good word of the angel' to the Virgin, in whose womb 'the word was made flesh'. In Florence itself, the feast of the Annunciation was observed with great solemnity, for the city, the Cathedral of which was dedicated to the Virgin, began its new year on that day. Indeed, one of the most venerated miracle-working images in Florence was the *Annunciation* in the church of Santissima Annunziata, so highly regarded that it was replicated in several churches in Florence and its environs (see 13). Although Angelico paid homage to this numinous work, he reinterpreted the theme in a dramatically new way.

Rejecting the crowded space of previous portrayals, the *Annunciation* is unprecedented in its lucid composition and portrayal of perspective. The altarpiece is defined by the classicizing loggia, the slender columns of which divide the composition evenly in thirds, isolating Adam and Eve from the miraculous event transpiring beneath its arches. As with the slender pilasters of the frame, the curving vaults and rational proportions seem inspired by the architecture of Brunelleschi. The columns and vaults of the loggia recede diagonally, creating the illusion of depth, an impression enhanced by the angled walls and bench of the room beyond. Although the perspective of the loggia is imperfect, Angelico's exploration of space and depiction of architecture are far more sophisticated than in the *San Domenico Altarpiece*. They suggest Angelico's response to Brunelleschi, who himself had experimented with perspective and may have assisted Masaccio in designing the mathematically precise, illusionistic architecture

of the *Trinity* (see 28), or to the works of Masaccio, which were unparalleled in their realistic descriptions of space.

But it was not the architecture or space alone that distinguished the *Annunciation*. Angelico's description of the hands of God, encircled by an orb of light and sending forth the Holy Spirit on golden rays, and of the Archangel Gabriel and the Virgin Mary are as extraordinary as the inclusion of Adam and Eve. The Archangel recalls Saint Thomas's description of his 'radiant face, splendid garments, and wondrous bearing'. His face glows with a pearly luminosity, his robes are richly embellished with gold and his wings are tensely poised, with each feather painted, gilded and incised to capture and reflect light. His magnificence contrasts to the humble demeanour of the Virgin, who lowers her head towards him in obedience to God's will. Antoninus explained Gabriel's greeting to Mary: 'I am saying 'Ave' [Hail] to you, the complete opposite of whom is Eva [Eve]'. The inscription on the frame of the altarpiece begins directly below the expulsion of Adam and Eve, making explicit the antithetical association between Eve and Mary: 'AVE MARIA GRATIA PLENA' (Hail, Mary, full of grace). Masaccio's *Expulsion* at the entrance to the Brancacci Chapel in Santa Maria del Carmine, evidently inspired the figures of Adam and Eve (37). Reversing the figures, Angelico concealed the nudity of the progenitors and suppressed their unrestrained grief while retaining the foreshortening of their luminously modelled legs. In this, the earliest known adaptation of these figures, Angelico revealed his response to the most advanced work of the mid-1420s and his intense engagement with Florentine visual culture.

The predella panels recount other events in the life of the Virgin. From her marriage to the aged Joseph to her funeral, each scene was painted with prodigious detail and delicacy, confirming Angelico's training as a manuscript illuminator. Angelico studied the predella of Gentile da Fabriano's *Adoration of the Magi*

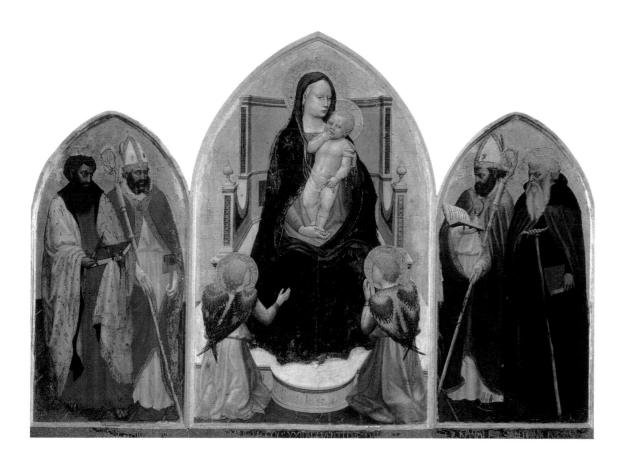

(see 29), as is evident in the rounded features of the figures, their expressive gestures and the slanting, diagonal walls that deepen the illusion of space, as in the *Marriage of the Virgin*. Angelico calibrated the perspective of the shed in the central scene, the *Adoration of the Magi*, tilting it to accord with the viewpoint of the kneeling worshipper, and transformed Gentile's urban piazza in the *Presentation of the Christ Child*, filling the space fully with a circular temple. Of all these scenes, Gentile's influence is most evident in the undulating, misty hills in the *Visitation* and *Adoration of the Magi*, which seem inspired by the landscape of the *Flight into Egypt*. By graduating the intensity of the azure sky as it rises from the horizon, Angelico simulated atmospheric perspective as depicted by Gentile – and as it appeared in nature.

The *Coronation of the Virgin* was located on the right altar of the choir screen (39). It complemented the *Annunciation*, portraying the ultimate glorification of Mary when Jesus crowned her as Queen of Heaven. Although this subject is apocryphal, it was inspired by a rich tradition of biblical writings, most of them from the Old Testament, thought to foretell this event. One of these texts was I Kings 2:19, in which King Solomon, the wisest Hebrew ruler, accorded homage to his mother following his coronation as king of the Israelites, by preparing 'a seat to be set' for her as 'she sat down at his right hand'. Christian theologians interpreted this as a prophecy of the coronation of the Virgin, and identified the 'seat to be set' as the Throne of Wisdom incarnated in Jesus. The theme had special significance for the Dominicans because of their dedication to Mary. In his sermon lauding 'the most holy Virgin Mary', Humbert of Romans, author of the Order's Rule, identified her as 'the throne of Christ's grace', who is 'extremely powerful in the court of heaven'. Dominican friars hailed Mary as 'Queen of Heaven' and 'Queen of Angels' in the concluding verses of the Office of the Virgin. They chanted the beautiful hymn known as the 'Salve Regina' ('Save us, O Queen') in the daily procession that they instituted

in her honour. With its multitudes of saints and choirs of angels, the *Coronation of the Virgin* expressed the Order's veneration of Mary.

Numerous altarpieces of the Coronation of the Virgin were painted in Florence in the early fifteenth century, from the panel for Santa Felicita, jointly executed by Spinello Aretino, Niccolò di Pietro Gerini and Lorenzo di Niccolò (see 14) to Lorenzo Monaco's celestial interpretation of 1414 (see 15). The altarpiece of San Domenico differs from them all. It is the first altarpiece of this theme in which perspective is not incidental, but central to the work's conception. The pattern of the floor is comprised of rectangles and lozenge shapes that seem to flatten and recede diagonally from foreground to back. Nine polygonal steps lead to the throne, which is enclosed in a hexagonal tabernacle draped in luxurious, gold-embossed brocade. The walls and arches of this imposing structure are portrayed at an angle as if seen from below, and the adoring saints and angels diminish in size as they ascend toward the throne, suggesting their distance from those below it. Angelico contrived these elements to be seen from the viewpoint of the kneeling worshippers who, like the saints below the throne, lifted their gazes to witness this holy ceremony. He even represented the wheel of Saint Catherine at a diagonal angle and foreshortened the lowered heads of several saints and angels. This further enhanced the illusion that the painted image was an extension of the viewer's space. These elements reveal a more knowledgeable engagement with perspective than the high altarpiece and the *Annunciation*, suggesting the artist's greater maturity.

Hosts of holy figures surround the tabernacle, conveying the majesty of heaven. Closest to the throne, choirs of youthful angels play lutes and trumpets and are distinguished by the light-suffused colours and gilded decoration of their flowing gowns. They call to mind Giovanni Dominici's writing on the Coronation, in which he imagined the resplendent, jewel-like colours worn by the ranks of 'blessed angels' whose instruments 'make sweet harmony'. These

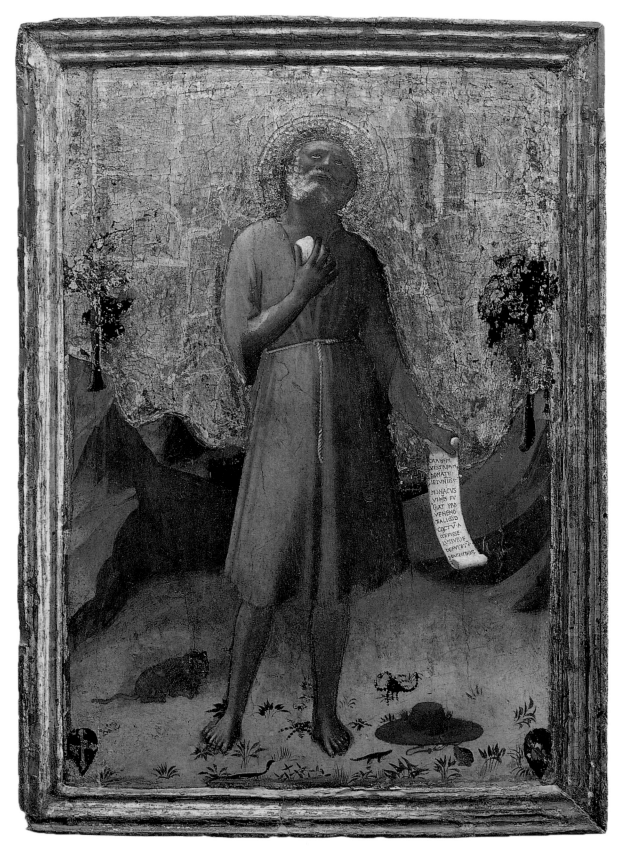

36
*Penitent Saint Jerome, c.*1424
Tempera and gold on panel;
56.5 × 41 cm (22¼ × 16⅛ in)
The Art Museum, Princeton
University, Princeton NJ

37 Opposite
Masaccio, *Expulsion of Adam
and Eve, c.*1425
Fresco; 208 × 88 cm (81⅞ × 34⅝ in)
Brancacci Chapel, Santa Maria
del Carmine, Florence

delicately painted figures suggest Angelico's study of Ghiberti's North Door reliefs (see 8, 58) in the grace of their gestures and garments, the variety of their expressions and even the refined description of each strand of their hair. Below them, bearded patriarchs, virgin saints and martyrs stand and kneel in adoration. These figures are modelled in a luminous chiaroscuro, giving them a sculptural presence. They are characterized by their varied responses to the sacred event, the splendour of their garments and their attributes.

Inscriptions on the haloes and books of the saints identify them and attest to the scholarly legacy of the Dominican Order. John the Baptist is described as 'Precursor of the Lord', Simon as 'Apostle and Preacher'. On the left, Saints John the Evangelist, Dominic and Thomas Aquinas hold open books inscribed with Latin texts, some biblical and others taken from their own writings. The words on John's book introduce his own Gospel, declaring the advent of 'the Word' and his role in bearing 'witness to the light'. There are several sources for the texts inscribed on Thomas's book, including the 'Sanctus', the hymn that was sung at the foot of the altar during the celebration of Mass. The invocation 'Holy, Holy, Holy, Lord God of Hosts' opens the 'Sanctus', proclaiming that 'cherubim and seraphim in unceasing voices', choirs of apostles and prophets laud the 'majesty of heaven and earth'. In this eternal realm, Jesus, identified as 'Lamb of God' by his halo, rules alongside the Virgin. Taken from Ecclesiasticus 24, the inscription on her halo praises her as 'Mother of Beauty' and 'Holy Hope'. These epithets were interpreted in a famous sermon by Saint Thomas, lauding Mary as consolation of the sorrowful and font of mercy.

The predella underscored the church's identity as a Dominican congregation. It portrays six miraculous events from the life of Saint Dominic flanking the *Man of Sorrows*, in which the Virgin and John the Evangelist mourn the entombed Christ. The narrative scenes are continuous, separated by painted gold columns. They begin with Dominic's support of the falling church of the Lateran that symbolized his renewal of the Church. They conclude with his death, when he bequeathed charity, humility and poverty to the friars before being received into heaven by the Virgin, her son and a multitude of angels. The space is deep, as epitomized by the receding arcades in *Saints Peter and Paul appearing to Saint Dominic*. Atmospheric perspective is rendered less abruptly than in the predella of the *Annunciation*, as seen in the softly graduated azure sky in the *Death of Saint Dominic*. The continuous space of the scenes, their evolved perspective and the highly expressive figures suggest Angelico's application of the innovations of Masaccio and Gentile da Fabriano, translated to the small scale predella.

As their style indicates, the altarpieces for San Domenico were painted over the whole course of the 1420s, from the opening years of the decade to its conclusion. Imbued with the spirituality and teachings of the Dominican Order, they reflect Angelico's response to the most innovative works of the time and his experiments with representing light and perspective. A parallel evolution is evident in the illuminations of a choir book, written on parchment, that contains the sung portions of the Mass and the liturgy for the feast

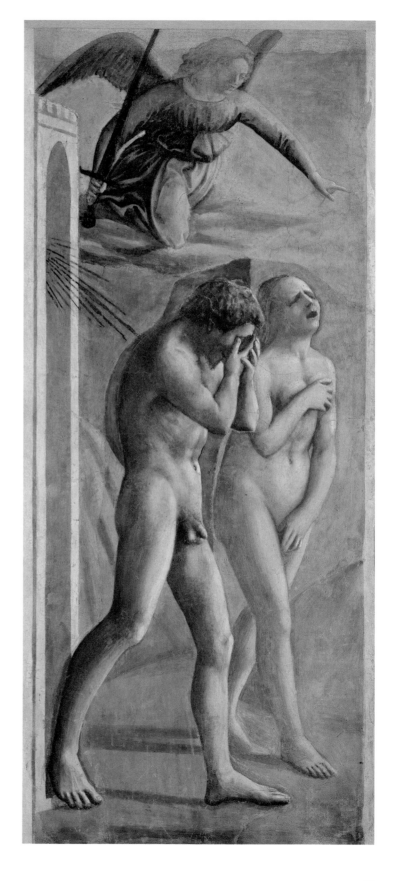

38
*Annunciation, c.*1425–7
Tempera and gold on panel;
194 × 194 cm (76⅜ × 76⅜ in)
Museo del Prado, Madrid

Overleaf
Detail of *The Birth and Marriage
of the Virgin*, predella panel of
Annunciation (38)

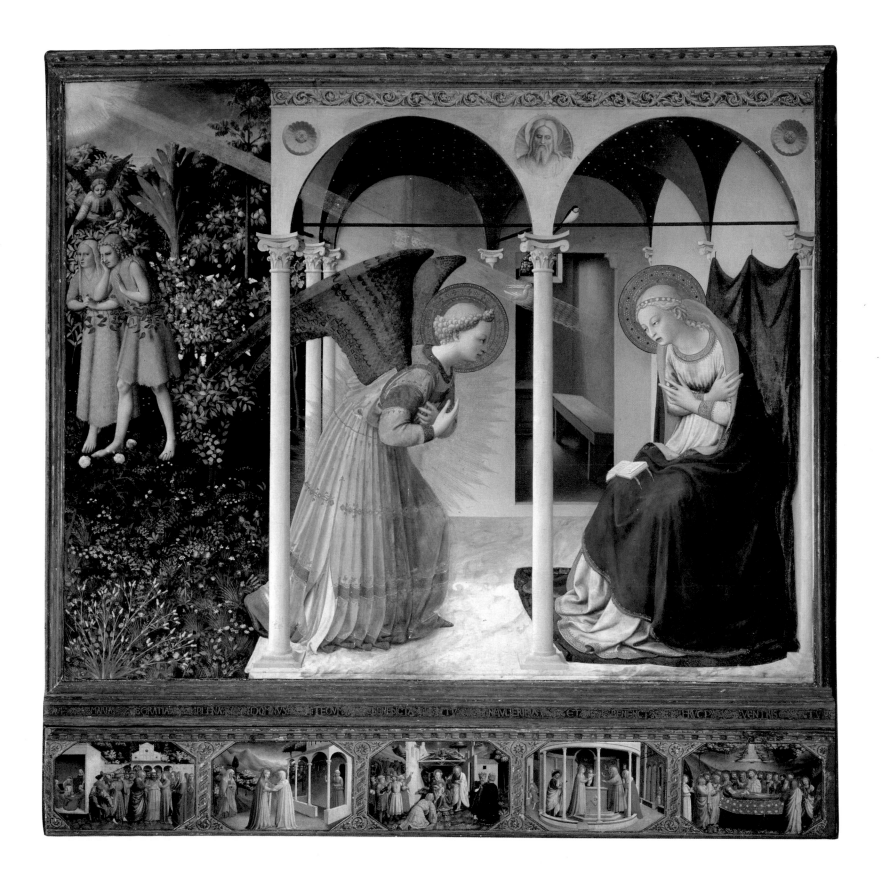

39

Coronation of the Virgin, c.1427–9
Tempera and gold on panel; main
panel: 213 × 211 cm (83⅞ × 83 in);
predella: 23 × 211 cm (9 × 83 in)
Musée du Louvre, Paris

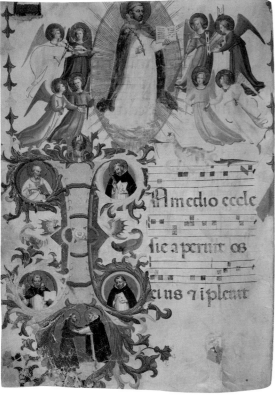

40
*Madonna of Mercy with Kneeling
Friars*, fol. 156v, from *Messale 558*,
begun *c*.1424
Tempera and gold on parchment;
whole folio: 47.5 × 35 cm
(18¾ ×13¾ in)
Museo di San Marco, Florence

41
Saint Dominic in Glory, fol. 67v, from
Messale 558, begun *c*.1424
Tempera and gold on parchment;
whole folio: 47.5 × 35 cm
(18¾ ×13¾ in)
Museo di San Marco, Florence

days of several saints. This book of hymns for the Mass, known
as *Messale 558*, comprises 261 folios (two-sided 'leaves' or pages),
thirty-six of which are embellished with large, decorated initials in
elaborate frames surrounded by brilliantly coloured vine scrolls.
Many of them are by Angelico, although another artist assisted him,
confirming his establishment of a workshop in San Domenico in
these early years.

No documentation exists for this exquisite missal, although
the predominance of Dominican saints and feast days indicates its
execution for one of the Order's churches. It was almost certainly
made for San Domenico, which, as a new foundation, did not
have its own choir books. The apostle Barnabus, patron saint of
the convent's benefactor, is portrayed among the saints of *Saint
Dominic in Glory* and is a strong indication of its provenance. The
choir book provides crucial evidence for the expertise of Angelico
in the field of manuscript illumination. Indeed, the production of
manuscripts would become an important source of income for the
convent well into the 1430s, when Battista di Biagio Sanguigni and
Zanobi Strozzi worked under Angelico's aegis.

One of the earliest of the illuminations represents the Madonna
of Mercy, in which the standing Virgin, radiating a softly coloured,
almond-shaped aura, shelters five Dominicans in the folds of her
mantle (40). This portrayal may illustrate a vision reported in a
thirteenth-century Dominican treatise. In this vision, the 'loving
Mother of Jesus Christ' was seen protecting the brethren beneath
her cloak because they made sure that her 'beloved son's blood
was not shed in vain'. Angelico's interpretation is solemn, his brush
controlled. The bright colours of the Virgin's garments recall the
palette of the *San Domenico Altarpiece*, and the delicate features
and hands of the figures, described in a subtle chiaroscuro, repeat
those of the altarpiece's predella.

The most vividly rendered page is *Saint Dominic in Glory* (41).
The hymn introduced the Mass for the feast of Saint Dominic and
was sung by the friars as the priest entered the choir. The saint's
vocation and the Order's mission to preach are conveyed by the
words and their illustration: 'In the congregation of the church, the
Lord opened his mouth and filled him.' Dominic appears at the top
of the page as a radiant, cloud-born apparition surrounded by
music-making angels. Carrying the burning torch of the apostolic
mission in his jaws, the dog that appeared to Dominic's mother while
the saint was still in her womb overlaps the top stave of the music.
The initial itself is embellished with portraits of saints, including
Barnabus, Peter Martyr and Thomas Aquinas. The meeting of
Saints Francis and Dominic, founders of the two mendicant orders,
is enclosed in the luxuriant foliage, attesting the perpetuation of the
Word of God through their preaching. The colours are subtle and
more transparent than in the other illuminations, and the angels
are characterized expressively through their instruments, varied
postures and flowing drapery. This illumination reveals Angelico's
sensibility as a manuscript illuminator at the end of the decade. The
entire page, not only the initial, was painted, illustrating the words
of the hymn while conveying its spirit. As the friars chanted the
Mass for the saint's feast, the image reinforced their identity as
Dominicans, preachers of the Word of God, who had revived the
ideals of their founder through the Observant reform.

Imbued with the Order's spirituality, Angelico's works for
San Domenico inspired commissions from other Dominican
congregations in this decade. For Santa Maria Novella, he painted
four reliquaries with scenes from the life of the Virgin. Their
subjects include the *Annunciation and Adoration of the Magi*,
the *Madonna of the Star*, the *Dormition and Assumption of the*

Virgin and the *Coronation of the Virgin*. One of the church's friars, Fra Giovanni Masi (see page 37), 'caused them to be made', as his obituary of 1434 recorded. The commission seems likely to date to 1424, the only year that Masi served as sacristan of Santa Maria Novella; as stipulated by Humbert of Romans, author of the Order's Constitutions, sacristans were explicitly obliged to protect their church's precious relics, preserving them in 'beautiful vessels' or 'little coffers'. The reliquaries by Angelico were indeed 'beautiful vessels', ornately framed, embellished with fine gilding and painted in glowing colours. Although made of wood, they simulated priceless reliquaries, made of gold, silver, gems and enamel, which were carried in religious processions and displayed on the altar for veneration. Their delicate style and jewel-like colours express a miniaturist's sensibility while revealing Angelico's response to monumental art.

The *Annunciation and Adoration of the Magi* (43) translates the influence of Gentile da Fabriano's magnificent *Adoration of the Magi* (see 29). The superimposed scenes are portrayed on a golden ground, the elaborately tooled patterns and rich array of colours of which seem inspired by the exquisite textiles and chromatic brilliance of Gentile's altarpiece. Angelico portrayed the very moment of the Incarnation, as shown by the Holy Spirit, delicately painted and incised over the gold ground, and the glowing light on the front of the Virgin's garments. In the *Adoration of the Magi*, Angelico reinterpreted Gentile's altarpiece, as seen in the rapport of the holy family, the obliquely angled shed and the brilliantly dressed Magi and their entourage. The nocturnal sky rises above the rhythmically curving golden ground, an allusion to the heavens beyond. The predella displays female saints, identified by inscription and distinguished by their attributes, who adore the Virgin and Child. Angelico may have based his depiction on the authoritative, full-length portraits frescoed on the ribs of the vaults in Santa Maria Novella, imparting authenticity to his representation.

The *Madonna of the Star* portrays the Virgin holding the Child on an incised, golden radiance as she embraces him tenderly (44). In the frame above, Christ, foreshortened and surrounded by a ring of seraphim, sends forth a jewelled crown, acclaiming her as Queen of Heaven. Pairs of angels adore her as they pray, swing censers and play organs in jubilation, their flowing garments aglow with light. The Dominican saints in the predella recall the Order's veneration of Mary as 'Queen of Heaven' and 'star of our salvation' through its liturgy and hymns, and as illustrated by the golden star on her mantle. The image of the standing Virgin and Child emerged from a rich biblical and visual tradition exemplified at Santa Maria Novella in a stained glass window in the Strozzi Chapel and in a marble statue by Nino Pisano (doc. 1334–68) (42). Angelico transformed these monumental works through his miniaturist style and poignant interpretation.

The last known work that Angelico painted for a Dominican congregation during this decade was the *Saint Peter Martyr Triptych*, the high altarpiece of the church of San Pietro Martire in Florence (7, 45 and 46). The church served a community of Observant nuns founded in 1418 by Leonardo Dati, Prior General of the Order (see page 18), who had negotiated Barnaba degli Agli's bequest to San Domenico di Fiesole the same year. Dati dedicated the church to the Order's first martyr, a disciple of Saint Dominic, who had preached the Gospel throughout Italy, converting heretics and strengthening the faith of multitudes. Praised by Saint Thomas Aquinas as the 'Herald of Christ' and the 'Light of the People', Peter Martyr was especially devoted to the spiritual instruction of women. His letter

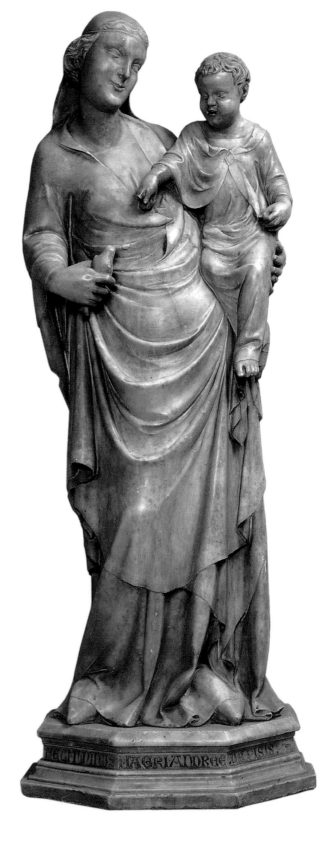

42
Nino Pisano, *Madonna and Child,*
*c.*1360s
Marble; 110 cm (43¼ in) high
Santa Maria Novella, Florence

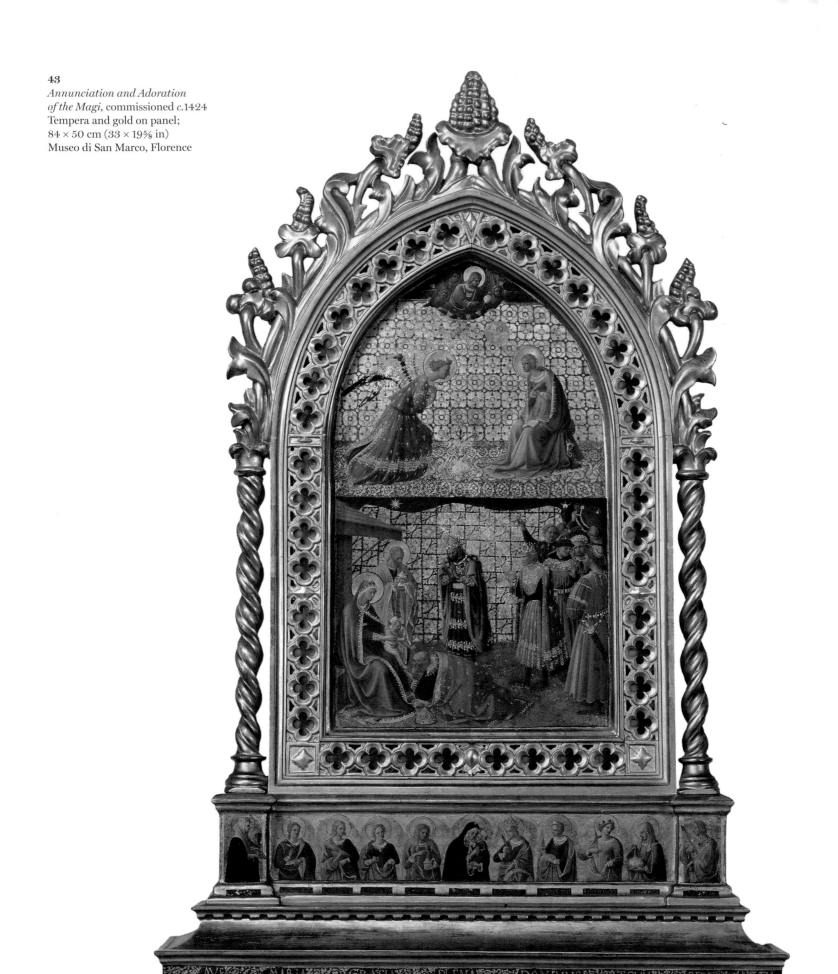

43
*Annunciation and Adoration
of the Magi,* commissioned *c.*1424
Tempera and gold on panel;
84 × 50 cm (33 × 19⅝ in)
Museo di San Marco, Florence

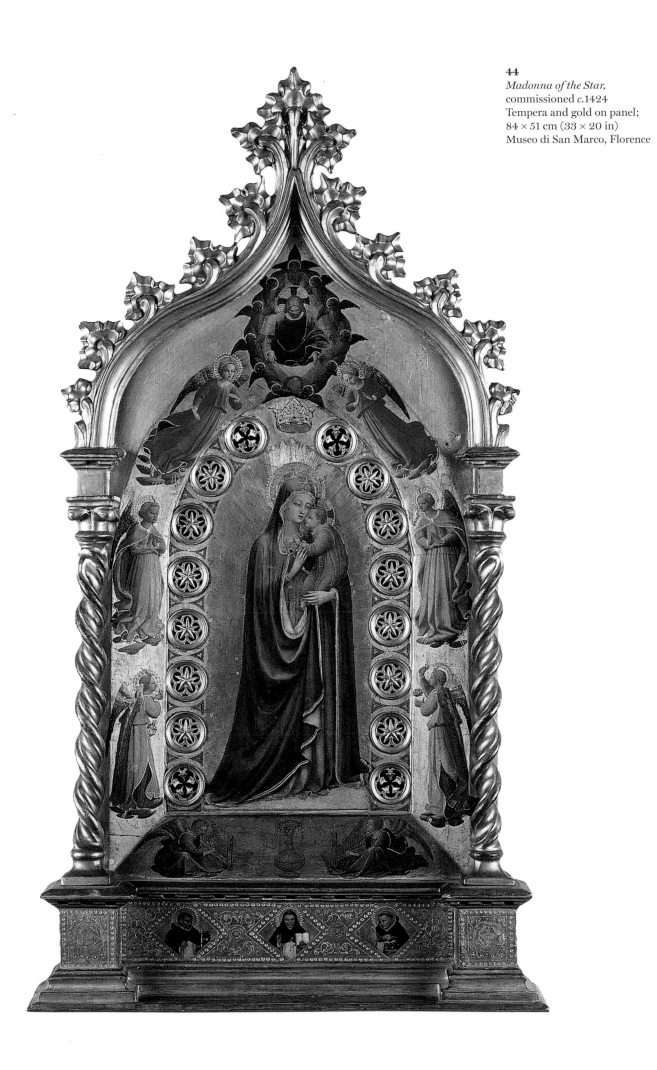

44
Madonna of the Star,
commissioned *c.*1424
Tempera and gold on panel;
84 × 51 cm (33 × 20 in)
Museo di San Marco, Florence

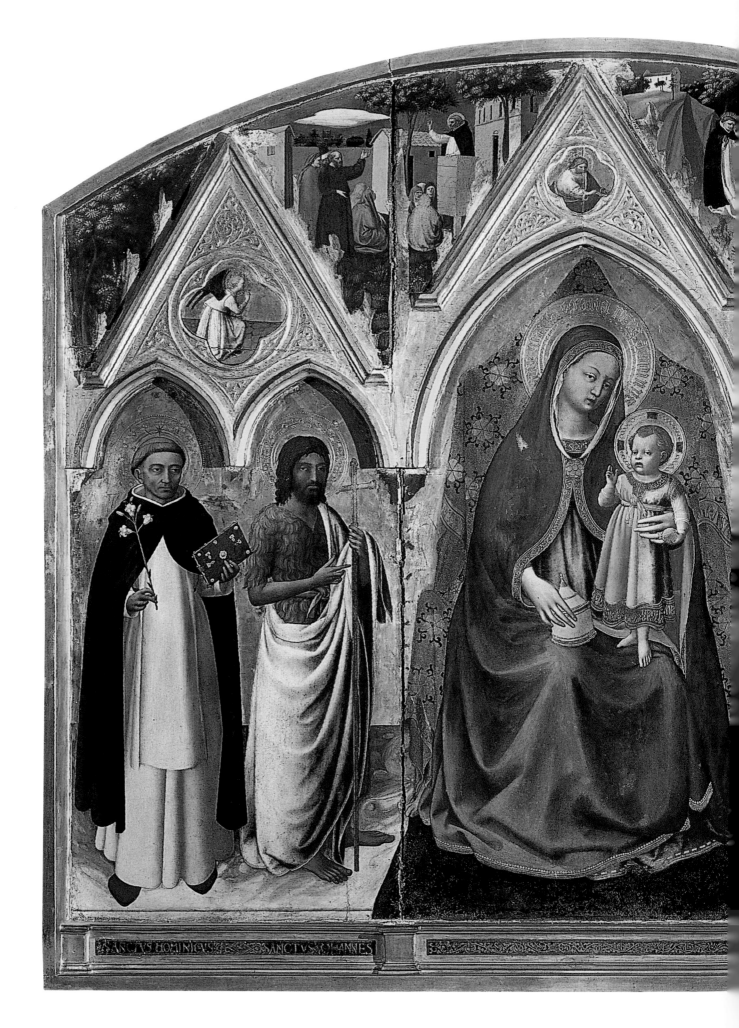

45
Saint Peter Martyr Triptych,
documented 1429
Tempera and gold on panel;
137 × 168 cm (54 × 66⅛ in)
Museo di San Marco, Florence

46
Dead Christ with Six Saints, predella
(now separated) of *Saint Peter Martyr
Triptych* (45), documented 1429
Tempera and gold on panel;
20.2 × 49.3 cm (8 × 19⅜ in);
20.3 × 54.8 cm (8 × 21½ in);
20.5 × 50.9 cm (8 × 20 in)
Courtauld Institute Galleries, London

to the prioress of a convent in Milan exhorted her to serve God 'in your ministry of prayer and to make your sisters pleasing to the Lord'. It was appropriate that the Order's first Observant nunnery in Florence be named in his honour. Sisters from the convent of San Domenico in Pisa, the most rigorous reformed congregation for women in all of Tuscany, were transferred to educate the new postulants. By March 1429, Angelico had completed the triptych, for an account ledger from San Domenico di Fiesole recorded that the convent still owed ten florins for 'the painting of the altarpiece'. This small sum, evidently a final payment that was overdue, suggests the work's completion before that time.

The *Saint Peter Martyr Triptych* was intended to shape the spirituality of the pious sisters so that they would be 'pleasing to the Lord'. At the top of the frame, Angelico portrayed events from the life of Peter Martyr, including his preaching and his assassination by a heretic, when the wounded martyr wrote the Apostles' Creed in his own blood (see 7). The pinnacles enclose roundels representing the Annunciation, a theme that was especially significant to the sisters. Peter Martyr was canonized on the feast of the Annunciation, an extraordinary honour acknowledging his sanctity. In the central panel of the triptych, the enthroned Virgin displays a golden pyxis, a gift from the Magi that contained the frankincense and myrrh with which she would embalm her son. The infant blesses the faithful, displaying the golden orb symbolic of his sovereignty over the universe. His gown is red, the colour of the vestments worn by the priest on Palm Sunday and the feasts of martyrs, a prophecy of his fate. The saints in the side panels include John the Baptist, last of the prophets and patron saint of Florence, and the three Dominican saints – Dominic, Peter Martyr and Thomas Aquinas – whose writings and example inspired the sisters' faith. The open book of Saint Thomas is inscribed with Psalm 104:13, the same text that appears in the *San Domenico di Fiesole Altarpiece* (see page 44). Praising God's majesty, it was believed to prophesy the Lord's merciful offering of Christ in the Eucharist.

The predella (now separated from the altarpiece) was addressed specifically to the sisters who knelt before it in prayer (46). It depicts six saints, five of whom are female, around the dead Christ, who is aligned with the Virgin and Child above. Among the saints are Chiara Gambacorti, the mystical founder of the nunnery of San Domenico in Pisa; Catherine of Alexandria, whose mystic marriage to Jesus, recounted in legends of her life, was re-enacted by the postulants when they entered the convent to become the 'brides of Christ'; and the young virgin martyr Agnes, some of whose relics were possessed by Peter Martyr. These holy women served as models for the piety of the sisters.

The style of the altarpiece reflects Angelico's response to the art of Gentile da Fabriano and Masaccio, whose popularity among the city's painters was at its zenith before their departure from Florence in the middle of the decade. The composition and golden cloth of honour behind the Virgin and Child, finely hatched,

47
Gentile da Fabriano, *Madonna and Child*, central panel of *Quaratesi Altarpiece*, 1425
Tempera and gold on panel;
140 × 83 cm (55⅛ × 32⅝ in)
Collection of Her Majesty the Queen, Hampton Court

48

*Madonna and Child with Saints
Jerome and John the Baptist and
Saints Francis and Onophrius*, known
as *Compagnia di San Francesco
Altarpiece*, documented 1429
Tempera and gold on panel; centre:
189 × 81 cm (74⅜ × 31⅞ in); each
side: 170 × 79 cm (66⅞ × 31 in)
Museo di San Marco, Florence

PAX VOBIS

49
The Apparition of Saint Francis at Arles. predella panel of *Compagnia di San Francesco Altarpiece* (48), documented 1429
Tempera and gold on panel;
26 × 31 cm (10¼ × 12¼ in)
Gemäldegalerie, Staatliche Museen, Berlin

stippled, and incised with floral patterns, recall those of Gentile's *Quaratesi Altarpiece* (47). But Angelico's primary inspiration was Masaccio. The panel is consistently illuminated from the left, and the habits of the Dominican saints are convincingly volumetric, like those of Masaccio's sculptural figures. The facial features, firmly modelled in a graduated chiaroscuro, and the heavy drapery of the Virgin and Child suggest Angelico's response to the *Madonna, Child and Saint Anne* by Masaccio and Masolino (see 31). Angelico characterized the saints of the predella distinctively through their expressive faces and gestures, as well as by the varied angles at which they stand against the gold ground, appearing almost to penetrate it. This illusionistic treatment of space seems inspired by Masaccio.

Angelico's renown extended beyond the congregations of his own Order. In accord with the mission of Saint Dominic to evangelize, the friar expressed the lessons of his faith for numerous clients. Documents demonstrate that a range of patrons sought his work throughout the decade. In 1423, the hospital-church of Santa Maria Nuova, the largest hospital in Florence, gave 'frate Giovanni' a payment for a 'painted Cross'. This work seems identifiable with a silhouetted *Crucifix* in which the sculptural conception, especially evident in Christ's muscular torso, seems inspired by Brunelleschi's wooden *Crucifix* in Santa Maria Novella (see 27). For his chapel in San Lorenzo, a wealthy Florentine, Alessandro Rondinelli, bequeathed funds in 1425 for an Annunciation by the 'friar from the convent of San Domenico'. Although the altarpiece evidently was never executed – Rondinelli lived on and revised his will – the intended bequest is indicative of Angelico's fame. In 1429, the penitential confraternity of San Francesco, which met in the cloister of Santa Croce, paid 'frate Guido' for its altarpiece. Though the altarpiece was cut apart at some point in its history, its components have been identified (48). Scenes from the life of Saint Francis comprised the predella. Among these panels, *The Apparition of Saint Francis at Arles* is especially remarkable for its deep architectural setting, its luminary effects and its atmospheric perspective (49).

In addition to these documented works, Angelico completed several paintings for which the original locations and patrons are now uncertain. They further clarify Angelico's response to the most important works of the decade. The austerity of the *Adoration of the Magi* seems a reinterpretation of Gentile's magnificent altarpiece that focuses on the solemnity of Epiphany rather than the splendour of the Magi's entourage or the richness of their garments (50, see 29). The *Madonna and Child of the Grapes* was inspired by the *Madonna, Child and Saint Anne* by Masaccio and Masolino (51, see 31). Perhaps the greatest loss is the altarpiece to which five beautifully painted predella panels once belonged (see 166). From the *Naming of the Baptist*, the setting of which is inspired by the architectural backgrounds of the Brancacci Chapel, to the *Vision of Saint Lucy*, in which the receding walls enclose the slumbering women, the panels reveal a distinctive narrative and spiritual voice. Monumental in conception yet nuanced in their description of colour, light and emotion, they foretell the works that Angelico would paint in the following decade.

50
Adoration of the Magi, c.1423–4
Tempera and gold on panel;
63 × 54 cm (24¾ × 21¼ in)
Abegg-Stiftung, Bern

51
Madonna and Child of the Grapes,
*c.*1425
Tempera and gold on panel;
101.6 × 58.6 cm (40 × 23 in)
Barbara Piasecka Johnson Foundation,
Princeton NJ

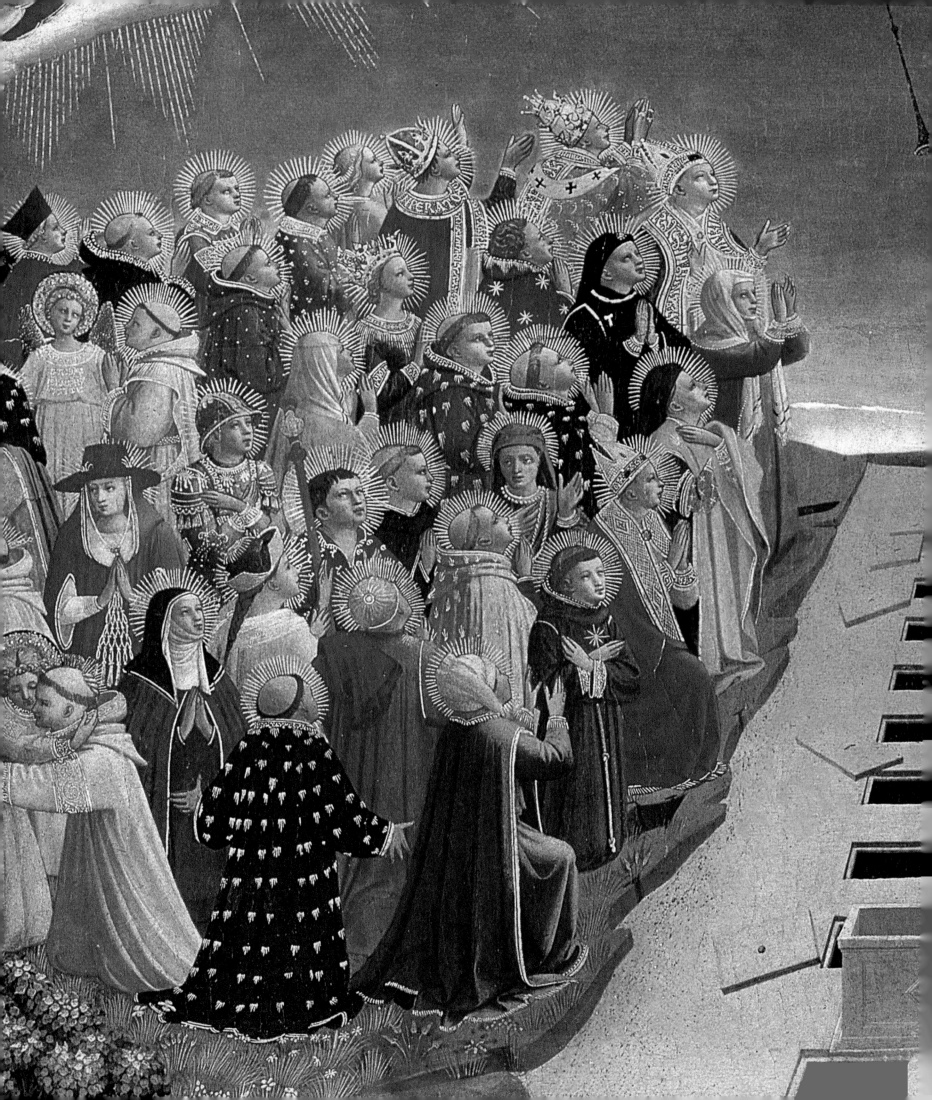

3
With all his Art and Expertise
Angelico in the early 1430s

By 1429, the three masters who had most profoundly influenced the course of early fifteenth-century painting were dead. Lorenzo Monaco, the last great artist of the late Gothic tradition and Angelico's probable teacher, died in 1424 or 1425. With his death, the illustrious school of painters and manuscript illuminators at Santa Maria degli Angeli disbanded, and the artists associated with his shop, including Battista di Biagio Sanguigni, established careers on their own. Gentile da Fabriano left Florence in 1425 after completing the *Quaratesi Altarpiece* (see 47) for one of the city's wealthiest families. At the behest of Pope Martin V, he went to Rome in 1427, but died in late summer or early autumn. Masaccio also was summoned to Rome, and collaborated with Masolino on an altarpiece for Santa Maria Maggiore, one of the most important pilgrimage churches in the city (see 113). In 1428, Masaccio succumbed to plague when he was only twenty-seven years old. The loss of these masters left a great void in Florentine painting that other artists sought to fill. The most outstanding of those left was Angelico, whose understanding of the masters' legacies was unequalled by any of his contemporaries in the early 1430s. He executed a remarkable group of works during these years that introduced innovative themes, techniques and style. Commissioned for ecclesiastical, guild and lay patrons of great prominence, the paintings to be discussed in this chapter include the *Last Judgement* (57), the Santa Maria Nuova *Coronation of the Virgin* (59), the *Descent from the Cross* (62), the *Linaiuoli Tabernacle* (63, 64) and the *Annalena Altarpiece* (67). They were created during crucial years in Florentine history, which began with the death of one of its most esteemed citizens and the rise of his younger son to power.

In February 1429, Giovanni di Bicci de' Medici (1360–1429) died after amassing a vast fortune as a merchant and banker to emperors and popes. Many in Florence mourned his death, from the working poor, whose causes he advocated, to the wealthy, bound to him through ties of kinship, friendship and economic obligation. Giovanni di Bicci shrewdly had cultivated a semblance of modesty and discretion that seemed to belie his wealth. He urged this behaviour upon his sons Cosimo (1389–1464) and Lorenzo (1395–1440), reputedly advising them to 'be wary' of giving advice in public, displaying pride or provoking 'litigation and political controversy'. A discriminating patron of architecture and art,

Giovanni di Bicci dedicated himself to helping rebuild the church of San Lorenzo (see 6), claiming for his family a double chapel sited in its transept. To perpetuate his memory, he commissioned Brunelleschi to build a private funerary chapel for himself and his wife in the sacristy, where the priests vested themselves and sang daily Masses for their salvation. Their grief-stricken son Cosimo is said to have composed the epitaph for his tomb, eulogizing his father's 'service to his native land' as well as 'the glory of his line' and his 'generosity to all'. These were the virtues that Cosimo himself sought to emulate as he assumed leadership of the Medici family and, eventually, of the city itself, enhancing the prestige and wealth of one while he covertly consolidated the power of the other.

Since the early years of the century, an autocratic government, escalating taxes and virtually interminable warfare, especially with Milan, had weakened Florence. Although the city was a republic that elected its officials, actual power was controlled by a small group of politically enfranchised citizens who proposed and administered laws. Wealthy merchants and old families invariably dominated key offices: the highest executive position (the Gonfalonier of Justice), the Signoria (Priorate, or Great Council) and the two major advisory colleges. To ensure the continuity of their power, office-holders controlled the lists of those eligible for election, whose names were drawn from voting pouches. Almost invariably, the wealthy mercantile families were elected to rule. By the time of Giovanni di Bicci's death, these magnates had brought Florence to dire financial straits by levying taxes, spending enormous sums on expanding the city's territories and launching military campaigns. In 1429, they plotted to invade Lucca, a longtime commercial rival with especially rich territories, located 74 kilometres (46 miles) west of Florence. Lucca immediately allied itself with Milan, which came to its defence. Together, they began their devastation of the Florentine army, which was completely outnumbered by their forces.

Opposing a war of which the outcome seemed inevitable, Cosimo de' Medici recognized the public's growing antagonism toward the oligarchy. He watchfully maintained his silence, feigning neutrality to avoid confrontation. Jealous of his wealth and fearful of his popularity, his enemies accused him of embezzling war funds and conspiring to overthrow the weakened government. In September 1433, Cosimo was arrested for treason and imprisoned.

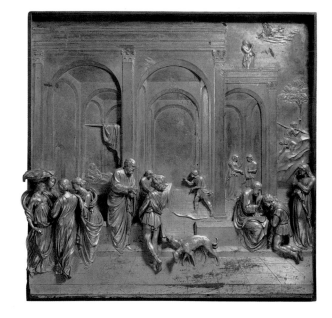

Although there were cries for his immediate execution, he and his kin received the lesser punishment of exile. Cosimo left Florence under cover of night for northern Italy, receiving the hospitality of local rulers along the way. While he watchfully bided his time, Medici partisans and allies began to lay plans for his return. By the summer of 1434, hatred of the oligarchy had erupted into open rebellion, fighting in the streets and calls for its overthrow. Little more than a year after his exile, Cosimo was recalled to Florence. Seventy of the city's wealthiest families, most of them involved directly or through kinship in the government, were banished. With the expulsion of his enemies in October 1434, Cosimo was able to control the city's government by covertly filling the election pouches with the names of his allies, a strategy that he and his descendants successfully followed for the next sixty years. By exiling his rivals and manipulating the electoral system, Cosimo became the richest and most powerful man in all of Florence.

The years around Giovanni di Bicci's death and Cosimo's rise to power witnessed dramatic transformations in the city's urban fabric, due largely to Brunelleschi. In summer of 1426, he had completed the loggia (porch) of the Foundlings Hospital, which cared for the city's abandoned children from birth to apprenticeship or marriage (52). Recalling the vocabulary of Roman architecture, the symmetry of its round-headed arches imparted a visual clarity that was unprecedented in Florence. As he had in San Lorenzo (see 6), Brunelleschi devised a modular and rigorously defined space. The length of each column equalled its distance from the wall, creating cubes of space that were extended by hemispherical domes. The proximity of the orphanage to Santissima Annunziata, conservator of the miraculous *Annunciation* (see Chapter One), and to the Cathedral ensured its importance within the urban fabric. Close by, Brunelleschi's great dome (see 5), as yet unfinished, loomed over Florence. It was regarded as an engineering marvel as well as a symbol of sacred and communal pride. Its construction had been delayed by economic instability brought about by the civic unrest and wars; when funds ran short, labourers were dismissed. After a truce with Lucca was reached in 1433, workers were rehired and the pace of building accelerated to hasten the dome's completion. In 1436, the Cathedral was consecrated anew with some of the most splendid and solemn festivities in the city's history.

Throughout the 1420s and the early 1430s, major civic and guild sculpture projects focused on the Cathedral complex, the centre of ritual and civic life. These works interpreted narrative, anatomy, emotion and classical Roman influence in dramatic new ways that redefined the possibilities of sculpture. The most important commission for the Cathedral complex was for Ghiberti, whose influence on Angelico increased dramatically in the 1430s. The magnificence of his North Doors for the Baptistery, installed with great ceremony in 1424, inspired the commission of another and final set of doors almost immediately. In contrast to the earlier reliefs in which single biblical events were framed within a quatrefoil (four-leaf clover shape) (see 8, 58), they expanded the chronological and spatial parameters of storytelling by portraying several episodes simultaneously within a square. Incorporating the element of time, Ghiberti represented a sequence of related events by graduating the scale of his figures and varying the depth of his relief. His architecture was classically inspired and depicted in convincing, perspective, organizing events in an optical continuum. In the *Story of Isaac*, Ghiberti rhythmically wove seven related episodes through the architecture and landscape, placing the most significant in the foreground in high relief (53). The variety and beauty of the figures, as well as their expressive postures and ardent gestures, conveyed the narrative as clearly as the written word.

Two important commissions for the interior of the Cathedral were begun during this time. Made for the organ lofts, the marble *Cantorie* (*Singing Galleries*) were composed of reliefs of dancing and singing angels carved by Luca della Robbia (1399/1400–82) and Donatello. Luca began work while Donatello was in Rome, interpreting Psalm 150, which begins with the exhortation 'Praise the Lord!' (54). He illustrated the psalm's musical imagery quite literally, representing the individual verses in single panels separated by paired pilasters and underscored by the words incised below. Gracefully composed in symmetrical groups, the child and adolescent musicians and dancers were inspired by Roman sculpture, as seen in their flowing garments and luxuriant curls. By contrast, Donatello expressed the jubilation of praise in the ecstatic dance of his infant angels, portrayed in a continuous stream behind the architecture (55). The glittering pieces of mosaic behind the dancers and on the columns, and the rich encrustation

54
Luca della Robbia, *Cantoria*
(*Singing Gallery*), *c*.1430–8
Marble; 328 × 560 cm
(129⅛ × 220½ in)
Museo dell'Opera del Duomo,
Florence

55
Donatello, *Cantoria* (*Singing Gallery*),
c.1433–9
Marble and mosaic; 348 × 570 cm
(137 × 224⅜ in)
Museo dell'Opera del Duomo,
Florence

of the marble with urns, shells, leaves, sunbursts and wreaths complemented the joyous abandon of the angels' dance. As suggested by the Baptistery Doors and the *Singing Galleries*, these were years of extraordinary creativity in sculpture.

A strikingly different situation prevailed in Florentine painting. The years between the death of Masaccio in 1428 and the first dated work of Fra Filippo Lippi (*c*.1406–69) in 1437 have been described as a 'no man's land' in fifteenth-century painting. In contrast to the illustrious decade that preceded it, no major painters except Angelico are known to have worked in Florence until after the middle of the decade. Most painters during this period elaborated upon the legacy of Masaccio and Gentile da Fabriano well into the 1430s. The prolific Bicci di Lorenzo ensured his popularity by recalling the works of Gentile in some of his paintings. His *Madonna and Child with Saints and Angels* reprised the Virgin and Child from the *Quaratesi Altarpiece* (see 47), without capturing its luminous colours, subtle modelling or the tender rapport between the figures (56). Little is known about the early works of Paolo Uccello (*c*.1397–1475), Filippo Lippi and Domenico Veneziano (active 1438, died 1461) until late in the decade. None of Uccello's paintings can be securely dated before 1436, and the other two artists spent the early 1430s in distant Padua and Venice. By the time they returned to Florence, Angelico had become the city's pre-eminent painter, receiving some of the most prestigious commissions of the decade.

Angelico's rise to prominence reflected the vibrant spiritual, humanist and political climate of Florence in the early 1430s. His clientele included major churches as well as private patrons, among them Palla Strozzi and Cosimo de' Medici, two of the wealthiest men in Florence. In 1433, a lucrative commission for the linen workers' guild placed him in direct contact with Ghiberti, whose sculpture greatly influenced the scale and conception of Angelico's works throughout this period. Producing income for his fellow friars, such commissions necessitated his engagement with the world beyond the convent walls but did not compromise his religious vocation. As vicar of San Domenico in 1432, 1433 and 1435, Angelico was entrusted with many responsibilities of conventual life, from the practical and economic to the spiritual. His remarkable productivity during these years attests his commitment to the Dominican mission to preach Christian beliefs through his painting.

The *Last Judgement* seems to be the earliest work from this crucial period (57). It was painted for the church of Santa Maria degli Angeli, outside the walls of which Lorenzo Monaco had established the prolific workshop where Angelico seems to have trained as a painter. The monastery's renown as a centre for spirituality and humanist studies had grown under Ambrogio Traversari, one of the most esteemed intellectuals and reformers of the Camaldolese Order, known for its mystical piety (see Chapter One). Traversari devoted his life to the translation of Latin and Greek sacred texts, introducing the spiritual legacy of the early Church Fathers to a wider readership. His recovery of these texts, especially Greek writings on the monastic life, moved him to reform Santa Maria degli Angeli, where he recreated the Order's original devotion to silence and contemplation. Within the monastery walls, Traversari established an academy for humanist studies, where the city's most prominent men – among them, the statesmen Coluccio Salutati and Leonardo Bruni as well as Palla Strozzi and Cosimo de' Medici – read sacred writings under his aegis, literally returning to the origins of Christian thought. In October 1431, Traversari was elected Abbot General of the entire Camaldolese Order, honouring his eminence as a scholar and spiritual leader.

In August 1431, a generous bequest allowed the monastery to begin building an oratory designed by Brunelleschi for the worship of both monks and laity. It was conceived as a domed octagon with radiating chapels dedicated to the twelve Apostles. The oratory, never completed due to lack of funds, was to have been the first centralized structure of the Renaissance. Consciously recalling ancient Roman temples and early Christian martyria as well as the city's own Baptistery, it commemorated Brunelleschi's creative interpretation of the past and memorialized Traversari's devotion to the Church and its origins. These circumstances may have inspired the commission of the *Last Judgement*. The work is first described in Santa Maria degli Angeli on the right side of the choir, where the priest sat while Mass was being sung.

Elevated in the deep azure sky and surrounded by concentric rings of cherubim and angels, Jesus sits on a glowing bank of clouds as he judges the world. He is flanked by the interceding figures of John the Baptist and the Virgin, whose luminous white mantle calls to mind the habits of the Camaldolese monks. Rows of saints and prophets, identified by their distinctive attributes, varied expressions and brilliantly coloured mantles, sit suspended on clouds in the heavens. A long row of tombs leads to the distant horizon, bisecting the valley below. To the right of Jesus, the Blessed kneel in adoration, their faces radiant with the love of God, as angels dance in a circle in the verdant vegetation of Paradise. Golden rays of light stream through the open gates of the City of God and illuminate the white gowns of the Blessed seeking entry. To Christ's left, demons with pitchforks drive the agonized Damned into the mouth of a mountainous Hell. The ghastly torments that await them are portrayed within its flaming circles, where naked sinners, some strangled by snakes, suffer for their transgressions. The abundance of figures (270 in all), nuanced evocation of their emotions, descending perspective of the row of tombs and ascending landscape reveal a mastery of narrative and space that was unprecedented in Angelico's small-scale works. They attest his attentive study of the New Testament scenes of Ghiberti's North Doors, in which the delicately modelled and lithe figures display a range of responses and, at times, are enclosed by hills rising behind them. In fact, the heavenly gates seem modelled after the walled city of Jerusalem as portrayed by Ghiberti in two of the reliefs (see 58).

An extraordinarily rich theological, literary and artistic tradition informed Angelico's conception of the *Last Judgement*. His imagery emerged from biblical sources that included the Old Testament prophets, who so vividly foretold the apocalyptic coming of the 'son of man' in the heavens, as well as Saint Matthew, who described the separation of the Blessed and the Damned sent into eternal life or infernal punishment. Dante Alighieri (1265–1321) evoked the horrors of Hell most dramatically in the *Divine Comedy*. His vision of Paradise and Hell was pictured in several sites in Florence, including Santa Maria Novella, where Nardo di Cione frescoed the *Last Judgement* on the walls of the Strozzi Chapel and Andrea da Firenze represented the subject in the Chapter House (see 96) where the friars met each day. Dante's intensely visual imagery impressed itself indelibly on the minds of Florentines, for during the mid-fourteenth to late fifteenth centuries, the *Divine Comedy* was read aloud in the Cathedral during Lent by the city's most esteemed humanists and statesmen.

While emerging from this legacy, Angelico's interpretation introduced elements that were almost certainly proposed by Traversari, for they were unprecedented in Tuscan art. Although Saint Thomas Aquinas imagined Paradise as a place of pure light devoid of plants, the sermons of early Greek theologians, such as

56
Bicci di Lorenzo, *Madonna and Child with Saint Louis of Toulouse, Saint Francis of Assisi, Saint Anthony of Padua and Saint Nicholas of Bari*, c.1420–30
Tempera on panel
Accademia, Florence

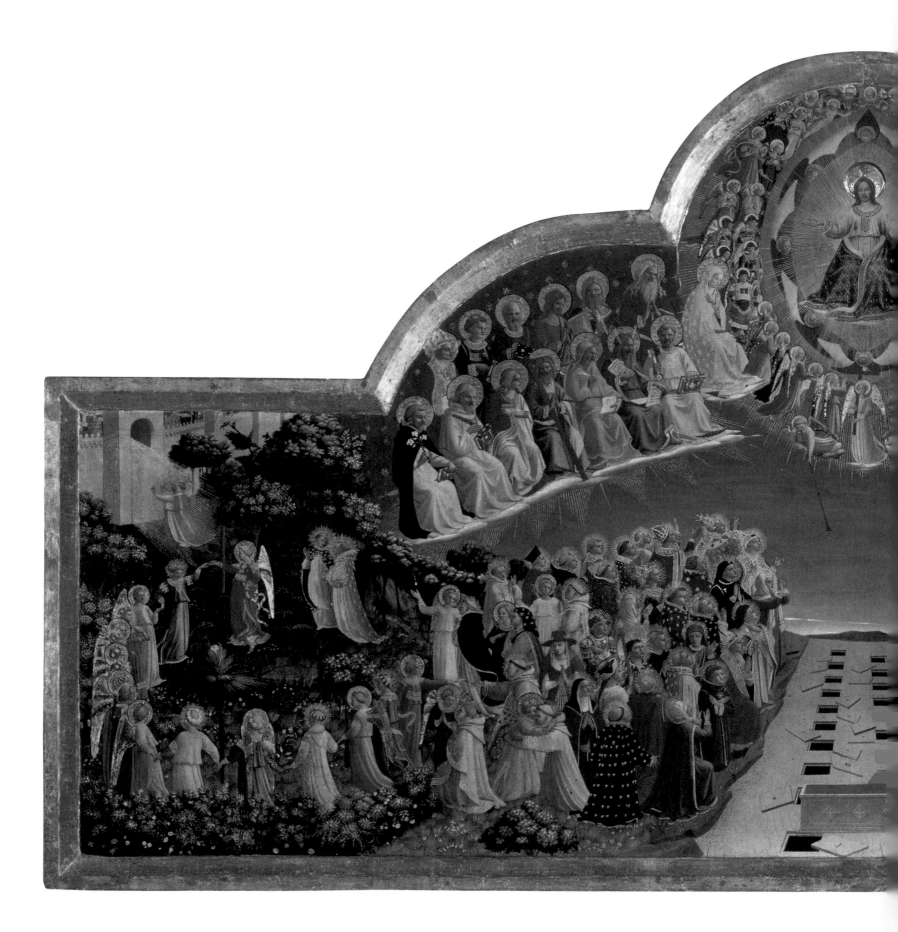

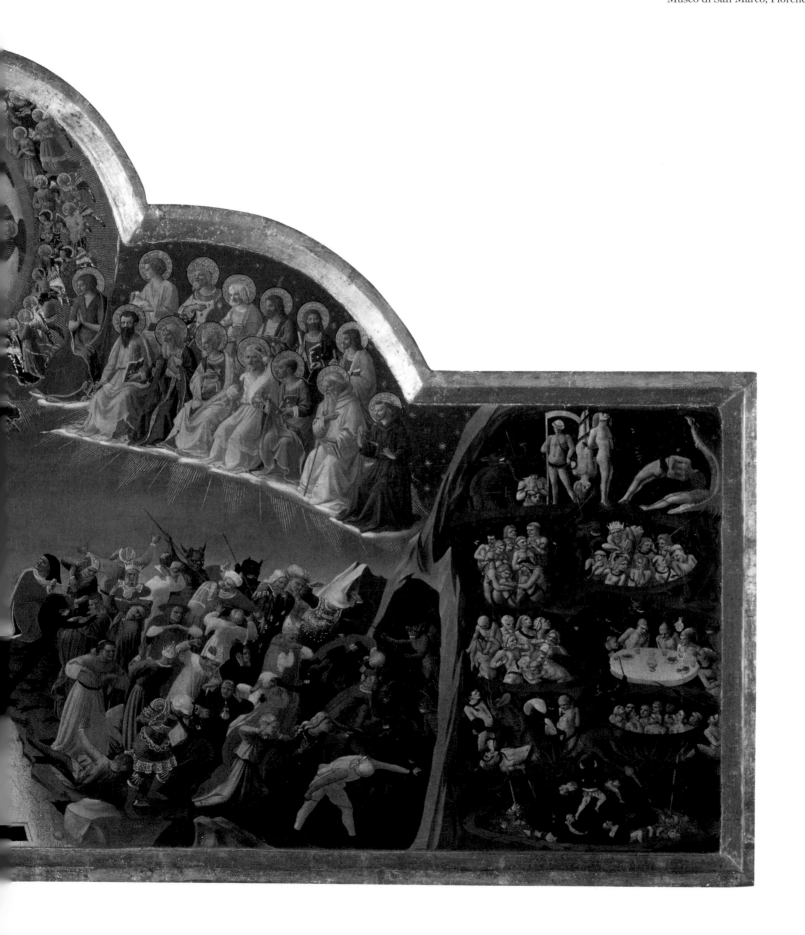

57
*Last Judgement, c.*1431
Tempera and gold on panel;
108 × 212 cm (42½ × 83½ in)
Museo di San Marco, Florence

58
Lorenzo Ghiberti, *Entry into Jerusalem*,
from North Doors, *c.*1418
Gilded bronze; 52 × 45 cm
(20½ × 17¾ in)
Baptistery, Florence

Saint Basil the Great (329–79), envisioned a realm like Eden, with a hill elevated above all others and covered with palm trees and verdant fields with fragrant flowers of varied colours. The most memorable feature of Angelico's Paradise – the circle of blissfully dancing angels and blessed souls – evidently was inspired by the sixth-century *Celestial Hierarchy*, composed by one of Traversari's favourite Greek authors, Pseudo-Dionysius the Areopagite, whose works he translated. Although the influence of Traversari and these texts on Angelico's personal spirituality is unknown, the *Last Judgement* inspired several variations by the artist, culminating in the apocalyptic vault frescos of the Chapel of San Brizio in Orvieto (see 119, 121, 122).

The *Coronation of the Virgin* (59) may have been painted around the same time as the *Last Judgement* (57). It was made for the church of the hospital of Santa Maria Nuova, one of the oldest charitable institutions in Florence. Founded in the late thirteenth century by Folco Portinari, the medieval hospital played a crucial role in civic life because of its caretaking of the poor. Within decades of its foundation, it outgrew its original quarters and was enlarged through the bequests of the faithful. A surgical clinic and medical library ensured a high standard of care. Pious lay sisters devoted themselves to caring for the sick and destitute, especially women, pledging themselves to lives of charity and poverty, while clergy ministered to the spiritual needs of those who lived within the hospital and performed the last rites for patients. Located at the entrance to the complex, the hospital church was dedicated to Egidio (Giles), a ninth-century saint. As the patron saint of beggars, cripples and the sick, he was endowed with special powers of healing, making the church an important site of worship.

But by the early fifteenth century, Sant'Egidio required extensive renovation and expansion to meet the growing needs of the hospital. In 1418, Bicci di Lorenzo was appointed the architect of a restoration that progressed with astonishing speed. Only two years later, the church was consecrated in a ceremony that was remembered among the most solemn events in Florentine history. It took place on 8 September, the feast of the Birth of the Virgin (one of the major days in the city's liturgical calendar), and was attended by Pope Martin V, cardinals, bishops and other dignitaries. Inaugurating the embellishment of the newly renovated church, Bicci di Lorenzo frescoed this auspicious event on its façade.

In the 1430s, the choir of Sant'Egidio became the focus of artistic patronage. Appropriately, given the dedication of the hospital, the Virgin was the theme of its decoration. In 1434, Zanobi Strozzi began to paint a *Madonna and Child with Angels* (see 69) for a chapel on the choir screen, and by May 1439, Domenico Veneziano, assisted by Piero della Francesca (*c.*1415–92), was frescoing scenes from the life of the Virgin for the apse that have since been destroyed. Painted for another chapel on the choir screen, Angelico's *Coronation of the Virgin* was part of this Marian programme. Although the commission is undocumented, the style of the altarpiece suggests that it was painted early in the decade. The heavenly setting and concentrically radiating rings of saints may have emerged from Angelico's experience in painting the *Last Judgement*, which shares a similarly luminous palette and intensely characterized figures.

Angelico may have been inspired by Lorenzo Monaco's high altarpiece (see 15) for the nearby church of Santa Maria degli Angeli when he conceived the *Coronation of the Virgin* as a truly celestial image. Christ and the Virgin are portrayed in the centre of the golden panel, which is incised with rays of varied length and a pattern that reflected the glow of candles offered by the devout.

59
*Coronation of the Virgin, c.*1431–2
Tempera and gold on panel;
112 × 114 cm (44 × 44⅞ in)
Galleria degli Uffizi, Florence

60
Marriage of the Virgin, predella
panel of *Coronation of the Virgin* (59),
*c.*1431–2
Tempera and gold on panel;
19 × 51 cm (7½ × 20 in)
Museo di San Marco, Florence

Seated on a bank of deep blue clouds formed by the wings of haloed seraphim, they receive the homage of the angels and saints who surround them. Jesus crowns Mary with a golden diadem as he displays the orb symbolic of his universal dominion. The inscription on the border of his mantle repeats the opening words of the 'Sanctus', one of the oldest texts in the Christian liturgy. Culminating the Eucharistic preface of the Mass, it invokes the Lord as 'Holy, holy, holy, Lord God of Hosts', whose 'heaven and earth' are full of His glory. The solemn expression and humbly crossed hands of the Virgin recall her gesture at the Annunciation (see 38, 43), when she accepted the will of God in bearing His son. Angelico's portrayal of the Virgin, garbed in a celestial blue gown and radiant mantle, called to mind one of many the hymns sung in her honour, when she was invoked as 'Hail, Queen of Heaven, Hail, Lady of Angels'. The dancing and music-making angels, whose brilliantly coloured gowns flow with their movements, seemed to illustrate these hymns for the faithful, as in the 'Sanctus', when the congregation joined the cherubim and seraphim in unceasing voices, saying 'Holy, holy, holy' in thanksgiving. Standing beside the others, two angels swing silver censers of incense, magnifying the liturgical associations of this celestial image. The elegant proportions of these figures, as well as their graceful postures and gestures, seem suffused with Ghiberti's influence.

Concentric rings of saints radiate from the Virgin and Christ in perspective, suggesting the depth and immensity of the heavens. Varied in appearance, gaze, gesture and dress, each saint bore a special relationship to the worshipper. In the foreground at the extreme left a bishop saint, perhaps Zenobius, the city's first bishop and one of its patron saints, engages the viewer with his raised hand and direct gaze. Beside him the bishop Sant'Egidio, wearing a brilliant blue cope, turns reverently towards the sacred event.

The border of his hood is inscribed in golden letters identifying him as 'intercessor', proclaiming his role as healer of the sick and patron of the church. To his right Saint Dominic, proffering his attribute of the lilies and book, regards the worshipper intently. The inscription on his collar proclaims that 'Saint Dominic preaches', reiterating the evangelical role of the Order to which Angelico belonged. Wearing the white habit of his Order, Saint Benedict, whose rule the hospital clergy followed, kneels behind Dominic to face the Coronation.

Perhaps most remarkable of all are the female saints, after whose example the pious sisters of the hospital modelled their own lives. Personifying the virtues of faith, chastity and obedience, they include Mary Magdalene, Margaret, Agnes, Lucy and Cecilia. Each is dressed in garments of luminous colours – scarlet, pale malachite, lapis lazuli and rose – that glow with reflected light. While three of the holy women turn towards the worshipper, only the kneeling Magdalene directly engages the viewer's gaze. Among them all, she alone witnessed the Crucifixion and Resurrection of Christ. Her devotion to Jesus and preparation of his body for the grave were emulated in the charity of the lay sisters as they tended the dying. Saint Margaret stands beside her and gestures toward the Coronation. As patron saint of childbirth, she held a privileged role within the devotions of all women, especially the indigent women who were cared for in the hospital.

Although the original frame of the altarpiece is lost (its present frame is a modern replacement), the two panels that formed its predella have been identified. They represent the *Marriage of the Virgin* (60), which theologians regarded as a prefiguration of the Coronation, and the *Dormition of the Virgin* (61), which immediately precedes the Coronation. Each scene displays Angelico's command of perspective, nuanced portrayal of emotion and radiant colour. The *Marriage of the Virgin* transpires before the foreshortened

61
Dormition of the Virgin, predella
panel of *Coronation of the Virgin* (59),
c.1431–2
Tempera and gold on panel;
19 × 50 cm (7½ × 19¾ in)
Museo di San Marco, Florence

walls of the Temple of Jerusalem, angled obliquely in space to create the illusion of depth. Angelico suggested a range of responses, from the solemnity of Mary and Joseph as they are united to the rage of the rejected suitors, who jealously pommel the aged groom with their fists. The *Dormition of the Virgin*, by contrast, takes places in a stark and mountainous landscape, in which angels and grieving Apostles sing a requiem Mass as they mourn her passing. The radiant colours of these panels perfectly complement those of the *Coronation*, as do their compositions, which focus on Mary, as was appropriate for the church at the hospital dedicated to her.

The celestial conception of the *Coronation of the Virgin* differed dramatically from most interpretations of this theme (see 12, 14), including Angelico's own altarpiece for his conventual church of San Domenico (see 39), where throngs of saints and angels surround the throne of Christ. While it may have been influenced by Lorenzo Monaco's altarpiece in Santa Maria degli Angeli (see 15), its remarkable sense of perspective and movement, glowing colours and individual characterization of each holy figure reveal Angelico's distance from the late Gothic tradition. The altarpiece translated both the solemnity and jubilation of this sacred event, presenting to the faithful a glorious vision of heaven.

With his next work, Angelico entered the most elite circle of patronage. Palla Strozzi, at one time the wealthiest man in Florence, commissioned the *Descent from the Cross* for an altar in his family's funerary chapel (62). The fifteenth-century historian Vespasiano da Bisticci lauded his distinguished ancestry, patriotism and love of Greek and Latin literature, which he studied with Ambrogio Traversari. Palla was the most devoted of sons. He dedicated his resources to completing the funerary chapel begun by his father, Onofrio, in the sacristy of Santa Trinita, the venerable mother church of the Vallombrosan Order founded by San Giovanni Gualberto in

the eleventh century. Immediately upon his father's death in 1418, Palla engaged Ghiberti as architect, later hiring the finest craftsmen and artists. The space was expanded to include a small, elevated chapel and a crypt, each with its own altar. It also was intended to house Palla's extensive library of classical and contemporary manuscripts, the second largest collection in the city. Between 1418 and 1423, the sacristy was embellished at great cost with blue vaults studded with gold stars, stained glass windows, new choir stalls for the monks and marble steps inlaid with the family's emblems. By May 1423, Gentile da Fabriano had painted the *Adoration of the Magi* (see 29) for its altar. Portraying the epiphany of the infant Jesus to the kings who paid him homage as King of Kings, the subject was unprecedented in a Florentine altarpiece. The *Adoration* was replete with Eucharistic associations, as suggested by the kneeling Magus, who lifts the infant's foot to kiss it as the priest would elevate the Host and chalice in the Mass. The theme ideally complemented the function of the sacristy as a room that preserved the vessels and vestments used by the priest in celebrating the Divine Office. So, too, the *Descent from the Cross* evoked these same associations.

As the foremost Florentine painter in the early 1420s, Lorenzo Monaco was commissioned to paint an altarpiece for the smaller chapel in the sacristy. Its original subject evidently was the Madonna and Child flanked by the patron saints of Palla's father and older brother, as predella panels representing scenes from the lives of these saints attest. But between 1424 and 1425, the wealthy Ardinghelli family commissioned a monumental altarpiece for their chapel in Santa Trinita to display a most precious relic, a fragment of the True Cross. Palla, who was related to them through marriage, helped subsidize the decoration of the chapel, which was located near the sacristy. The proximity of this charismatic relic may have

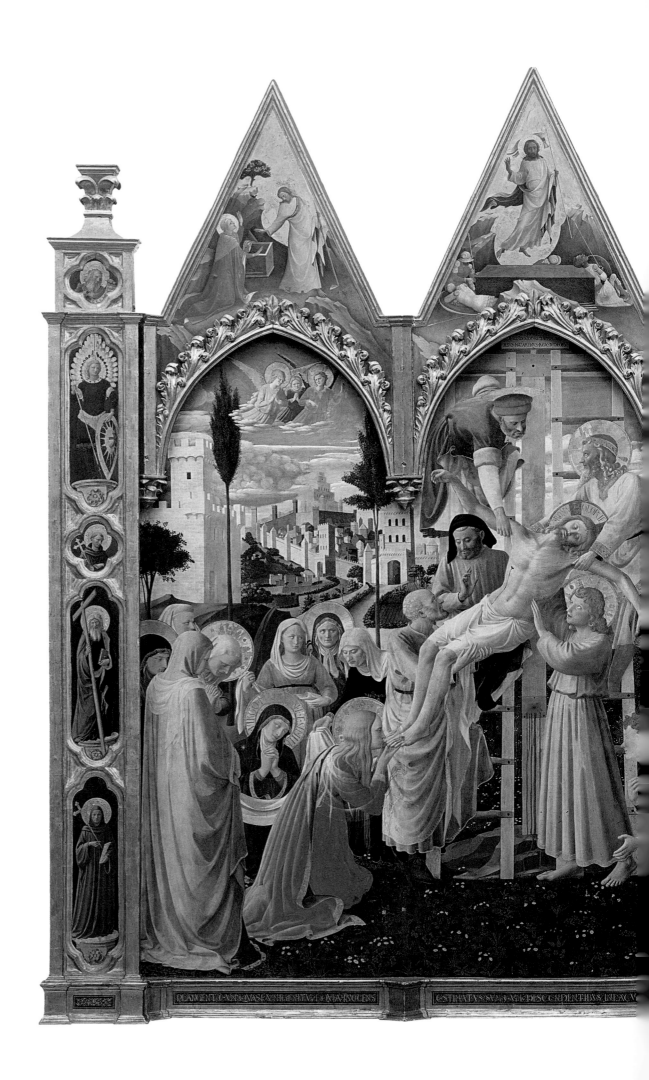

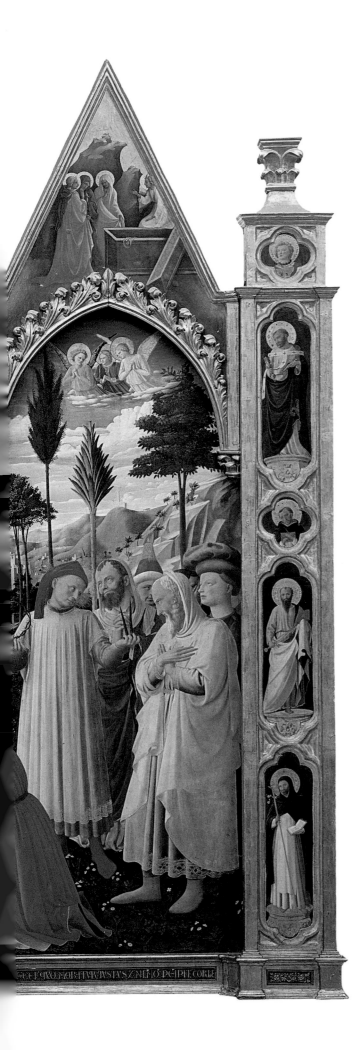

62
Descent from the Cross, installed 1432
Tempera and gold on panel;
277 × 280 cm (109 × 110¼ in)
Pinnacles by Lorenzo Monaco
Museo di San Marco, Florence

Overleaf
Detail from *Descent from the Cross*
(62)

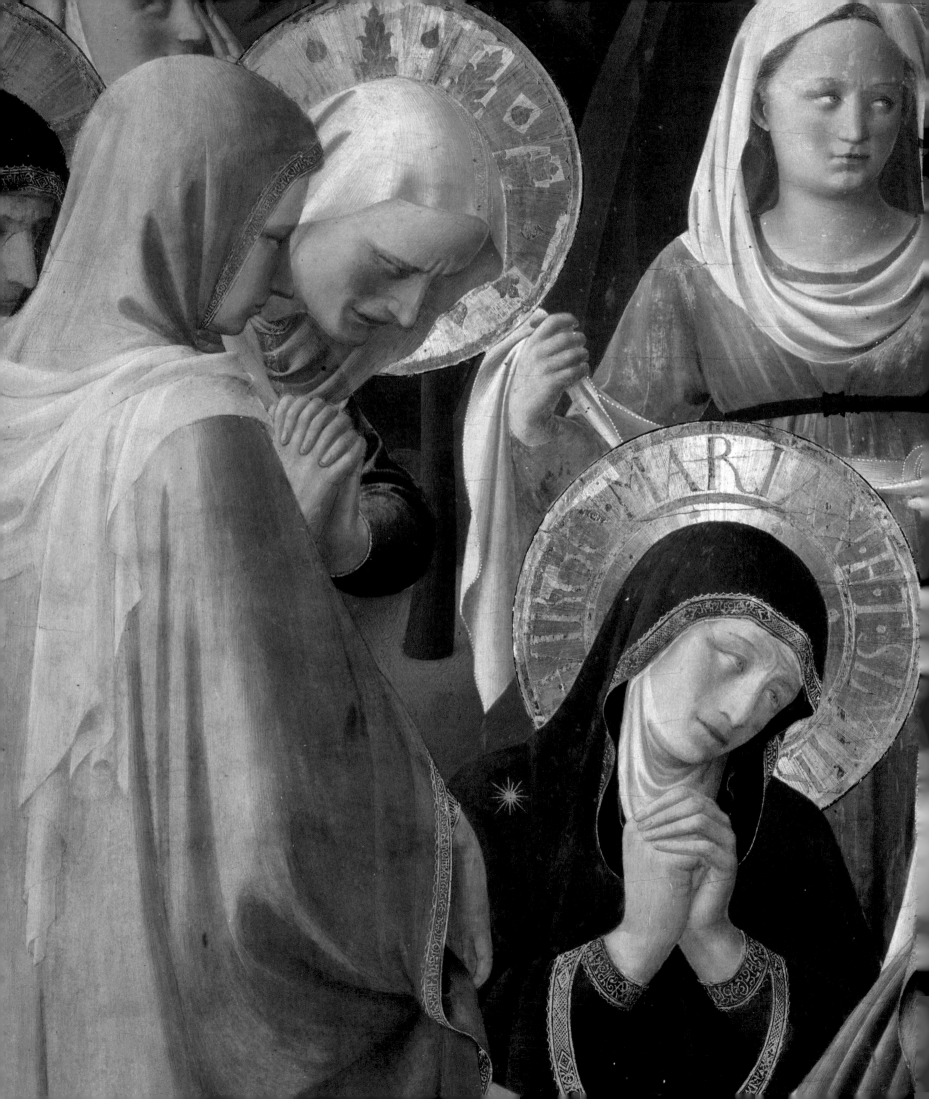

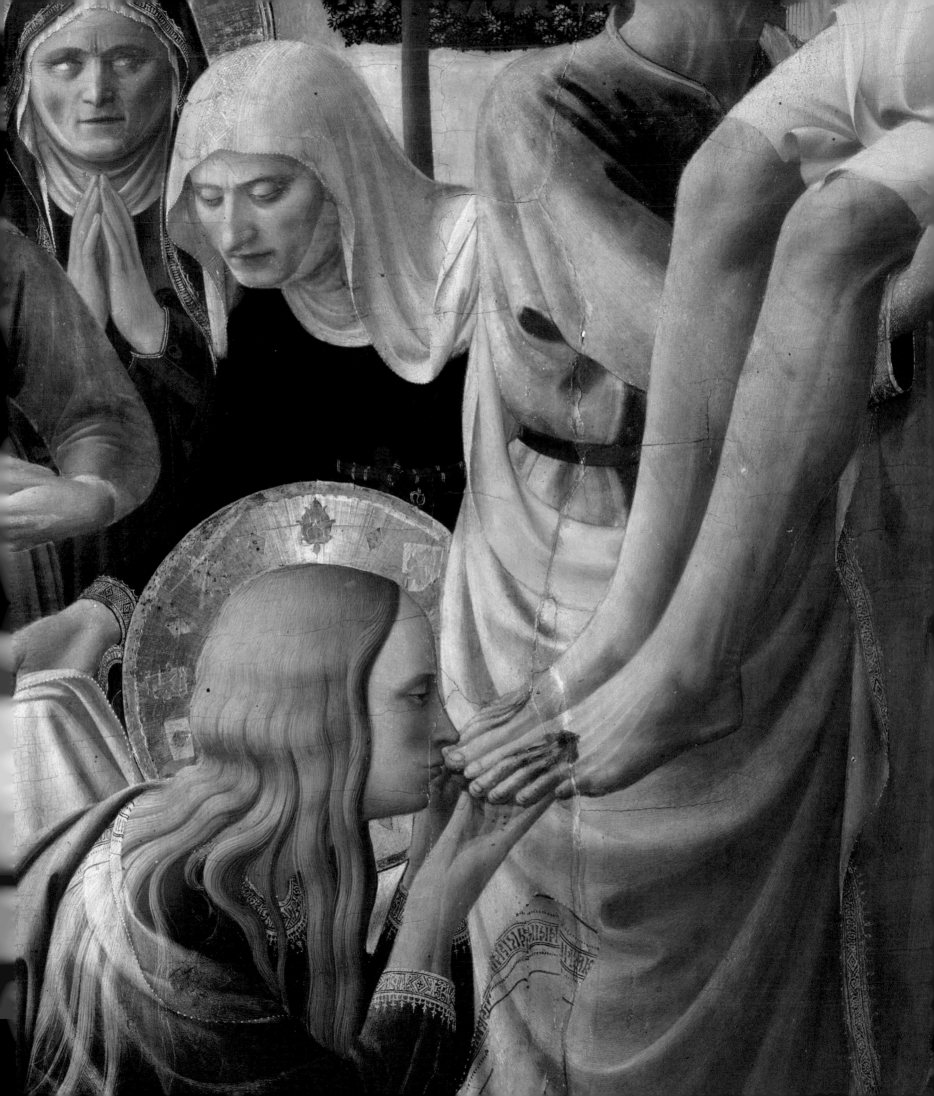

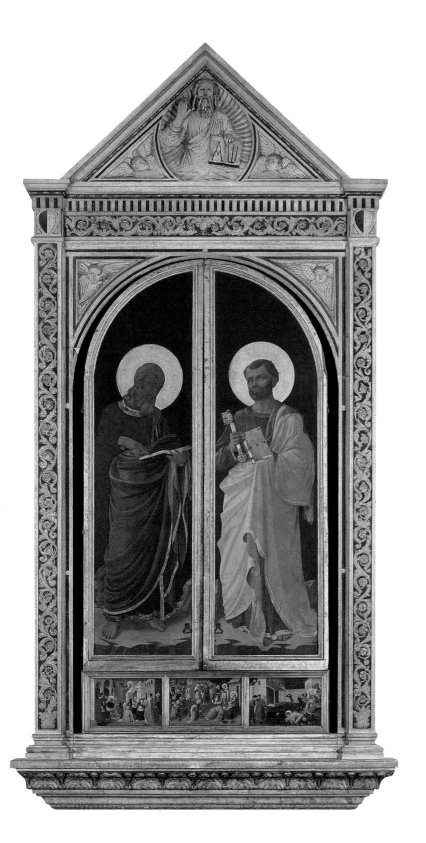

63
Saints Mark and Peter, outer panels of
*Virgin and Child Enthroned with
Saints John the Baptist and Mark*,
known as *Linaiuoli Tabernacle*
(closed), 1433
Tempera and gold on panel (marble
frame designed by Lorenzo Ghiberti);
frame: 528 × 269 cm (207⅞ × 105⅞ in)
Museo di San Marco, Florence

inspired him to change the subject of his altarpiece to the Descent
from the Cross. The elderly Lorenzo Monaco painted the pinnacles
of *Christ Appearing to Mary Magdalene*, the *Resurrection of Christ*
and *Three Maries at the Sepulchre*, but it is clear that he died before
fulfilling his obligation.

The choice of Angelico to complete the altarpiece may have
been motivated by his association with Lorenzo Monaco. The
radiant colours of the pinnacles and luminous drapery of the
holy figures harmonize well with the *Descent from the Cross*,
suggesting the wisdom of this decision. Palla may have seen the *Last
Judgement* in Santa Maria degli Angeli (see 57), where he studied
sacred texts with Ambrogio Traversari, or Angelico's paintings in
Florence and Fiesole. The importance of this commission indicates
the professional stature Angelico had achieved by the opening years
of the 1430s. Although the altarpiece itself is not documented,
it was probably underway when Palla Strozzi made a generous
donation of wine to the friars of San Domenico di Fiesole in July
1431. Exactly a year later, it was installed in the sacristy chapel.

The *Descent from the Cross* transpires within a light-filled,
idealized landscape that extends continuously below the arches of
the frame. Its great depth is calibrated by the diminishing height
of the trees from foreground to back, the recession of the winding
roads toward the background, and the buildings that become
increasingly smaller until they are barely visible among the hills.
The holy city of Jerusalem, the turreted walls of which resemble
those that surrounded Florence, rises in the distance, giving way on
the right to mountains, the undulating peaks gradually meeting the
misty horizon. This deep and verdant landscape provides a spacious
setting in which the drama of human salvation unfolds. Luminous
colours, from varied shades of blue and green to deep crimson,
impart serenity to the figures and setting. The pinnacles organize
the participants of this solemn drama into three groups. On the
left, the Holy Women unwind the shroud in which Jesus will be
wrapped, while the Virgin kneels, hands clasped in prayer, to receive
the body of her son. At the foot of the Cross, Mary Magdalene
kisses his feet, recalling their first encounter when she washed
his feet with her tears and proclaimed him as her saviour. As the
women watch, Jesus is lowered gently from the Cross and received
reverently by the men who stand beneath it. They include the
haloed John the Evangelist, Nicodemus, identified by inscriptions
on his garments, and Joseph of Arimathea, who gave Jesus his
own tomb. A group of men gathers beside them, one proffering
the crown of thorns and nails for the others to contemplate. Before
them, a kneeling young man, possibly the devout Alessio degli
Strozzi (d.1383), one of Palla's ancestors who had been a friar at
Santa Maria Novella, strikes his chest in penance. He extends one
hand, exhorting the beholder to reflect upon the scene before
them, whether through grieving with the Holy Women and weeping
angels or joining the men as they meditate upon the Passion.

The three Latin inscriptions on the base of the frame were
taken from the liturgy for Holy Saturday (the final penitential day
before Easter). The texts are illustrated by the figures who, along
with the pinnacles, organize the composition. The words below
the Holy Women lament: 'They shall mourn for him as if for an
only son, for he is innocent.' The words below Jesus proclaim, 'I am
counted with those who go down into the pit', an allusion to his
death. The liturgical text below the man displaying the instruments
of the Passion admonishes the worshipper: 'See how the just man
dies and no one takes it to heart'. While the inscriptions exhorted
the faithful to grieve the death of Christ, the pinnacles illustrated
the certainty of his Resurrection. The tranquillity of Jesus's face and

the inscription 'Crown of Glory' on his halo anticipate the imminence of Easter Sunday and his Resurrection. As with the Mass itself, the altarpiece commanded the worshipper to call to mind, in the words of the liturgy, 'the blessed Passion of this same Christ' and 'also his resurrection from the grave and glorious ascension into Heaven'. Angelico visualized for the devout the 'remembrance' of Jesus's life that was celebrated in the Mass.

Angelico's presentation of the Descent from the Cross was virtually unprecedented. Although the Lamentation over the dead Christ had been portrayed in earlier devotional panels, this is the first known depiction of the Deposition in a Florentine altarpiece. The composition and modelling of the monumental figures, as well as the subtle range of their responses, suggest that Angelico's inspiration may have been life-size groups of wooden Passion sculpture. As early as the late tenth century, Good Friday rituals involved the creation of a sepulchre on the altar in which a cross was venerated and laid in the tomb in imitation of the burial of Christ's body. Entire sculptural groups were included in Holy Week processions, devotions and Passion plays to intensify emotions. The relationship of these mimetic recreations to the altarpiece seems unmistakable. From the Holy Woman seen from the back, whose blue mantle leads the beholder into the scene, to the idealized, luminously modelled body of Christ, the figures reveal Angelico's study of Ghiberti's reliefs. The same is true of the saints on the pilasters. The saints display their profound engagement with Christ's death through their remorseful gazes and empathetic gestures.

Palla had little more than two years to celebrate requiem Masses for his father after the installation of the altarpiece. On 9 November 1434, he was expelled from Florence, unjustly condemned of treason by the newly installed regime of Cosimo de' Medici, whose exile, in fact, he had opposed. Although Palla expressed his desire to be buried in 'the chapel made by me' in his testament, he was never allowed to return to his native city. With Palla's departure, Cosimo became the richest man in Florence. Within two years of Cosimo's return to power, Angelico would enter his employ by painting the altarpiece for the family's chapel in San Lorenzo.

Angelico's next commission was for a monumental triptych of the Madonna and Child with saints, the great size of which (5.28 × 2.69 metres; 17 × 9 feet, when closed) rivalled the city's largest altarpieces (63, 64). It was painted for the council room in the offices of the Arte dei Linaiuoli, Sarti e Rigattieri, the guild of linen vendors, tailors and second-hand clothing dealers. Although the guild was by no means the most powerful or prestigious, its involvement with Florence's major industry, the production and sale of cloth, ensured its importance within civic and economic life. The guild maintained a niche at Orsanmichele, filled by Donatello's statue of *Saint Mark*, its patron, attesting its progressive taste in public works. Its offices occupied a large stone building on the Piazza Sant'Andrea near the Mercato Vecchio, the city's commercial heart.

Although the original contract for the *Linaiuoli Tabernacle* no longer survives, an official of the guild summarized it and other documents related to the commission. The fortuitous preservation of these contemporary records allows the commission to be traced virtually from beginning to end. In October 1432, the wooden panels for the triptych for the room 'where the image of Our Lady now is painted' were ordered from a carpenter working from a 'model' provided by Ghiberti. The painting itself was commissioned from Angelico on 11 July 1433. 'With all his art and expertise', the friar was required to paint a 'tabernacle of Our Lady' both 'inside

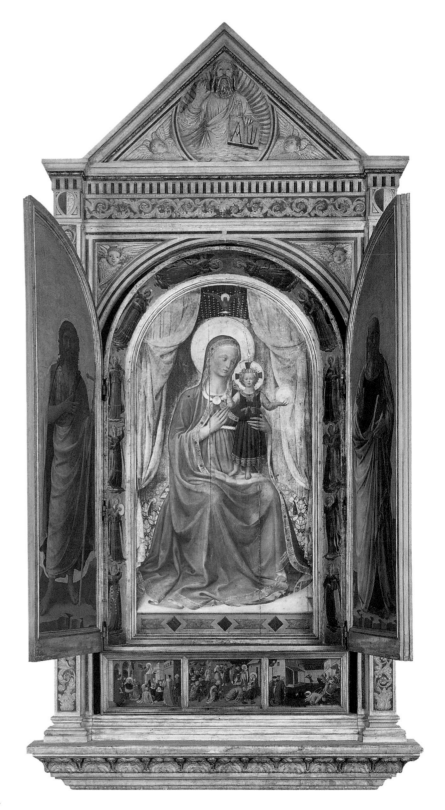

64
Virgin and Child Enthroned with Saints John the Baptist and Mark, known as *Linaiuoli Tabernacle* (open), 1433
Tempera and gold on panel (marble frame designed by Lorenzo Ghiberti); panel: 250 × 133 cm (98½ × 52⅜ in); predella: 39 × 168 cm (15⅜ × 66⅛ in)
Museo di San Marco, Florence

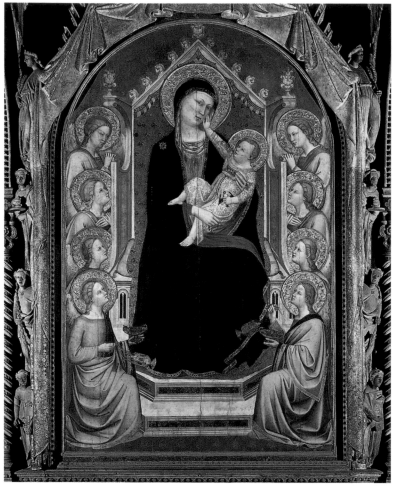

65
Bernardo Daddi (marble frame
by Andrea Orcagna, dated 1359),
*Orsanmichele Madonna and Child
with Angels*, 1346–7
Tempera and gold on panel, marble
frame
Orsanmichele, Florence

and out with the best and finest colours, gold and blue and silver,
that can be found'. He was to be paid 190 gold florins – the largest
sum to date for a Florentine altarpiece – 'or less, as his conscience
sees fit'. This stipulation, unprecedented in artists' contracts,
attests the friar's humility and the trust accorded him by the guild.
Finally, he was to paint the tabernacle using 'those figures that are
in the drawing'. On 11 August 1433, the marble frame in which the
altarpiece was to be enclosed was contracted from stone carvers
following a drawing provided by Ghiberti. The tabernacle seems
to have been complete by 23 November 1435, when the artist Piero
di Lorenzo was paid for 'gold and other colours' for painting the
niche in which it was installed. He also constructed a window beside
it, ensuring its visibility by natural light. A nineteenth-century
photograph of the council room records that the wall above the
niche was studded with golden stars, creating a celestial setting
for the tabernacle.

This series of documents raises important questions regarding
the work's conception. Clearly the tabernacle was planned as
a replacement for 'the image of Our Lady' already in the guildhall.
Angelico's Madonna may have been intended to approximate the
appearance of the earlier work, the spiritual charisma of which it
would have inherited. Late medieval and early Renaissance histories
considered the replacement or recreation of an older painting as an
act of homage. It was believed that the potency of the original was
inherited or even intensified by the substitute. Such was the case
with the monumental *Madonna and Child with Angels* by Bernardo
Daddi in the church of Orsanmichele, which replaced two earlier
miraculous images (65). Located in the oratory where all guilds
met, and tended by its own confraternity whose members devoutly
sang hymns before it, the *Orsanmichele Madonna* was among
the city's most venerated works. The conception of the *Linaiuoli
Tabernacle* seems inspired by its example. Ghiberti reinterpreted
the *Orsanmichele Madonna's* elaborate marble frame and inner
arch, carved with music-making angels, in a more contemporary
style. In both works, the Virgin and infant Jesus are portrayed
beneath a baldachin (canopy), the curtains of which part to reveal
them, reflecting the devotional practice of concealing or veiling
sacred images to preserve their potency. Just as the viewing of
the Orsanmichele *Madonna and Child* was originally controlled
by iron grilles and drapes, the display of the Linaiuoli *Madonna*
was regulated by the shutters that enclosed the image. In 1436,
the installation of a lock – aligned with the key of Saint Peter and
unobtrusively located near his feet – vigilantly protected access to
the sacred image. The statutes of the Linaiuoli list numerous holy
days when 'each and every man of this guild' was to worship in
the guildhall, including Sundays, feasts associated with Jesus and
the Virgin, and the holy days of several saints. On these solemn
occasions, it seems likely that the tabernacle was unlocked and the
image exposed for veneration.

Equally significant was the role of Ghiberti in planning
the altarpiece. Providing drawings for the carpenter and stone
carvers, the sculptor was involved with the commission almost
nine months before Angelico. Ghiberti's design of the actual
painting as well seems indicated by the stipulation that Angelico
follow 'those figures that are in the drawing'. As Ghiberti professed
in his autobiography, he made drawings for many painters and
sculptors, especially for 'figures larger than lifesize' that demanded
a sculptor's understanding of 'rules and proportions'. Angelico's use
of a preparatory drawing is proven by the lightly scored incisions
that outline the contours of the saints and angels, but not those of
the Virgin and Child. Evidently their conception was entirely his

own, emerging from his intense devotion, as a Dominican friar, to them both. Through this commission, Angelico, whose earlier works already displayed the sculptor's influence, entered into direct dialogue with Ghiberti. The beauty of the altarpiece is a result of their close collaboration and Angelico's own invention.

The *Linaiuoli Tabernacle* was perhaps the most lavish of Angelico's altarpieces. In its centre the Virgin and Child are revealed within a baldachin made of precious fabrics, in homage to them and in tribute to the fine linen produced by the guild. To reproduce the luminous sheen of damask in the curtains, Angelico employed gold leaf, incising variegated floral patterns at different angles to capture and reflect light and suggest the lustre of actual cloth. The Virgin sits upon a crimson cushion, perhaps more fine than any manufactured by the guild, with tri-coloured tassels and patterns that seem woven in golden and coloured threads. Her throne is covered with an exquisite brocade of gold and crimson leaves woven through a ground of lapis lazuli. These costly fabrics and the starry blue sky in which the Holy Spirit seems suspended create a celestial setting for the Virgin and Child. The gown of the infant, now darkened, was once verdigris (a coppery green) painted on top of a silver-leaf ground and enhanced by an elegantly patterned golden hem and neckline. Golden leaves and vine scrolls, like those seen in the hems of Ghiberti's saints from Orsanmichele, embellish the letters forming his name, IHS XPS (Jesus Christ). The border of the Virgin's blue mantle, painted with lapis lazuli, is elaborately inscribed in gold with words from hymns that invoke her as 'O Glorious Lady, elevated above the stars', among other epithets. This image is truly regal, for the infant proffers a golden orb, signifying his dominion over heaven and earth, and the star on the Virgin's shoulder alludes to her as 'Star of the Sea, Port of our Salvation'.

Painted on the splays of the frame, twelve angels pay homage to Mary as 'Queen of Heaven' and 'Queen of Angels', as hymns beseeched her. These angels, today reproduced on innumerable greeting cards and souvenirs, were seen as members of a celestial choir whose music could be imagined by the faithful. Their luminously coloured garments glow with varied rays, stars and vine scrolls painted in gold, and the recessed punch work of their haloes and multi-coloured wings would have captured and reflected light when seen by candles, creating the illusion of motion. Angelico had depicted adoring angels in the frame of the *Madonna of the Star* (see 44), but these arise from a different conception. Now, the proportions are gracefully elongated, their postures seem lithe and varied, and their gestures are foreshortened with a sculptural sensibility. They seem culled from Ghiberti's vast repertoire of figures and suggest the sculptor's contribution.

The intervention of Ghiberti seems most apparent in the saints of the inner and outer wings. Their stature, physique and voluminous drapery recall his figures for Orsanmichele (66). Standing on rocky ledges and turned at different angles, they convey an extraordinary sense of three-dimensionality. On the outer wing Saint Mark, patron of the guild, intently lowers his head and turns away to read his own Gospel, the angle of his body directing the beholder to the sacred image within. On the opposite wing Saint Peter, proffering his key and book, inscribed with the invocation 'Hail, Mary, Full of Grace', guards access to the image, his vigilant gaze and the outward angle of his body forming a counterpoint to Saint Mark's spiritual absorption. Inside, John the Baptist, precursor of Jesus and patron saint of Florence, directs the beholder to the Virgin and Child with gesture and gaze, while Saint Mark, his eyes averted and his Gospel closed, raises a perfectly foreshortened hand to demand attention.

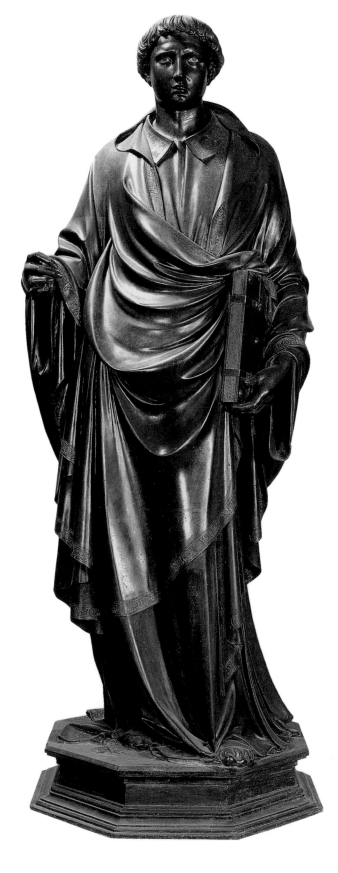

66
Lorenzo Ghiberti, *Saint Stephen*, installed 1428
Partially gilded bronze; 230 cm (90½ in) high
Museo di Orsanmichele, Florence

Specific quotations from Ghiberti's Orsanmichele saints, two of which had been completed a couple of decades earlier, cannot be identified. Yet the intensely sculptural sensibility of these noble figures, who stand with such mobility and ease against the golden ground, the deep horizontal and diagonal folds of their drapery and the attentiveness to such anatomical details as the tightened muscles of Saint Peter's neck and the Baptist's chest attest unmistakably to Ghiberti's crucial role in planning these figures.

Ghiberti's influence on the narratives of the predella is less certain. Although individual figures may be paralleled to those in the North Doors (see 8, 58) or the Gates of Paradise (see 53), this does not necessitate Ghiberti's planning of the scenes, which are quite different from the multi-episodic narratives that the sculptor introduced in the Gates of Paradise. The deep and slightly uptilted space, the diagonal placement of architecture and, above all, the concentration on a single episode seem compatible with Angelico's predella for the *Coronation of the Virgin* for San Domenico di Fiesole (see 39) and such narratives as the *Last Judgement* (see 57) and the *Descent from the Cross* (see 62). The predella scenes reveal his astute observations of social behaviour, as with the gamut of responses in *Saint Peter Preaching*, and even of weather, as in the hailstorm that darkens the sky in the *Martyrdom of Saint Mark*. Here, as with the main panels of the altarpiece itself, Angelico worked 'with all his art and expertise', as his patrons demanded.

The *Annalena Altarpiece* may have been painted next (67). The altarpiece at one time belonged to San Vincenzo d'Annalena, a Dominican nunnery founded by a relative of the Medici in 1450, but it was not painted for this location originally. Neither Vincent Ferrer nor Stephen, the saints to whom the convent was dedicated, is depicted, and its style indicates a date of around 1435. Although the commission is not documented, the altarpiece seems to have been painted for the double chapel of the Medici family, dedicated to Saints Cosmas and Damian and located on the south transept of San Lorenzo. In the mid-1430s, San Lorenzo was still under construction, so it is probable that the altarpiece, although evidently intended for this site, was not installed until later.

The chapel led directly to the Old Sacristy, where Cosimo and Lorenzo had buried their father, Giovanni di Bicci, with honour, in 1429. Together, they created a virtual enclave of the family's power that proclaimed the status of the Medici dynasty. As the chapel's sole adornment, the altarpiece would have illustrated the continuity of Giovanni di Bicci's lineage. It depicted the patron saints of the male members of the dynasty as they paid homage to the Virgin. To the left of the Virgin are Saints Cosmas (Cosimo), Damian (patron, along with Cosmas, of the entire family) and Peter Martyr (Piero, son of Cosimo). Flanking her to the right are Saints John the Evangelist (Giovanni di Bicci), Lawrence (Lorenzo, son of Giovanni di Bicci, as well as dedicatee of the church of San Lorenzo) and Francis (Francesco, son of Lorenzo). The altarpiece rests on a predella with scenes of the lives of Cosmas and Damian (68). Cosimo and Lorenzo were so devoted to these saints that in 1430, they donated the enormous sum of 800 florins to the church for the celebration of their patrons' feast days.

67
Virgin and Child Enthroned with Saints Peter Martyr, Cosmas and Damian, John the Evangelist, Lawrence and Francis, known as *Annalena Altarpiece*, c.1435
Tempera and gold on panel;
200 × 235 cm (78¾ × 92½ in)
Museo di San Marco, Florence

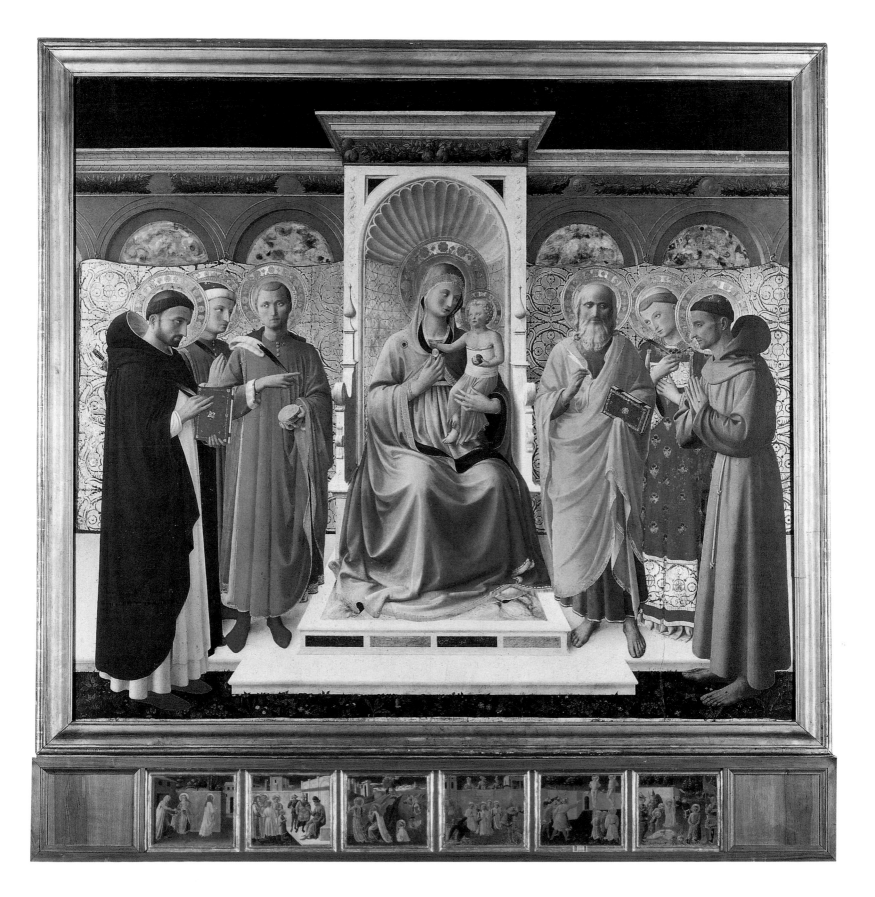

68
Zanobi Strozzi, *Saints Cosmas and Damian Saved from Drowning*, predella panel of *Annalena Altarpiece* (67), *c.*1435
Tempera and gold on panel;
20 × 22 cm (7⅞ × 8⅝ in)
Museo di San Marco, Florence

Demonstrating the faith of the Medici and their protection by these saints, the *Annalena Altarpiece* proclaimed the crucial role of the family as patrons of San Lorenzo. From Giovanni di Bicci, who served on the original building committee, to Cosimo, who eventually assumed the right to construct the choir, the crossing beneath the dome and the nave, the Medici dominated the church and its programme of construction. In June 1434, while Cosimo was still in exile, it was resolved that any new chapel in San Lorenzo had to follow the model, proportions and decoration of the family's chapel in the Old Sacristy. An altarpiece that was 'square and without pinnacles' was to be the only adornment. The *Annalena Altarpiece* seems to have been the prototype for this new style of altarpiece, establishing the precedent that all devotional panels in the church were required to follow. A work of extraordinary importance, it may have been the first Renaissance altarpiece of the Virgin and Child with saints conceived in a single-panel format. This new and influential type of devotional painting is known as a *sacra conversazione* ('sacred conversation'), in which the Virgin and Child and flanking saints were placed within a unified space.

In painting the *Annalena Altarpiece*, Angelico replaced the triptych format and gold leaf background of earlier altarpieces with a continuous space created by classically inspired architecture. A rose-coloured cornice and a frieze of luxuriant wreaths embellish a wall articulated by arches that frame the figures. The only allusion to the traditional golden background is the cloth of honour, incised with ornate patterns that probably were inspired by actual silk. The Virgin's throne rests on a white marble base that extends across the width of the panel. Although the area above the wall evidently was over-painted in an ill-advised restoration, it almost certainly was embellished with palm trees and cypresses. This may be surmised from the settings of the *San Marco Altarpiece* (see 84) and the *Bosco ai Frati Altarpiece* (see 136), which Angelico later painted for the Medici. The similar compositions and unified, architectural settings of these works suggest that the *Annalena Altarpiece* established a type of devotional painting recognizably associated with the Medici.

In several respects, the *Annalena Altarpiece* seems comparable with the *Linaiuoli Tabernacle*. Both share the same brilliant colours – deep cerulean blue, pale rose, vibrant red. The slender proportions and sharply delineated features of the saints seem alike and the appearance of the Virgin, portrayed in three-quarters view, is almost identical in each. At the same time, the works are significantly different in sentiment. In the *Annalena Altarpiece* the figures exchange sorrowful gazes as they behold the infant. The child is partly swaddled in allusion to his death and the shroud in which his body will be wrapped. The characterization of each figure, each absorbed in solemn contemplation, poignantly expresses compassion for the child's future suffering. This empathy is particularly pronounced in Saint Lawrence, who looks mournfully towards Jesus. Lawrence was the focus of a special cult at San Lorenzo, and was believed to rescue souls from Purgatory. As patron of the deceased Giovanni di Bicci, John the Evangelist gazes away from Jesus beseechingly, while Cosmas directs the worshipper to the Virgin and Child. Such exchanges, moving yet restrained, arose

from the same empathetic engagement with Christ's Passion that Angelico portrayed in the *Descent from the Cross*.

Only one Latin manuscript of the lives of Saints Cosmas and Damian is recorded in Florentine libraries during the Renaissance. Belonging to Cosimo de' Medici in 1418, the text, which was not illustrated, was probably the literary source for the predella (see 68). It recounted the miracles portrayed in the panels and suggests the subjects of the two that are missing. Angelico is likely to have designed these scenes, which reflect his experiments with architecture in oblique and diagonal perspective, but he did not paint them himself. The figures are inconsistently proportioned, their postures and gestures are awkward and their facial features are too small and closely spaced to be by Angelico. Although the colours generally correspond to those of the main panel, they lack the harmonious modulation and luminosity of the friar's works. The sky is dull blue, without the graduation of atmospheric perspective, and the palette is restricted.

By this time, Angelico and his brother, the scribe Fra Benedetto, had established a workshop of painters at San Domenico di Fiesole. It took the place of the workshop of Santa Maria degli Angeli, disbanded after Lorenzo Monaco's death, as an important producer of liturgical manuscripts. One artist associated with the shop was Zanobi Strozzi, who lived in the parish of San Domenico di Fiesole from around 1427 to 1445, when Angelico left for Rome. Zanobi is known primarily as a manuscript illuminator, but his earliest documented work is an altarpiece of the Madonna and Child with angels (69). It was painted for a chapel on the choir screen of Sant'Egidio, for which Angelico had executed the *Coronation of the Virgin* (see 59). In 1434, the panel for the *Madonna* was delivered to Zanobi 'in the place of the friars of San Domenico di Fiesole', confirming his presence in the workshop around this time. Given the popularity of Angelico, the commission may have been intended for him, but was diverted instead to this member of his shop. Traces of incisions on the *Madonna and Child with Angels* indicate that Zanobi used a cartoon (drawing to scale), possibly one provided by Angelico. The Virgin and Child of the *Linaiuoli Tabernacle* inspired Zanobi (see 64), and the blue-gowned angels recall, albeit gracelessly, the Archangel Gabriel from the *Annunciation* for San Domenico (see 38). Zanobi's figures lack Angelico's delicate grace, and their facial features are closely spaced and linear. His colours fail to display the subtle range of the master's works. These same characteristics are seen in the predella to the *Annalena Altarpiece*, confirming his authorship and employment in Angelico's workshop.

In the early 1430s, Angelico was indisputably the pre-eminent painter in the city. During the years sometimes described as a 'no man's land' in fifteenth-century painting, Angelico reinterpreted traditional themes, infusing them with deep and intense spirituality, and introduced a new style of altarpiece. His clients represented a broad spectrum of Florence: a guild of workers, the two wealthiest men in Florence and three churches. In the years that immediately followed, his identity as a Dominican painter would be reinforced as he worked for congregations of his own Order, preaching the truths of faith through his art.

69
Zanobi Strozzi, *Madonna and Child with Angels*, begun 1434
Tempera and gold on panel;
138 × 127 cm (54⅜ × 50 in)
Museo di San Marco, Florence

4
Angelico the 'Master Painter'
Dominican Connections in Fiesole, Cortona and Florence

On the last Sunday of October in 1435, the esteemed Bishop of Recanati ceremoniously consecrated the church and convent of San Domenico in Fiesole. So terse is the convent's own account of this momentous event that we must use our imagination to picture what the bishop saw. By this time, construction and decoration of the complex, begun under the Observant reformer Giovanni Dominici two decades earlier, was nearly complete. Within the walls of the rustic church, three altarpieces by Angelico shaped the spirituality of both friars and laity, expressing the devotion of the Dominican Order to the Virgin and Christ (see Chapter Two). Built of rough-hewn stone, the dormitory housed over twenty friars who pledged themselves to lives of austerity as they preached the word of God. To enhance their piety, Angelico also painted frescos inside the convent and on the façade of the church. As his first surviving works in this medium, they demonstrate his mastery of a technique for which Florentine painters were especially admired.

The earliest of these images was the *Crucified Christ* on a wall of the Chapter House, where the friars, sometimes joined by the laity, assembled for meetings (70). As they listened to readings from the Gospels and the Order's Constitutions, recited psalms and prayers, remembered the dead and confessed their sins, the solemn image of their dead saviour, brilliantly illuminated by the room's only window, was always before them. To enhance its poignant realism, Angelico foreshortened Jesus's lowered head and torso from the perspective of the kneeling worshipper. The slender, idealized body is anatomically detailed and luminously modelled, recalling the portrayal in the *Descent from the Cross* (see 62). The inscriptions – in Hebrew, Greek and Latin – on the titulus of the cross identify Christ as 'Jesus of Nazareth, King of the Jews'. At a time when most learned humanists and theologians in Tuscany were ignorant of Hebrew and Greek, the multilingual inscription demonstrated the erudition for which the Dominican Order was famous. The luxuriant, interlaced vine scrolls of the frame paraphrase those of the *Linaiuoli Tabernacle* (see 63, 64), suggesting its execution as early as August 1433, when Ghiberti provided the drawing for the altarpiece's marble frame.

Commemorating the dedication of the Dominican Order to the Virgin Mary, Angelico frescoed the *Madonna and Child* in the lunette above the church's portal (71). The image may well have been completed before the consecration of the church. Extensive repainting has obscured the original fresco, which was damaged by centuries of exposure to the elements. The preparatory underdrawing (*sinopia*), however, was detached from the wall in 1960 and it clearly indicates the artist's hand and original conception (72). In this loving portrayal of mother and son, Angelico showed Mary teaching the infant to bless the worshipper by raising her fingers in a gesture that he imitates. The composition and intimate rapport between Virgin and Child recall those of the *Annalena Altarpiece* (*c*.1435) (see 67), confirming that the works are nearly contemporary. Standing on the threshold of the church and looking up at the fresco, the Bishop of Recanati and other dignitaries at the consecration would have been reminded of Saint Dominic's devotion to Mary, who was honoured by the altarpieces inside. As the chronicle of San

70
Crucified Christ, *c*.1433–4
Fresco; 363 × 212 cm (142⅞ × 83½ in)
Chapter House, San Domenico, Fiesole

Previous page
Detail from *Madonna and Child with Saints Matthew, John the Baptist, John the Evangelist and Mary Magdalene*, known as *Cortona Triptych* (76)

Domenico recorded, these altarpieces had been 'painted by the hand of Fra Giovanni, friar of this convent, many years' earlier, before this church was consecrated'.

The consecration of San Domenico coincided with momentous years in the history of the Renaissance papacy and the Dominican Order. On 11 March 1431, Gabriel Condulmer (1388–1447), scion of a prominent family from Venice, was crowned pope, taking the name of Eugenius IV (reigned 1431–47). From the moment of his election, Eugenius incurred the wrath of the Roman Curia by asserting his absolute supremacy as pope. He sought to limit the clergy's power, reappropriate its landholdings and reform its excesses. The early months of his rule coincided with the Council of Basel (1431–49), which Pope Martin V had convened to unify the Church. Eugenius perceived the Council's potential to challenge his authority and issued a Bull (papal edict) to dissolve it in December 1431. In retaliation, the Council defiantly refused to disband, commanding him to appear before its members. After two years of escalating confrontations, Eugenius finally acknowledged the Council's legitimacy, but his authority had been damaged irreparably. In late May 1434, after a pontificate torn by attempted assassination, conspiracy and rebellion, he fled Rome in fear for his life. He took refuge in Florence, where, as recounted by the chronicler Vespasiano da Bisticci (1421–98), the leaders of the city received him 'with the greatest honour'. Despite intermittent attempts to depose him, Eugenius would serve as pope to the end of his days.

For nearly a decade, Eugenius established his court in the convent of Santa Maria Novella, placing Florence and the Dominican Order at the very heart of his papacy. An intensely pious man committed to strengthening the Church, he strongly supported all reform movements, especially the Dominican Observance. In January 1436, the pontiff issued a decree evicting the Silvestrine monks from the monastery of San Marco in Florence in response to complaints of their impiety and the squalor of their church. Against their protests, he consigned San Marco to the Observant friars at Fiesole, securing the financial support of Cosimo and Lorenzo de' Medici to rebuild the church and convent. As will be described in the following chapter, San Marco soon became an important centre of the reform because of its prominent location within the city, the advocacy of the pope and the munificence of its patrons.

Although Giovanni Dominici, founder of San Domenico, had introduced the Observance in the opening years of the century, it was Antoninus of Florence who secured its acceptance in the 1430s. Antoninus was among the original friars of San Domenico di Fiesole forced into exile during the last years of the Great Schism, spending nearly a decade in Observant convents in Foligno and Cortona. He was ordained a priest in Cortona in 1413, rising to subprior in 1417 and to prior from 1418 to 1421. His return to Fiesole, where he served as prior several times, coincided with Fra Angelico's novitiate and earliest years as a Dominican (see Chapter Two). As prior, Antoninus played a crucial role in Angelico's spiritual and intellectual formation, as is evident in the altarpieces painted for the church. Already known for his distinguished writing and preaching, Antoninus was elected Vicar General of the Observant

Dominicans in Tuscany in 1424 and served in numerous administrative positions at the highest levels, including the papal court. He zealously promoted reform in the Order's congregations throughout the Italian peninsula and visited the closely linked network of Dominican reformed communities to ensure their strict adherence to Observant ideals.

In 1435, the year of San Domenico's consecration, Antoninus persuaded the Master General of the Dominican Order, Barthélemy Texier, to endorse the Observance and advance the reform. As Antoninus recalled in his *Summa historialis*, 'the convents of the Observance greatly multiplied' under Texier's aegis, extending from Venice and Fabriano in northern Italy to Rome and Naples in the south. One of the most important congregations within the Order's network was San Domenico in Cortona, located in a hilltown 117 kilometres (72.7 miles) south-east of Florence. It was for this church that Angelico executed the *Cortona Annunciation* (see 73) and the *Cortona Triptych* (see 76) as well as the *Madonna of Humility with Saints Dominic, Peter Martyr and the Four Evangelists* (see 78), which he frescoed above its portal in 1438. Along with the *Madonna of Humility with Saints Nicholas, Michael, John the Baptist and Margaret of Hungary* (see 77), painted by Sassetta (c.1400–50), they serve as crucial documents of the church's devotional and artistic life.

San Domenico in Cortona occupied a unique place in the history of the Observance (74, 75). By 1230, its friars, among the first followers of Saint Dominic, were preaching in the town and had begun to build a small church and convent just outside its ancient walls. In 1391, at the behest of the pope, Giovanni Dominici chose this congregation as the first to be reformed in all of Tuscany. He planned to build a separate dormitory for the novices, who were to live apart from those already professed, and to expand the complex to serve the community of Observants. By late 1404, the convent of Santa Maria Novella had begun sending its novices to Cortona, although the dormitory was not yet complete. In 1413, Cortona served as a refuge for the friars from Fiesole, including Antoninus, during the final years of the Great Schism. They endured miserable lives of poverty and privation.

Despite its importance as the centre of the reform movement in Tuscany, the convent of San Domenico was in ruinous condition throughout these years. In 1409, Ladislaus of Naples invaded Cortona, defeating the local lords who had ruled it since 1325 and placing himself in power. His troops looted the city before returning to Naples. Cortona became a pawn in the ceaseless battle between Naples and Florence for control of the region. The following year, Florentine troops attacked Cortona, battering down its walls to enter the town. Before the populace succeeded in routing them, they had sacked San Domenico and its properties, leaving the church and convent in near ruins. In 1411, Ladislaus, in desperate need of cash to support his army, sold Cortona to its greatest rival for 60,000 gold florins. Florence installed its magistrates to rule the town and began the domination of its communal life.

In 1412, the populace turned to rebuilding their devastated town and the convent of San Domenico. Recent archival discoveries illuminate the progress of this project and identify the patrons of

71
Madonna and Child (repainted), 1435
Fresco (detached and transferred to
masonite support); 116 × 75 × 2 cm
(45⅝ × 29½ × ¾ in)
San Domenico, Fiesole

the church's altarpieces. Documents indicate that friars from the convent and the wealthiest citizens of Cortona jointly supervised the reconstruction of San Domenico, ensuring communal involvement from the beginning. From 1412, when alms 'for the new church then being built' were offered, until 1437, when the roof was erected, the populace subsidized the project through donations and bequests. On 13 February 1438, Pope Eugenius IV promulgated a Bull to advance the decoration of the church. He permitted the friars to allocate alms for the 'perfection' and 'adornment' of their church, especially by 'commissioning painted images' that enhanced devotion.

Yet even before the papal Bull was issued, three of the town's most prominent citizens had already endowed private chapels that they embellished with altarpieces in the restored church (75). These benefactors were members of the confraternity of Saint Dominic, which was under the spiritual aegis of the friars, and were joined through bonds of parish, commerce and friendship. At different times, they assisted the friars by negotiating sales of land and facilitating other transactions. They donated funds for the construction of the church and for raising its roof. The altarpieces for their chapels were likely to have been painted after the walls were erected in 1432.

The wealthy apothecary Niccolò di Angelo di Cecco commissioned Sassetta, a native of Cortona who became one of the most important painters in the nearby city of Siena, to execute the *Madonna of Humility with Saints Nicholas, Michael, John the Baptist and Margaret of Hungary* for his chapel (77). Located to the left of the high altar, this chapel seems to have been adorned with frescos, as suggested by the patron's testament. In choosing Sassetta, Niccolò di Angelo followed long-established patterns of patronage in Cortona, the churches of which had been decorated by Sienese masters since the early Middle Ages. Although local artists executed minor works for the town, Sienese masters had controlled major commissions in Cortona from the early fourteenth century, when Pietro Lorenzetti frescoed the life of Saint Margaret of Cortona on the walls of her hilltop sanctuary. Given the nearly exclusive patronage of Sienese artists by the citizens of Cortona, the selection of Angelico to execute the other two altarpieces and the portal fresco was remarkable. The commissions were likely to have emerged through the direct intervention of Antoninus, who had helped supervise the construction of the church between 1418 and 1421, when he was prior of the convent. The similarity between the subjects of the altarpieces in Fiesole and Cortona further underscores Antoninus's probable involvement with the decorative programme of the church.

Of the two altarpieces Angelico made for the church, the first was the *Cortona Annunciation*, painted for the wealthy cloth merchant Giovanni di Cola di Cecco (73). His chapel seems to have been located on the right side of the choir screen. The merchant's involvement with San Domenico dates from 1423, when he witnessed the sale of land from the convent to the patron of the *Cortona Triptych*. Giovanni di Cola's personal dedication to the Annunciation is attested by his endowment of Masses on 25 March, the feast of the Annunciation, and the requirement that an oil lamp illuminate his chapel 'in perpetuity'. As the primary adornment of the altar,

72
Sinopia for *Madonna and Child*, 1435
Fresco (detached and transferred to
masonite support); 116 × 75 × 2 cm
(45⅝ × 29½ × ¾ in)
San Domenico, Fiesole

73

*Cortona Annunciation, c.*1432
Tempera and gold on panel;
175 × 180 cm (68⅞ × 70⅞ in)
Museo Diocesano, Cortona

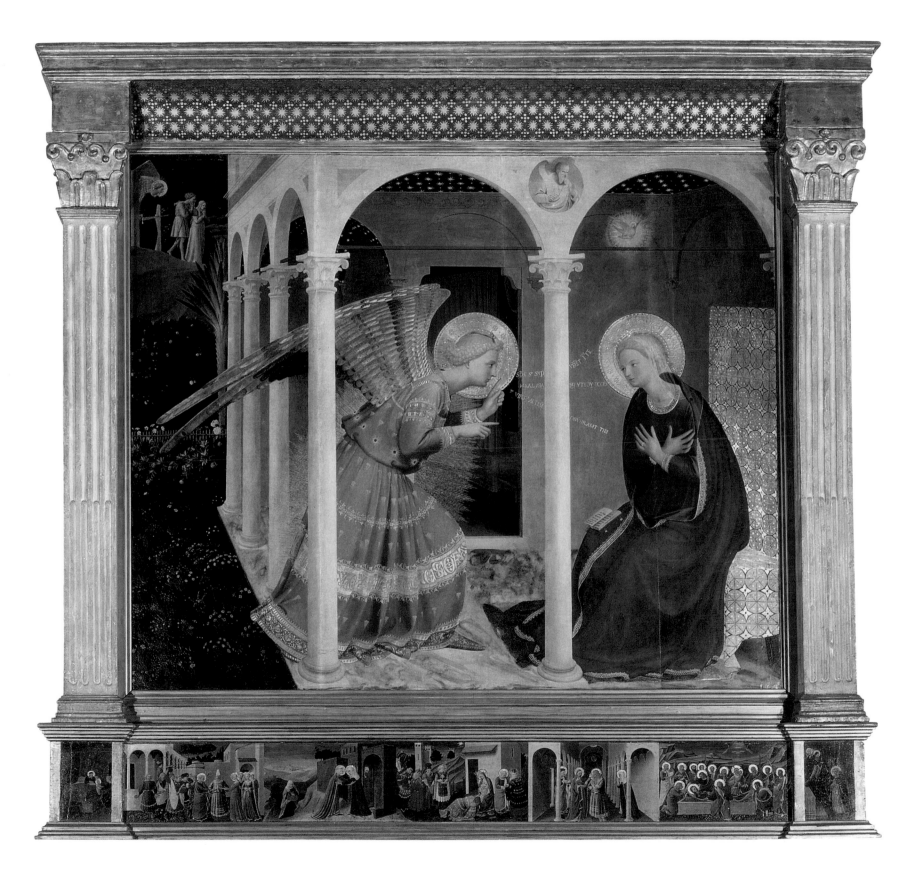

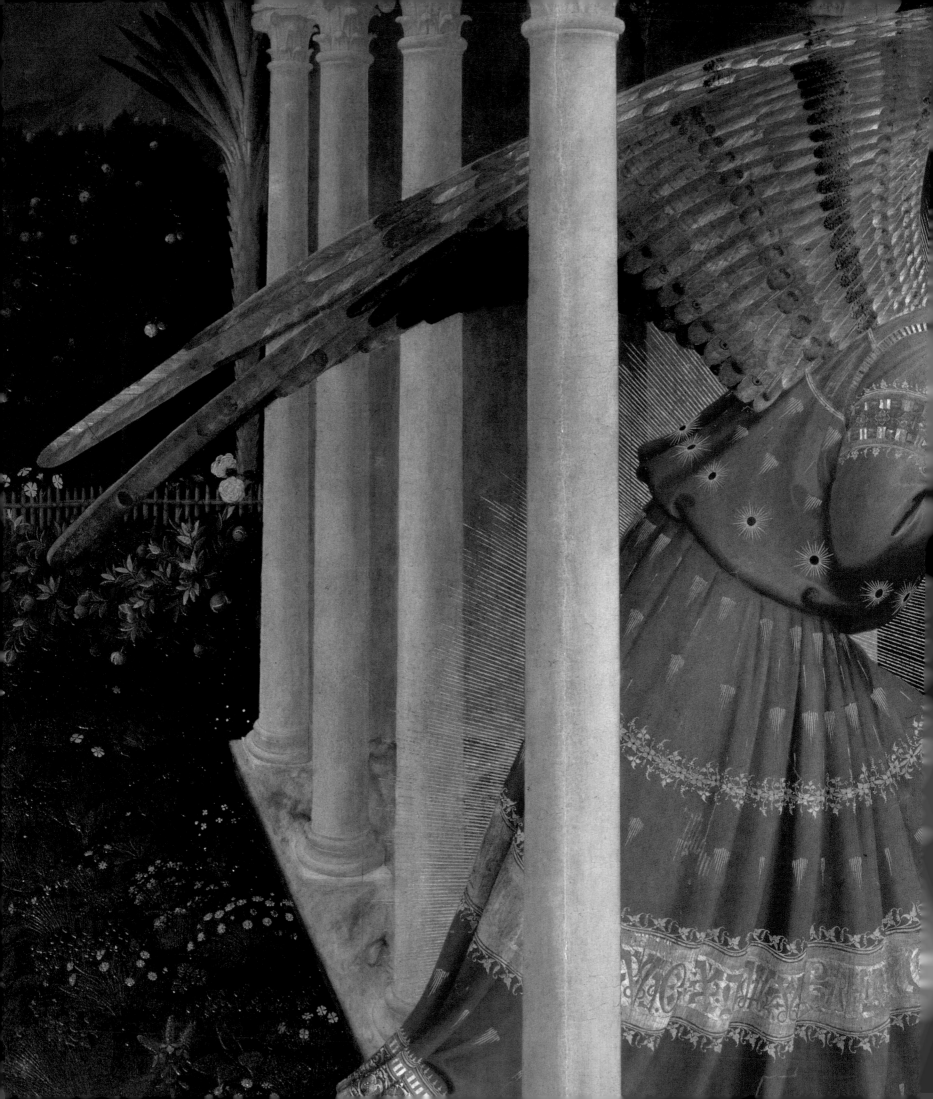

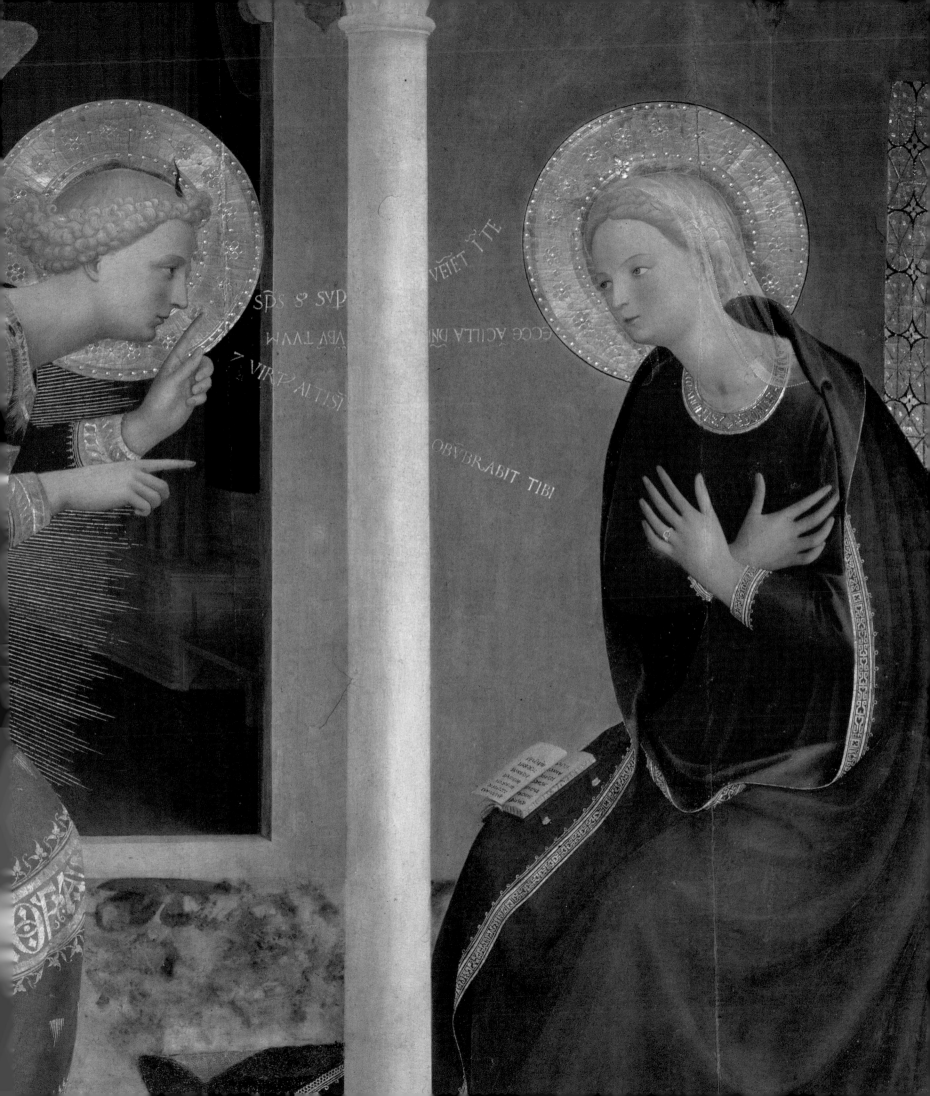

SĐS S SVP ... VĒĪĒT T̄TE

ECCE ÁCILLA DN̄ ... VBV TVVM

7 VIRṖ ALTISI ...

OBVBRÁBIT TIBI

74
San Domenico, Cortona, *c.*1411–38
Façade

75 Opposite
San Domenico, Cortona, *c.*1411–38
Interior, whitewashed 1596, restored
early nineteenth century

the *Cortona Annunciation* commemorated his devotion. While inspired by Angelico's altarpiece in San Domenico in Fiesole, the *Cortona Annunciation* departs from the earlier work in significant ways.

Here, as in the Fiesole *Annunciation* (see 38), the Annunciation is set beneath a classicizing loggia placed in a garden, an allusion at once to the enclosed garden of Mary's virginity foretold in the Song of Songs, as well as to Eden, from which Adam and Eve were expelled, as portrayed in the corner. Angelico has represented the fulfillment of the Old Testament prophecy of Isaiah (Isaiah 7:14), who is displayed with his unfurled scroll in the roundel between the arches: 'Behold, a virgin shall conceive and bear a son.' Following a longstanding tradition, words from the Book of Isaiah may also have been inscribed in the open book on the Virgin's lap, although the original text no longer is visible. As the Holy Spirit descends in an aureole of golden rays to the Virgin, the Archangel Gabriel pronounces the words from the Gospel of Luke (1:35) that are inscribed in gold on the panel, linking him to the Virgin: 'The Holy Spirit shall come upon thee, and the power of the Highest shall overshadow thee.' The urgency of the archangel's mission is emphasized by his forceful gesture, the thrust of his head and his tensely poised wings, as he kneels before Mary. Angelico described the Virgin's humble response to Gabriel's salutation as she crosses her arms over her breast and proclaims her submission to the Lord's will. The words incised on the golden collar of her gown and in reverse on the panel itself signify her reply to God: 'Behold the handmaid of the Lord. Be it unto me according to thy word.'

Although there are Annunciations, especially by Sienese artists from the early fourteenth century, inscribed with the angel's greeting, the sacred colloquy as portrayed by Angelico is without precedent in Italian art. In contrast to the altarpiece painted for Fiesole (see 38), where the inscription is relegated to the frame below the figures, this emphasizes speech and the written word. Conveying the meaning of the Annunciation as theologians –

especially the Dominicans – understood it, Angelico literally replaced the Lord's hands, enclosed in an aureole, by the Logos, the divine Word. This was the moment when the Word was made flesh through the Incarnation of Jesus. In one of his commentaries on the Incarnation, Saint Thomas Aquinas affirmed that Jesus, as 'the flesh of the Word of God, had to be formed by the Spirit of the Word'. Two centuries later, Antoninus proclaimed that Eve's sin, inherited by 'the inhabitants of the earth', could only be redeemed through the Incarnation and the Word that was Christ. With the 'Ave' (Hail) of the Archangel, a word endowed with 'many mysteries', the transgressions of Eva (Eve) were reversed. While the chronology of Antoninus's sermons and writings, especially in the 1430s, is highly problematic, the novel conception of the Cortona *Annunciation* might have reflected his evolving thought on the Incarnation, which he regarded as the central mystery in humankind's salvation.

Though based on the altarpiece that Angelico had painted for San Domenico di Fiesole less than a decade earlier, the Cortona *Annunciation* reflects a more mature understanding of architecture and perspective inspired by his study of Brunelleschi as well as his experience of urban space. Nearly square in shape, the frame is composed of fluted pilasters surmounted by Corinthian capitals and a heavy entablature. Contrasting the pinnacled, gilded frames of most contemporary works, it displays the structural clarity that Brunelleschi was to demand of the altarpieces for San Lorenzo in 1434. While the composition is still lucidly divided in thirds, the space is deeper, due to the diagonal recession of the arcade, where the wide arches diminish in circumference and the columns decrease in height. This perspective corresponds to the actual experience of spectators viewing the Foundlings Hospital (see 52) from the Via dei Servi, which connects it to the Cathedral. Angelico contrived the foreshortening of the Virgin's loggia and its inner sanctum for another reason as well: the oblique angle anticipated the viewpoint of the worshippers who knelt, genuflected or prostrated themselves before the altarpiece as they prayed. In accord with devotional

practices that date to the eleventh century, they then would have repeated the 'Ave Maria', Gabriel's salutation to Mary: 'Hail, Mary, full of Grace, the Lord is with thee.' The altarpiece literally inscribed and pictorialized the invocation of the worshippers.

The Cortona *Annunciation* differs in other significant respects from its predecessor in Fiesole. Here, the 'enclosed garden' of Mary's virginity, invoked in countless hymns, writings and sermons, is well tended and separated from the teeming vegetation of Eden by a gate. Adam and Eve are expelled from a darkened Paradise at the upper left, their diminished scale indicating their chronological and spiritual distance from the Annunciation that would redeem their transgression. With their slender, more elongated proportions and smaller features, the Virgin and Archangel suggest the influence of Ghiberti present in Angelico's works from the early 1430s. The exquisite cloth of honour and the gown of the Archangel – adorned with shimmering rays, simulated gems and intricately patterned bands of gold unparalleled in their splendour – may have responded to the desire of the donor, a cloth merchant, to express his devotion to the Virgin in a display of conspicuous splendour.

As with the *Annunciation* for Fiesole, the predella depicts events from the life of the Virgin. The differences between the two could not be more striking. In the earlier altarpiece, the scenes are framed individually and space is tilted up. Here, the narrative is unframed and flows continuously, with episodes simultaneously divided and linked by painted architecture. Angelico's exploration of perspective is seen in the receding arcade of the *Marriage of the Virgin* and in the interior of the *Presentation in the Temple*, in which parallel aisles converge near the altar. In the *Visitation*, the distant hills and valley gleam in the sun, dissolved in the mist of atmospheric perspective. The figures' expressive postures and warm interactions contrast to the restraint of the predella of the Fiesole *Annunciation*. These features are shared with Angelico's other predellas from the early 1430s, including the panels for the *Coronation of the Virgin* (see 60, 61) for Santa Maria Nuova and the *Linaiuoli Tabernacle* (see 63, 64).

The *Cortona Triptych* appears to be the later of Angelico's altarpieces for San Domenico (76). It was painted for the chapel of Giovanni di Tommaso di ser Cecco, a merchant whose property holdings and transactions suggest that he may have been the wealthiest man in Cortona. His chapel was prominently located to the right of the high altar. Much is known about Giovanni di Tommaso through his four testaments, written at different points of his life, and myriad other documents. Although he first intended to be buried in the town's parish church, where his father's tomb was located, by 1432 he had endowed his own funerary chapel in San Domenico, as recently discovered documents have proven. On 26 March 1438, only six weeks after the papal Bull encouraging the church's decoration, the last testament of this 'noble and circumspect merchant' was notarized in the infirmary of San Domenico. Among the three Dominican witnesses was 'friar Giovanni di Pietro di Gino da Mugello' – Fra Angelico. He was identified as a member of the 'Florentine community and a Master painter', who 'at present' was a friar 'at the convent of San Domenico of Cortona'. Another witness was the patron of Sassetta's altarpiece, Niccolò di Angelo di Cecco, whose chapel was located to the left of the high altar. Giovanni di Tommaso's testament is very significant. It pinpoints the precise and only time that Angelico is known to have been in the town, relating his presence to the church's decoration. It also confirms that Giovanni di Tommaso commissioned the *Cortona Triptych* to honour the patron saints of his family. The will further establishes direct contact between the artist and his client, suggesting their probable interaction in determining the chapel's decoration.

The *Cortona Triptych* pays homage to the Virgin and Child as well as to the patron saints of the donor, his son and his wife, whose names are known through Giovanni di Tommaso's testament. On the left panel Saint Matthew, the patron of his son Matteo, stands next to John the Baptist, while John the Evangelist and Mary Magdalene, patron of his wife Maddalena, are portrayed on the right. The postures, gestures and interactions of the saints are

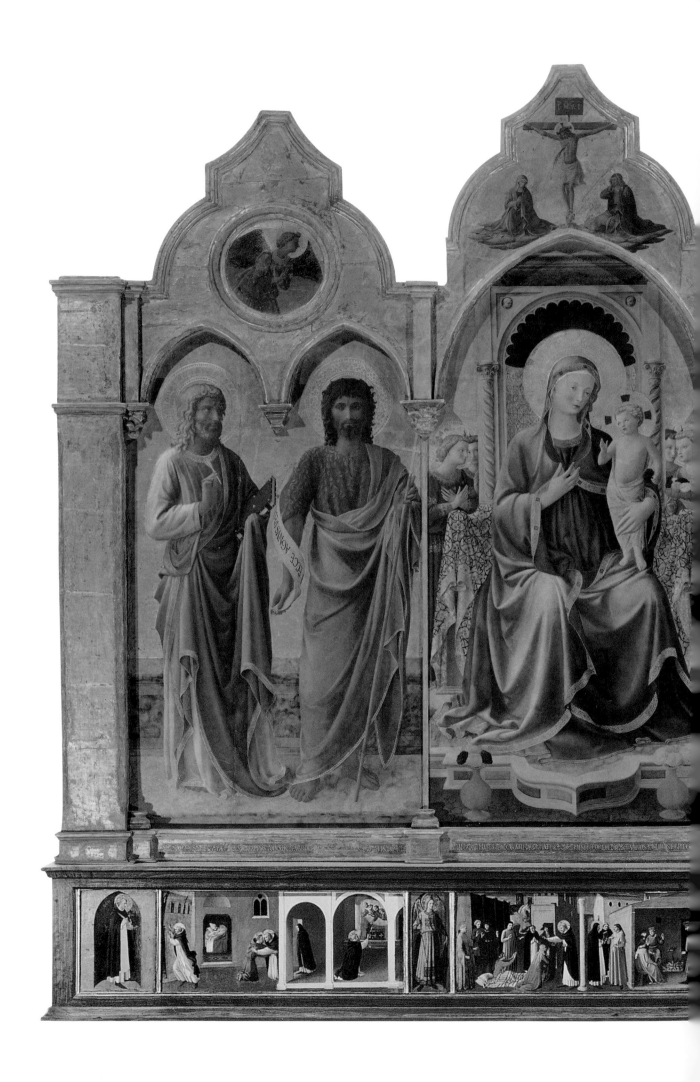

76
*Madonna and Child with Saints
Matthew, John the Baptist, John the
Evangelist and Mary Magdalene,*
known as *Cortona Triptych, c.*1434–5
Tempera and gold on panel
(transferred); centre panel:
137 × 68 cm (54 × 26¾ in); each side
panel: 117 × 69 cm (46 × 27⅛ in);
predella: 23 × 230 cm (9 × 90½ in)
Museo Diocesano, Cortona

77
Sassetta, *Madonna of Humility
with Saints Nicholas, Michael,
John the Baptist and Margaret
of Hungary, c.*1434
Tempera and gold on panel;
172 × 257 cm (67¾ × 101¼ in)
Museo Diocesano, Cortona

complementary and individualized, as seen in the two Evangelists. While Matthew, turning to the Virgin and Child, holds his quill upright and Gospel closed, his counterpart lowers his head in concentration to write in his open book. As the Magdalene, bearing the jar of myrrh with which she would anoint Jesus's body at his entombment, gazes sombrely at the infant, the Baptist turns away as he unfurls the scroll exhorting the faithful to 'Behold the Lamb of God'. In the central panel, the Virgin supports the partly swaddled Jesus, who stands to bless the faithful, already assuming his role as redeemer. Angels stand behind the throne, serving as guardians and attendants at the celestial court. The vases of roses before the throne allude to Mary as 'rose of Sharon' and 'rose without thorns', as she was invoked in lauds and sermons in praise of her virginity. Portraying the Annunciation, the roundels of the frame affirm her purity as the vessel of divine grace. The inscription on the frame below the Virgin implores her protection on behalf of Giovanni di Tommaso and his family at the Last Judgement, invoking her as 'Mary, Mother of Grace, Mother of Mercy'.

In many respects, the triptych calls to mind the *Linaiuoli Tabernacle* and the *Annalena Altarpiece*, two of Angelico's most important paintings from earlier in the decade. They suggest his continuous engagement with rendering figures and space convincingly, even within the confines of the triptych format and the gold background. The slender proportions, voluminous drapery with thinly edged folds and foreshortened hands of the saints resemble the intensely characterized figures of the *Linaiuoli Tabernacle* (commissioned 1433) (see 63, 64). With his body turned at a slight angle and head lowered as he composes his Gospel, John the Evangelist seems a mirror of Saint Mark from the outer wing of the *Linaiuoli Tabernacle*. The foreshortened right hands of Matthew and John the Evangelist are analogous to the convincingly projected gesture of Saint Mark from the tabernacle's inner wing. The Virgin's graceful gesture and flowing mantle virtually repeat those of the Linaiuoli Madonna. As with the *Annalena Altarpiece* (c.1435)

(see 67), the shell-like niche and frieze of luxuriant festoons on the Virgin's throne were inspired by classicizing architecture. They reveal an interest in space that is seen in its foreshortened pedestal, which repeats the alternating bands of deep green and rose-coloured marble, and the elevated perspective of the ledge that implies the viewpoint of a kneeling worshipper. At the same time, the altarpiece seems traditional because of the triptych format, elaborate frame and gold ground.

Notwithstanding Angelico's consistent interest in perspective, there is a disjunction between the central and side panels of the triptych that cannot readily be explained. The floor of each panel is differently patterned and the base of the Virgin's throne only extends continuously into the right wing. The contours and drapery of the sinuously posed saints on the left seem linear rather than sculptural, and the palette is less intensely saturated. To account for these discrepancies, it has been suggested that the altarpiece may be a composite of elements from diverse altarpieces. This seems improbable, for the height and proportions of the saints all accord, and the relationship between the figures is complementary and reciprocal. Instead, these features may have been a calculated response to Sassetta's *Madonna of Humility* (see 77), which was probably already in place in the chapel to the left of the high altar. The relationship between the two triptychs seems especially clear when the saints of the left wings are compared. In Angelico's work, the crisply delineated contours, the angle of their postures and the direction of their gazes seem to mirror those of Saints Nicholas and Michael. The resemblance between the altarpieces, located in chapels adjacent to the high altar, is not likely to have been fortuitous. They may have been dictated by the patron himself or by the traditions of local art, which were suffused by the influence of Sienese painting.

The scenes from the predella are perfectly aligned with the tripartite divisions of the frame, articulating its structural clarity while unfolding continuously below the altarpiece. They illustrate scenes from the life of Saint Dominic, a subject appropriate to the

78
*Madonna of Humility with
Saints Dominic, Peter Martyr and the
Four Evangelists*, 1438
Fresco; 144 × 238 cm (56⅝ × 93¾ in)
San Domenico, Cortona

Order's founder, the church's dedication and to the patron himself, a member of the confraternity dedicated to the saint. It closely paraphrases the predella from the *Coronation of the Virgin* (see 39) for San Domenico in Fiesole, suggesting that Angelico may have used the same drawings, as is particularly evident in the last two episodes. Significantly, he did not repeat the deep perspective and dramatically foreshortened architecture in the later predella, for such illusionism might have appeared stylistically incongruous with the gold-ground triptych.

Angelico's final work for San Domenico was the *Madonna of Humility with Saints Dominic, Peter Martyr and the Four Evangelists* that he frescoed above the portal of the church (78, see 74). It was painted during the painter's residence in Cortona, documented in March 1438 in Giovanni di Tommaso's testament. Angelico's entrance into the community of San Domenico only six weeks after the papal Bull that encouraged its decoration may suggest a more ambitious campaign to fresco the church and convent. Although San Domenico's murals were destroyed when its walls were whitewashed in 1596, recovered fresco fragments confirm that some of the interior was painted. In fact, the testament of Sassetta's patron refers to the adornment of his chapel with 'paintings' (murals) as well as an altarpiece, suggesting the possibility that Giovanni di Tommaso's chapel may have been similarly embellished. As for the convent, several historians recorded the tradition that Angelico painted frescos there, but this is not possible to confirm. Most of the convent was destroyed and replaced by a park in the nineteenth century. Considering the importance of images in shaping Dominican spirituality, there may be truth in this assertion.

The *Madonna of Humility* proclaimed the church as a Dominican foundation and displayed the Order's devotion to the Virgin. Although the lower part of the fresco was obliterated after centuries of exposure to the elements, much of the composition is still legible. Saints Dominic and Peter Martyr kneel before Mother and Child, who emanate a multi-coloured radiance of light against

the starry sky. They may have been suspended on clouds, now effaced, as are the Evangelists in the surrounding arch. This celestial vision called to mind innumerable prayers and hymns that evoked Mary as 'Queen of Heaven' and 'Star of the Sea, Port of Salvation' and Jesus as 'King of the Universe' and 'Light of the World'. Her expression mournful in contemplation of his future, Mary presents the child to the saints who kneel in adoration. As the infant blesses them, he proffers a globe inscribed with 'EUROPA' and 'ASIA', demonstrating his terrestrial dominion. The four Evangelists are frescoed inside the arch. Seated on clouds and radiating light, they inscribe their Gospels of Jesus's words and his life in their open books. The heavenly placement of the Virgin, Child and the court of Evangelists conveyed to the faithful that Christ was the divine Word made flesh, ruler of heaven and earth. The themes of the lunette are more complex and resonant than those of the Fiesole portal fresco (see 71), which represented the Virgin and Child alone, for they imply his cosmic kingship and assert the revelation of his presence to the Dominican saints who adore him. These evocative, visionary portrayals forecast the deep spirituality of the cell frescos at San Marco.

The poor condition of the lunette precludes definitive analysis of Angelico's style, although the greater volume of the figures and their drapery anticipate the frescos at San Marco. A more significant comparison can be drawn between the preparatory *sinopia* that has been detached from the fresco, and the underdrawing for the Fiesole *Madonna and Child* (79, see 72). The Cortona *sinopia* reveals a dramatic flow of movement not found in the earlier *sinopia*, which is uniformly linear and precise. The Virgin and Child are freely painted in thin, lightly inflected strokes that describe their contours and convey the weight and shadows of their drapery. Saint Dominic's form is indicated with the lightest, most rudimentary of lines, while Peter Martyr's posture as he leans toward the Virgin and Child is described by cursive strokes of varying width. The *sinopia* reveals a confidence and economy of means that is absent in the careful *sinopia* for the Fiesole *Madonna*

79
Sinopia for the Madonna of Humility
with Saints Dominic, Peter Martyr,
1438
Fresco (detached and transferred
to masonite support); 144 × 238 cm
(56⅝ × 93¾ in)
Museo Diocesano, Cortona

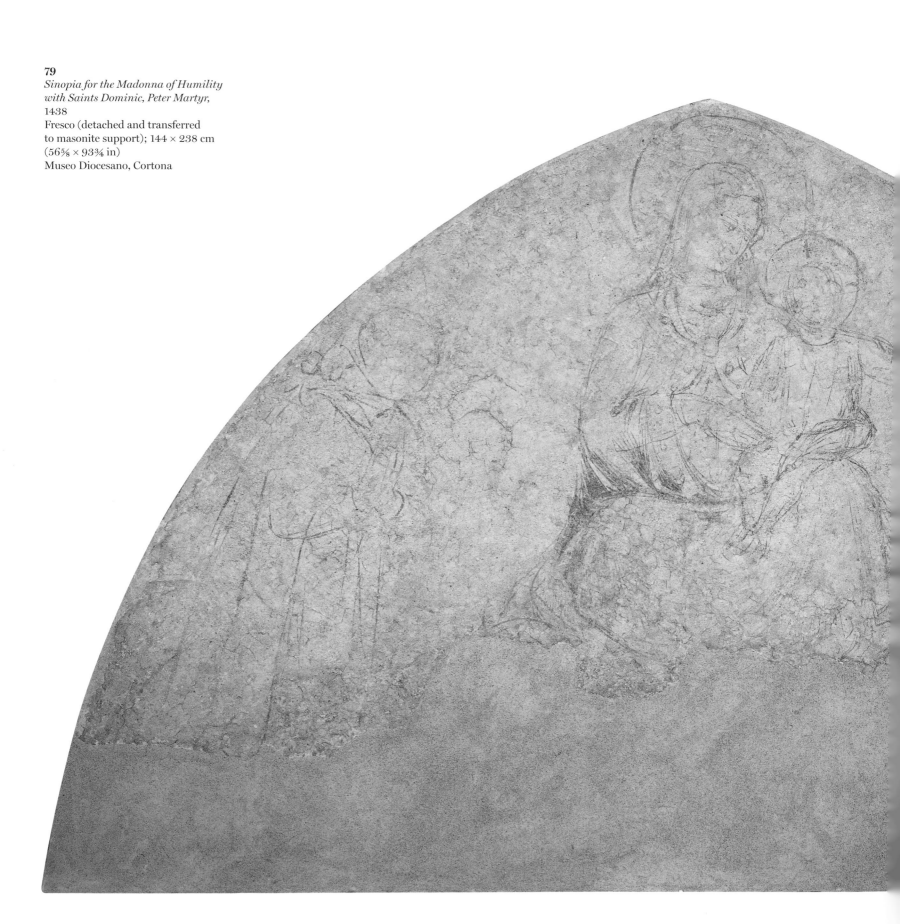

and Child. It suggests a newly found proficiency and experience as a muralist, lending support to the belief that Angelico may have frescoed other works during his residence at San Domenico.

By the time the portal lunette was painted, three chapels in the church had been embellished with altarpieces. The *Annunciation* was intended for the choir screen, the numinous threshold that separated the friars from the laity. It portrayed the moment when the 'word of God was made flesh' through the Incarnation, which promised salvation to the worshippers who knelt before it. Two chapels flanked the high altar. To the left, the *Madonna of Humility* by Sassetta paid homage to Mary as the Mother of God, tenderly embraced by her son and flanked by angels. On the right, the *Cortona Triptych* by Angelico honoured the Virgin as Queen of Heaven and intercessor on behalf of the patron. The high altar itself, however, had not yet been provided with its own altarpiece. Although a wealthy widow in the town promised the church funds for a high altarpiece in her testament of 1437, she lived for two more years. The friars did not receive her bequest until November 1439. However, it seems unlikely that the altarpiece was ever begun, since other events precluded its commission. Even from distant Florence, the long arms of the Medici reached out to the Observant friars in Cortona.

In 1438, Cosimo and Lorenzo de' Medici promised the friars the high altarpiece that was already in place in San Marco when they assumed patronage of the church two years earlier. Enclosed in an ornate gothic frame with lofty pinnacles, the *Coronation of the Virgin* (see 12) had been painted by Lorenzo di Niccolò in 1402. Although the fifteenth-century chronicle of San Marco described the venerable altarpiece as 'great in size and beautiful' and 'adorned with many figures', its style was outmoded by 1438. Moreover, the *Coronation* was associated with the Silvestrine monks who commissioned it, for it portrayed that Order's saints. Most important, its subject was inappropriate for the new high altar chapel of San Marco because the Medici had rededicated the church to Saints Mark, Cosmas and Damian. At the same time, it perfectly suited the decorative programme of San Domenico, which focused on the Virgin.

On 26 December 1438, the priors of Cortona expressed their gratitude to the Medici for munificently offering 'this grand and most devout work' to 'the new church of San Domenico in our city, where the holy friars live'. While the priors of Cortona praised the magnanimity of their benefactors, the Medici were not prompted by generosity alone. By then, the reconstruction of the church and convent of San Marco was proceeding apace. The time had come to engage Angelico to paint the most extensive surviving fresco cycle in a convent in all of Renaissance Italy. By offering the splendid *Coronation of the Virgin* to San Domenico, Cosimo and Lorenzo completed the decoration of the church, thereby freeing Angelico from further responsibilities in Cortona. The Silvestrine saints in the altarpiece were repainted in Dominican habits and a new inscription was affixed below the predella recording the donation by the two Medici brothers 'for their souls and those of their deceased kin'. By the time the altarpiece was finally delivered to Cortona in 1440, Angelico's work at San Marco was well underway.

5
A Man of Absolute Modesty
Devoted to Religious Life
Angelico at San Marco

On 21 January 1436, Pope Eugenius IV ceded the church and monastery of San Marco to San Domenico in Fiesole, establishing the Observance in the heart of Florence. Although pious Silvestrine monks founded San Marco in 1299, the spiritual fervour of their followers had declined dramatically over time and the church had fallen into complete disrepair. In 1418, the Observant reformer Giovanni Dominici implored that the friars of Fiesole, newly returned from exile, be given the Silvestrines' monastery so that they might minister to the needs of the urban populace. The parishioners of San Marco and the residents of the neighbourhood, Giovanni di Bicci de' Medici among them, joined Dominici's petition, complaining that the dissolute Silvestrines lived 'without poverty and without chastity'. Nearly two decades passed before Eugenius finally succeeded in honouring the will of the people by ousting the Silvestrines. When the Dominicans took possession of San Marco on 1 February 1436, it was deemed an event of both civic and sacred importance. The Signoria ordered a ceremonial procession, which was led by mace-bearers representing the city of Florence and followed by high-ranking clergy dressed in splendid vestments. Chanting hymns continuously, a group of seventeen Observant friars from Fiesole solemnly made their way through the streets to the convent. Although the roof of the church had collapsed and the dormitory was in ruins, the entire complex would be rebuilt, enlarged and decorated in less than a decade through the largesse of the Medici, an honour to the city as well as the patrons.

In the beginning, San Domenico in Fiesole and San Marco were administered as one congregation. They shared the same prior, who was advised by a subprior from each convent. Angelico was involved directly with this process of governance, for he was elected vicar of San Domenico in 1436. His responsibilities in managing the convent's affairs placed him in direct contact with San Marco, although he lived in Fiesole, where he painted works for Dominican and lay patrons. On 13 April 1436, he accepted the commission for the *Lamentation over Christ* for the Florentine confraternity of Santa Maria della Croce al Tempio, the members of which were devoted to consoling condemned criminals before their execution (80). The altarpiece actually was completed in 1441, as the gold numerals inscribed around the Virgin's collar recorded. Fra Sebastiano Benintendi, a friar at Santa Maria Novella, commissioned the altarpiece in honour of his ancestor, the Dominican mystic Blessed Villana delle Botti (1332–61). Angelico depicted her kneeling near Jesus's feet, her arms crossed in humility over her chest. The *Lamentation* was made for the confraternity's oratory, the façade of which was painted with scenes from the Passion of Christ. During their final hours, prisoners were chained before the altar, where they were brought to pray and repent their sins while gazing upon the image. The *Lamentation* portrayed the loving compassion of the Virgin, Mary Magdalene and other saints as they mourned the death of Jesus and prepared him for the grave. The scene is located outside the city walls, as were the confraternity's chapel and the actual site where criminals were executed. This solemn altarpiece was intended to stir members of the confraternity to greater charity toward the condemned as well

as to solace prisoners as they faced their own demise. Prayer manuals written for justice confraternities instructed prisoners to contemplate such images and confess their crime while meditating upon the suffering of the innocent Jesus. Through his Crucifixion, they were told, their own salvation was effected.

The *Descent from the Cross* (see 62) for the Strozzi Chapel inspired the *Lamentation*, which continued the narrative of Christ's Passion. At the same time, it displayed Angelico's greater maturity in its deeper palette, the austerity and depth of its landscape and its subtle luminosity. From the grieving Virgin, who lowers her head to gaze upon Jesus for the last time, to the Magdalene, who ritualistically lifts Jesus's feet to veil them in a shroud, the sorrow of the mourners is more nuanced in its characterization. Anachronistically, Saint Dominic and Blessed Villana are portrayed in prayer behind the historical witnesses to the Crucifixion. The saint's solemnly lowered gaze signals his intense contemplation, while the inscription issuing from Villana's lips, 'Christ Jesus, my crucified Love', proclaims a mystic union with Jesus attained through fervent meditation on the Passion. Both Dominic and Villana display the exemplary devotion to Christ that was extolled in the Order's writings and portrayed in its art. Angelico condensed this moving theme and the composition of the altarpiece in one of the first frescos in the convent of San Marco (81).

Executed between late 1438 and 1443, the works for San Marco comprised the most extensive surviving programme of decoration for a religious community. It included the high altarpiece, nearly fifty monumental frescos for the cloister, Chapter House and dormitory cells, as well as illuminated choir books for the celebration of Mass (82). These paintings translated the brilliant spiritual, intellectual and visual culture of the Dominican Order for diverse constituencies, from its patrons and parishioners to the community of friars, novices and lay brothers who lived within its walls. The works were imbued with the didactic character of the Order's art, translating the concept of 'Christ, the example for our way' that was expressed in the writings of Antoninus of Florence, the esteemed theologian under whose administrative aegis the reconstruction and decoration of San Marco began.

From 1439 to 1444, Antoninus served as head of the Observance in Tuscany as well as prior of the convents in Florence and Fiesole. Although he would later condemn grandly decorated convents with 'enlarged houses and cells' in his *Summa theologica* (completed 1458), he willingly accepted the financial support of the Medici. While the Order's Constitutions demanded absolute poverty, he believed that this was not possible at San Marco because Florence's importance demanded an appropriately fine convent. Further elevating the status of the city, Pope Eugenius convened the ecumenical Council of Florence between February and July 1439. The conference represented the most significant effort to unify the Western Church with the Eastern Church, which included a vast population of Christians from Greece, Turkey, Russia, Armenia, Ethiopia and Egypt. As announced at its inception, the council sought to end centuries of division that began with the fall of the Roman Empire in the late fifth century. In addressing the

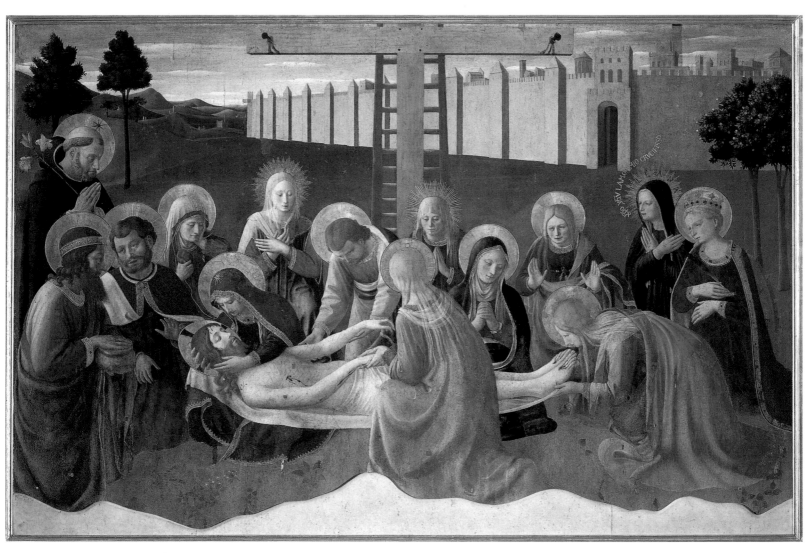

80
Lamentation over Christ (bottom
damaged), commissioned in 1436,
completed in 1441
Tempera and gold on panel;
109 × 166 cm (42⅞ × 65⅜ in)
Museo di San Marco, Florence

Previous page
Detail from *Lamentation over Christ*
(80)

delegation, Ambrogio Traversari proclaimed his joy at seeing 'the members of the holy and mystical Body, who have come together from different lands' in order 'to be united in a single faith'. Hundreds of dignitaries from throughout the world congregated in Florence, marvelling at the splendour of its churches, the spectacle of its sacred plays and the magnificence of its art. By the time the official Decree of Union was signed on 6 July 1439, the city had become the triumphant centre of Christendom. This was due in part to the Medici, who brought the delegates to Florence and administered the council's staggering expenses through their bank, profitably loaning money at interest to the city as well as to the pope.

As bankers who had gained their great wealth through usury, a practice condemned by the Church, Cosimo and Lorenzo de' Medici endeavoured to expiate their egregious sins (and those of their father) by restoring and adorning churches. Vespasiano da Bisticci recounted how Cosimo sought the counsel of Pope Eugenius to assuage the 'prickings of conscience' from his ill-gotten gains and conduct in 'affairs of state'. The pontiff advised him to unburden his soul by building a convent for the Observants at San Marco, which Cosimo pledged to provide 'with everything needed for divine worship'. When Lorenzo, younger than Cosimo by six years, died in 1440, the necessity of planning in this world for the next must have seemed even more pressing. The generosity of Cosimo, though, may not have been motivated by conscience alone. The restoration of San Marco served to extend the sphere of Medici influence and to promote his political agenda. Located in close proximity to the ancestral *palazzo* of the family and to San Lorenzo, a cynosure of Medici patronage, the newly rebuilt and decorated complex asserted Cosimo's prosperity, strengthened the allegiance of his neighbours and epitomized his commitment to the spiritual welfare of the city.

The Medici chose the rising architect, Michelozzo di Bartolommeo (1396–1472) to rebuild San Marco. Only a few years earlier, Michelozzo had completed a similar restoration for the family at the Observant Franciscan church and convent of Bosco ai Frati, located in the village of San Piero a Sieve in the Mugello, the ancestral region of the Medici. In renovating Bosco ai Frati, Michelozzo harmoniously united the original, medieval structure with innovations inspired by Brunelleschi's architecture and his own study of ancient buildings (see 137). A comparable challenge awaited him at San Marco, on the ruins of which he built the new complex, a symbol of the spiritual renewal inaugurated by the Observant Dominicans in the parish.

Fra Giuliano Lapaccini became the prior of San Marco after Antoninus, who was appointed archbishop of Florence in 1444. Fra Giuliano composed a chronicle describing the convent's history and reconstruction before his death in 1457. He recounted how the restoration of San Marco proceeded with remarkable speed. The twenty cells of the east corridor of the dormitory were built between late 1437 and 1438, when renovation of the church was begun. Reconstruction continued sequentially, from the north corridor for lay brothers and guests (1440–1) to the south for the novices (completed in 1442) (83). While his discussion of the rebuilding of the convent was quite detailed, Fra Giuliano described the decoration in a few concise sentences, lauding Angelico's fame and piety rather than the works themselves. Beginning with the high altarpiece, he briefly noted the friar's works in San Marco, asserting that they were 'all painted' by Angelico. He exalted the friar as 'the greatest master of the art of painting in Italy' and extolled him as a 'man of absolute modesty devoted to religious life'. Fra Giuliano's statement that the artist executed all the works alone must not be

82
King David, fol. 170v, from *Psalter MS 531*, painted *c*.1443–5 and bound 1449
Tempera and gold on parchment; whole folio: 39.5 × 27.5 cm (15½ × 10⅞ in)
Museo di San Marco, Florence

81 Opposite
Lamentation over Christ, *c*.1440–2
Fresco; 184 × 152 cm (72½ × 59⅞ in)
Cell 2, Museo di San Marco, Florence

83
Michelozzo di Bartolommeo, Corridor
of the North Dormitory, *c.*1440–1
Museo di San Marco, Florence

84 Opposite
Fra Angelico assisted by Benozzo
Gozzoli, *Virgin and Child Enthroned
with Angels and Saints Cosmas
and Damian, Lawrence, John the
Evangelist, Mark, Dominic, Francis
and Peter Martyr*, known as
*San Marco Altarpiece, c.*1438–40
Tempera and gold on panel;
225 × 234 cm (88½ × 92⅛ in)
Museo di San Marco, Florence

understood literally, for a commission of this ambitious scope, in
accord with Renaissance artistic practice, demanded collaboration.
At the same time, the conception and extraordinary quality of the
paintings demonstrate the involvement of Angelico in virtually
every aspect of their creation. As for his devotion 'to religious life',
it seems embodied in the works themselves.

Angelico began by painting the high altarpiece in Fiesole,
away from the noise and dust of San Marco's construction (84).
Its inception may date from late 1438, when the Medici offered
Lorenzo di Niccolò's *Coronation of the Virgin* (see 12), the former
high altarpiece, to San Domenico in Cortona, after acquiring rights
to the high altar chapel in San Marco from another family (see
Chapter Four). To identify the Medici as patrons of this most sacred
space, Michelozzo adorned the lofty choir screen that separated the
friars from the laity with the family's coat of arms. He extended the
height of the walls, which, like those of the nave, were whitewashed
to reflect light and were illuminated by circular windows. The
entrance to the chapel was elegantly framed by Corinthian pilasters.
It is within this rigorously geometric, luminous and elevated space
that the *San Marco Altarpiece* must be envisioned.

It is difficult to imagine the original appearance of the *San
Marco Altarpiece*. In the nineteenth century, it was completely
dismembered and its frame destroyed. Its pilasters, adorned with
saints, as well as its predella, depicting the *Dead Christ* (85) flanked
by scenes from the lives of Saints Cosmas and Damian, were cut
apart and sold separately to museums and collections world-wide.
In an effort to remove centuries of accumulated dirt and smoke
from the candles lit before it, the main panel was cleaned with
caustic chemicals. This eliminated the multiple layers of tempera
and glazes that Angelico had superimposed to intensify its
chromatic richness. The badly abraded panel is a ghost of its former
self, its now-lost brilliance suggested by the depth and luminosity of
its predella. Although the original appearance of the altarpiece and
its frame may be irreparably lost, a recent digital reconstruction
brings together the dispersed components (see 165). It unites them
in a frame that recalls the architecture of the site itself, and it
suggests the compositional integrity of the main panel, the pilasters
that flanked it and the predella.

As in the *Annalena Altarpiece* (see 67), Angelico's first
commission for the Medici, the *San Marco Altarpiece* unites the
holy figures in a single panel around the Virgin and Child instead
of aligning them hieratically in separate wings. Angelico replaced
the traditional gold background by a unified landscape, revealed
by parted gold curtains simulating those that veiled sacred images
in the Renaissance. Festoons of roses are strung behind the
curtains, alluding to Mary and rosary devotions promoted by the
Dominican Order. Casting painted shadows, the fictive Crucifixion
at the foot of the altarpiece imitated the appearance of panels that
were placed on the altar recalling Christ's Eucharistic sacrifice.
Angelico made this association explicit by aligning it with the
central scene in the predella representing the *Dead Christ* (85).
Enhancing the experience of the worshipper, Angelico perpetuated
the sense that the painted realm of the altarpiece, visible to the
laity through the opening of the choir screen, was co-extensive with
the nave. The Virgin's throne further augmented the illusion, for
its classically rounded arches and fluted pilasters replicated the
architecture of the newly renovated church. It was as if the Virgin
and Child, joined by saints and angels, were suddenly revealed to
those who worshipped in San Marco, parishioners and friars alike.

This sacred gathering transpires in the forecourt of Paradise
and the garden of Mary's virginity, identifiable as such by the roses,

cedars, cypresses and palms described in the biblical Song of Songs. These arboreal symbols of the Virgin are evoked in the Little Office of the Virgin Mary, the ritual prayers, readings and psalms recited by the friars in her honour eight times each day. The richly embellished textiles adorning the throne and the hanging behind it augment the splendour of this regal setting. Mary presents the infant Jesus, who blesses the faithful as he proffers the globe of the world, symbolic of his dominion over heaven and earth. Reverently standing to either side, angels clasp their hands in prayer. The two Dominican saints – Dominic and Peter Martyr – and Francis stand together to the right of the altar. Symmetrically balancing them on the left are Saint Mark, to whom the church was dedicated; John the Evangelist, protector of Giovanni di Bicci de' Medici, father of the church's patrons; and Lawrence, name saint of Cosimo's brother Lorenzo, who assisted him in rebuilding San Marco. Cosmas and Damian, advocates of the Medici, devoutly kneel before the Virgin and Child. Gazing intently outward as they gesture toward the throne, Lawrence and Cosmas exhort the faithful to join them in their adoration.

The meaning of this holy convocation is elucidated by the passage to which the Bible in Saint Mark's hands is partly open. The text is taken from the Gospel of Mark (6:2–8) and recounts how Jesus, accompanied by his disciples, 'began to teach in the synagogue', confounding the 'many who heard him' with his wisdom. He sent forth his disciples 'two by two' and 'gave them authority over the unclean spirits', ordering them 'to take nothing for their journey', not even bread or money. Only the friars would have been close enough to read these words as they knelt within the sacred space of the choir. Sanctioning their mission, Mark's text recorded Christ's command to convert, preach and observe poverty, upon which Saint Dominic had based the Order's Rule. Another inscription that the friars alone were privileged to view was written in gold letters on the border of the Virgin's mantle. Taken from the Little Office of the Virgin Mary, it exalts her as 'mother of beautiful love and fear and knowledge and holy hope', the inspiration for their piety. These were among the invocations to Mary that the brethren repeated eight times each day as they paid homage to her as seat of wisdom, source of salvation, bearer and mother of God.

Leading the viewer into the sacred space of the altarpiece, the foreshortened squares of the splendid Anatolian carpet recede consistently toward the Virgin's throne to create the illusion of depth. Their area flattens and diminishes from foreground to back, measuring distance proportionately. More than a decade earlier, Brunelleschi had devised a mathematical approach to representing distance convincingly, perhaps designing the realistic architectural background of Masaccio's *Trinity* (see 28). Although Angelico knew this work, the *San Marco Altarpiece* may have been inspired by the rigorous system of perspective described in *On Painting*, written in 1435 by the humanist theoretician Leon Battista Alberti (1404–72), a member of Pope Eugenius's Florentine court. Alberti's treatise calculated the recession of orthogonal lines mathematically so that they diminished in proportion, converging on a single point in the middle of the panel. In the *San Marco Altarpiece*, that point was the devotional centre of the work, near the head of the Virgin. While Angelico's earlier works reveal his engagement with portraying space convincingly, the *San Marco Altarpiece* may be the first painting – not only in his career but in Florentine art – to reflect Alberti's theories. Indeed, Angelico's characterization of Saints Lawrence and Cosmas may have responded to Alberti's recommendation that a work should include someone who 'points out what is happening' to the viewer or 'beckons with his hand

85
Dead Christ, predella panel of
San Marco Altarpiece, c.1438–40
Tempera and gold on panel;
38 × 46 cm (15 × 18⅛ in)
Alte Pinakothek, Munich

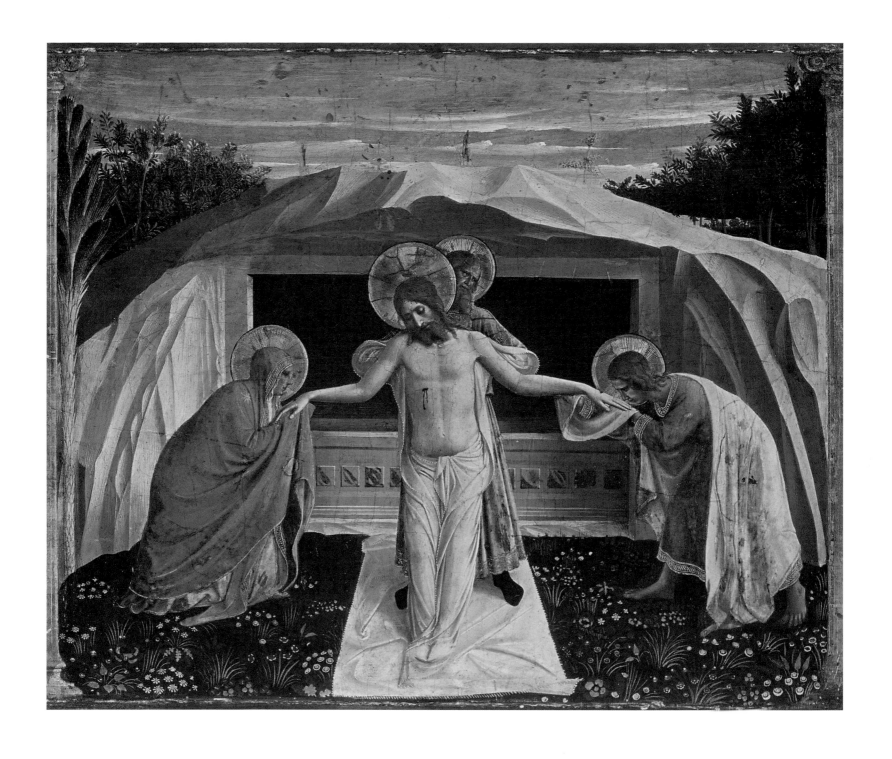

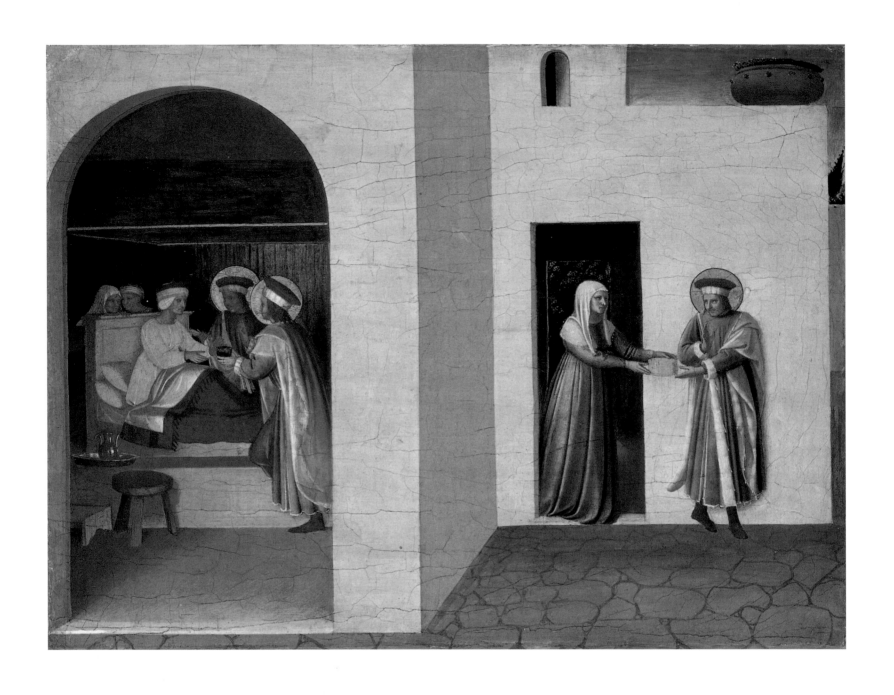

A Man of Absolute Modesty Devoted to Religious Life

86
Healing of Palladia, predella
panel of *San Marco Altarpiece*,
c.1438–40
Tempera and gold on panel;
38.1 × 47.5 cm (15 × 18¾ in)
National Gallery of Art,
Washington, DC

to see'. Through perspective and the gestures, gazes and expressions of the holy figures, Angelico engaged worshippers, exhorting them to enter the forecourt of Paradise and venerate the Virgin and Child.

The narratives from the lives of Saints Cosmas and Damian that extended continuously across the foot of the altarpiece were conceived with great imagination as well as geometric rigour. Angelico apparently turned to the same manuscript of the saints' lives that he had consulted in preparing the predella to the *Annalena Altarpiece* (see 67). His interest in representing narratives of greater complexity, deeper perspective and more dramatic light effects is evident by comparison. In contrast to the earlier panel, the multi-episodic *Healing of Palladia* (86) demonstrates the saints' cure of the ailing widow as well as her payment to them. The obliquely angled walls frame the miracle that occurs within the darkened sickroom, separating it from the luminous courtyard outside. In the *Attempted Drowning of Saints Cosmas and Damian*, the saints' prayer to God, the judge's attack by demons and their salvation by angels are represented in varied scale throughout the landscape to connote different moments in time (87). The undulating forms of the landscape recede and flatten as they approach the horizon, itself dissolved in the mist of atmospheric perspective. The figures are more intensely characterized through their varied ages, garments, postures and expressions. Such features demonstrate the influence of Ghiberti's East Doors (known as the 'Gates of Paradise') (see 53) for the Florence Baptistery, the casting of which may have been complete as early as 1437. They document the continued dialogue between Angelico and Ghiberti that was inaugurated with the *Linaiuoli Tabernacle* (see 63, 64).

Although the quality of the altarpiece is exceptionally high, Angelico did not paint it alone. Among the angels, the three closest to the throne on the right appear slightly different from the others. Their features are closely spaced and modelled with shadows that are opaque rather than softly graduated. Their eyes are rounded and heavily lidded, and their noses are elongated. Their hair clings to their heads instead of flowing in loose curls. These characteristics are seen in miniature scale in the kneeling saints and their brothers in the *Attempted Drowning of Saints Cosmas and Damian* and in some of the other predella panels. Although these figures appear almost indistinguishable from those by Angelico, these subtle differences suggest their execution by Benozzo Gozzoli, who had joined the friar's workshop in the late 1430s. Comparison to later works by Benozzo confirms these attributions and indicates that the artist adapted himself to Angelico's style with great facility. As the decoration of the convent progressed, he assumed an increasingly important role within the workshop, as may be seen in the frescos of the convent. Their restoration, which began in 1969 with the *Grand Crucifixion with Saints* and continued between 1978 and 1983 with the cell frescoes, revolutionized our understanding of Angelico's technique and workshop practices.

Using red sinoper (an iron oxide pigment) suspended in limewater, Angelico painted the underdrawing for each mural directly on the prepared wall to ensure consistency of scale and conception in all of the images. Most of the frescos were quickly executed, requiring only six or seven days to complete. The Crucifixions in the novices' cells took only two days each (see 91, 104). Even taking into account the numerous feast days and ceaseless hours of prayer that engaged the friar, the frescos required no more than two years to finish in their entirety. There is no secure documentary evidence to trace the sequence in which the cells were decorated or their precise date. It may have parallelled the

construction of the convent or been completed all at once. To ensure the timely completion of this ambitious commission, Angelico worked with three other artists, Benozzo among them, who followed his sinoper underdrawings closely. Although the frescos at first may seem uniform in their appearance, differences in style become apparent with closer study.

In the dormitory, only the *Annunciation* (97) at the top of the stairs, the *Madonna of the Shadows* (111) in the corridor and several frescos in the east wing of the friars' cells appear to be entirely by the master's hand. The cells of the east wing, which Michelozzo rebuilt first, may have been the earliest that Angelico painted. Their surfaces shimmer with light and their colours glow. The figures' ardent expressions and interactions compel the beholder's engagement by their intensity, as in the yearning gaze and gesture of the Magdalene, who reaches toward the resurrected Jesus in the fresco of the first cell (88). Reflecting the radiance cast by Christ's luminous garments, the modelling of her features and drapery is graduated with hues of extraordinary subtlety. This expertise is evident in the *Coronation of the Virgin*, where the celestial event, transpiring on clouds, inspires the devotion of the kneeling saints, who include Francis and Benedict (founders of major religious orders devoted to Mary) as well as Dominicans (89). The luminous garments of the Virgin and Christ and the soft rings of coloured light that they radiate reveal a mastery of colour distinctive to Angelico alone. Similarly, the changing values of the priest's gown, which range from deep malachite to soft yellow, and the expressive faces of the holy figures in the *Presentation of the Christ Child in the Temple* in Cell 10 demonstrate a sensitivity to light, colour and nuanced emotion that only Angelico possessed (90).

Over the course of the commission, the friar's direct participation in painting the frescos seems to have diminished, while that of Benozzo and his other assistants increased. This is especially evident in the images of the Crucifixion with Saint Dominic in the novices' cells of the south corridor, on which construction began in 1441. The frescos were completed in only two days each (see 91, 104). They seem to have been painted almost entirely by Benozzo, as is evident in the linear description of Christ's idealized anatomy, especially his ribcage, and the uninflected modelling of Dominic's habit. Other artists seem to have executed several frescos along the east corridor, as suggested by the somewhat awkward postures and gestures of the figures, the unmodulated contours and flat colours (92). Such differences in style confirm the importance of Angelico's assistants to the completion of this commission. The composition and conception of these images, however, were due to Angelico. Traces of his underdrawings are still visible beneath several of the frescos, revealing his unerring hand and mind.

The frescos of the cloister, refectory, Chapter House and cells of the dormitory encompass various themes centred on the life of Christ and the Order's saints. Other convents, including Santa Maria Novella, had been embellished over the course of one or two centuries, documenting the long evolution of their history, patronage and devotions. San Marco is distinguished from them all because a single artist conceived its decoration at one time, expressing a coherent and unified vision. As the prior of San Marco, the learned Antoninus was certain to have guided Angelico in choosing the Christological themes of the frescos. Antoninus ascribed a special role to images in inducing meditation and wrote extensively on many of the themes that Angelico interpreted, from the Annunciation to Christ's posthumous appearance to Mary Magdalene (see 88). Antoninus's thought, in turn, emerged from that of the Order's greatest luminary, Saint Thomas Aquinas.

87
Fra Angelico assisted by Benozzo Gozzoli, *Attempted Drowning of Saints Cosmas and Damian*, predella panel of *San Marco Altarpiece*, c.1438–40 Tempera and gold on panel; 38 × 45 cm (15 × 17¾ in) Alte Pinakothek, Munich

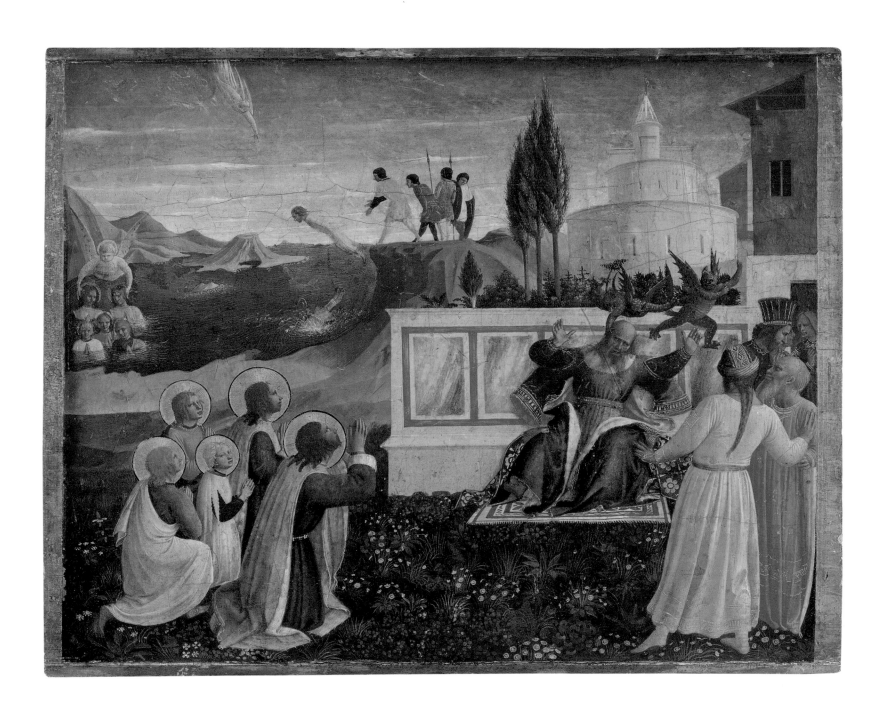

Thomas devoted the third part of his final and greatest work, the *Summa theologiae* (1267–73), to explicating the life of Jesus. He systematically placed each event into one of four categories: the introduction of Christ to the world, from his Incarnation to his baptism; his public ministry, from his temptation by Satan through the Transfiguration; his departure from the world and return to God, comprising his Passion, Crucifixion and descent into Limbo; and finally his exaltation, inaugurated by his Resurrection. The frescos at San Marco portray all of these 'acts and deeds of Christ incarnate'. Thomas believed that these 'acts and deeds' led to the gift of God's grace and the salvation of the faithful.

But while numerous parallels may be drawn between the decoration of the convent and the writings of both theologians, no single source is known for the subjects or sequence of the frescos. They emerged from the venerable doctrinal, visual and devotional culture of the Dominican Order to collectively communicate its mission and spirituality. Although diverse constituencies, including a few select laymen, had access to the convent, the paintings seem to have been directed primarily to the brethren. Devoting their lives to Christ and the Virgin, the friars perceived the images mystically. For them, the portrayals were not historical depictions distant in time and place, but pervasive evocations of the ubiquitous presence of Jesus. They evoked his inspiration as 'the first and principal teacher', as Saint Thomas proclaimed, who taught the Apostles by his deeds and sayings. For Antoninus, who compared the monastic state to discipleship under Christ's perfect aegis in the *Summa theologica*, the life and teachings of Jesus provided 'the example for our way'.

The murals that embellished the doorways and walls of the cloister, the Chapter House and the refectory on the ground floor introduced the themes seen throughout the complex (93). They identified the function of the rooms issuing from the cloister, from the fresco of *Saint Thomas Aquinas* above the door to the study, to the image of *Christ as Pilgrim Welcomed by Two Dominican Friars* identifying the hostel of the pilgrims. They depicted the Order's devotion to Christ and portrayed its exemplary saints to reinforce the faith, preaching and scholarship that were central to its mission. Immediately on crossing the threshold of the cloister, each individual beheld an elevated, larger than lifesize portrayal of the kneeling Saint Dominic embracing the Cross and gazing upward at the crucified Jesus (94). To the laymen accorded access to the convent, this image designated the liminal boundary between the secular world and the sacred space of the cloister. To the friars, it served as an exhortation to kneel in prayer in emulation of their founder, to contemplate the magnitude of Jesus's suffering and to devote themselves, as Dominic and their vows required, 'to study always' so that they could preach the truth of the Christian mysteries.

As the focal point of the cloister, the fresco nearly fills the arch in which it was painted. Angelico dramatically silhouetted the crucifix against a deep, azurite sky to highlight the beauty of Christ's body, foreshortened as if seen from below. To convey the agony of the Crucifixion he lengthened Jesus's torso, attenuating the muscles of the arms and pulling the skin tautly over the ribcage. Angelico subtly modulated the tones of the paint which he applied in parallel and rounded strokes to create the illusion of Jesus's robust physique, evoking his presence more believably than in the Fiesole *Crucified Christ* (see 70), where the body is slender and less intensely modelled. In contrast to the earlier fresco, which depicted Christ with his head lowered in death, Angelico showed Jesus as if still alive: the eyes, although lowered, seem not yet closed. Kneeling at the foot of the cross, stained with rivulets of blood painted in

88
Noli me tangere (The Risen Christ appearing to Mary Magdalene), c.1440–2
Fresco; 166 × 125 cm (65⅜ × 49¼ in)
Cell 1, Museo di San Marco, Florence

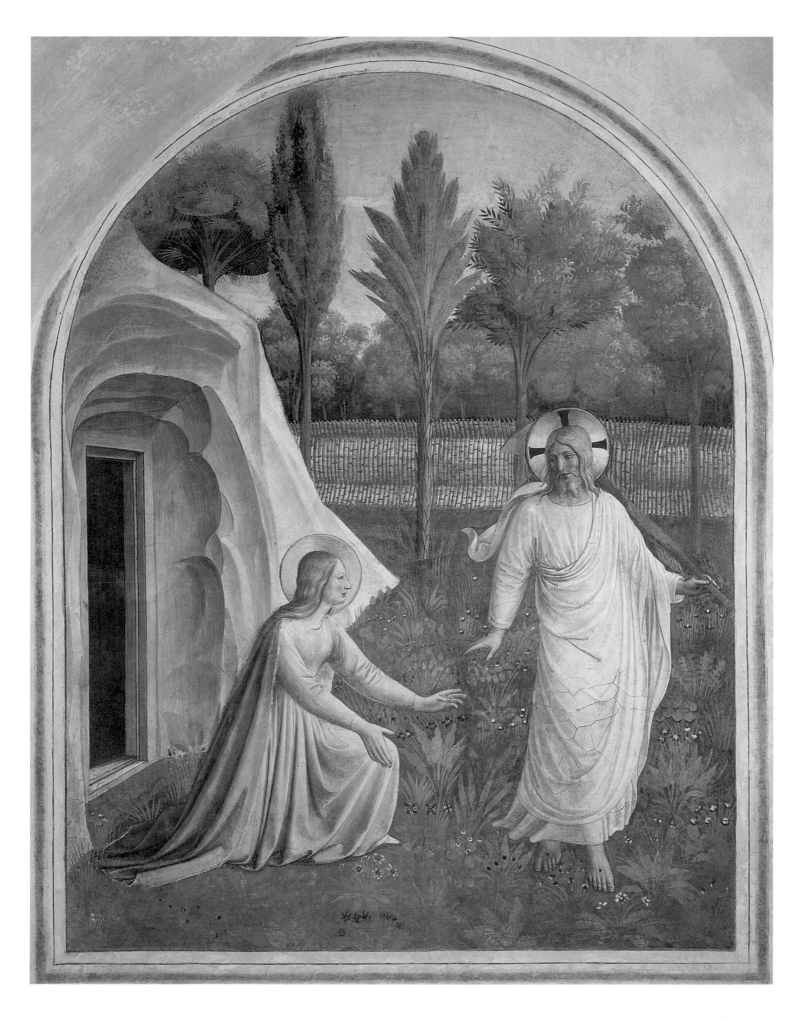

127

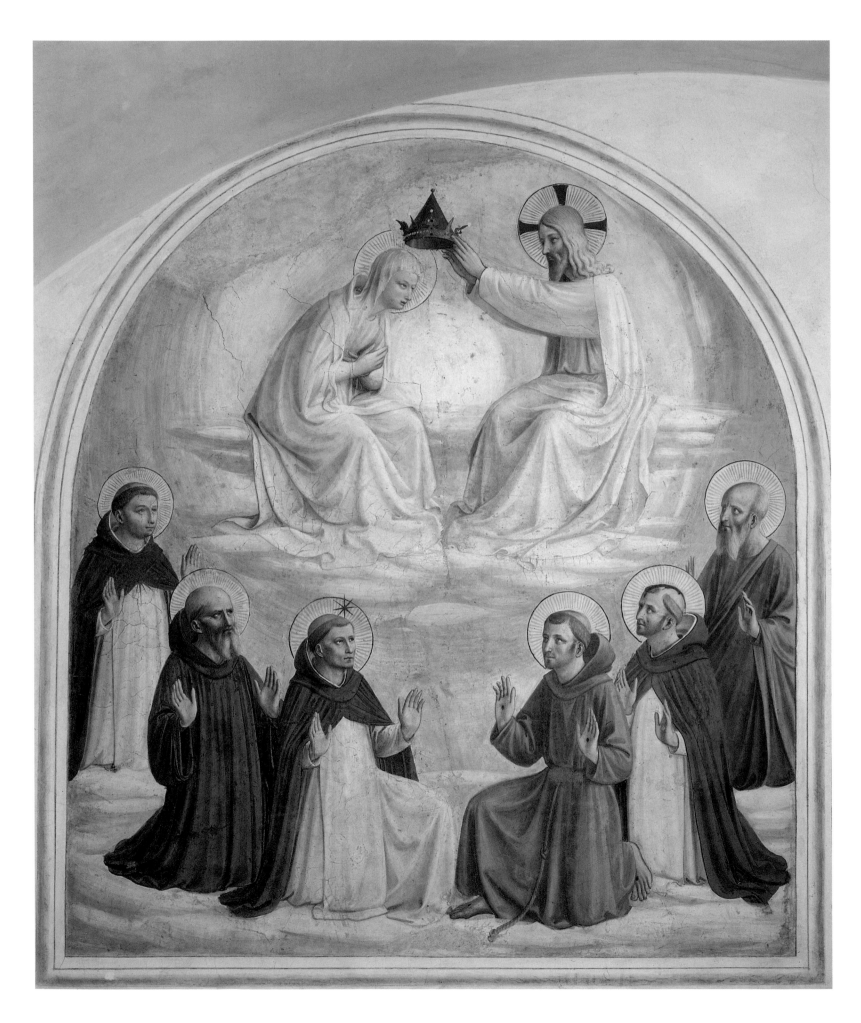

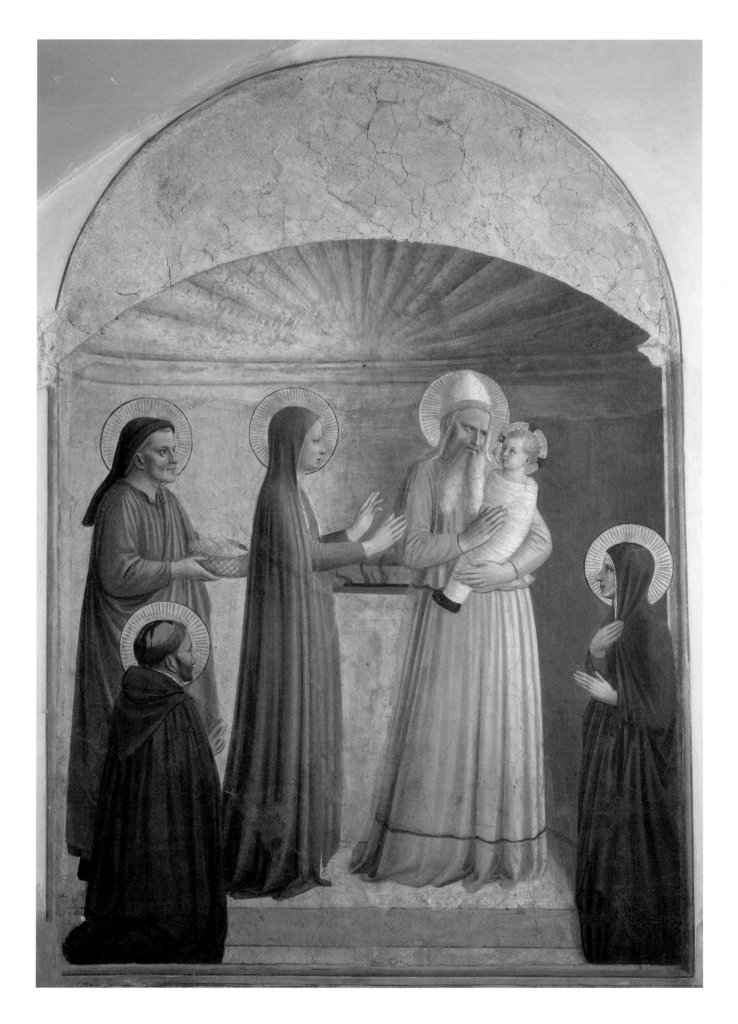

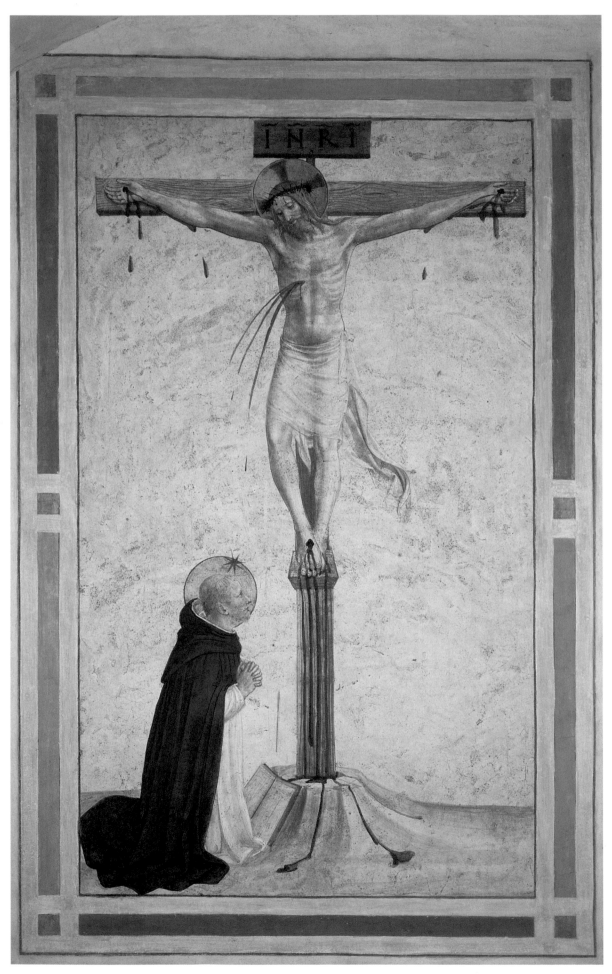

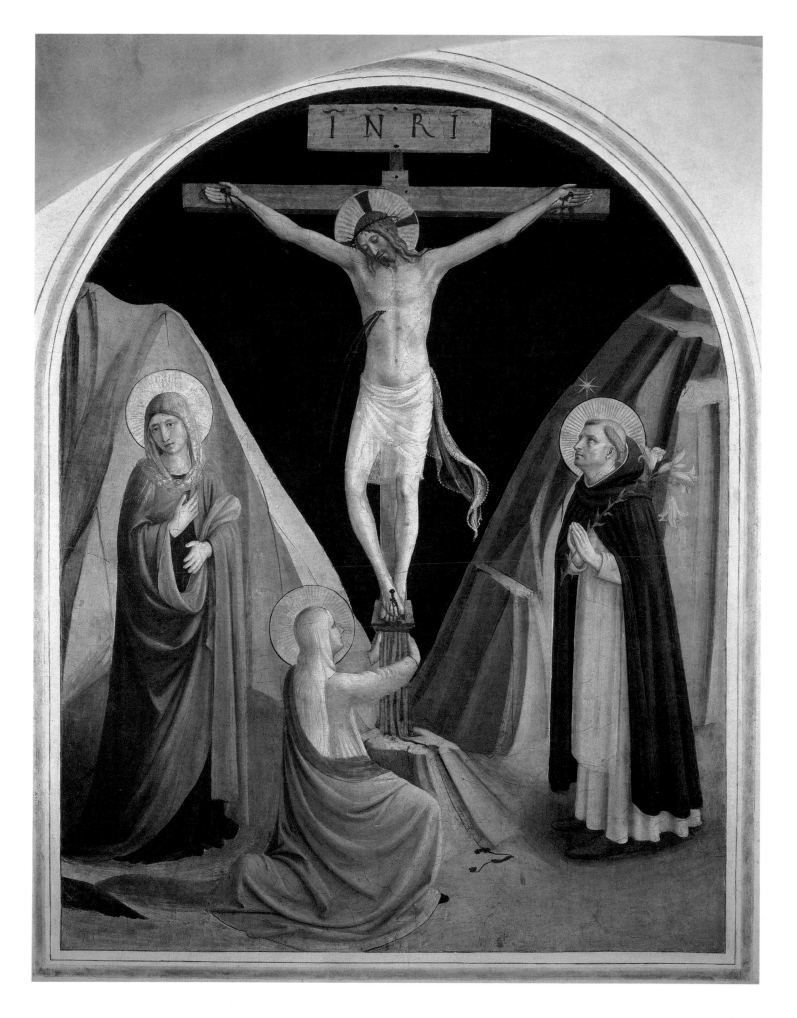

93
Michelozzo di Bartolommeo,
Cloister, begun 1440
Museo di San Marco, Florence

94 Opposite
*Saint Dominic adoring Christ
on the Cross, c.*1441–2, enclosed
in a later frame
Fresco; 340 × 206 cm
(133⅞ × 81⅛ in)
Cloister, Museo di San Marco,
Florence

hematite pigment, Dominic looks up with tear-reddened eyes
to meet Christ's gaze. Angelico portrayed the saint's affective
relationship with Jesus, attained through vigilant meditation,
charity and discipline, as a model for the friars' private and
collective devotions.

Angelico frescoed the imposing *Grand Crucifixion with Saints*
across an entire wall of the Chapter House, the locus of the
convent's communal, penitential and public lives (95). This room
was the centre of the rituals that punctuated the rhythms of the
brethren's existence, most notably the daily meeting, which included
sacred readings and sermons. Here, beneath the attentive eyes of
the prior and their fellows, the friars confessed and were punished
for their sins, and novices were received into the Order. Visitors,
from the Order's own dignitaries to the laity, were formally greeted
in the Chapter House, where all legal and financial transactions
were negotiated. The *Grand Crucifixion with Saints* was the witness
and background to these events, portraying the inspiration for the
friars' way of life. The vast scale of the fresco, the scroll-bearing
figures in its frame and the inclusion of the crucified thieves recall
the *Crucifixion* in the Chapter House of Santa Maria Novella,
situating the fresco within the venerable continuum of Dominican
visual culture and lending authority to this portrayal (96). At the
same time, Angelico omitted the teeming crowds, multitudes of
angels and related episodes that fill the earlier image. The *Grand
Crucifixion with Saints* is not a narrative of events as described in
the Bible, but the history of Christ and his Church, from the
prophets who foretold his coming to the founders of the major
religious orders standing in eternal vigil below the cross.

Enclosed in hexagons in the frame above, intensely
characterized prophets, sibyls and theologians unfurl scrolls
inscribed with prefigurations of the death and Resurrection of
Jesus. Their texts include the prophecy of Daniel (9:26) that 'after
three score and two weeks shall the Messiah be cut off' and the
lamentation of Isaiah (53:4) that 'Surely he hath borne our griefs,
and carried our sorrows' – allusions, it was believed, to the span
of Christ's life and sacrifice. At the bottom of the fresco as its
very foundation, Angelico represented the genealogy of his Order
by portraying seventeen of its greatest luminaries. Enclosed in
branches held by Dominic, these individualized saints, scholars
and popes comprised the family tree of his Order, and were based
on venerable portraits preserved in its art. Dominic is aligned
with the pelican feeding her young with her own blood, a symbol
of the Eucharistic sacrifice of Jesus, in the frame, and with the
crucifix, underscoring his devotion to Christ. The titulus of the
cross, inscribed 'Jesus Christ King of the Jews', is written in
impeccably correct Hebrew, Greek and Latin, attesting the Order's
singular devotion to biblical scholarship and the cosmopolitan
character of Christian humanism following the Council of Florence.

The Chapter House fresco is the largest and most moving
Crucifixion in all of Angelico's works. Three towering crosses are
silhouetted against the sky that once intensified in saturation from
a misty blue on the horizon to a deep azurite. (The present red sky
reveals Angelico's use of hematite as a binder for the original
azurite pigment, which has flaked off over time. The red, which was
mistakenly reinforced in an early restoration, was never intended
to be seen.) The good and bad thieves, still alive, diagonally flank
Jesus, their muscular bodies placed obliquely in depth. In
fulfillment of the prophecies inscribed on the scrolls above, Jesus
is shown as already dead and beginning the passage to his
Resurrection. His body, slender and idealized, was foreshortened
to appear realistic to those who beheld it while kneeling in prayer.

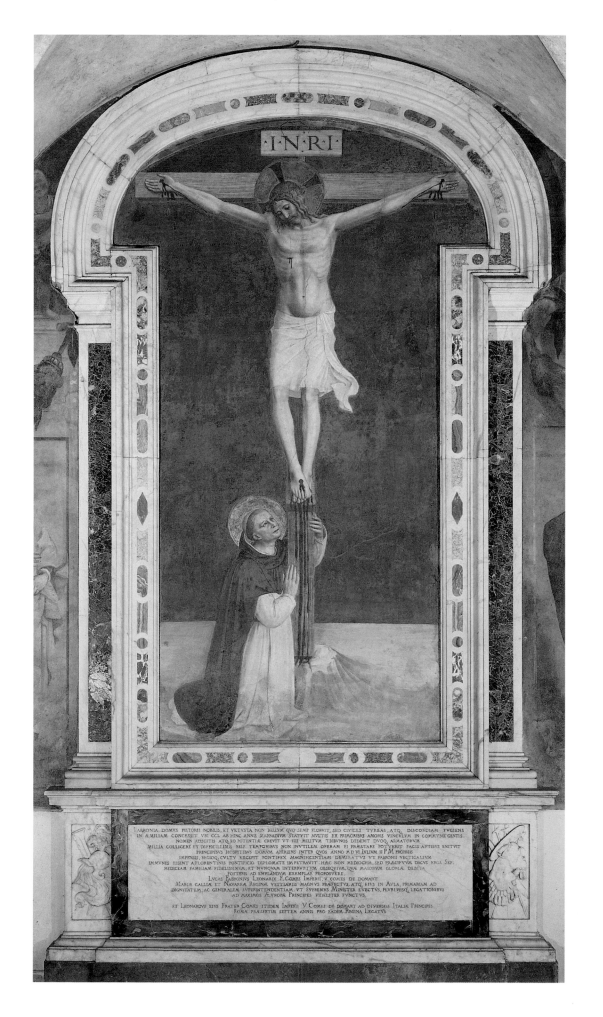

133

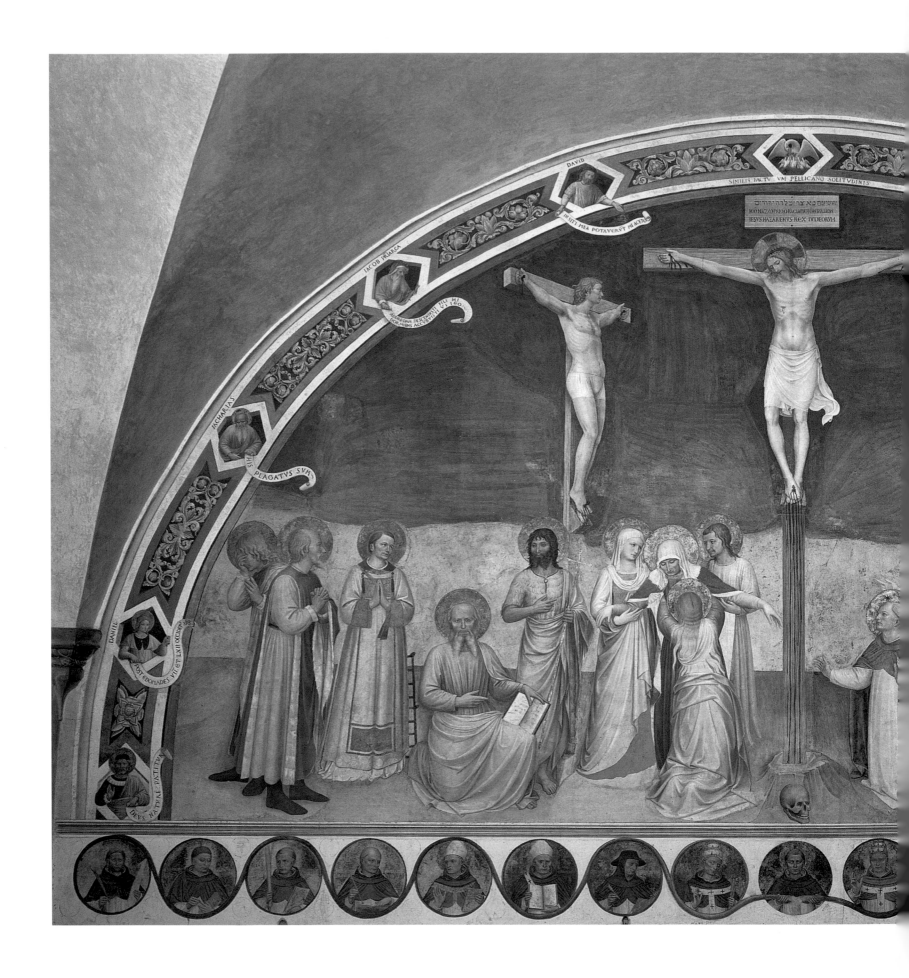

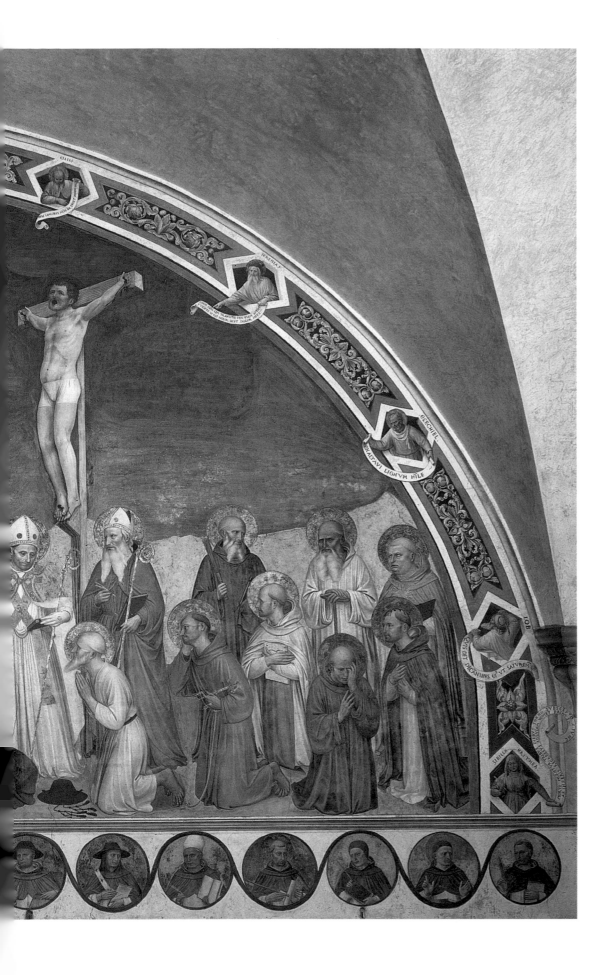

Grand Crucifixion with Saints
(*Prophets and Sibyls* in the frame
by Benozzo Gozzoli), 1441–2
Fresco; 550 × 950 cm (216½ × 374 in)
Chapter House, Museo di San Marco,
Florence

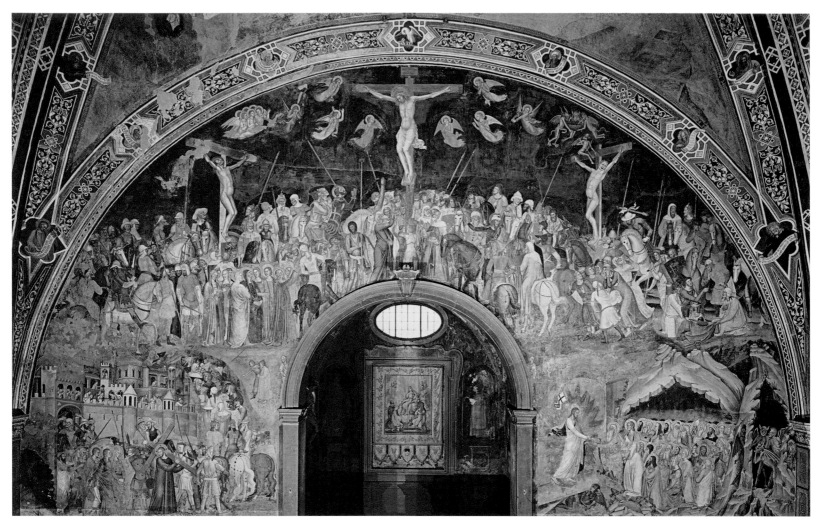

96
Andrea da Firenze, *Crucifixion*,
begun 1365
Fresco; 11.6 m (38 ft) wide
Spanish Chapel (former Chapter
House/Guidalotti Chapel),
Santa Maria Novella, Florence

Below the crosses, twenty saints meditate upon the meaning of his death. To the left are those specifically associated with Florence, San Marco and the Medici: John the Baptist and Mark, whose open Gospel was inscribed with words that now are too faded to decipher, as well as Lawrence, Cosmas and Damian. To the right are Fathers of the Church and representatives of the religious orders, including Augustine, Ambrose, Jerome, Francis, Benedict and the Order's own saints: Peter Martyr, Thomas Aquinas and Dominic. Of them all, only the swooning Virgin and the mourners supporting her actually witnessed the Crucifixion, their glistening tears and sorrowful faces authenticating the suffering that Christ endured.

Angelico distinctively characterized all of the saints in this ecumenical gathering to express the unique relationship of each one to Jesus. The Baptist stands behind the mourners, pointing toward the fulfillment of his prophecy of Christ's death. Incapable of viewing Jesus's pain, the youthful Damian covers his eyes while the older Cosmas and Lawrence turn toward the cross, beholding it with reverence and sorrow. Wearing a rich malachite cope and bishop's mitre, Augustine stands on the other side below the bad thief. This eminent theologian and author of the *City of God* (as well as innumerable writings on the soul) points to Christ as the source of truth as he lowers his sombre gaze to his contemporary, Jerome. Angelico's depiction of the ascetic saint, the foremost translator and biblical scholar in Church history, was inspired by Jerome's own letter recounting his suffering in the desert as he knelt before a crucifix, striking his breast in penance for his sins. Kneeling beside him at the foot of the cross, Dominic gazes ardently at Jesus, extending his arms in empathy toward the crucified Christ. His affective relationship with Jesus contrasts to the intellectual one of Thomas Aquinas, at the far right, whose liturgy for the feast of Corpus Domini exalted 'the priceless blood shed by our immortal King'. Evoking sorrow at the magnitude of Jesus's sacrifice, the *Grand Crucifixion with Saints* also honoured those who devoted their lives to Christ. Foremost among these were the Dominican saints, whose example the friars aspired to follow.

From the cloister, members of the religious community ascended the stairs to the dormitory on the floor above. As they approached the landing, they beheld the *Annunciation* (97). This image was located at the intersection of two wings of the dormitory, one for the friars and the other for the lay brothers and visitors to the library. This *Annunciation* differed markedly from Angelico's altarpieces of this theme (see 38, 73), for it omitted the expulsion of Adam and Eve. The simplified composition may have been inspired by a fresco on the entrance wall of San Marco, which replicated the much-venerated miraculous image in Santissima Annunziata (see page 20). Angelico focused on the reverent exchange between the Virgin and the Archangel Gabriel, whose greeting to her – 'Ave Maria' (Hail, Mary) – the friars repeated innumerable times each day as they communally recited the Little Office of the Virgin, knelt in prayer, and passed by this image. The inscription written in majuscules below the fresco addressed the brethren directly, reminding them to honour her: 'When entering and standing in front of the pure Virgin, do not forget to say an Ave.' Another, inscribed in Gothic letters on the base of the Virgin's loggia, acclaims her: 'Hail, O Mother of Mercy, and noble resting place of the Holy Trinity', an invocation appropriate to all who entered the dormitory.

Evoking the illusion of the Virgin's presence at the top of the stairs, Angelico portrayed the Annunciation in a loggia placed within an enclosed garden and inspired by the architecture of the convent itself. Supported on slender, unfluted columns like those of the cloister (see 93), the arches clearly articulate space and recede proportionately in perspective. They create an idealized, harmonious frame for the Incarnation, suggested by Mary's hands, crossed in humility and placed above her womb, as the Archangel reciprocates her gesture. The Holy Spirit, painted in translucent pigments (now barely visible) above her head, descends to make the Word flesh. Their gowns are soft and luminous, their features delicately drawn and their expressions serene. Described in curving strokes of related hue that follow the contours of her lovely face, the Virgin reifies the beauty that Antoninus lauded in his sermon on the Annunciation and embodies the grace proclaimed in the Archangel's greeting. Like the Holy Spirit, Mary's dress was painted with diaphanous pigments, suggestive of the mystery of the Word contained within her.

While Angelico portrayed the Annunciation according to tradition, each element of the image inspired a host of associations for the learned friars. Like the barred window in the room behind the loggia, the garden was long recognized as a symbol of the virginity of Mary. The enclosed garden was opened only to the Word of God. According to the Dominican theologian Albertus Magnus (1206–80), who composed a lengthy encyclopedia in her praise, the flowers of her virginal garden were sown 'with a mystical breath' and its grasses shaded by cedars, palms and cypresses, as portrayed here. The harmonious proportions of the loggia recall litanies and sermons describing Mary as the tabernacle and temple of God, the Ark of the Covenant, the dwelling place of the Holy Spirit; its columns evoke those of Christ's wisdom supporting the Church. They represent Mary herself, honoured as 'the triclinium (resting place) of the Holy Trinity' by the inscription on the floor of the loggia. The variegated, jewel-like colours of the Archangel's wings evoke those imagined of Paradise, to which theologians devoted countless explications. The stool on which Mary sits alludes to her peerless humility and, simultaneously, to the throne of God, where she will be crowned Queen of Heaven. Visible beneath her translucent dress and emphasized by the placement of her hands, her newly swollen womb suggests the formation of Jesus's body that occurred instantaneously, according to Saint Thomas Aquinas and Antoninus, with Gabriel's 'Ave', when the Word was made flesh.

For the lay brothers and those using the library on the north wing, the fresco demarcated a part of the convent that they were not privileged to enter. But for the friars who recited the Little Office before it, the *Annunciation* stood at the threshold to the liminal, private space of the dormitory. It inaugurated their transit through the Passion and Resurrection of Jesus and the joys and sorrows of the Virgin, which they relived through the murals on the walls of their cells. The monumental frescos augmented the images of 'the Crucified Lord, the Blessed Virgin, and our Father Dominic' mandated in the Order's Constitutions. In painting them, Angelico eschewed and responded to tradition, creating an elevated visual language that only the friars and novices were privileged to understand. They translated the concept of Christ as 'the example for our way', expressed in the *Summa theologica* of Antoninus, and paid homage to the Virgin. Most of the frescos include Dominican saints who empathetically seem to meditate upon the images before them. These images attest the primacy of prayer and contemplation to the Order's spirituality. Although scholarship was always crucial to the Dominicans, meditation was deemed even more important in approaching God, as Saint Thomas claimed, teaching him more than books. Here, the Order's saints stand or kneel in the diverse and distinctive modes of prayer and penance that were practised by Saint Dominic and illustrated in one of the Order's earliest devotional manuals, *De modo orandi* (*The Modes of Prayer*) (98, 99). As the

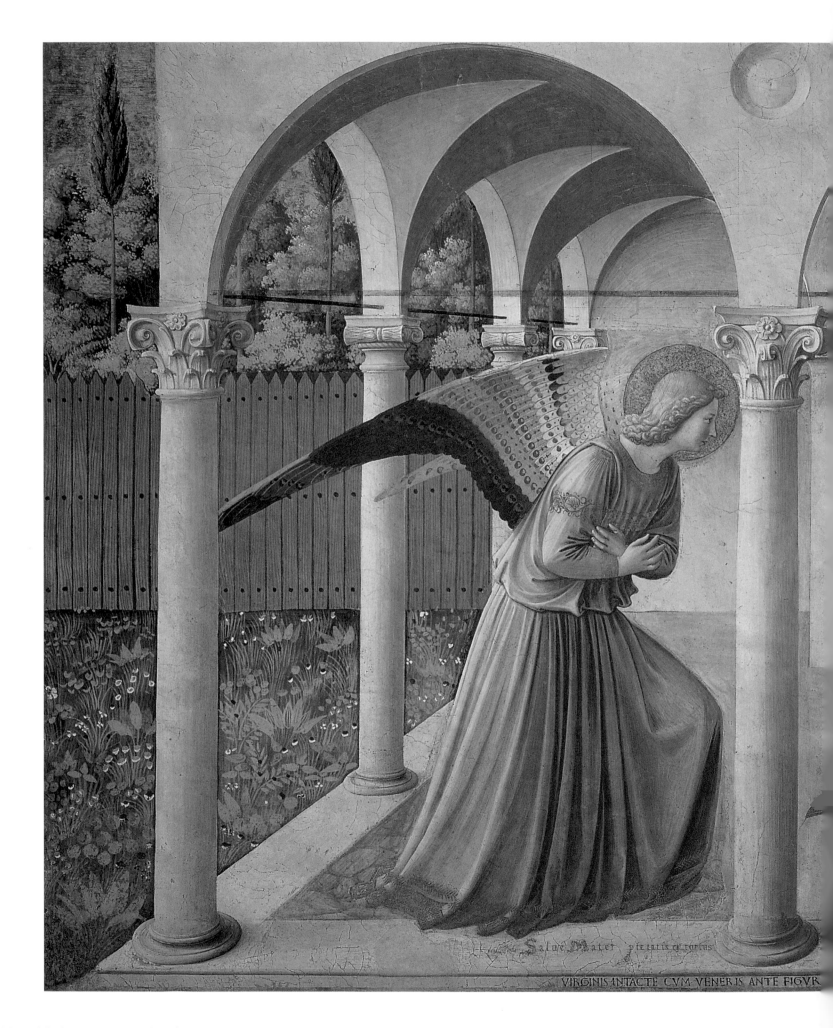

97
Annunciation, c.1442–3
Fresco; 230 × 297 cm
(90½ × 116⅞ in)
North Corridor, Museo di San Marco,
Florence

preface to one such manual counselled, 'the soul uses members of the body in order to rise more devoutly to God'. By imitating the 'bodily motions' of the saint as he was depicted at prayer, the friars could evoke in themselves both the agony and the rapture experienced by their founder.

In accord with the Order's original Constitutions, every member of the community at San Marco had his own private cell, in which he slept, read and meditated. The individual rooms were organized in separate wings for the three constituencies of the convent: the friars who devoted themselves to meditation, scholarship and preaching; the novices, whose spiritual lives were still in formation; and the lay brothers, who had limited theological education, but served the others through manual labour, such as gardening. In total, there were forty-four cells, all painted by Angelico and his shop to enhance the devotions of each audience. Almost every cell of the friars includes the Virgin or a Dominican saint, who anachronistically bears witness to each scene, shaping the friars' response through posture, gesture and gaze.

In several of the friars' cells, Angelico suppressed conventional components of the narrative, as in the *Annunciation* in Cell 3, which he portrayed without the garden symbolic of Mary's virginity (100). The luminous vaults of the architecture resemble those of the cloister at San Marco (see 93), heightening the sense of the Virgin's actual presence within the convent. As Mary bows to the Archangel in accepting the Word of God, her slender body, covered by a filmy gown, seems without weight or substance. From outside the loggia Saint Peter Martyr, who was canonized on the feast of the Annunciation, seems to gaze upon the event. He joins his hands in prayer, prompting the friar who beheld the image to do the same. This spiritualized portrayal contrasts to the more detailed *Annunciation* at the top of the stairs (see 97), which was regarded not only by the friars, but also by the lay brethren, who were less versed in Dominican spirituality, and those who visited the convent's library.

Angelico employed this condensed, allusive mode of narration in other frescos in the friars' corridor. In Cell 6, the *Transfiguration* is devoid of sky and landscape, save for the mountain-top on which Christ stands, surrounded by a glowing aureole (101). His outstretched arms prophesy the Crucifixion, and his gleaming raiments foretell the Resurrection, for according to Saint Thomas Aquinas, the Transfiguration presages 'the light of our future glory'. The *Mocking of Christ* in Cell 7 similarly differs from traditional representations, which portray Jesus, dressed in a robe of scarlet or purple, being beaten and spat upon by his tormentors in the palace of Pontius Pilate (102). Here, Christ wears a luminous white gown in allusion to his Resurrection while being surrounded by symbols of his torture: the profile of the man who spat at him, the hands that beat him, the rod with which he was flailed. Seated below him, Saint Dominic and the Virgin contemplate the magnitude of his torment, suffered, according to Saint Thomas, out of his love for humankind. The fresco in the adjacent cell depicts the *Resurrection with the Maries at the Sepulchre*, in which Christ ascends behind the image's very frame (103). Angelico conflated the visit of the holy women to the tomb with the Resurrection, two themes that previously

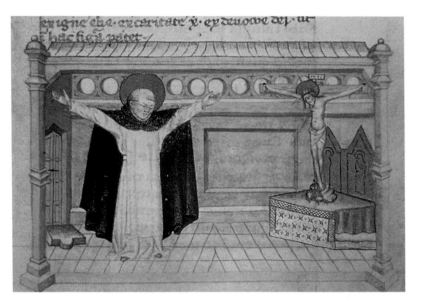

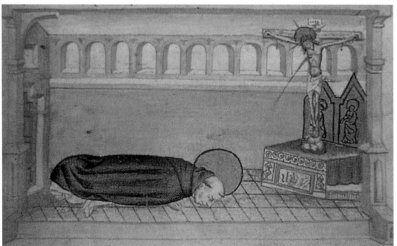

98
Saint Dominic in Prayer, from
De modo orandi, fol. 10r, MS
Rossianus 3, *c.*1260–88
Biblioteca Apostolica Vaticana, Rome

99
Saint Dominic Prostrating Himself,
from *De modo orandi*, fol. 6v, MS
Rossianus 3, *c.*1260–88
Biblioteca Apostolica Vaticana, Rome

were shown separately. Prompted by the angel's gesture, two of the Maries gaze into the empty sepulchre. They verify the miracle that, according to Saint Thomas Aquinas, inaugurated the 'eternity of glory'.

Epitomizing the Order's devotion to the Eucharist, the Crucifixion is represented more than any other theme in the friars' dormitory. It adorns all seven of the novices' cells. In each fresco, Christ is starkly silhouetted against the bare walls, with no indication of topography or setting. The Virgin or Saint Dominic sits or kneels at the foot of the cross, engaged in meditation or penance in contemplating Christ's suffering (see 91, 104). The portrayals of Dominic approximate illustrations in *The Modes of Prayer* (see 98, 99). In Cell 20, the saint is depicted flagellating himself, reminding the brethren to do the same, as *The Modes of Prayer* counselled, 'either for their own sins or for those of others whose gifts supported them' (104). In the adjacent cell, Dominic's arms are 'spread out like a cross', as depicted in *The Modes of Prayer*, in imitation of the crucified Christ. While Angelico varied the responses of Dominic, he replicated the slender, idealized Jesus in each of the frescos to recall the monumental *Grand Crucifixion with Saints* in the Chapter House (95). This is unlikely to have been done out of haste or lack of imagination, as has sometimes been implied. Rather, it ensured the continuity of the brethren's devotion to Jesus so that he seemed ever present before their eyes and in their hearts. It reinforced their faith, reminding them to follow the example of Dominic, who humbled himself in prayer each time he passed a crucifix.

In contrast to most frescos in the cells of the friars and novices, those in the corridor of the lay brethren are illustrative narratives that closely follow the Gospel of Matthew. These portrayals were directed to a community that was less attuned to theological and visual abstraction. Consequently, the images pictorialized events in a more literal and descriptive way than those frescos for the friars and novices who were educated in the Order's spiritual and intellectual culture. Many of the scenes are situated in mountainous landscapes or detailed architectural settings. In *Christ in Limbo* in Cell 31, scaly demons hide in the rocky fissures of Purgatory while the faithful escape the darkness of Limbo to rush toward the resurrected Jesus (105). The *Institution of the Eucharist* in Cell 35 underscored the Order's devotion to the Eucharist, which Saint Thomas articulated most eloquently in composing the office for the feast of Corpus Domini (106). It transpires in a spacious room similar to the convent's actual refectory and repeats elements of San Marco's own architecture – the arched windows of the dormitory, the well in the second cloister – to emphasize its relevance to the lay brothers.

The Crucifixion is depicted in seven cells in this corridor. While the friars and novices may have been moved to prayer at the thought or sight of the crucified Jesus, the lay brothers required more direction in imagining the Passion. By incorporating more narrative elements, these images were able to prompt their devotion more efficaciously. In Cell 36, Roman soldiers mount ladders to nail Jesus to the cross, below which the grieving Virgin and Magdalene stand as the Sanhedrin look on (107). In six of the other cells, Angelico included the grieving Virgin and other mourners along with Saint Dominic or Peter Martyr to cue the beholder's response.

So it was for the fresco in the adjacent cell, the large size of which suggests it may have served as the Chapter Room for the lay brethren as they met each day under the guidance of their own prior (108). Angelico adapted the monumental portrayal of the *Grand Crucifixion with Saints* (see 95), excluding the congregation of saints and didactic frame, but including all three crosses. While John the Evangelist and the Virgin express their grief, Saint Dominic stands with his arms extended to form a cross. According to *The Modes of Prayer*, such posture would have signified the saint's imitation of Jesus 'when he hung on the cross'. Thomas Aquinas kneels below, his book open as he regards Christ's Crucifixion, about which he wrote so eloquently in the *Summa theologiae*.

One cell at the end of this corridor was distinguished by its occupant and size. It was intended for Cosimo de' Medici, who belonged to the community by virtue of his patronage. He himself may have selected this prominent space, located, as the convent's chronicle specified, 'in the first cell that looks over the second cloister', where he could hear Mass as it was celebrated in the church below. His room, in fact, was a double cell, in which the superimposed chambers were joined by a short flight of stairs. Of all the cells along this corridor, Cosimo's was the most spacious and elaborately decorated. On the entrance wall of the lower room, Angelico painted the crucified Jesus against a ground of costly lapis lazuli, rather than the bare plaster background found in the other cells (109). The inscribed haloes identify the saints kneeling alongside the Virgin as Cosmas, Peter Martyr and John the Evangelist, protectors of Cosimo, his oldest son, and his father, Giovanni di Bicci. Through their piety, the saints served to secure Christ's merciful intervention for the Medici. The entreaties 'Mother, behold your son' and 'Son, behold your mother' are inscribed on the wall, prompting Mary's imploring gaze toward the beholder. As Cosimo entered the cell, they reminded him to put aside worldly concerns and devote himself to penance and prayer.

The *Adoration of the Magi* and the image of Christ as *Man of Sorrows* in the recessed tabernacle below met Cosimo's gaze once he ascended the stairs (110). Benozzo, whose style closely resembled that of Angelico, and an assistant painted these frescos, as shown by the slightly awkward stance and proportions of some of the figures as well as by their linear, closely spaced facial features. Both images conveyed profound Eucharistic and personal associations. The visit of the three kings to pay homage to Christ marked the first epiphany (Greek for 'apparition') of Jesus to the Gentiles – what Thomas Aquinas called 'the first beginning of faith' – while the entombed Man of Sorrows symbolized his last. The *Adoration* portrays the journey of the Magi through a mountainous landscape to Bethlehem. They traverse the walls of the cell from the east, 'where day was born', as Saint Thomas wrote, to west, their path illuminated by a star that miraculously appeared 'at midday'. The men on horseback gaze toward the heavens, one shielding his eyes from the star's radiance, which is reflected on the exquisitely pale garments of the Magi's entourage. The retinue displays pleasing variety, from their ages to the colour of their skin and garments. In contrast to this scene, the *Man of Sorrows*, framed by symbols of the Passion,

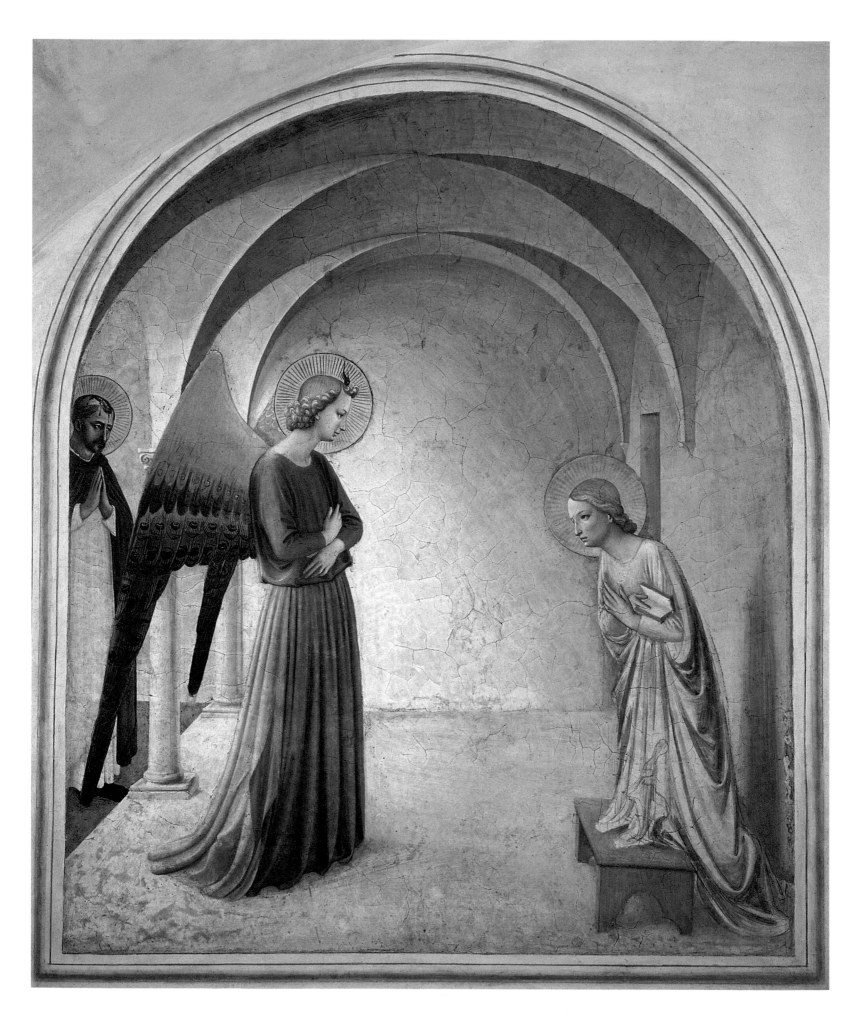

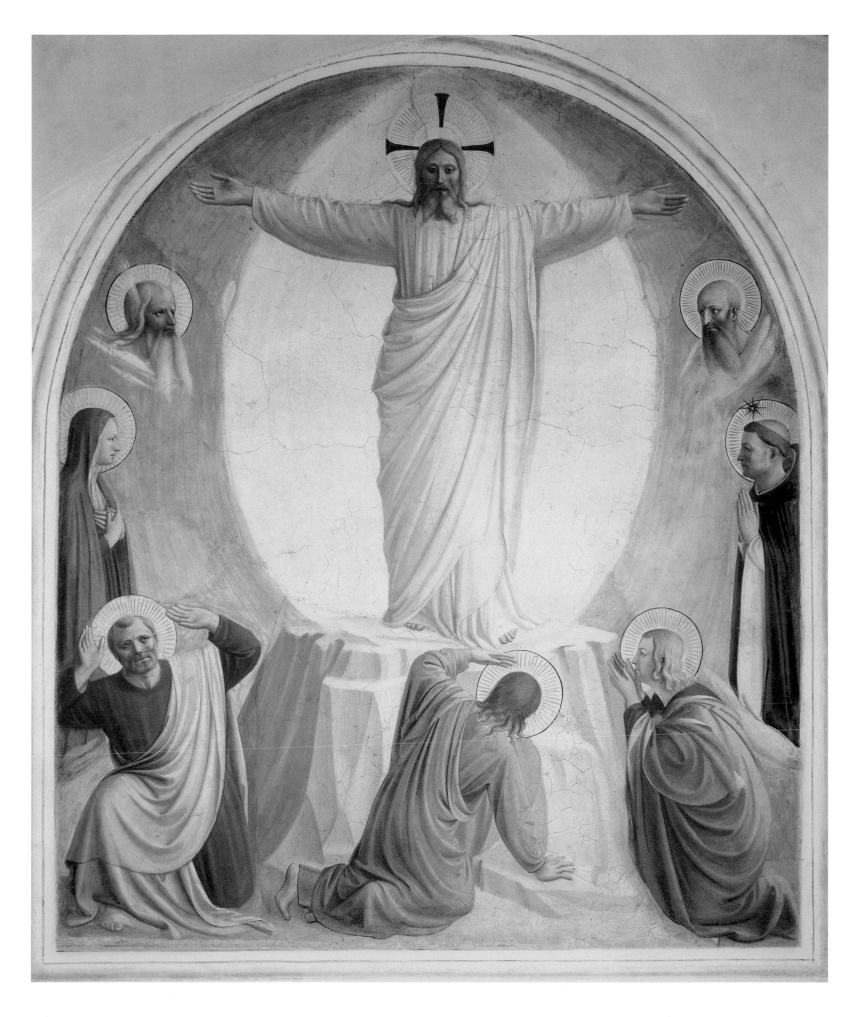

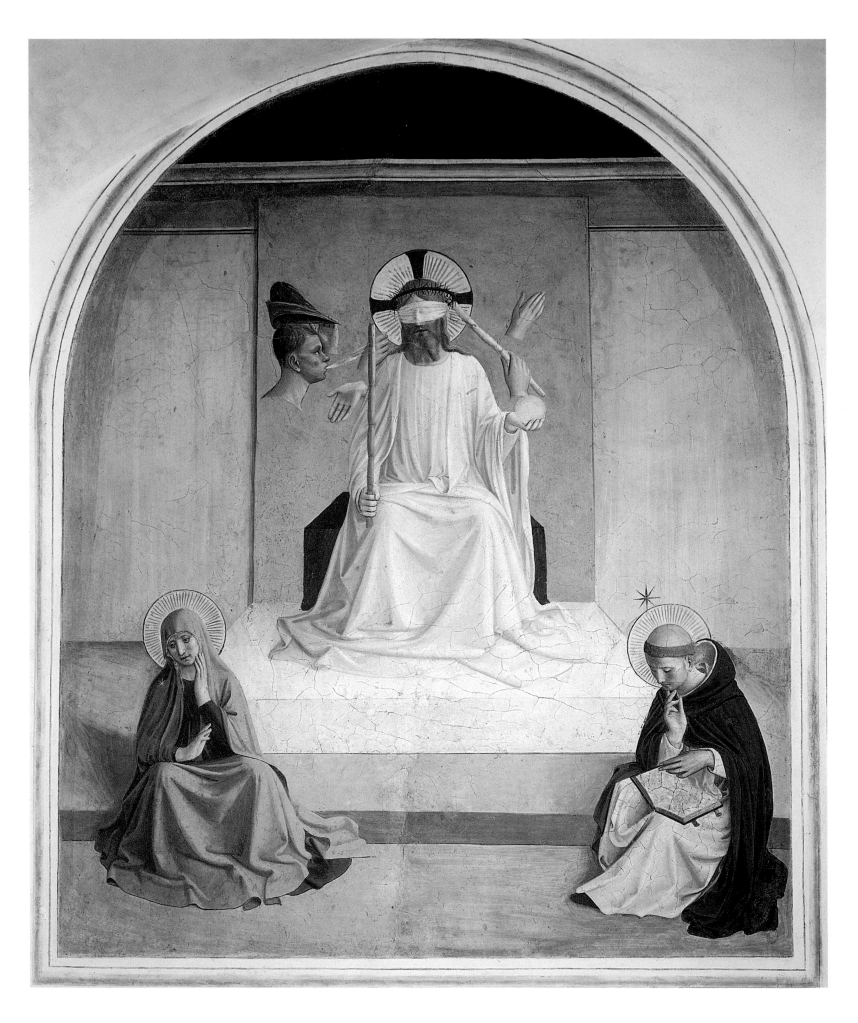

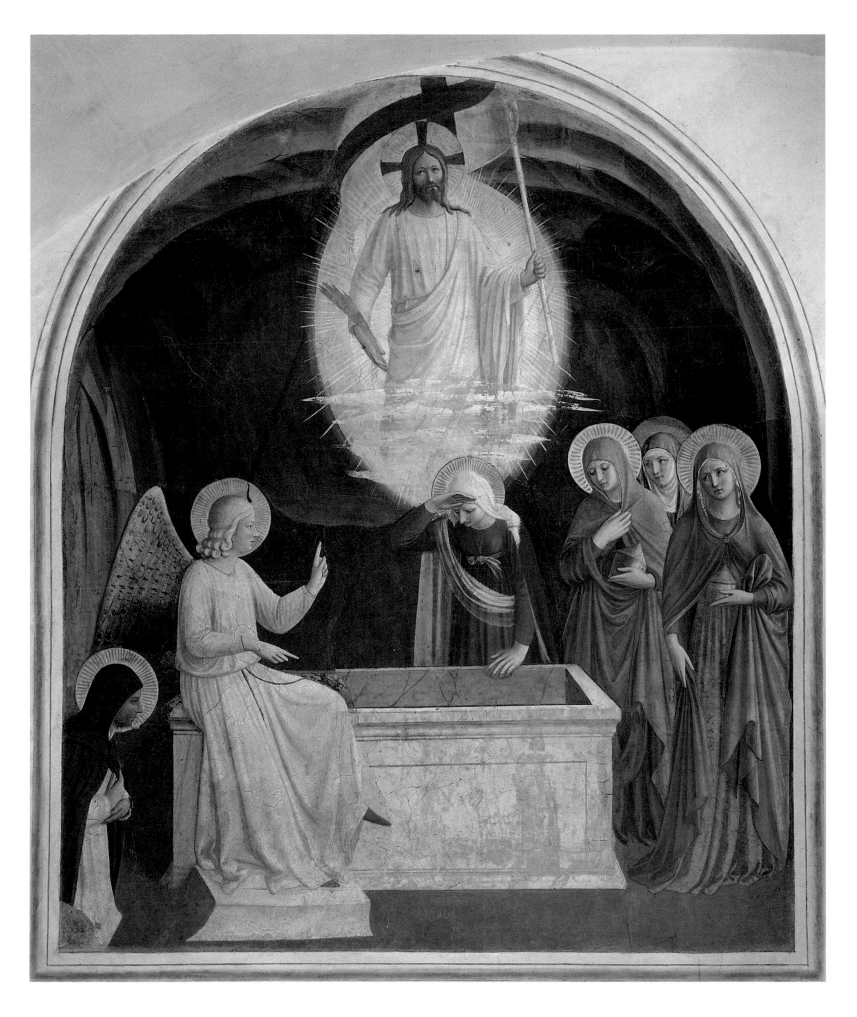

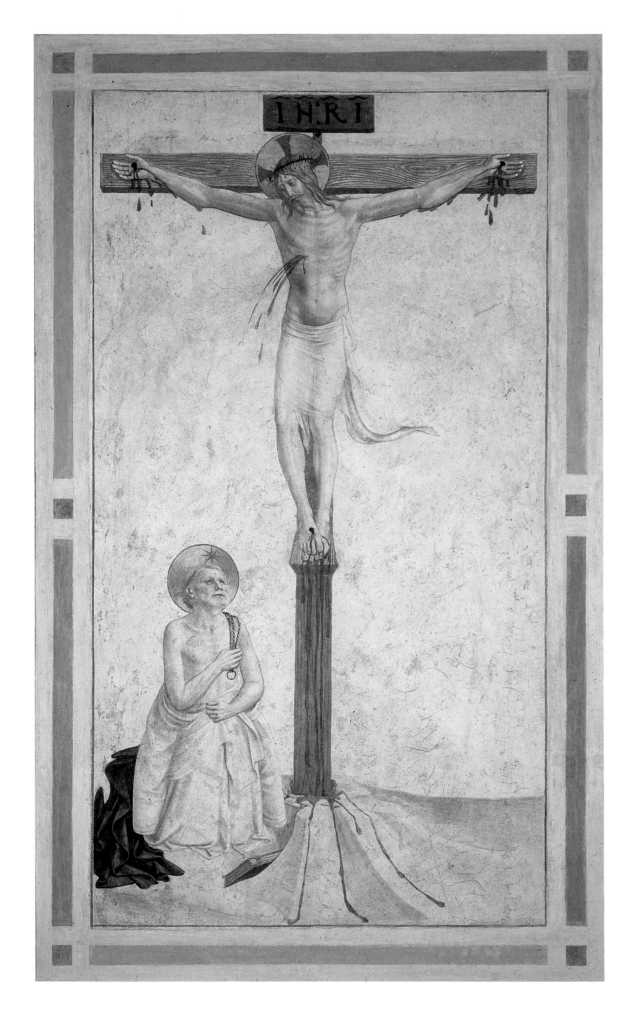

100 Page 142
Annunciation, c.1440–2
Fresco; 176 × 148 cm (69¼ × 58¼ in)
Cell 3, Museo di San Marco, Florence

101 Page 143
Transfiguration, c.1440–2
Fresco; 181 × 152 cm (71¼ × 59⅞ in)
Cell 6, Museo di San Marco, Florence

102 Page 144
Fra Angelico assisted by Benozzo
Gozzoli, *Mocking of Christ*, c.1440–2
Fresco; 181 × 151 cm (73⅝ × 59¾ in)
Cell 7, Museo di San Marco, Florence

103 Page 145
Fra Angelico assisted by Benozzo
Gozzoli, *Resurrection with the Maries
at the Sepulchre*, c.1440–2
Fresco; 181 × 151 cm (71¼ × 59¾ in)
Cell 8, Museo di San Marco, Florence

104
Benozzo Gozzoli, *Crucifixion with
Saint Dominic Flagellating Himself*,
c.1442
Fresco; 155 × 80 cm (61 × 31½ in)
Cell 20, Museo di San Marco, Florence

105 Opposite
Fra Angelico and Assistant, *Christ
in Limbo*, c.1441–2
Fresco; 183 × 166 cm (72 × 65⅜ in)
Cell 31, Museo di San Marco, Florence

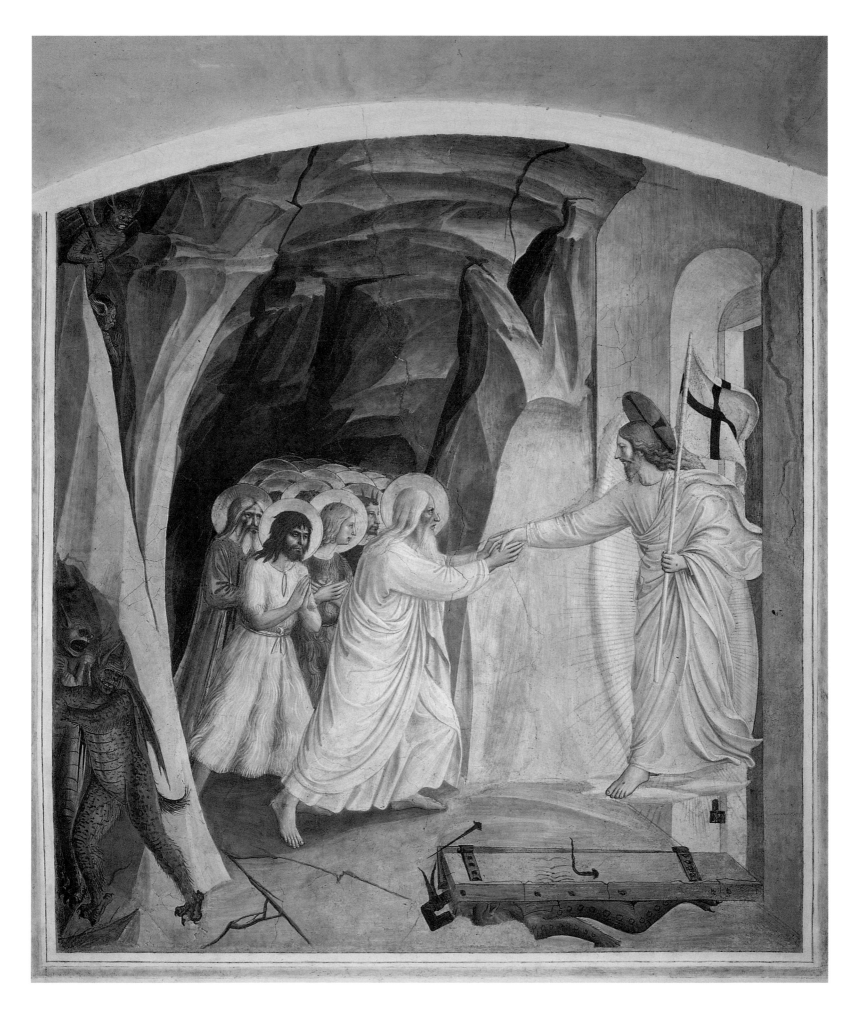

147

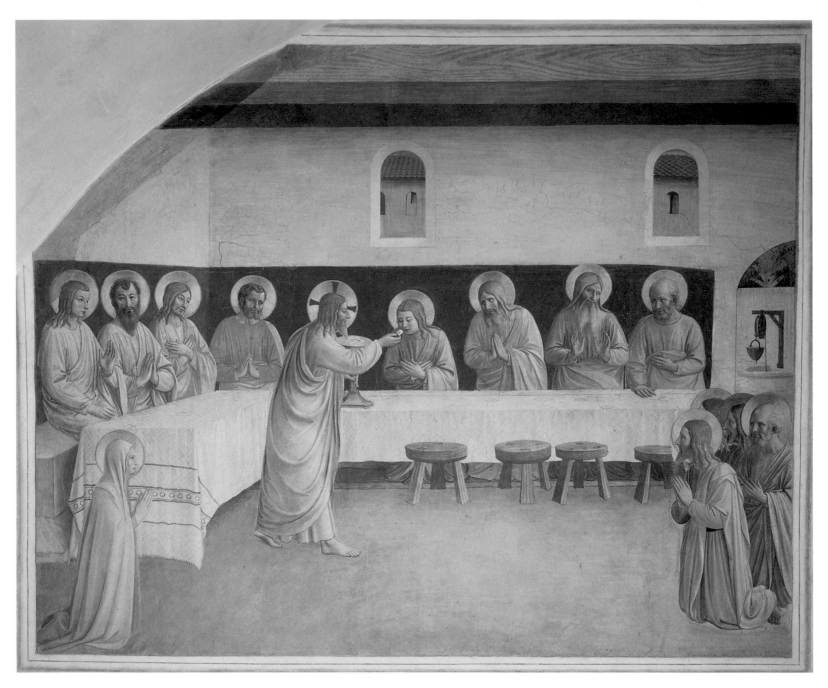

106
Assistant of Fra Angelico, *Institution
of the Eucharist*, *c.*1441–2
Fresco; 186 × 234 cm (73¼ × 92⅛ in)
Cell 35, Museo di San Marco, Florence

107 Overleaf, left
Fra Angelico and Assistant, *Nailing
of Christ to the Cross*, c.1441–2
Fresco; 169 × 134 cm (66½ × 52¾ in)
Cell 36, Museo di San Marco, Florence

108 Overleaf, right
Fra Angelico and Assistant,
*Crucifixion with Mourners and
Saints Dominic and Thomas Aquinas*,
c.1441–2
Fresco; 213 × 165 cm (83⅞ × 64 in)
Cell 37, Museo di San Marco, Florence

was depicted against a sombre dark background. It formed the setting for the Host, which was displayed in the niche for Cosimo's private veneration, and poignantly visualized Christ's sacrifice.

The *Adoration* had extraordinary resonance for Cosimo, a member of the prominent confraternity of the Magi. Its members, who included the wealthiest men of Florence, many of whom were Medici partisans, established a private oratory for their devotions within the complex of San Marco. Cosimo took part in the group's magnificent processions on Epiphany (6 January), when splendidly dressed members mimetically recreated the Magi's journey through the streets of Florence, which they imagined as the Holy Land. Their destination was San Marco, in front of which a manger was placed to receive their offerings. Cosimo's participation in this sacred and civic ritual, one of the most important in the liturgical calendar, displayed his power and magnanimity for all of Florence to see. Through his generosity to the Dominicans, Cosimo continued the tradition established by the Magi in their giving of precious gifts to Christ. The portrayal of the kings from the East may also have evoked recent memories of the Council of Florence, when hundreds of potentates and priests from the Eastern Church thronged the city's streets. The exotic headgear, patterned gowns and rare presents, including the gold armillary sphere proffered by one of the men, recalled these magnificent delegations, whose expenses had been administered through the Medici bank.

By the time the *Adoration of the Magi* was painted, both the church of San Marco and its munificent patron were associated inextricably with the feast of Epiphany and the Magi's cult. So it was that Pope Eugenius himself reconsecrated San Marco in a spectacular ceremony attended by the entire College of Cardinals as well as bishops, civic dignitaries and the general populace on 6 January 1443. In the presence of them all, the pontiff expanded the church's dedication to include Cosmas and Damian. To commemorate this solemn occasion, he issued indulgences to those who took part in the confraternity's Epiphany processions and to worshippers at the church. As Fra Giuliano Lapaccini recorded in the convent's chronicle, that night, the pope slept in Cosimo's cell, honouring the friars with his holy presence.

Around the time of the reconsecration, Angelico executed his last image for San Marco. The *Madonna of the Shadows* was painted in the friars' corridor outside of the prior's cell, where the brethren gathered to pray before descending to the church to recite morning prayers (111). The *Madonna of the Shadows* is distinguished from the other works in the convent because of its technique. After completing the fresco, Angelico repainted the image in tempera as if he were executing an altarpiece on panel. From the deep cinnabar of the exquisite cloth draping the Virgin's throne to the gold of the niche behind her, the rich colours of the mural replicate those of a tempera altarpiece, although passages, including the infant's gowns, have peeled away. The tempera also imparted greater texture, physicality and highlights to the figures and setting. The most remarkable illusion of all may be the simulated shadows, seemingly cast by the painted architecture, that have given the work its name.

The *Madonna of the Shadows* has been described as a reprise of the *San Marco Altarpiece* (see 84). It unites all of the figures in a single space, the classicizing architecture of which was inspired by that of the convent itself, and it portrays the saints paying homage to the Virgin. At the same time, it reveals significant differences. Angelico eschewed the rigorous Albertian perspective and garden setting of the altarpiece to accord with the evocative frescos in the cells of the friars and novices, to whom this image was addressed. He omitted the angels, and the saints stand in an arc

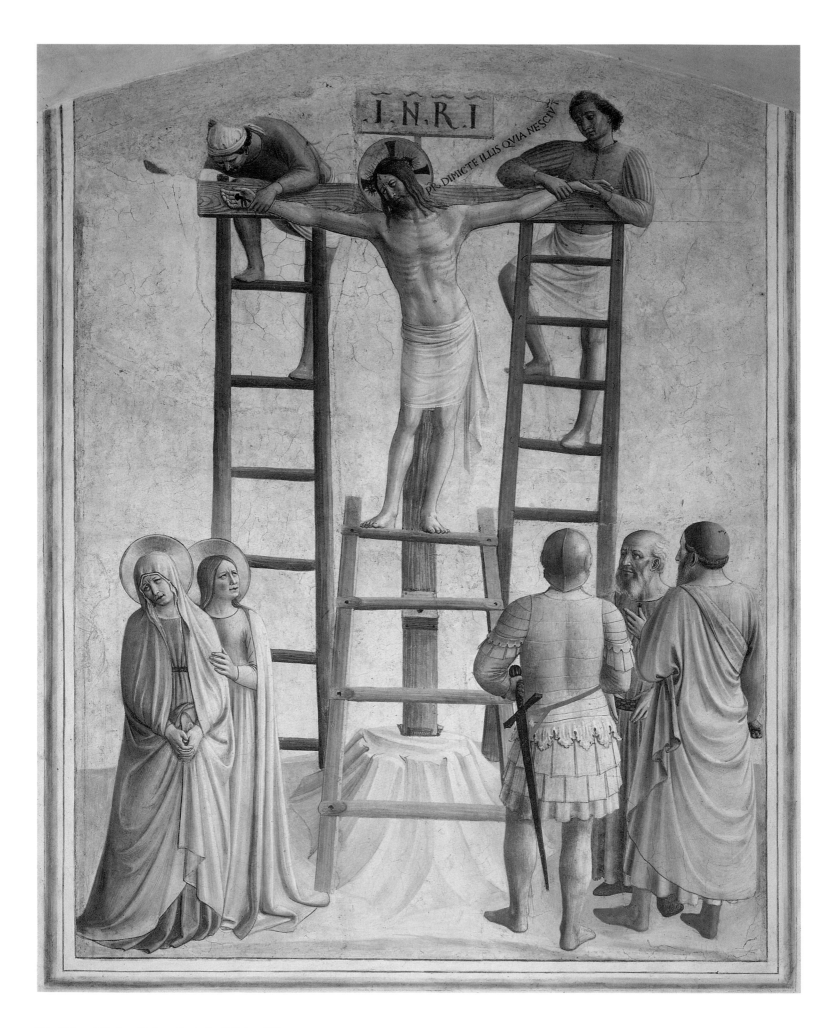

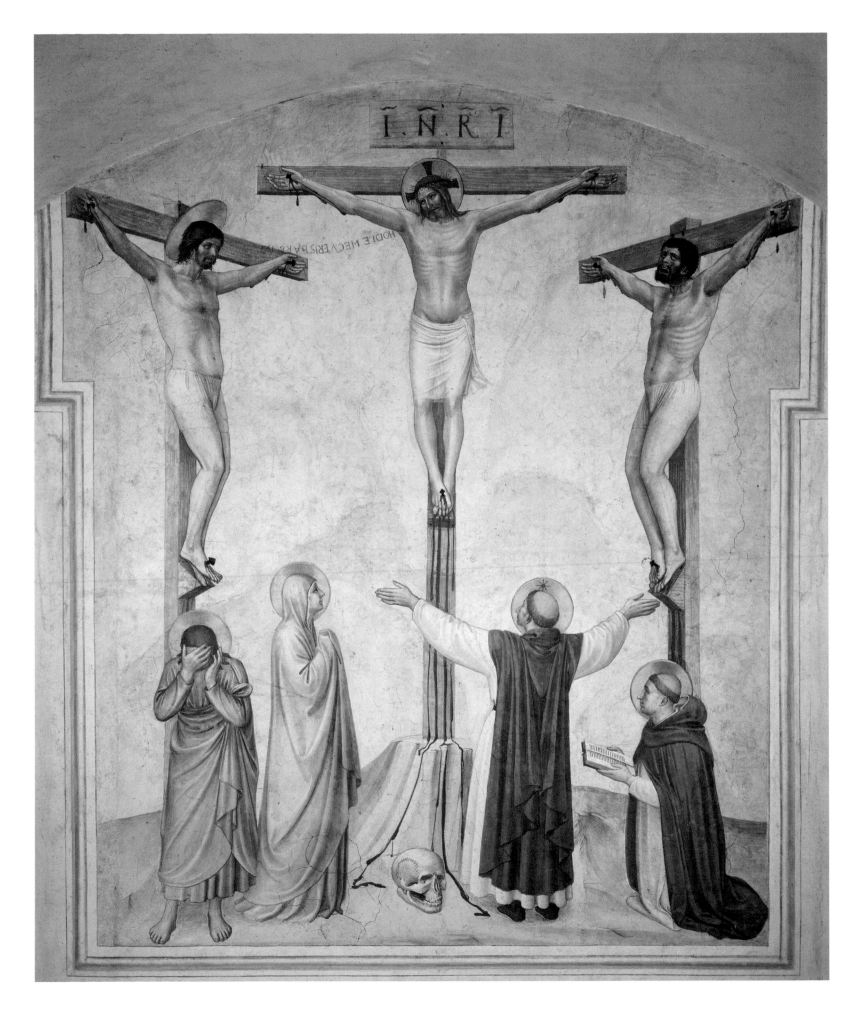

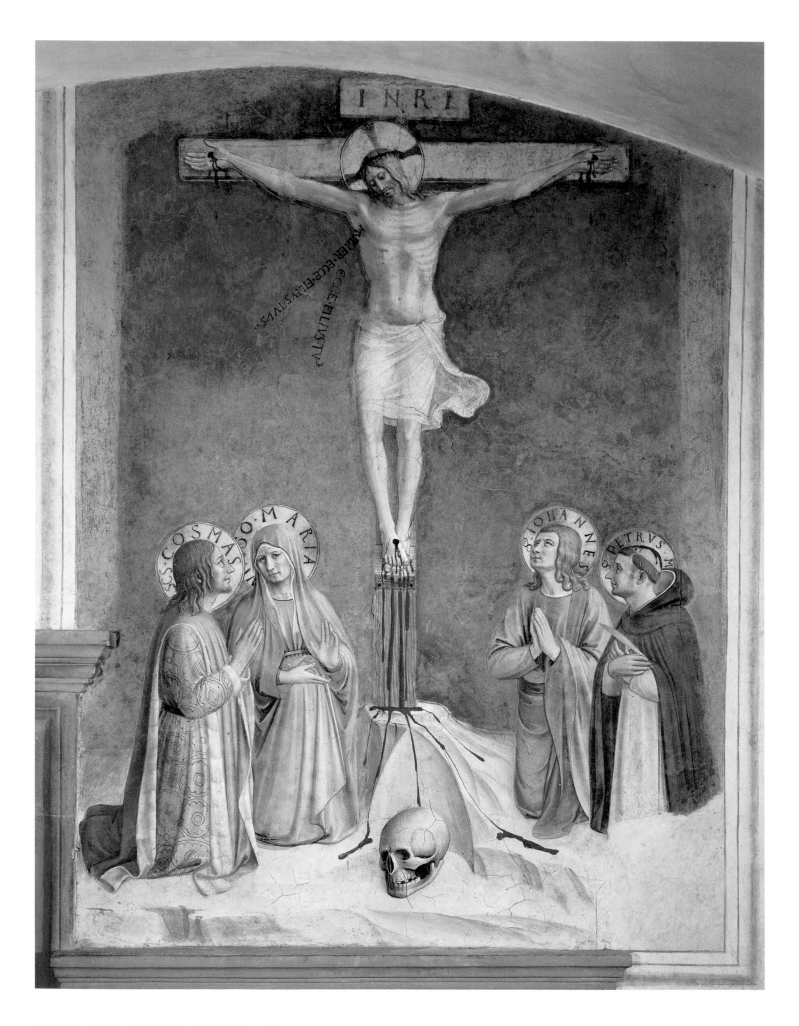

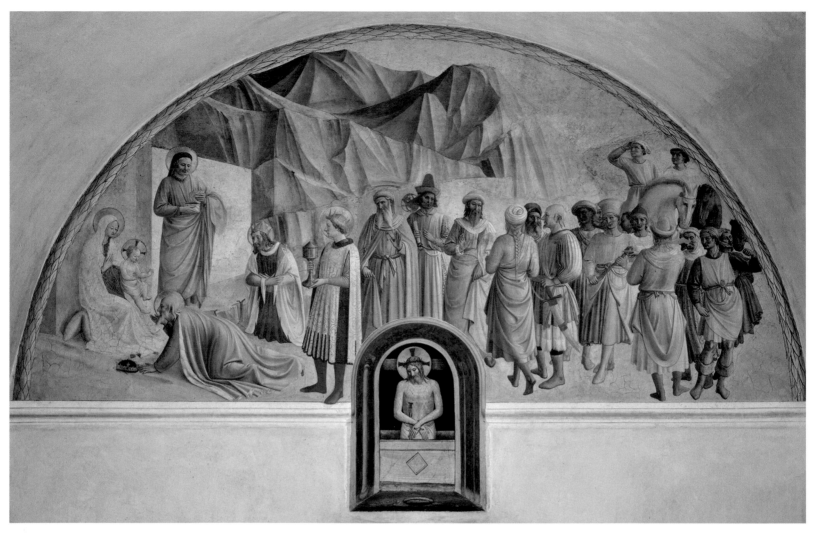

110
Benozzo Gozzoli and Assistant of
Fra Angelico, *Adoration of the Magi*
and *Man of Sorrows*, c.1441–2
Fresco; 175 × 357 cm (68⅞ × 140½ in)
and 86 × 60 cm (33⅞ × 23⅝ in)
Cell 39, Museo di San Marco, Florence

109 Opposite
Fra Angelico and Assistant,
*Crucifixion with the Virgin and
Saints Cosmas, John the Evangelist
and Peter Martyr*, c.1441–2
Fresco; 152 × 112 cm (59⅞ × 44 in)
Cell 38, Museo di San Marco, Florence

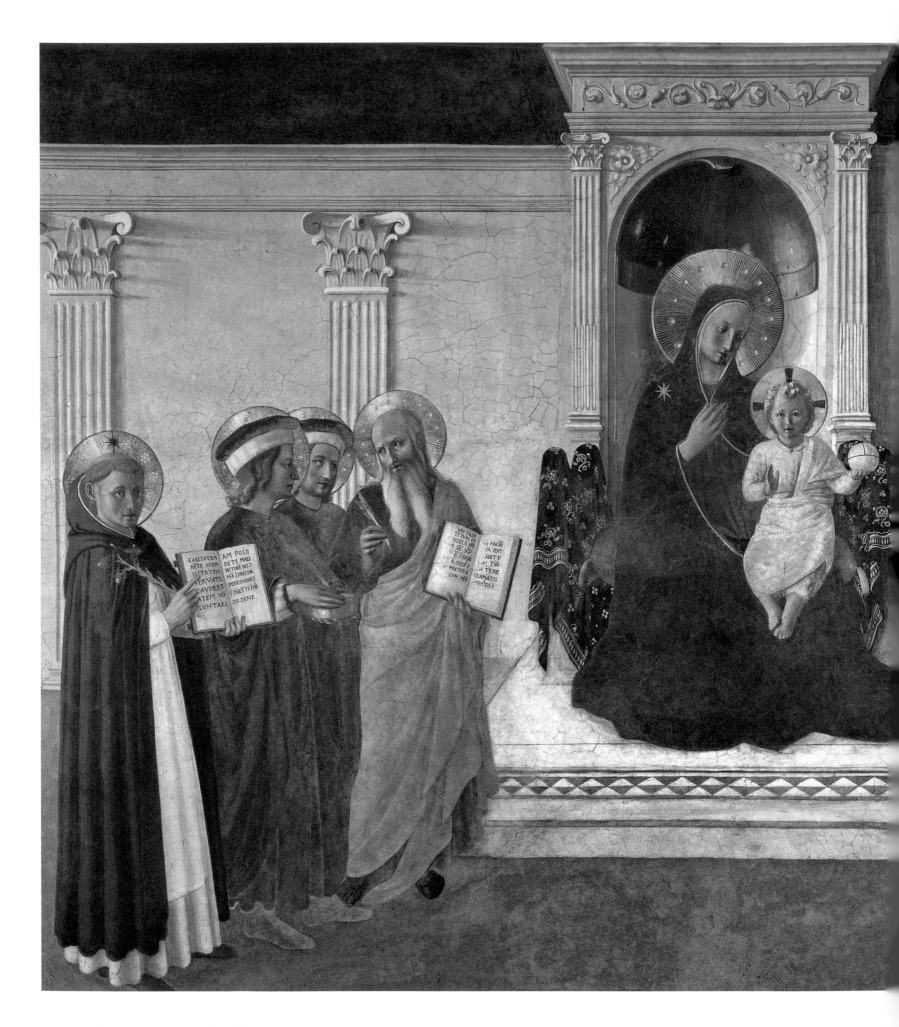

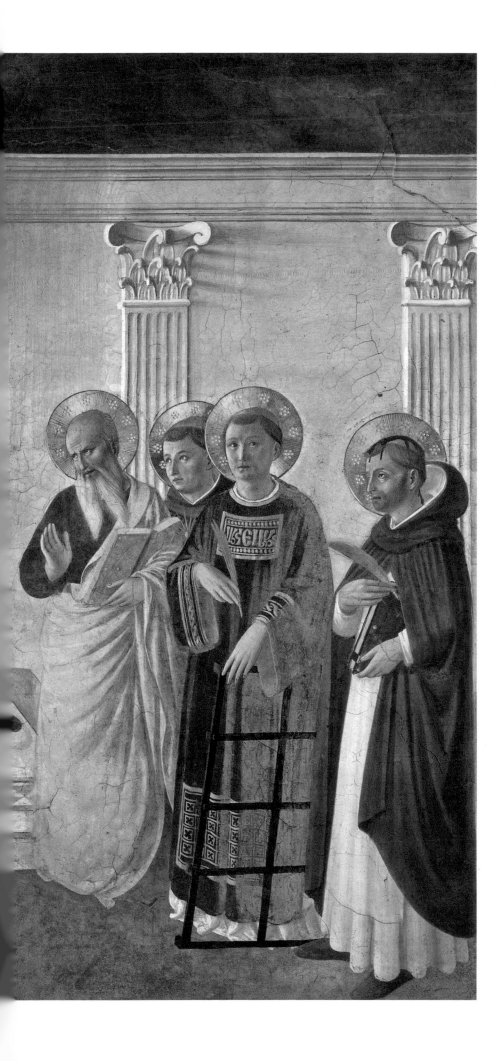

111
Madonna of the Shadows, c.1443
Fresco and tempera; 195 × 273 cm
(76¾ × 107½ in)
East Corridor, Museo di San Marco,
Florence

that radiates from the Virgin's throne. While Mary lowers her eyes as she presents her son, Saint Dominic engages the beholder's gaze, directing it to his book. The text, which has no known source in his writings, is an exhortation to the friars: 'Have charity, preserve humility, possess voluntary poverty. I call forth God's curse and mine on the introduction of possessions into this Order.' Balanced by Peter Martyr, Dominic stands at a distance from Saint Mark, as well as from Saints Cosmas and Damian, to whom the convent was jointly dedicated. His admonition, which seems explicitly addressed to the community of friars, seems not to have been heeded.

When Pope Eugenius IV ceded San Marco to the Observant Dominicans of Fiesole in 1436, he imagined the creation of an ideal religious community in the heart of Florence. While the wealth of the Medici permitted the convent's renovation and embellishment, it also compromised the humility and poverty that Saint Dominic demanded of his followers. Within years of its foundation, the sons of Florence's wealthiest citizens had entered San Marco, their expenses covered by Cosimo's generosity. Angelico himself knew of their escalating expenditures, for in 1443, he served as the convent's bursar. In 1444, the newly constructed library of San Marco was opened to the public as well as the friars. It housed 400 books, many from Cosimo's own collection, and included classical texts as well as sacred ones. It was located in the dormitory, where the corridors of the friars and the lay brethren intersected. Visitors to the library brought the religious community in contact with the outside world, compromising the solitude and silence required for the friars' contemplation. Although Antoninus later justified the magnificence of the convent as an appropriate complement to the city's grandeur, it accorded poorly with Observant ideals. Tension increased between San Marco and San Domenico di Fiesole, where the friars had always embraced the vow of poverty.

In July 1445, the community of San Marco was officially separated from San Domenico, bringing to an end nearly a decade of shared governance. Each convent now would have its own prior and administration. The agreement recording this crucial event was witnessed by Antoninus, vicar of the Observant reform and prior of San Marco, as well as by Angelico. Identifying himself as 'Fra Giovanni of Florence', the artist 'agreed with everything written above, in testimony of which' he inscribed his 'own signature'. He soon left Florence for Fiesole, where he seems to have painted his final work for San Domenico. The fresco (now detached) was located at the top of the stairs leading to the dormitory (112). It portrays the Virgin and Child flanked by Saints Dominic and Thomas Aquinas, on whose book the opening words of his inaugural lecture as doctor of theology are written, reprising the inscription of the church's high altarpiece (see 33). The Virgin and infant are so similar in proportion and appearance to those of the *Madonna of the Shadows* as to suggest that Angelico may have employed the same drawing, although the fresco for San Domenico was imagined against a cerulean sky instead of the architecture of San Marco. Significantly, Angelico included only the Order's founder and its greatest scholar as intermediaries for the friars' prayers, in contrast to the *Madonna of the Shadows*, with its gathering of Medici patron saints. The austerity of Angelico's portrayal is suggestive of the irreconcilable difference between the two convents that led to their separation. Although Angelico evidently returned to San Domenico, where his brother had become prior in 1445, he did not stay long. Eugenius IV, who had departed from Florence after rededicating San Marco, summoned him to Rome in late 1445 or early 1446. In obedience to the pontiff, Angelico left Fiesole for the Eternal City, where he embarked on another crucial phase in his career.

112
Madonna and Child with Saints Dominic and Thomas Aquinas, c.1445
Fresco (detached and tranferred to canvas); 196 × 187 cm (77⅛ × 73⅝ in)
Hermitage, St Petersburg

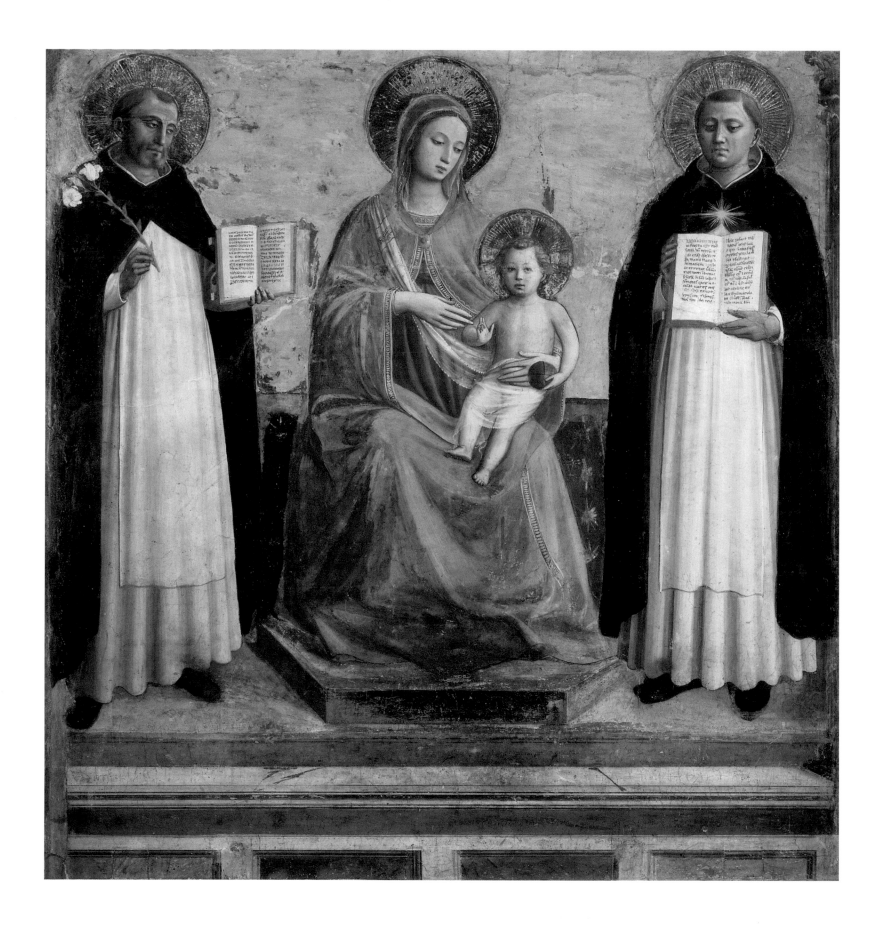

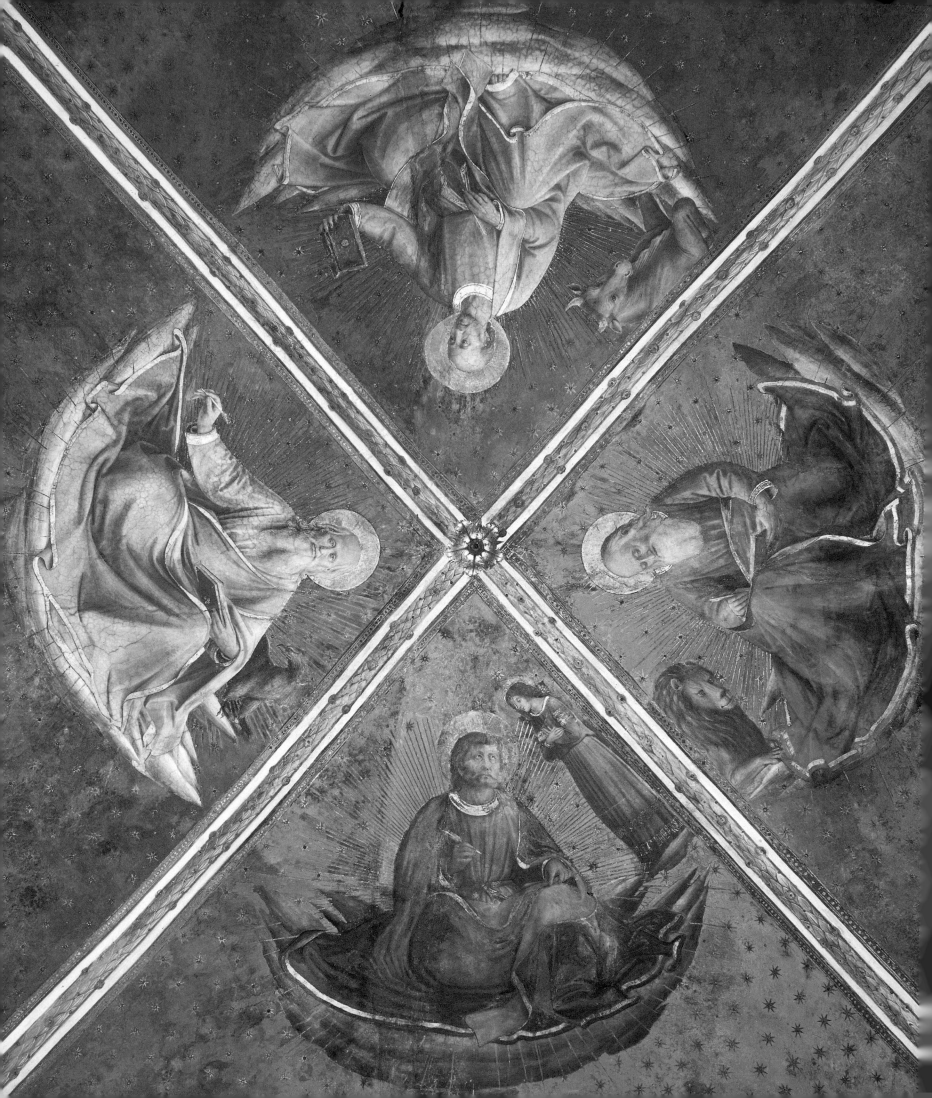

6
Famous Beyond All Other
Italian Painters
Angelico in Rome and Orvieto

On 24 September 1443, Pope Eugenius IV and his court returned to Rome after nearly a decade of exile in Florence. As the procession made its way to St Peter's, the aging pontiff traversed a city of squalor and poverty, where muddy streets were strewn with refuse and the offal discarded by butchers, fishmongers and tanners. Animals wandered the streets where peddlers hawked their goods. The city's abandoned monuments, both pagan and Christian, had fallen into ruin or been plundered for building materials. The area around the church of St Peter was so dilapidated and crime-ridden that pilgrims to the Holy City feared to visit the basilica. Part of the roof had even fallen in, exposing Peter's tomb to the elements. The humanist historian, Vespasiano da Bisticci, lamented that in the absence of the pope, 'Rome had become a land of cow herds', with cattle grazing among the ruined buildings of the Forum.

The desolation that Eugenius found in the Eternal City had been long in the making. Conflict between Church and State was virtually incessant throughout the Middle Ages, involving all of Europe and focusing on Rome. Violence and vendetta besieged the ravaged city, from which popes were often kidnapped, imprisoned or forced to flee for their lives. During the Great Schism (1309–1417), the supremacy of the pope as Vicar of Christ was challenged (see Chapters One and Two). At times, as many as three popes, each representing diverse political factions, ruled simultaneously from different locales. After more than a century of discord, the Great Schism came to an end with the election of Pope Martin V. He established civic order and began to restore monuments that had fallen into ruins due to neglect, looting and political disorder. He recommenced the tradition of artistic patronage established by his predecessors by ordering the embellishment of the city's most venerable churches, calling upon such esteemed masters as Gentile da Fabriano, Donatello, Masaccio and Masolino (see Chapter Two).

One of Pope Martin's most important commissions was the magnificent *Santa Maria Maggiore Polyptych*. Masaccio and Masolino painted this double-sided altarpiece for Santa Maria Maggiore, a major pilgrimage church where the popes celebrated Christmas Mass. The central panel portrayed the miraculous snowfall on 5 August 352 that covered the Esquiline Hill, indicating to Pope Liberius where and in what form the church should be built (113). Masolino portrayed Pope Martin in the guise of Liberius and represented many monuments in the background that the pontiff himself had restored. The composition recalls the late thirteenth-century mosaic on the church's façade commemorating this event, placing this work within the continuity of the site's distinguished visual legacy. The *Santa Maria Maggiore Polyptych* re-established the tradition of papal patronage that Martin's immediate successors, Eugenius IV and Nicholas V, were determined to follow. Their commissions would celebrate the antiquity of Rome, the history of the Church and the divinely ordained supremacy of the papacy. This was the legacy that Martin left to Eugenius, who summoned Angelico to Rome about two years after his own arrival in 1443.

Eugenius brought renowned humanists and artists to his court. The learned Poggio Bracciolini (1380–1459) explored the

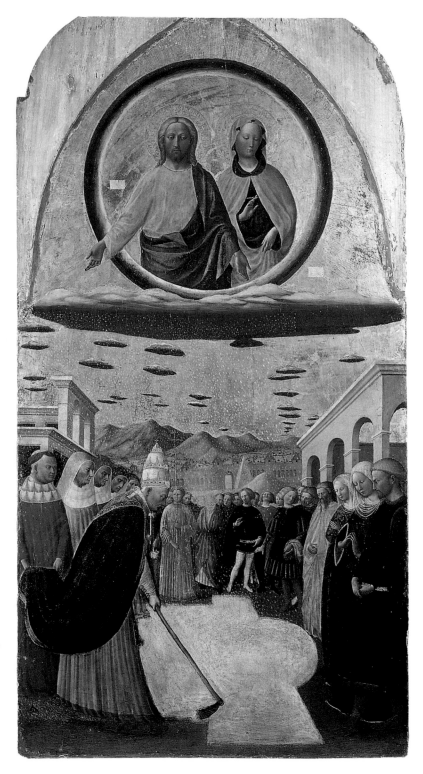

archaeology of Rome, writing a treatise on its history, pagan monuments and the sacred places that confirmed its links to the Christian past. Flavio Biondo (1388–1463) composed *Rome Restored* (*c.*1445), a guide to ancient and Christian sites within and beyond the city walls. He focused on those associated with martyrdom, for he believed that the blood of martyrs had sanctified Rome as the true locus of Christendom. At Eugenius's command, architects restored bridges and the most venerable basilicas, especially St Peter's. To embellish its entrance, the sculptor and architect Antonio Averlino, known as Filarete (*c.*1400–69), cast bronze doors depicting Christ and the Virgin as well as Saint Paul and Saint Peter, from whom Eugenius was shown receiving the keys symbolic of papal power (114). Jean Fouquet (*c.*1420–77), painter to the king of France, travelled to the Eternal City to paint a portrait (now lost) of Eugenius and two prelates, which was acclaimed by Filarete for seeming 'truly as if they were alive'. By late 1445, Angelico had joined their distinguished company. After almost a decade of exile in Florence, the pontiff knew his works well. Among the many artists and architects summoned to the Eternal City, the friar was praised as 'famous beyond all other Italian painters'.

Angelico's years in Rome were extraordinarily prolific. Before he returned to Fiesole by June 1450, the friar had completed four fresco cycles in Rome and had begun the decoration of the New Chapel (now known as the Chapel of San Brizio) in Orvieto Cathedral. His Roman commissions included a chapel in the Vatican Palace and frescos in the apse of St Peter's for Eugenius IV as well as a chapel and study for Nicholas V in the Vatican Palace. Except for the Chapel of Nicholas V, all of his Roman works fell victim to changing tastes and were destroyed in later renovations. In Orvieto, he frescoed two quadrants of a vault in the New Chapel before abandoning the commission when his clients proved insolvent. Such extensive activity was due in part to the efficient organization of his workshop, which had expanded to include four artists by May 1447. Benozzo Gozzoli was foremost among them, receiving seven times more money than the others and illuminating manuscripts for each of the popes. At the same time, his pay represented but a fraction of Angelico's salary in Rome, which totalled 200 ducats annually with a supplement of twenty-two florins monthly. Although Benozzo's importance within the shop increased during these years, Angelico was responsible for securing and directing all of the commissions.

The precise date of Angelico's arrival in the Eternal City is unknown. The friar was living in Rome prior to 10 January 1446, when Eugenius appointed Antoninus as archbishop of Florence. Elderly witnesses at Antoninus's canonization hearings (1516–20) declared that the pontiff had consulted 'a pious man' before nominating Antoninus. One witness identified the 'pious man' as 'Fra Giovanni [Angelico], the painter who was painting in the chapel of the Pope'. Their testimony, which Vasari elaborated to suggest that the pontiff first had chosen Angelico as archbishop, reveals Eugenius's great respect for the friar's opinion. It also indicates that even before Antoninus became archbishop, Angelico had moved to Rome to begin work on the chapel for Eugenius.

114
Antonio Averlino (known as Filarete), *Saint Paul and Saint Peter Giving the Keys to Pope Eugenius IV*, from Doors of Old St Peter's, inscribed and dated 1445
Silver gilt bronze; 630 × 358 cm (248 × 141 in)
St Peter's, Vatican, Rome

113 Opposite
Masolino, *The Foundation of Santa Maria Maggiore*, central panel of *Santa Maria Maggiore Polyptych*, *c.*1427–8
Tempera and gold on panel; 144 × 76 cm (56⅝ × 30 in)
Museo Nazionale di Capodimonte, Naples

Previous page
Detail from *Evangelists* and *Four Saints* (126)

115
Donatello, *Tabernacle of the Sacrament*,
1445
Marble; 225 × 120 cm (88½ × 47¼ in)
St Peter's, Vatican, Rome

The 'chapel of the Pope', also described as the 'little chapel', was located on the second floor of the Vatican Palace. It was destroyed by Pope Paul III (reigned 1534–49) to build the Pauline Chapel (painted by Michelangelo in 1542–50). Vasari identified the subject of its frescos as 'stories from the life of Jesus Christ', according well with the chapel's sacramental function, and noted that it included 'many portraits from life' of esteemed contemporaries, including the pope himself. Of the chapel's original embellishments, only the marble *Tabernacle of the Sacrament* by Donatello survives (115). Reverent angels gaze and gesture fervently towards the niche (now filled with an image of the Virgin and Child) that once held the Host for veneration. Above the pediment, the tragic *Entombment of Christ* with its grief-stricken mourners magnified the Eucharistic theme of the now-lost frescos.

A beautiful drawing attributed to Angelico may be associated with one of the lost scenes (116). The drawing, made on pink tinted paper, was executed in pen and wash with intense bistre (white) highlights on the drapery of the figures. The luminous, deep folds of the men's mantles, so sculptural in their reflection of light, may indicate the artist's response to the *Tabernacle of the Sacrament*. Although the subject of the drawing has been identified as Christ sending forth the Apostles to preach, this seems unlikely. The composition suggests instead that it represented the Institution of the Eucharist, a subject in keeping with the chapel's function. Holding the Host in his right hand with his left hand extended, Christ gazes down at the Apostles who kneel in reverence at his feet, their faces uplifted and hands clasped in prayer. Two other Apostles stand behind them at a distance, awaiting Communion. Their faces are averted, but their bodies turn toward him, conveying their yearning.

The complexity of the scene's architectural setting may be surmised from the perspective study on the back of the drawing, in which intersecting diagonal lines record Angelico's continued engagement with constructing space convincingly. As for the setting, it conceivably might have resembled the austere architecture that serves as a backdrop to the solemn *Institution of the Eucharist* (see 106) in Cell 35 of San Marco.

The chapel had only recently been completed when the aged pontiff passed away on 23 February 1447. A member of the papal court solemnly recorded that the body of Eugenius, who 'had died in the Palace of St Peter', was taken from his room 'to the newly painted little chapel' before being brought for public viewing to the basilica of St Peter's. In paying homage to the dead pontiff, mourners passed the frescos that Angelico had been painting in the apse, but neither their subject nor how advanced they were at the time of the pope's death is documented.

Within days of Eugenius's passing, the College of Cardinals chose Tommaso Parentucelli (reigned 1447–55) as the pope's successor. Although the new pontiff had only recently been elected a cardinal, he had completed diplomatic missions for Eugenius in Italy and Germany. Taking the name of Nicholas V, he inaugurated a new era in the history of the papacy. Nicholas was a humanist who dedicated himself to promoting learning, greatly expanding the holdings of the Vatican Library with classical and theological

116
Attributed to Fra Angelico, *Institution
of the Eucharist, c.*1445–6
Pen and wash with bistre highlights
on pink tinted paper; 13.5 × 17.9 cm
(5¼ × 7 in)
His de la Salle Collection, No. 47r,
Musée du Louvre, Paris

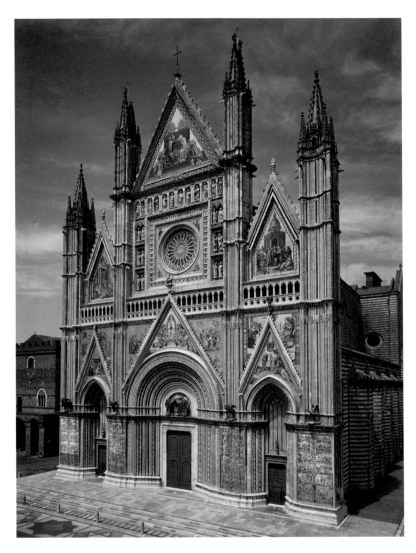

117
Lorenzo Maitani, façade of Orvieto
Cathedral, begun 1370
Orvieto

texts. He reformed and unified the Church, subduing dissent and returning authority to the papal office. As the first pontiff to reside continuously in Rome since the Great Schism, Nicholas devoted himself to the city's restoration. To make it more habitable, he repaired ruined aqueducts, bridges and dwellings. He widened streets and shored up the protective walls that surrounded Rome, which were built by Emperor Aurelius (reigned 270–5). He planned to restore the Borgo, the medieval area around St Peter's and the Vatican Palace, to create a majestic setting 'in honour of Saint Peter' and the basilica that enshrined his relics, although these plans were never realized. Above all, Nicholas devoted himself to recalling the Church's venerable past by reviving the cult of saints and martyrs. He refurbished their churches, celebrated their feasts with new hymns and commissioned new histories of their lives.

As had his venerable predecessors, Nicholas recognized the importance of art in defining the spiritual ideology of his papacy. Like Eugenius, he chose Angelico to execute two important commissions: his private chapel and his study in the Vatican Palace. Neither work was initiated immediately upon his election. Angelico was still completing the frescos in the apse of St Peter's, destroyed when the church was enlarged in the early sixteenth century. The pope's immediate concern was securing the support of the Roman nobility, negotiating a treaty with Germany and resolving pressing matters that Eugenius had left unfinished at his death. That summer, Nicholas gave the friar permission to leave Rome. By early June, Angelico had departed for Orvieto, where he began painting the New Chapel in the Cathedral.

Located 121 kilometres (75 miles) north of Rome. Orvieto had long been associated with the papacy and the Dominican Order. It was one of the most important strongholds of the Papal States, the vast territories owned and ruled by the pope. Its proximity to Rome and elevated location provided refuge to the papal court in times of war and pestilence. In the early thirteenth century, Pope Gregory IX (reigned 1227–41) established in Orvieto a Dominican *studium generale* (house of theological study), one of the first in Europe, to defend orthodox belief against heresy. The prominence of the city escalated dramatically in 1263, when Pope Urban IV (reigned 1261–4) endowed it with a most precious relic: a corporal marked with the blood of Christ that miraculously had flowed from the Host during the celebration of Mass. (A corporal is the cloth veiling the consecrated Host during Communion.) This proof of Jesus's actual presence in the Eucharist occurred at the height of the controversy over transubstantiation, a belief challenged by heretics but adamantly defended by the Dominicans. To commemorate this miracle, Urban instituted the feast of Corpus Domini in 1264. Promulgating the Bull from Orvieto, he charged Saint Thomas Aquinas to write the liturgy and hymns for the feast. This great honour further strengthened the affiliation between the papacy, the city and the Dominican Order.

To enshrine the sacred relic, the populace immediately began to erect a magnificent Cathedral (117). Over the next two centuries, such eminent artists as Lorenzo Maitani, Andrea Pisano, Andrea Orcagna and Gentile da Fabriano as well as local masters

participated in its construction and ornamentation. They adorned it with sculpture and stained glass, embellishing the lofty walls with frescos. In the mid-fourteenth century, scenes from the Passion of Christ and the history of the miraculous corporal were painted in the Chapel of the Sacred Corporal, located in the north transept, which was specially constructed to house the relic (118). Angelico was soon to join the company of these artists. On 10 May 1446, the magistrates of the Cathedral proposed to invite 'the greatly esteemed master painter' from the 'Order of Preachers' to fresco the 'New Chapel', built two years earlier to display the relics of the city's patron saints. The 'master painter' was Angelico.

The chapel was dedicated to the Assumption of the Virgin, a feast second in importance in Orvieto to only that of Corpus Domini. It was located in the south transept directly opposite the Chapel of the Sacred Corporal, and enshrined the relics of the city's most honoured saints (119). On 11 May 1447, the magistrates of the Cathedral convened to discuss the commission at length. They agreed to hire the friar, whom they described as 'famous beyond all other Italian painters', and proposed that he come in June, July and August of 'every year until he finished all the work'. His salary was to total the prestigious sum of 200 gold ducats, with the magistrates providing his board as well as the necessary scaffolding and materials. On 2 June, the magistrates met in anticipation of Angelico's arrival before the feast of Corpus Domini (8 June). After considerable discussion, they resolved to seek the friar's 'advice' of 'what should be painted'. From the very beginning, Angelico was personally involved in selecting the chapel's theme. The final contract was issued on 14 June in his presence, and the working period was extended to include September. The magistrates agreed to pay seven ducats a month to Benozzo, who was described as Angelico's 'associate', and one ducat to each of his three apprentices. 'Beautiful and praiseworthy' figures, as well as speedy execution, were paramount to the magistrates. They pressed Angelico to start the very next day, asking him to prepare 'drawings of the paintings and figures'. Three days later, they placed a special order for an exceptionally large sheet of paper so that he could plan the chapel's decoration.

Numerous documents chart the progress of the commission through the course of Angelico's stay. Account ledgers include payments for all manner of expenses, from the cost of food and travel to expenditures for plaster, paper and pigments. They record the erection of scaffolding, begun the day after the contract was signed, as well as the pittance for burying the unfortunate worker who fell from its height on 25 June. They trace delays in obtaining pigments, which had to be fetched from Florence and Rome. The walls were not completely plastered until late July, further postponing execution. To expedite work, the magistrates hired a local painter, Pietro di Nicola. Some pigments were not purchased until late August. A month later, the friar closed his accounts with the magistrates, having frescoed the *Judging Christ with Angels* and the *Prophets* in two quadrants of the vault. While Pietro di Nicola continued to work in the chapel for another year, 'painting and flowering' the ribs, which he adorned with ornate friezes, Angelico never returned to the city.

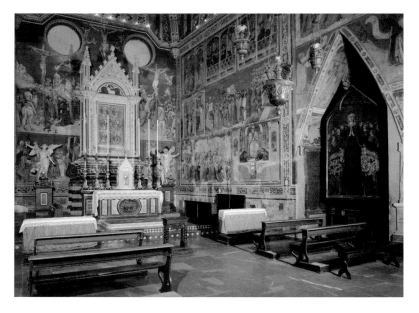

118
Chapel of the Sacred Corporal with frescos by Ugolino di Prete Ilario, Orvieto Cathedral, mid-fourteenth century
Orvieto

119 Overleaf
New Chapel (now known as the Chapel of San Brizio), begun by Fra Angelico assisted by Benozzo Gozzoli in 1447 and completed by Luca Signorelli in 1499–1504
Fresco
Orvieto Cathedral, Orvieto

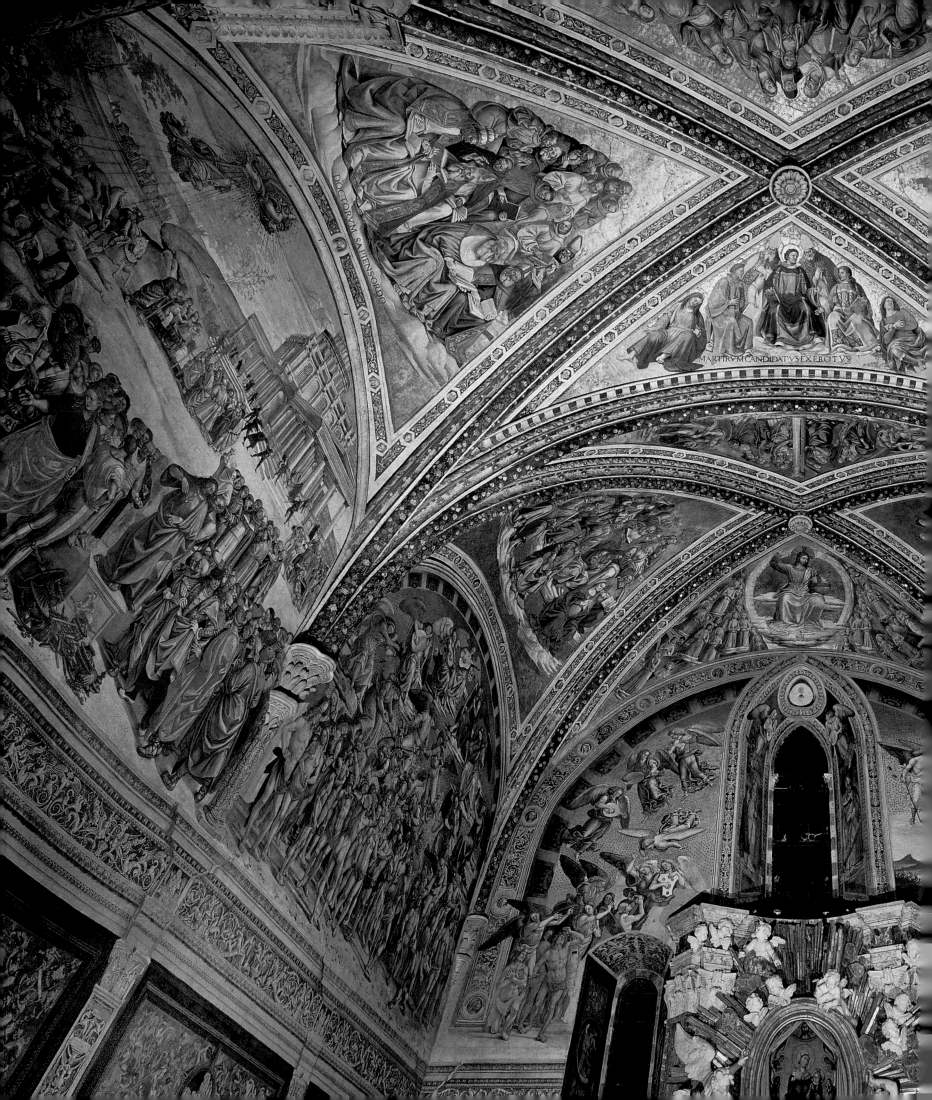

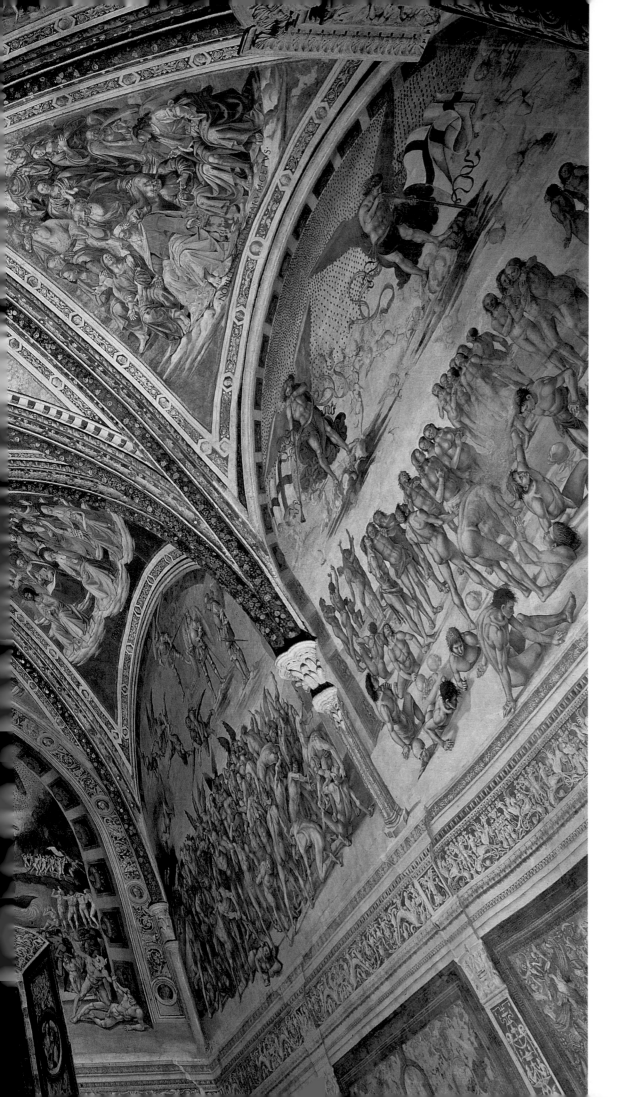

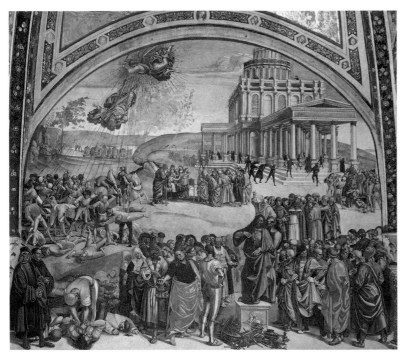

120
Luca Signorelli, *Preaching and Rule of the Antichrist with Self-Portrait and Portrait of Fra Angelico*, 1499–1504
Fresco
Chapel of San Brizio, Orvieto
Cathedral, Orvieto

Contrary to what has been claimed, the friar did not violate his contract in leaving the chapel unfinished. In truth, the magistrates had run out of money. On 11 May 1449 – nearly two years after Angelico's departure from Orvieto – they conceded that they could afford to pay his salary for only three months. Although Pietro di Nicola asked to replace the master at that time, they refused him. Beauty was more important than cost, the magistrates asserted, perhaps hoping for a change in their fortunes. In July, Benozzo Gozzoli, who had since left Angelico's employ, also tried to secure the commission for himself, but failed. The magistrates' meagre resources and political unrest in Orvieto conspired against the timely completion of the frescos, as did the magistrates' futile wish that the friar might return. It was not until 1499 when finally Luca Signorelli (*c.*1445–1523) was hired to complete the chapel. As his contract stipulated, he was required to follow the drawings for 'half of the New Chapel' that Angelico had prepared more than fifty years earlier. Acknowledging his predecessor's crucial role in the chapel's genesis, Signorelli portrayed the friar standing beside him in the *Preaching and Rule of the Antichrist* at the entrance (120, see 4).

The quadrants of the *Judging Christ with Angels* and the *Prophets* indicate that Angelico had chosen the Last Judgement theme from the beginning. The friar had interpreted this subject in the *Last Judgement* for Santa Maria degli Angeli in the early 1430s (see 57), but planning an entire cycle on so vast a scale and for so crucial a site presented unique challenges. Rising almost 14 metres (46 feet) from the floor, the lofty vault required Angelico to foreshorten and paint figures on a monumental scale that was unprecedented in his work. The friar elevated Christ to the vault directly above the altar, simultaneously conveying Jesus's omnipotence as Judge and his presence in the Eucharist (121). These complementary associations were proclaimed in the Gospels and repeated in the liturgy, when Jesus promised eternal life following the 'last day' to him 'who eats my flesh and drinks my blood' (John 6:54). Given the chapel's proximity to the miraculous corporal in the north transept, this image would have seemed especially resonant for the faithful in Orvieto.

In the centre of the quadrant above the altar, Jesus proffers the globe of the universe as he raises his right hand to summon the dead from their graves. Seated upon banks of clouds against a golden ground, he radiates a gilded aureole of light, the scintillating rays of which illuminate the faces and garments of the seraphim surrounding him. These ethereal beings are diverse in appearance and expression. Their wings and gowns vary in colour, ranging from pale rose and scarlet to deep green and azure, and they rhythmically kneel or stand upon clouds. While some clasp their hands in prayer and gaze towards Jesus, others solemnly lower their heads in reflection. Angelico composed the seraphim to conform to the curving walls of the vault. From the trumpeting angels at the lower corners to the seraphim near the upper apex of the vault, they diminish in height and scale, enhancing the illusion of their distance from the beholder.

In the adjacent quadrant, Angelico portrayed Old Testament prophets whose writings, it was believed, foretold the coming of

Christ (122). To accord with centuries of tradition, Angelico placed them to Christ's left. Like Christ, they are painted against a golden ground and suspended on clouds, their garments radiant with the reflected light of his glory. Angelico varied their ages, appearance and attributes, conveying the personality of each man, from the introspective King David, fingering his harp as he composes his psalms, to Moses, his face and azure mantle glowing with the light of God. The tablets held by Moses are inscribed with the first of the Ten Commandments in Hebrew: 'Thou shall have no other gods before me' was equally appropriate to the authority of Christ. The gilded vault is emblazoned with the words PROPHETARVM LAVDABILIS NVMERVS ('The company of prophets praises you'). This inscription was taken from the second verse of the ancient hymn, 'Te Deum laudamus' ('We praise you, O Lord'), which invokes Christ as 'King of Glory' and 'Judge' through the offering of his 'precious blood'. Portraying cherubim, seraphim, prophets, Apostles and martyrs as well as patriarchs and Doctors of the Church, Signorelli's adjacent vaults (see 119) also illustrate and quote words from the hymn, evidently fulfilling Angelico's original intentions for the chapel's programme. Elevated in the heavens, these holy figures evoke the eternal praises sung of God in the celestial court and chanted in the Cathedral during the celebration of Mass.

Completed in 1996, restoration of the chapel consolidated weakened plaster and removed centuries of dirt and repainting. Transforming the appearance of the frescos, it also disclosed new technical information about the vaults and their execution. Colours that were once murky are now suffused with light, and subtle values are again evident. Angelico's brilliant tonalities are especially apparent in the faces and garments of the angels and prophets, which glow with the radiance cast by Christ. Minute filaments and lines of gold trace the folds of the prophets' drapery, translating the gilt striations of the venerable Byzantine tradition with subtlety. Tempera embellishes various colours and surfaces, enhancing their chromatic depth and providing detail. Angelico prepared cartoons to facilitate rapid execution of the figures by his shop. They were used extensively for the repetitive yet richly varied friezes of flowers, leaves, simulated stone and tiny heads that embellish the ribs of the vaults (see 122). Prior to the cleaning, qualitative differences between the figures were often ascribed to the condition of the frescos. As is now more evident than ever, they reveal the collaboration of his shop, and especially that of Benozzo.

The figure of Jesus epitomizes Angelico's style (see 121). Christ's body is expertly foreshortened to appear proportionate to those viewing it from below and his garments, particularly the cerulean blue mantle, are radiant with light that illuminates the angels closest to him. The contours of his features are delineated with a subtle range of colours and values, most luminous across his forehead and nose and darkest along the sides. Angelico painted each strand of the beard and moustache separately, so the texture is soft and wispy as distinguished from Christ's thick, wavy locks. The gilt halo is incised with finely drawn lines and its circumference is exactingly inscribed with circular punches. Flattened spheres of gilded plaster embellish the crimson cross that is painted within the halo. They reflect light while recalling late medieval images of Christ that were venerated in Orvieto.

Although Angelico executed the towering Jesus by himself, Benozzo painted several of the angels. Two seraphim near the bottom left of Christ's oval mandorla reveal the different styles of each artist. Angelico frescoed the angel whose gaze is devoutly lowered and whose golden locks flow softly around his solemn face. Partly covered by the quills of his gilded wings, the angel's pale scarlet gown is illuminated by the radiance surrounding Christ, the graduated values fading or intensifying according to their distance from him. Although closely related in appearance, the seraph beside him reveals another personality. His hair falls in lank curls close to his head and his features are less subtly modelled. His gown is rather uniform in colour and the shadows falling between the folds are emphasized, instead of the glowing surfaces, as in the drapery of Angelico's angel. Similar characteristics are seen in the pair of angels above. Benozzo painted the seraph closer to Jesus, as seen in his closely spaced features and tightly curled hair, while Angelico frescoed the other angel, as his luminously graduated drapery reveals. Both artists are likely to have worked together on the scaffolding, accounting for the uniformity of the angels' appearance throughout.

The *Prophets* similarly reveal the close collaboration between the painters, although Benozzo appears to have had a greater share in their execution. The prophets in the bottom two rows display Angelico's sensibility in the characterization of their distinctive features and personalities. Their expressive gestures are expertly foreshortened and their drapery is refulgent with light and voluminous, with deep, simplified folds. By contrast, the closely spaced, less refined features and limp hair of the five youthful prophets suggest Benozzo's execution. Benozzo may have completed the fresco as Angelico prepared the drawings for the adjacent vault, the sinoper for which was not obtained until 9 September. Indeed, this quadrant seems to have been executed in haste and without the same attention to detail seen in the *Judging Christ with Angels*. The haloes are flat, gold disks and lack the fine tooling and incision found in the halo of the *Judging Christ*. So, too, the borders and hemlines of their garments are simplified. At the end of the month, Angelico descended the scaffolding in the chapel for the last time. He left behind frescos of a mastery that no painter would match for more than half a century.

By October 1447, the friar had returned to Rome, where he was to paint his only surviving papal commission. This was the Chapel of Nicholas V in the Vatican Palace, for which gold and ultramarine pigments were acquired in February and March of 1448. The chapel commemorates Saint Lawrence (martyred in the year 258) and Saint Stephen (martyred in the year 34), to whom the pope was deeply devoted (123). As deacons (ministers) and preachers, both martyrs were especially venerated in Rome, where Lawrence was grilled alive for his steadfast faith in Christ. Although as many as twenty churches and chapels were dedicated to him in the city, his tomb was located outside the city walls in San Lorenzo fuori le mura, one of the five patriarchal basilicas in Rome. As recounted in the Acts of the Apostles, Stephen was stoned to death in distant

121
Fra Angelico assisted by
Benozzo Gozzoli, *Judging Christ
with Angels*, 1447
Fresco
Chapel of San Brizio, Orvieto
Cathedral, Orvieto

122 Opposite
Fra Angelico assisted by
Benozzo Gozzoli, *Prophets*, 1447
Fresco
Chapel of San Brizio, Orvieto
Cathedral, Orvieto

PROPHETARVMLAVDABILISNVMERVS

123
Fra Angelico assisted by Benozzo
Gozzoli, Chapel of Nicholas V
(facing the entrance), 1448
Vatican Palace, Rome

124
Frescos of the *Martyrdom of
Saint Stephen* and the *Martyrdom
of Saint Lawrence* in the Sancta
Sanctorum, 1277–80
Lateran Palace, Rome

125 Opposite
*Crucified Christ with the Virgin,
Saint John the Evangelist and
Cardinal Juan de Torquemada,*
*c.*1440–2
Tempera and gold on panel; 88 × 36 cm
(34⅝ × 14⅛ in)
Fogg Art Museum, Harvard University,
Cambridge MA

Jerusalem for his preaching of the 'God of glory' and his accusation that the Sanhedrin had killed 'the Righteous One'. In the year 425, Stephen's relics were translated to Lawrence's tomb in recognition of the saints' common apostolate as deacons and their devotion to Christ. From that point on, their lives were paralleled in sacred writings and ennobled in art.

Although Lawrence and Stephen were venerated throughout Rome, the popes accorded them particular honour. Their martyrdoms were frescoed in the private papal chapel known as the Sancta Sanctorum (Holy of Holies) in the Lateran Palace, the official residence of the popes through the end of the Great Schism (124). The chapel was commissioned by one of Nicholas's eponymous predecessors, Pope Nicholas III (reigned 1276–80). It preserved the miraculous, painted portrait of Christ, believed to have been completed by angels, and some of the most treasured relics from the Holy Land, including a coal from the fire that roasted Lawrence and drops of Stephen's blood. In devoting his own chapel to the lives of the two saints, Nicholas V reaffirmed the new locus of their cult and the residence of the popes in the Vatican Palace.

But shortly after Nicholas was elected, the Observant Franciscans challenged the authenticity of the relics in San Lorenzo fuori le mura. They claimed to have found the remains of the saints in Santa Maria in Aracoeli, their mother church in Rome, prompting Nicholas to order an inquest. After much investigation, a committee of the most distinguished theologians of the day concurred that the relics in San Lorenzo were indeed legitimate. Their ruling inspired even greater devotion to the saints. To promote their cult, Nicholas restored the church and their shared tomb with all due magnificence, commissioning hymns that exalted their devotion to Christ. He ensured the inclusion of their lives in a history of early Christian martyrs written by the humanist Antonio Agli (c.1400–77), a member of his court, who praised their 'every virtue and glory, full of grace and fortitude'. Most significantly, Nicholas commissioned the frescos that recounted their pious lives for his chapel. On the lower walls, fictive tapestries of crimson and gold hang from painted rings. Embellished with the crossed keys and tiara of Saint Peter, these sumptuous 'hangings' adorn the chapel for the papal and liturgical ceremonies that took place within its walls. The pontiff's name – NICOLAVS PP QUINTVS (Pope Nicholas V) – is inscribed four times in the marble floor to proclaim his patronage.

Although authorship of the chapel's programme has been little discussed, the esteemed Dominican Juan de Torquemada (1388–1468) may well have composed it. The frescos assert the primacy of the papacy as established through Scripture and portray the triumph of faith through the martyrdom of Saints Stephen and Lawrence. As the leading theologian at the papal court, Torquemada was appointed Master of the Sacred Palace in 1434. He was entrusted with selecting preachers and sermons to support orthodox belief on Church doctrine and papal authority, themes that his own writings specifically engaged. Of equal importance, he composed devotional treatises, including the *Meditationes* (*Meditations*), which recognized that images were crucial to spiritual enlightenment.

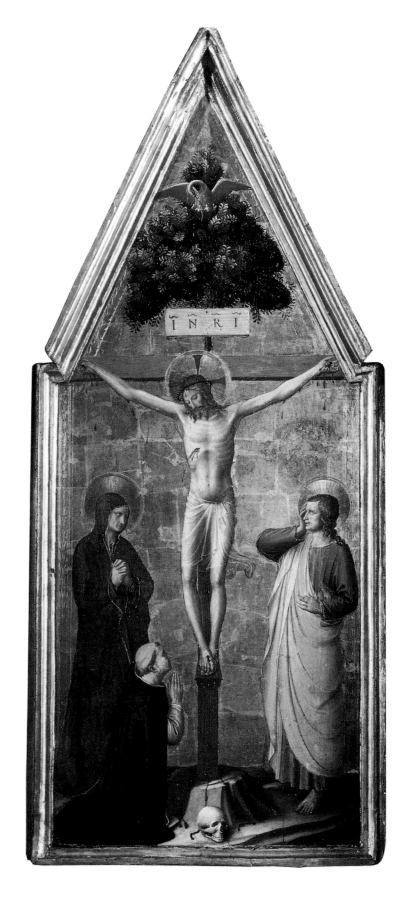

126
Fra Angelico assisted by Benozzo
Gozzoli, *Evangelists* and
Four Saints, 1448
Fresco
Chapel of Nicholas V, Vatican Palace,
Rome

It is certain that Angelico and Torquemada, as Dominicans at the papal court, knew each other. Their acquaintance may have dated to 1439, when Eugenius IV, still in Florence, appointed Torquemada cardinal and named him Defender of the Faith. Perhaps around this time, Torquemada commissioned from Angelico an exquisite devotional panel representing the crucified Christ with the Virgin and John the Evangelist (125). As has long been recognized, the Dominican friar kneeling at the foot of the cross against which his cardinal's hat rests is Torquemada, the only Dominican cardinal in the papal court. In subject and style, the painting corresponds to the Crucifixion frescos in San Marco, suggesting its probable execution while the convent's decoration was being completed.

It is likely that Torquemada influenced some of the themes in the Chapel of Nicholas V. The Evangelists, Church Fathers and prophets in the vaults, arches and embrasures of the windows signify the hierarchy of faith through divine revelation, a crucial theme in his thought (126). Their writings recounted, interpreted and foretold the life of Jesus, forming the basis of Christian biblical exegesis. In the vaults of the chapel, the Evangelists are suspended on clouds amid the starry blue heavens. Their luminous faces and pale garments seem suffused with incandescent light as they compose the Gospels of Christ's life. Saint Matthew is portrayed in the vault above the altar, where the pope celebrated Mass. He is given special prominence as he writes the divinely inspired words dictated by the angel beside him. Matthew (16:18–19) recounted how Christ recognized Peter (Petrus) as the 'rock' (petra) upon which he founded the Church and gave him 'the keys to the kingdom of heaven'. This established the doctrine of papal supremacy that Torquemada defended throughout these years, culminating in his treatise Summa de Ecclesia (Compendium regarding the Church) (1450–3), which he dedicated to Pope Nicholas.

Seven Fathers of the Church – the major theologians of the Latin and Greek Churches – are depicted on the underside of the arches of the north and south walls. Joining their distinguished company is Saint Thomas Aquinas, who was not a Church Father. His presence here signifies his importance to Torquemada and Angelico as well as to the pope. This staunch Dominican theologian was the patron saint of Nicholas (born Tommaso [Thomas] Parentucelli) and a resolute defender of papal authority. Saints Augustine, Jerome, John Chrysostom, Athanasius and Ambrose, who wrote eloquently of the martyrs' lives, are portrayed with two saints, Gregory the Great and Leo the Great, who were also popes. These esteemed papal saints were known for their writings on Church unity and the liturgy. Standing beneath nearly identical tabernacles, they are identified by inscription and distinguished by attribute, age and dress. They proffer or read their books, underscoring their importance as interpreters of Scripture, authors of liturgy and commentators on the lives of saints.

Hebrew patriarchs and prophets are represented in the embrasures of the chapel's two windows. Enclosed in rosettes, they inscribe or unfurl their scrolls in allusion to their authorship of sacred texts. Their faces glow radiantly against the golden background as if illuminated by the fulfillment of their prophecies. In the centre of one embrasure, Moses displays the Tablets of the Law (inscribed in Latin) that, in Christian thought, were superseded by Jesus's teachings. In the other, Abraham proffers his knife while presenting his son Isaac, foretelling the sacrifice of Christ. This Eucharistic theme was visualized in the now-lost altarpiece that adorned the south wall. Vasari described its subject as the Descent from the Cross and praised it among the chapel's 'most beautiful' embellishments. Nothing is known of its appearance.

127
Fra Angelico assisted by Benozzo Gozzoli, Ordination of Saint Lawrence, 1448
Fresco; 271 × 197 cm (106¾ × 77½ in)
Chapel of Nicholas V, Vatican Palace, Rome

128 Overleaf
Fra Angelico assisted by Benozzo Gozzoli, Ordination of Saint Stephen and Saint Stephen Distributing Charity, 1448
Fresco; 322 × 472 cm (126¾ × 185¾ in)
Chapel of Nicholas V, Vatican Palace, Rome

129 Page 180–1
Fra Angelico assisted by Benozzo Gozzoli, Expulsion and Martyrdom of Saint Stephen, 1448
Fresco; 322 × 473 cm (126¾ × 186¼ in)
Chapel of Nicholas V, Vatican Palace, Rome

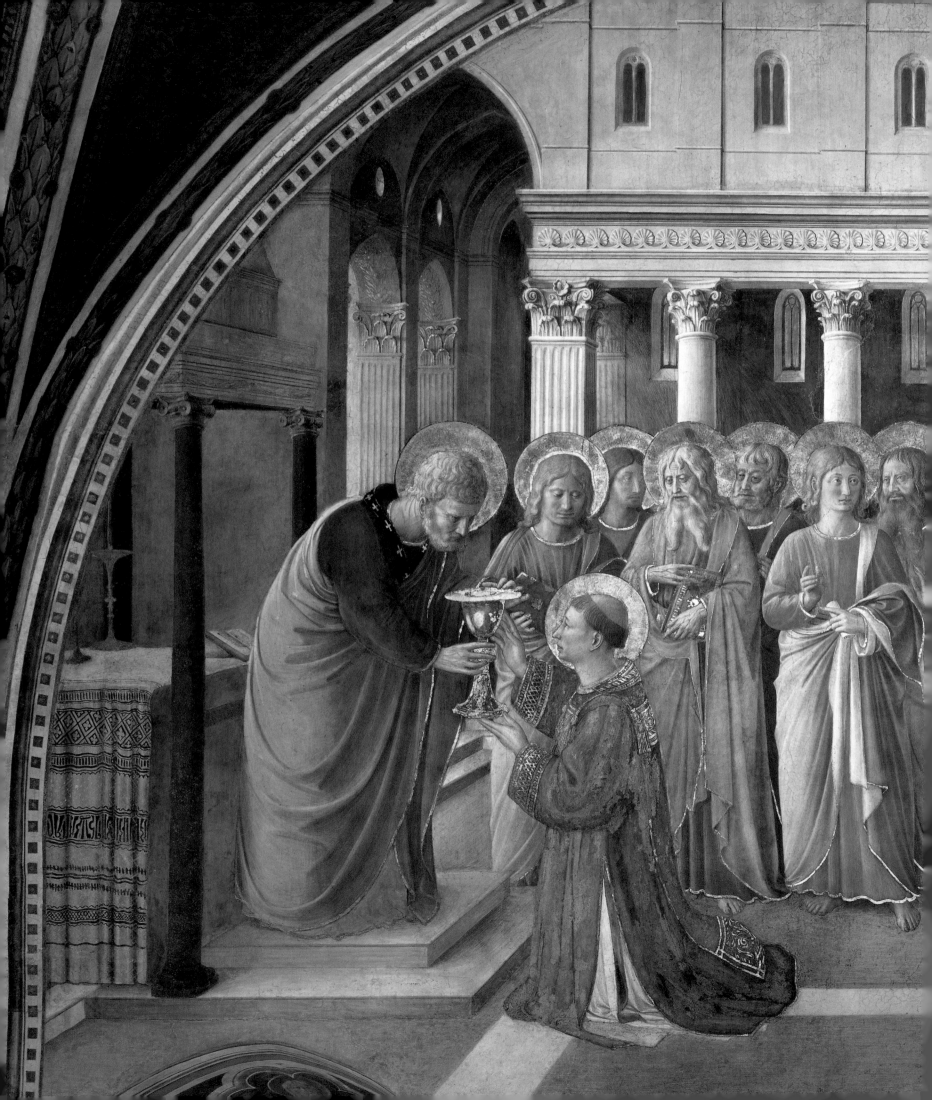

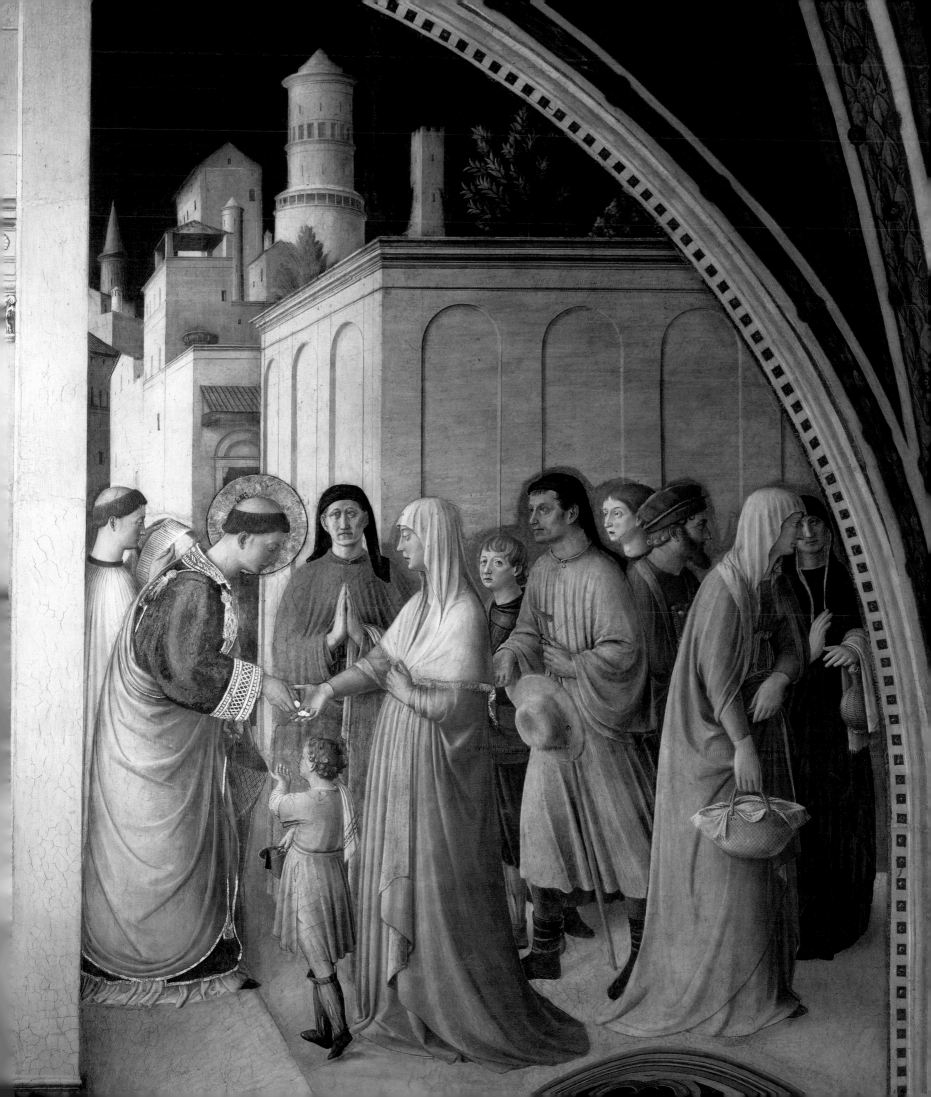

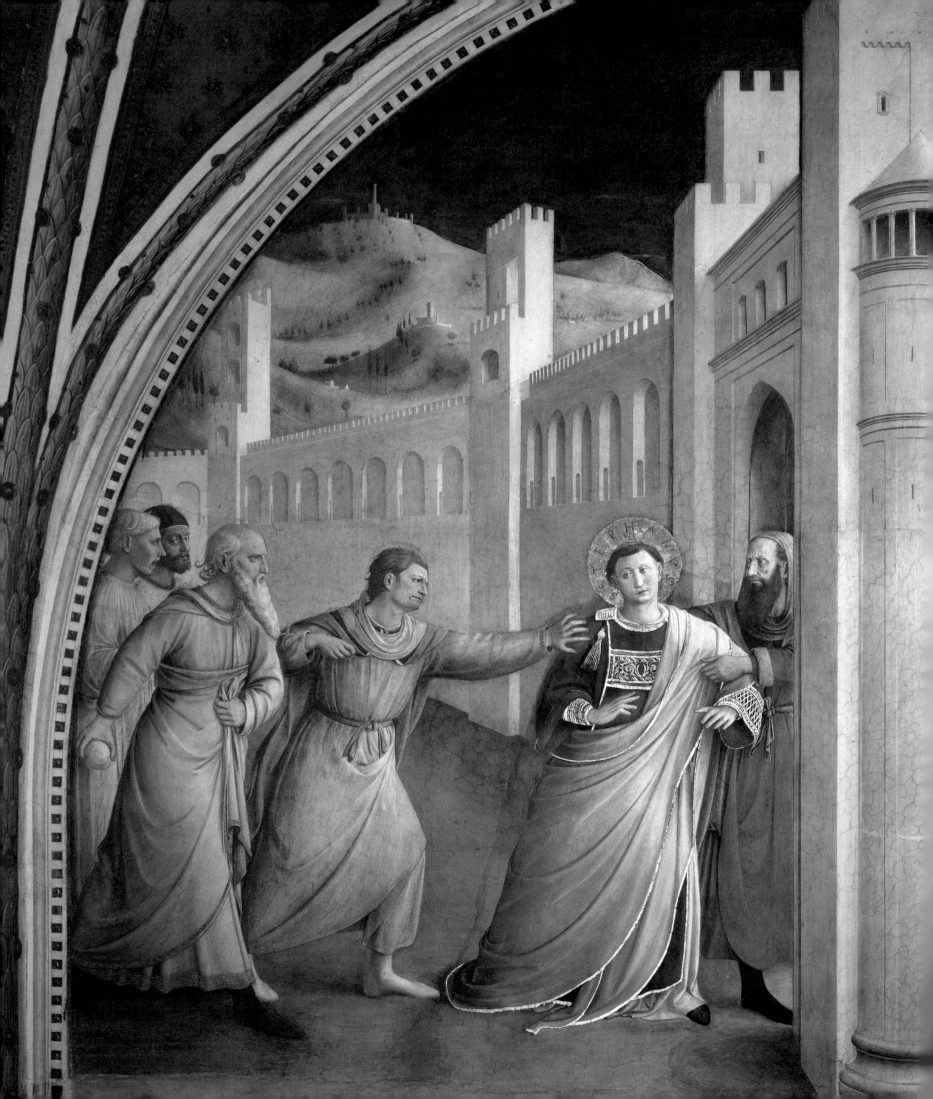

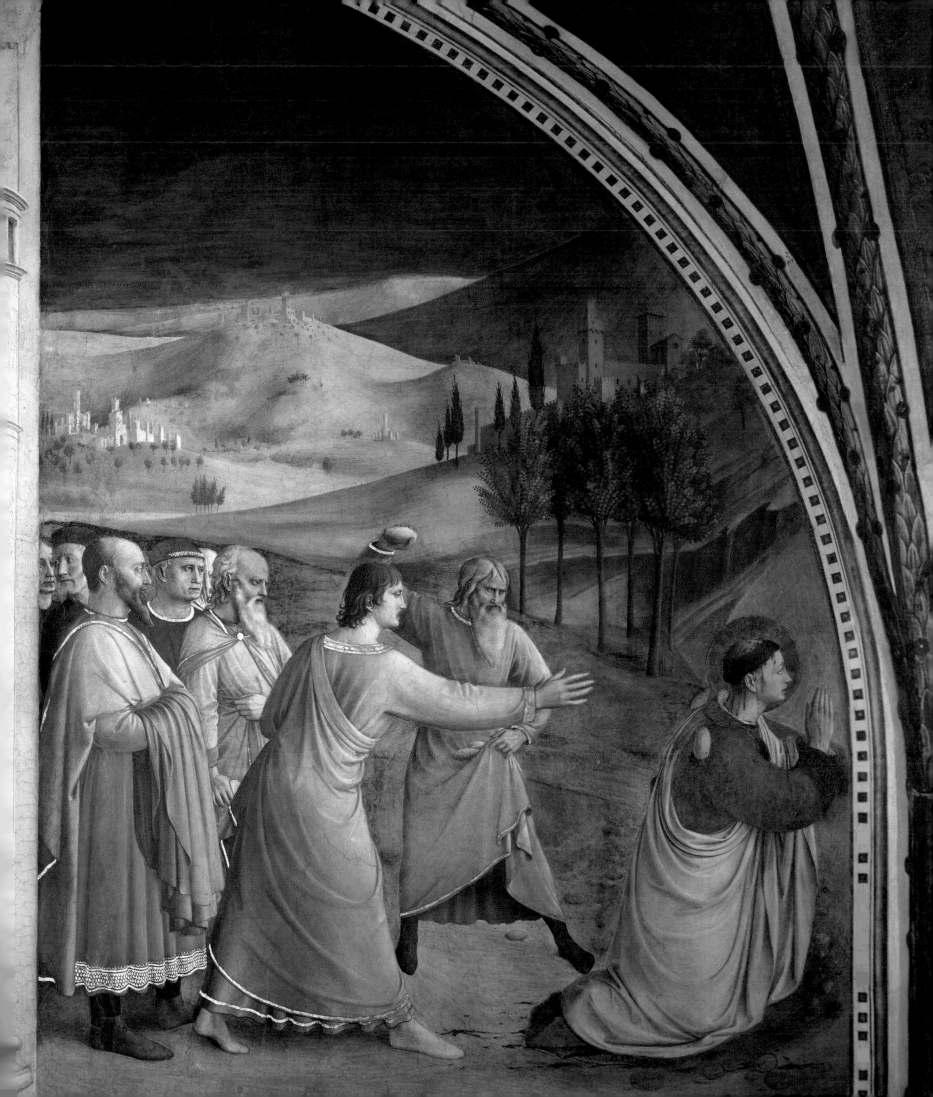

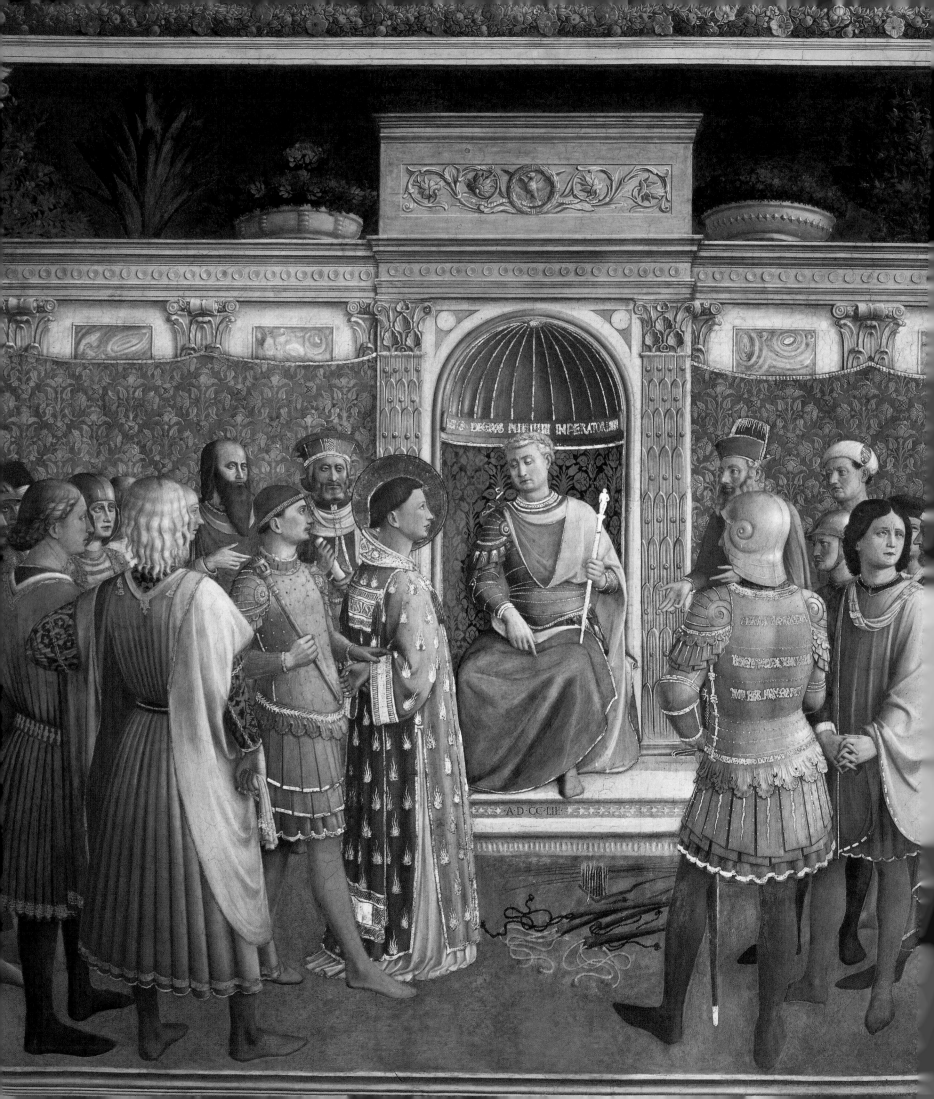

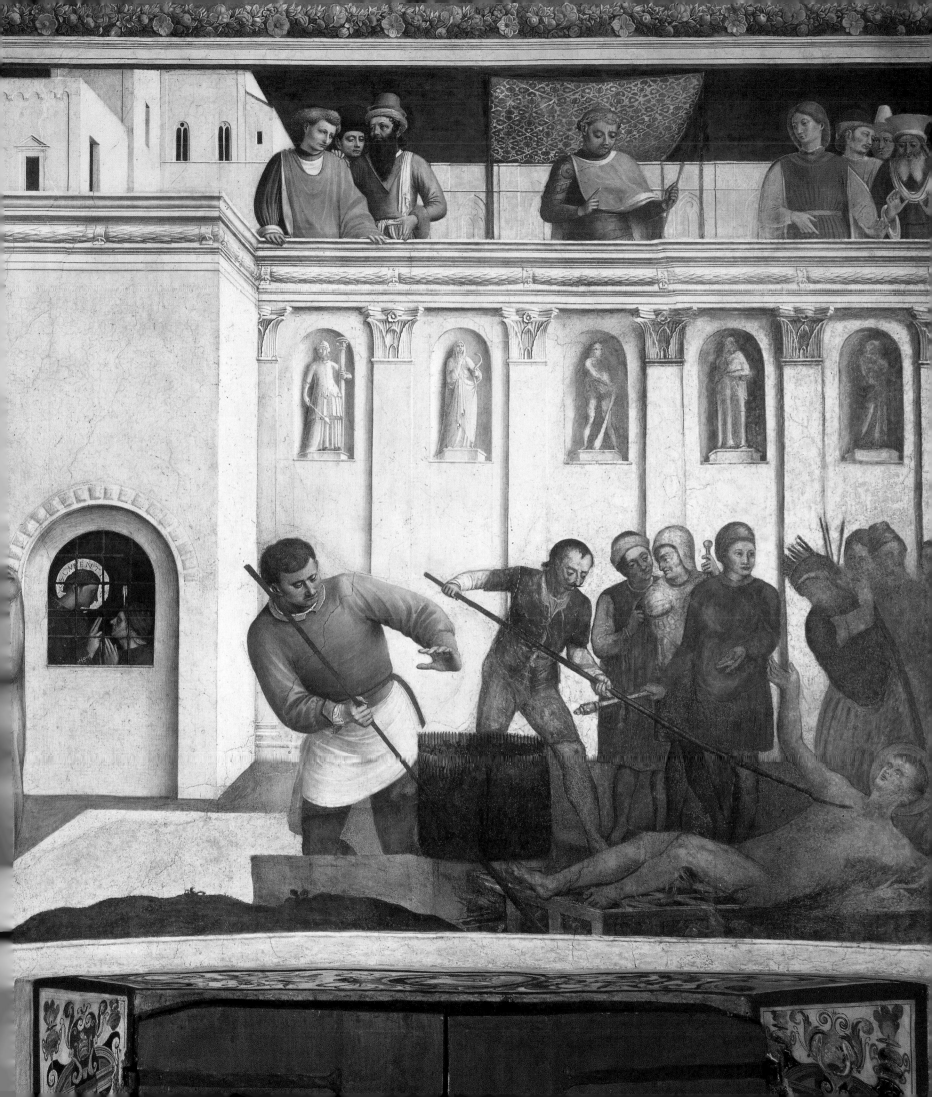

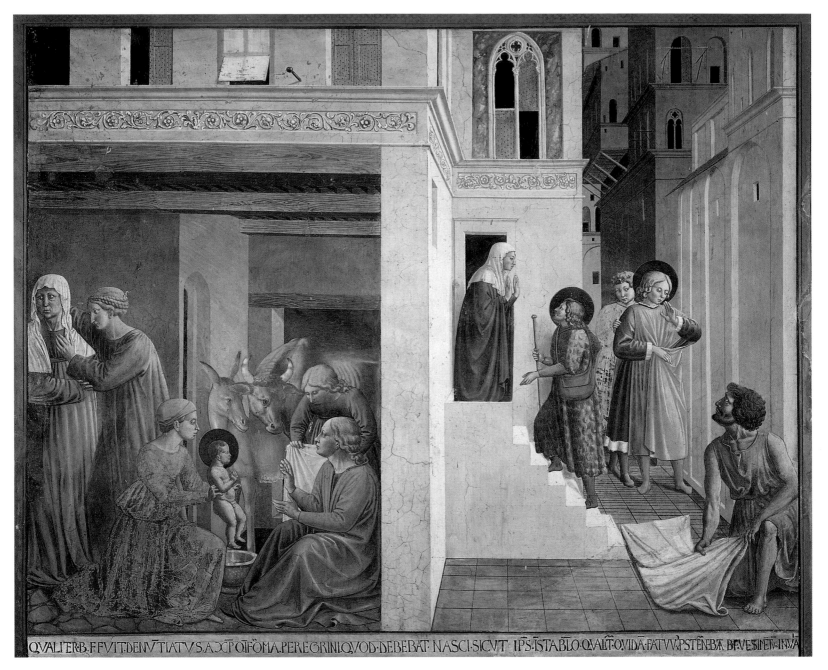

QVALITER·B·F·FVIT·DENV̄TIATVS·A·ɔCP̄OIFŌMA·PEREGRINI·QVOD·DEBEBAT·NASCI·SICVT·IP̄S·ISTABLO·QVALIT·OVIDA·FATVV̄·PSTĒNBA·BĒVESIIĒI·INV̄A

131
Benozzo Gozzoli, *Birth and Youth
of Saint Francis*, 1452
Fresco; 220 × 304 cm
(86⅝ × 119¾ in)
Ex-Church of San Francesco/
Museo Comunale di San Francesco,
Montefalco

130 Previous page
Fra Angelico assisted by Benozzo
Gozzoli, *Judgement and Martyrdom
of Saint Lawrence*, 1448
Fresco; 271 × 473 cm
(106¾ × 186¼ in)
Chapel of Nicholas V, Vatican Palace,
Rome

The lives of the martyrs Lawrence and Stephen extend across three walls of the chapel (see 123). As prototypical saints who followed the ministry of Christ through their ordination, preaching of the Gospel and charity to the poor, they experienced arrest, persecution and martyrdom in his name. Portraits of the martyrs once filled the stained-glass windows on the west wall, transfiguring the light by which Mass was experienced. The scenes in the chapel were chosen to demonstrate the similitude of the saints to each other. Although Lawrence died in Rome and Stephen was martyred in Jerusalem, their lives were united through their calling as deacons, their devotion to Jesus and the tomb that they later shared. As proclaimed in *The Golden Legend* (c.1260), the most popular source for saints' lives during the late Middle Ages and early Renaissance, the two men were 'as brothers' in their martyrdom and steadfast faith. Their numinous presence graced the Eternal City, as the *Golden Legend* proclaimed: 'O happy Rome, that in one tomb guardest these glorious heroes.'

The frescoed narrative describes the saints' histories in twelve episodes arranged in two superimposed registers. The life of Saint Stephen is represented in three lunettes, while that of Saint Lawrence unfolds in five rectangular panels below. The sequence, arrangement and subjects of the scenes were carefully contrived. Of the twelve episodes, eight are identical in subject, portraying the saints' ordination, distribution of charity, judgement and martyrdom. These paradigmatic acts underscore the saints' shared apostolate and common fate as martyrs. Compositions, postures and gestures are repeated to reiterate this theme, as in the scenes of their ordination, portrayed on the same wall (127, 128). Appropriately tonsured and dressed in rich dalmatics, the saints are shown identically in profile as they take priestly vows. They kneel devoutly to receive from the pope the chalice and paten for celebrating Communion. Ritualistically, Lawrence kneels again while receiving the goods of the Church to distribute to the poor (see 123), as does Stephen while being stoned to death (129). Emphasizing their shared fate, the scenes of their martyrdoms are situated on the wall facing the altar. Such placement makes explicit their devotion to Christ and their imitation of his sacrifice.

Numerous figures participate in these scenes to witness the saints' holy deeds and attest their veracity. To authenticate their ordination as deacons, Angelico represented as observers members of the Church, including Apostles, bishops, deacons and acolytes. Their luxurious garments, adorned with golden sleeves and hems, may have imitated the sumptuous vestments that Nicholas commissioned for the celebration of special Masses in honour of the saints. In the scene of St Lawrence's ordination, Pope Nicholas is portrayed in the guise of the devout Pope Sixtus II, who promoted the martyr's cult (see 127). To emphasize the charity of the martyrs, Angelico portrayed them distributing coins to the poor, from a babe in arms to an old woman in widow's weeds (see 123, 128). Although accounts of Stephen's life do not describe almsgiving among his pious deeds, the saint is shown offering money to the needy to parallel him with Lawrence. Lawrence's distribution of charity is elevated to a sacred act, for it transpires at the entrance to a church and is framed by the apse. The poor and crippled are depicted with dignity and compassion as they meekly wait their turn. In the cycle of Lawrence's life, Nicholas V is portrayed twice as Pope Sixtus II, who himself was martyred and canonized. Through these surrogate images, Nicholas identified himself with his predecessor whose piety, devotion to the saints and commitment to charity he shared.

Throughout the cycle, architecture is expertly rendered in perspective and assumes a crucial role in articulating the narrative.

It frames every action, directs the viewer's gaze and calibrates space as well as the passage of time, separating and joining crucial events in the saints' lives. Several episodes incorporate archaeological elements, evoking the sacred places and antiquity of Jerusalem and Rome. In the *Ordination of Saint Stephen* (see 128), a Corinthian colonnade frames the Apostles and focuses attention on the kneeling martyr as he receives the chalice and paten from Saint Peter himself. The interior is an amalgam of historical styles, fusing Corinthian capitals, Gothic windows, fluted piers, groin vaults and *oculi*. Half-hidden by the arch of the lunette, the ciborium recalls the altars of early Christian and medieval churches. Architectural historians concur that the fusion of elements in the frescos would never have occurred in real structures and that, in fact, the buildings could not be constructed. Yet the dramatic scale and monumentality of the architecture frame the narrative ideally, imparting the gravity appropriate to such portentous events.

Pagan elements, both real and imagined, lend apparent authenticity to several scenes. In the *Expulsion and Martyrdom of Saint Stephen* (see 129), the curving arc of Jerusalem's walls recalls the ancient Aurelian fortifications of Rome, restored by Pope Nicholas himself. In the *Judgement and Martyrdom of Saint Lawrence* (130), the wreathed eagle in the cornice of the emperor's throne replicates an actual relief dating to the reign of Trajan (98–117) that was incorporated into the atrium of Santissimi Apostoli, one of Rome's most important churches. This imparted an appropriately historical flavour to the event, suggesting its antiquity and authenticity. In the adjacent episode of his martyrdom, the fancifully luxuriant pilasters and capitals are fabrications without precedent in ancient architecture.

The variety, copiousness and fantasy of such embellishments reveal an archaeological engagement with antiquity that is unprecedented in Angelico's paintings. They suggest the possible influence of Leon Battista Alberti (see pages 120–1), a practising architect and member of the papal court. This learned humanist and antiquarian studied the city's archaeology, mapped its monuments in his *Description of the City of Rome* and praised imaginative design and ornament in his treatise *On the Art of Building*, which he formally presented to Pope Nicholas in 1452. Alberti's profound understanding of the structure, proportions and commensurability of Roman architecture may not have been equalled by any of his contemporaries, except Brunelleschi. It seems unthinkable that Alberti conceived the architecture here, as has equivocally been suggested, for the structures are unbuildable. Yet it is likely that his sensibility, shared by others within his humanist circles, influenced the variety of the buildings and their adornment.

It recently has been proposed that Benozzo, the most accomplished of Angelico's assistants, was largely responsible for composing the architecture in the frescos as well as conceiving the scenes themselves. This argument deserves serious consideration. Architecture is a crucial element in all of Benozzo's work from his early frescos in the church of San Francesco, Montefalco (1452) (131) to the magisterial Old Testament cycle in the Camposanto of Pisa (1468–85), executed late in his career. As in the Chapel of Nicholas V, it provides an authoritative frame for the narrative, separates successive episodes and deepens space. The architecture in Benozzo's frescos is embellished with elements of diverse inspiration, culled from the structures he saw around him or imagined. Specific components, such as the vine scroll frieze above the throne in the *Judgement of Saint Lawrence* (see 130), are repeated throughout his works. They reveal a lifelong fascination

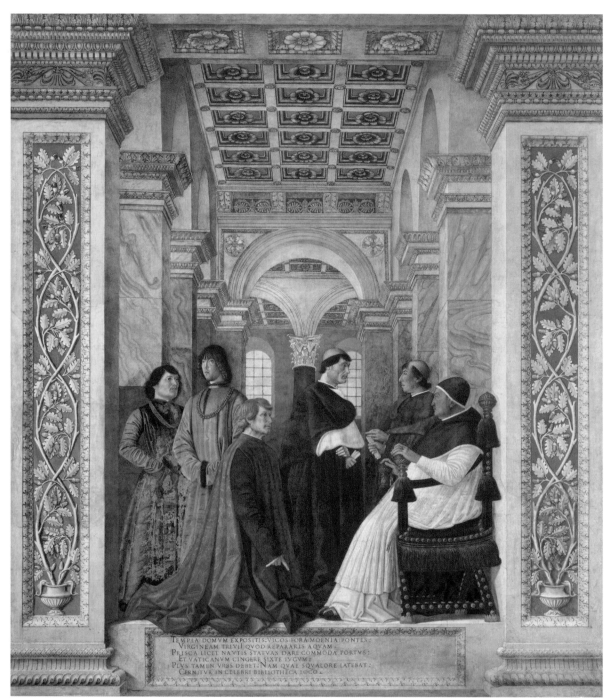

132
Melozzo da Forlì, *Pope Sixtus IV Naming Bartolomeo Platina Prefect of the Vatican Library, c.*1477
Fresco (detached and transferred to canvas); 400 × 300 cm
(157½ × 118⅛ in)
Musei Vaticani, Rome

with antiquity that the painter preserved in detailed drawings of cornices, friezes, capitals and Roman sculpture. Among these drawings is one of the Trajanic eagle from Santissimi Apostoli, portrayed in the *Judgement of Saint Lawrence*.

Benozzo's consistent interest in embellishing architecture with classicizing and fanciful ornament suggests that he, rather than Angelico, adorned the buildings in the Chapel of Nicholas V. Whether this may be said of the architectural settings themselves is entirely another matter. They frame and complement the scenes with the restraint that typifies all of Angelico's work, revealing an assured command of perspective and clarity of conception that contrast to the complex spaces and multi-episodic scenes of Benozzo's paintings. Although Angelico conceived the architecture, Benozzo executed its varied adornment.

The restoration of the frescos, completed in 1999, has revealed a chromatic brilliance once obscured by centuries of dirt, candle smoke and repainting. Except for the torturers in the *Expulsion of Saint Stephen* and *Martyrdom of Saint Lawrence*, who were badly damaged and repainted in the past, the paintings are consistently of very high quality. The colours are luminous, revealing subtle gradations of hue and an extraordinary sensitivity to light. In the vaults, the garments of the Evangelists range from the palest violet and rose to deep malachite. They glow with radiance seemingly reflected from the clouds and the heavens that surround them. The same chromatic brilliance is evident in the scenes of the saints' lives below. The deep azurite and lapis lazuli skies contrast to the soft colours of the architecture, landscape and figures. Although true fresco predominates, Angelico subtly enhanced these glowing surfaces with tempera pigments. Ranging from white lead to deep cinnabar and vermillion, these refinements varied the colours and textures of the frescos. An abundance of gilding embellishes haloes, the borders of mantles, the binding of books and the stars in the vaults. The costly pigments and glittering gold displayed the splendour appropriate to the chapel where Nicholas celebrated Mass each day and ordained bishops with members of the papal court in attendance.

Restoration of the chapel also has revealed new information about Angelico's working procedure. As with the San Marco frescos, Angelico prepared sinoper underdrawings for the composition and figures. Brushed directly on the wall with assured strokes, they provided a guide that he and his assistants could follow in executing the murals. A tautly pulled rope or cord was suspended from the wall and snapped against the wet plaster to provide straight, parallel lines as guides for the architecture, while compasses were used for arches and vaults. The repetitive tabernacles of the Church Fathers as well as the decorative friezes of the vaults were prepared with cartoons. The drawings served as templates that were perforated with a needle and dusted ('pounced') with charcoal or chalk for transfer to the wall. Re-using the same cartoon, members of Angelico's shop repeated the master's careful drawings. The efficient process facilitated execution while guaranteeing uniformity of style, design and scale.

Assistants aided Angelico in completing the frescos, as is known from an account ledger of 1447. In addition to preparing the plaster and pigments for the frescos, the less important members of the shop may have followed the master's designs for the decorative elements of the chapel. These include the fictive wall hangings as well as the variegated friezes that embellish the ribs of the vaults, frame the scenes and adorn the window embrasures. Benozzo actively collaborated with Angelico, not only by contributing his repertoire of classicizing ornament for the

architecture, but by executing figures in nearly every scene. As with the San Marco frescos, his contributions seem almost indiscernible from those of the friar and can only be perceived through the most exacting study. The acolytes (standing to the right) in the *Ordination of Saint Lawrence* exemplify his style. Benozzo's figures have slightly rounded faces, with closely spaced features. Their eyes are heavily lidded and their gazes seem less focused and attentive. Colours appear less luminous than those of Angelico and the drapery lacks the subtle range of modelling found in the master's work, as demonstrated by the opacity of the acolytes' white surplices. These slight distinctions, perhaps visible only at close range, attest Benozzo's expertise at imitating Angelico's style. The truly collaborative relationship between the master and the most important member of his shop accounts for the exceptional quality of the frescos.

The Chapel of Nicholas V occupies a unique place in Angelico's development. The dramatic narratives differ in kind from the austere, visionary images in the cells at San Marco. They speak an elevated visual language, in which monumental architecture articulates the narrative and frames the figures. The incorporation of recognizable archaeological elements and the portrayal of the pope in the guise of one of his predecessors made the Church's past seem ever present and alive. These elements established an authoritative style that profoundly influenced papal commissions to the end of the century. Their influence resonated most profoundly in Melozzo da Forlì's *Pope Sixtus IV Naming Bartolomeo Platina Prefect of the Vatican Library* (132), which portrayed members of the papal court in architecture of similar magnificence, and in the narratives of the lives of Moses and Jesus in the Sistine Chapel (1481–2) by Sandro Botticelli, Pietro Perugino, Domenico del Ghirlandaio and others. In both programme and style, the Chapel of Nicholas V established the decorum of papal narrative for decades to come.

Angelico's final commission in Rome was the decoration of the *studiolo* (study) of Nicholas V. Located near his chapel, it was destroyed in the early sixteenth century. Little is known about this room, except for what may be gleaned from expenditures recorded in papal account books. In 1449, an entry notes the payment of more than 182 ducats to 'Fra Giovanni da Firenze and his shop' for painting the *studiolo*, but the subject is unspecified. Expenditures from 1450 record purchases of thousands of leaves of gold to gild cornices, capitals and other parts of the room, which was adorned with fine intarsia cabinets. They suggest a glittering, magnificent space in which paintings might be seen. Light filtered through richly coloured windows, made by a specialist in stained glass in 1451. Like the studies made for the pope's contemporary, Federigo da Montefeltro, in Gubbio and Urbino, the room served as a private refuge for reading and reflection. If only momentarily, they distracted the pope from the ceaseless obligations of his office.

There is one more work that belongs to this phase of the Angelico's activity. It is the *Perugia Altarpiece*, one of Angelico's most beautiful paintings (133). The friar painted it for the Chapel of Saint Nicholas, which was maintained by the venerable Guidalotti family in the church of San Domenico in Perugia. Although the church was ceded to the Dominicans at the beginning of the fourteenth century, it only became an Observant congregation in 1437. According to a late sixteenth-century chronicle, the altarpiece 'was given that year to Fra Giovanni da Fiesole, the most holy friar and most famous painter of our Order'. While many critics have dated the altarpiece to 1437 for this reason, the chronicle, composed and embellished more than two centuries after the friar's death,

133
*Virgin and Child Enthroned,
with Four Angels and Saints Dominic,
Nicholas, John the Baptist and
Catherine of Alexandria*, known
as *Perugia Altarpiece, c.*1447–8
Tempera and gold on panel (modern
frame); centre panel: 128 × 88 cm
(50⅜ × 34⅝ in); left panel:
102 × 75 cm (40⅛ × 29½ in); right
panel: 102 × 76 cm (40⅛ × 30 in);
Annunciation roundels: 29 cm
(11½ in) diameter; pilaster saints
panels: 30 × 4 cm (11¾ × 1½ in)
each; predella panels (left and centre
panels copies of originals now in
Musei Vaticani): 34 × 60 cm
(13⅜ × 23⅝ in) each
Pinacoteca Nazionale dell'Umbria,
Perugia

189

134
*Martyrdom and Death of Saint
Nicholas*, predella panel of *Perugia
Altarpiece* (133), *c.*1447–8
Tempera and gold on panel;
34 × 60 cm (13⅜ × 23⅝ in)
Pinacoteca Nazionale dell'Umbria,
Perugia

191

is not entirely reliable, for it contains demonstrable inaccuracies. Although the triptych might conceivably have been requested from Angelico the year of the convent's reform, it is apparent that it was executed more than a decade later.

Until recently, it was believed that the patron of the altarpiece was Benedetto Guidalotti (1388–1429), archbishop of Recanati, who is buried in a magnificent marble tomb in the chapel. This learned prelate devoted himself to the welfare of indigent students at the University of Perugia, founding a free hostel, the famous Collegio di San Girolamo, two years before his death. It was long assumed that Benedetto Guidalotti himself bequeathed funds for the altarpiece that Angelico ultimately executed. New research, however, indicates instead that his sister Elisabetta (died 1460) may have been responsible for completing his ambitious projects, including the chapel's decoration. At a time when women were accorded few rights, Elisabetta oversaw sales of real estate and negotiated loans. When her husband died in 1441, she inherited a substantial legacy that she conceivably used to subsidize the adornment of the chapel. By 1446, Elisabetta had established personal and legal ties to Orvieto, where Angelico began the New Chapel in summer 1447. Through these contacts, which included members of her own family, she may have persuaded him to undertake the commission.

Prominently located in the transept of San Domenico, the triptych conveyed the devotion of the Guidalotti to the Virgin and the saints worshipped in the church. They include Saint Dominic, founder of the Order; Saint Nicholas, to whom the chapel was dedicated; John the Baptist, the herald of salvation and first martyr; and Saint Catherine of Alexandria, personification of faith, wisdom and divinely inspired eloquence. The diverse saints on the pilasters, almost all bearing books, reflect the commitment to scholarship by the Order that was shared by the Guidalotti. Indeed, the extensive, beautifully written inscriptions on the open books of the Dominican saints presuppose a learned beholder. The verses on Saint Dominic's open book served as a charge to the friars; taken from the Second Letter of Saint Paul to Timothy (4:1–13), the lengthy passage exhorted them to 'preach the word' and 'do the work of an evangelist' in fulfilling Christ's ministry. Saint Thomas Aquinas, portrayed in the right pilaster, reiterated this message. His book is inscribed with words from four of the Psalms. One of the texts was the subject of the saint's inaugural lecture as Doctor of Theology at the Sorbonne, recalling the Order's commitment to biblical exegesis; another, on 'the unfolding of [God's] words' to enlighten, seemed prophetic of its mission to preach.

The angels share in celebrating the Virgin and Child. They bear wreaths of roses, like those in the vases before the throne, recalling invocations to Mary as the 'rose without thorns'. Their offerings seem literal illustrations of a fourteenth-century prayer to which historians trace the origins of the rosary, the series of prayers and meditations on the life of Christ that were recited by the laity:

> I greet you, Mary, my Lady,
> Accept this little rose chaplet
> That I have recited for you today.

Rosary devotions were promoted by the Dominican Order, which was dedicated to the Virgin.

It is difficult to imagine the altarpiece as Angelico conceived it. The triptych was completely dismembered nearly two centuries ago, when its frame was destroyed, the panels cut apart and the predella dispersed. The original frame is perhaps more likely to have resembled that of the *Cortona Triptych* (see 76), than the reconstruction, which dates to the early twentieth century. The heavy, ornate forms, especially the paired colonnettes and towering spires, overpower the figures and emphasize the division of the predella, which was originally united as a single panel. A depiction of God the Father must have adorned the central cusp. Instead of the current configuration, the saints on the pilasters are likely to have been portrayed in single rows on the front and side faces of the frame. The recent restoration of the altarpiece (1998) has repaired the damages that once marred the surface, enhancing its appearance and the brilliance of its colours. At the same time, many elements of the original work, such as the silver-covered niche of the throne, abraded over time, are irretrievably lost.

Although the triptych format was outmoded by Florentine standards of the 1440s, it accorded perfectly with the traditions of sacred art in Perugia and may have responded to the wishes of the patron. In conceiving the altarpiece, Angelico followed the model of the *Cortona Triptych*, made for an Observant Dominican congregation only 50 kilometres (31 miles) away. Working within the limitations of its golden ground, Angelico created a deep and believable space. The angels stand assuredly around and behind the classicizing throne, the festoon frieze of which is deeply sculptural. More convincingly foreshortened and monumental than in the *Cortona Triptych*, the pedestal extends across both wings to unify the central and side panels. Strongly projected, brocade-covered benches replace the shallow ledges of the earlier work, imparting greater depth and spatial clarity.

The saints seem unconfined by the arches of the triptych, their garments and attributes overlapping its divisions. Their proportions are more massive than those of the Cortona saints and their drapery is voluminous. Equally impressive is the greater intensity with which they and the angels are characterized. Their stance, gestures and expressions are varied, conveying the personality of each. Perhaps most striking are the colours which reveal a depth and luminosity not found in the *Cortona Triptych*. Garments shimmer with light, as in the radiant gown of one of the angels, in which the hues are subtly transmuted from green to blue. Fabrics are ornately patterned, as in the intricately tooled golden border of Nicholas's cape, adorned with the heads and wings of angels.

Before the altarpiece was cut apart, the life of Saint Nicholas in the predella unfolded in a continuous space. Each panel is multi-episodic, enhancing the richness and suspense of the narrative. The deep, receding walls of the architecture, adorned with friezes of classical inspiration, and the distant, atmospheric horizons display a mature command of perspective. The scale of the diminutive figures with respect to the varied settings is believably proportioned, perhaps for the first time in Angelico's predellas. This is especially evident in the *Martyrdom and Death of Saint Nicholas*,

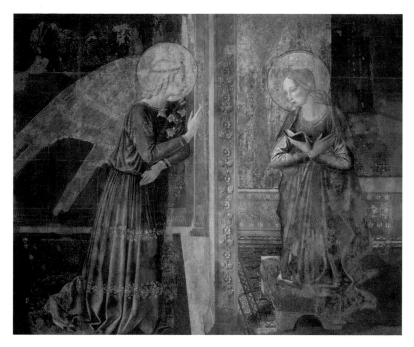

135
Benozzo Gozzoli, *San Domenico Annunciation*, c.1449
Tempera; 120 × 140 cm
(47¼ × 55⅛ in)
Pinacoteca Comunale, Narni

where the open walls sheltering the mourners extend to almost twice their height (134). The figures are vibrant and dramatic, displaying a range of emotion that is unequalled in the Cortona predella.

The *Perugia Triptych* emerged directly from Angelico's experience in Rome. Parallels between the altarpiece and the frescos in the Chapel of Nicholas V may readily be discerned (see 127, 128, 129, 130). Despite the different media, their colours are similarly luminous, with deep malachites and pale violets that are rare elsewhere in the friar's works. The continuous, foreshortened ledge uniting the panels, as well as the angled walls and slowly receding hills of the predella, parallel Angelico's investigation of space in the frescos. Most significant of all may be the relationship between the saints in the arches of the chapel and the figures of the main panel and pilasters (see 126). Their monumentality, gravity and intensely characterized personalities are especially striking. Finally, the representation of Saint Nicholas is, as has been observed, a portrait of Nicholas V, whom Angelico had depicted as Pope Sixtus II in the chapel (see 123, 127). It was fitting that Pope Nicholas, a renowned humanist, served as a model for the saint, shown absorbed in his reading.

The *Perugia Triptych* is the last of Angelico's altarpieces to reveal the collaboration of Benozzo. His participation seems evident in the saints of the right panel, whose drapery is less volumetric compared to that of Dominic and Nicholas, whose garments fall in deeply shadowed folds. His colours lack the subtle range, modulation and luminosity of Angelico's, as shown in Saint Catherine's patterned dress and mantle. Rather than being modelled in graduated light and shadow, the saints' features are defined by line. As has been observed, the face and proportions of Catherine correspond closely to those of the Virgin Mary that Benozzo painted between 1449 and 1450, suggesting his execution of the saint. Indeed, two of his commissions from this period, both for Dominican churches, almost certainly were obtained through Angelico's intervention (135).

In 1449, Pope Nicholas V issued a Bull that proclaimed 1450 a Jubilee Year, during which the sins of countless pilgrims to Rome would be forgiven 'through the great and infinite mercy of God'. Papal account ledgers from this time recorded payments for works by many artists, but Angelico was not among them. After more than a decade of collaboration, Benozzo had parted company with the master. By July 1449, Benozzo had arrived in Orvieto, where he hoped to win the commission for the New Chapel that Angelico had abandoned almost two years earlier. His petition was unsuccessful.

In the early months of 1450, Angelico's brother, Fra Benedetto, died in San Domenico at Fiesole, where he had long served as prior and director of the scriptorium. He was eulogized as the brother of 'Fra Giovanni the painter', 'an excellent scribe' and the 'subprior of San Marco' under Antoninus. His obituary recorded that he 'had written all the choir books for San Marco', notable for their beautiful calligraphy. Fra Benedetto's work had provided the income required for the subsistence of the friars in Fiesole, and his guidance as prior was crucial. With his death, the convent urgently needed Angelico. By 10 June 1450, Angelico had returned to Fiesole, where he assumed his brother's responsibilities as prior of San Domenico.

7
The Servant of God
The Final Works

136
Virgin and Child Enthroned with Two Angels, and Saints Anthony of Padua, Louis of Toulouse and Francis, and Saints Cosmas, Damian and Peter Martyr, known as *Bosco ai Frati Altarpiece*, c.1450–1
Tempera and gold on panel;
174 × 173 cm (68½ × 68⅛ in);
predella: 28 × 174 cm (11 × 68½ in)
Museo di San Marco, Florence

Previous page
Detail from *Bosco ai Frati Altarpiece* (136)

In virtually every way, the final years of Angelico are an enigma. From June 1450 until his death nearly five years later, only a few of the friar's activities may be securely traced. Not a single work can be documented with certainty and his location for much of this time is unknown. He fulfilled his obligations as prior of San Domenico, supervising an election there in June 1450 and meeting with Fra Giuliano Lapaccini, the prior of San Marco, to administer financial matters in February 1451. In early 1452, Angelico was invited to paint the high altar chapel of the cathedral of Prato, a nearby city under Florentine rule, but he declined the commission. In December 1454, Angelico, along with Filippo Lippi and Domenico Veneziano, was named as a possible appraiser of frescos being commissioned from Benedetto Bonfigli in Perugia, but his whereabouts at that time are unknown. The final reference to the friar records his death on 18 February 1455 in the Dominican church of Santa Maria sopra Minerva in Rome. The date of his arrival, the length of his stay and his reason for travelling to Rome: all remain a mystery. Had he gone there to execute a commission for the aging Pope Nicholas or another client? Or had Juan de Torquemada, the distinguished prior of the Minerva, summoned the friar to decorate the church and convent?

Although a few paintings have been ascribed to the friar's final years, only the *Bosco ai Frati Altarpiece* and the *Santissima Annunziata Silver Chest*, both Medici commissions, can be dated with any certainty to this time. The apparent dearth of works seems confounding for so prolific a master, but circumstances had changed. With Benozzo Gozzoli's departure in 1449, a successful, decade-long collaboration came to an end. Over the years, Benozzo had assumed an increasingly greater role in completing the friar's works, and his departure unquestionably compromised Angelico's efficiency. Of equal importance was the friar's advanced years. Since his birthdate is unknown, his actual age cannot be determined, but he was at least well into his mid-fifties or early sixties at the time. His health was no doubt impaired by the penitential rigours of Observant life, which included fasting and flagellation. Perhaps most significantly, the friar suffered from crippling arthritis, as was discovered when his body was exhumed from its original burial place in the Minerva. His affliction was so advanced and severe that the act of painting must have been extremely painful.

As the last works securely attributed to Angelico, the *Bosco ai Frati Altarpiece* and the *Santissima Annunziata Silver Chest*, executed while he was still in Fiesole between 1450 and 1452, assume exceptional importance. They conclude a crucial chapter in the history of Medici patronage, attesting the family's enduring esteem for his work, which began with the *Annalena Altarpiece* almost two decades earlier. They reveal his response to the distinctive spirituality of the sites for which they were commissioned. The importance of these commissions may have inspired his return from Rome.

The *Bosco ai Frati Altarpiece* was painted for the high altar of the Observant Franciscan church of Bosco ai Frati (136). The church and accompanying convent were located in the village of San Piero a Sieve in the Mugello. This was the ancestral region of the Medici, whose country villas at Trebbio and Cafaggiolo were nearby. As early as 1417, Giovanni di Bicci had assumed patronage of the hilltop convent surrounded by woods, where the Observant Franciscans had established their congregation. After his death in 1429, Giovanni's sons fulfilled his commitment to the friars, engaging Michelozzo di Bartolommeo to rebuild the complex. Here, the architect reconciled the Observants' requirement for simplicity with the demands of his patrons for self-aggrandizement and self-promotion. Michelozzo retained the original plan of the aisle-less

137
Michelozzo di Bartolommeo, Choir
of Bosco ai Frati, San Piero a Sieve,
c.late 1420s–late 1440s

138 Opposite, top
Domenico Veneziano, *Saint Lucy
Altarpiece*, *c*.1445
Tempera and gold on panel;
210 × 215 cm (82¾ × 84¾ in)
Galleria degli Uffizi, Florence

139 Opposite, bottom
Fra Filippo Lippi, *Altarpiece
of the Novitiate*, *c*.1440–5
Tempera and gold on panel;
196 × 196 cm (77⅛ × 77⅛ in)
Galleria degli Uffizi, Florence

church, but augmented its length and height. He left the
whitewashed walls unadorned, as appropriate to an Order that
embraced poverty. However, he embellished corbels and capitals
with the balls of the Medici coat of arms to clearly identify the
family's patronage of the site. Finally, he added a polygonal apse
illuminated by recessed, arched windows (137). It was for this
austere and lucid setting that Angelico conceived the altarpiece.
Almost certainly, the painter began it shortly after returning to
Fiesole in 1450. This coincided with the canonization of the famous
Franciscan Observant preacher Bernardino of Siena (1380–1444),
who is represented with a saint's halo in the predella.

The *Bosco ai Frati Altarpiece* reprises the single-panel, sacred
conversation recognizably associated with the Medici since the
Annalena Altarpiece (see 67) while reflecting Angelico's maturity
in the monumentality of its figures and architecture. As in the
Annalena Altarpiece, the Virgin and Child are seated within
a classicizing throne with a shell niche, although the figures are
more massive. Their contours are sculptural, with their anatomy
modelled in a subtly graduated chiaroscuro rather than by line.
The throne, wider than the Annalena one to shelter the angels,
is rendered in accurate perspective. It projects from a wall
rhythmically articulated with engaged columns and niches culled
from Michelozzo's rich vocabulary, as seen in the church of Bosco
ai Frati itself. A continuous entablature adorned with a frieze
of fictive marble and crimson balls reiterates the family's patronage
of the site. Cypresses and palm trees, symbols of the Virgin taken
from the biblical Song of Songs, extend above the wall. They allude
to Mary as well as evoke the site itself. (Bosco ai Frati means 'Forest
of the Friars'.) Extending across the niche, the golden cloth of
honour is finely incised with flowers, the petals of which seem
comprised of balls, again calling to mind the Medici coat
of arms. The cloth of honour, gilt brocades of the Virgin's throne
and cushion, haloes of the holy figures and intricately patterned
angels' wings would have shimmered in the candlelight that
illuminated the image.

Franciscan saints as well as the patron saints of the Medici
stand symmetrically to either side of the Virgin and Child, who are
flanked by angels. In this portrayal, Angelico suggested the nuances
of Franciscan devotion for the friars who prayed before the image.
Saint Anthony of Padua gazes ardently toward the Virgin and the
infant Jesus, as if to direct the prayers of the devout. Behind him is
Saint Louis of Toulouse, who renounced his right to rule the
Kingdom of Naples to become a Franciscan. Beside him stands
Francis himself, whose stigmata, visible on his hands, feet and chest,
replicated the wounds of the crucified Christ. Holding a copy of
his Rule below his heart, Francis gazes entreatingly toward Anthony
and raises his hand as if preaching. The intent expressions of the
saints convey their empathy with Jesus's suffering that lay at the
heart of the Order's spirituality, as expressed in the writings of
Saint Bonaventure (1221–74), author of the authoritative life of
Saint Francis and one of the Order's greatest theologians. To the
right of the Virgin, Saints Cosmas, Damian and the Dominican
Peter Martyr join them in veneration. Peter Martyr's presence

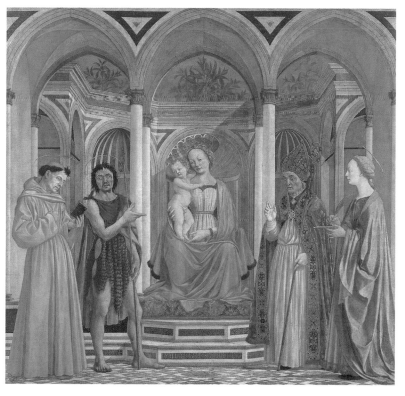

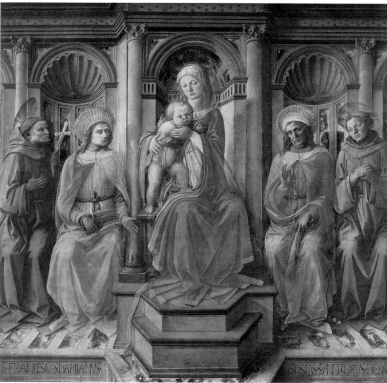

proclaims the crucial involvement of Piero de' Medici, Cosimo's eldest son and eventual successor, in the commission. By the late 1440s, Piero had begun to enter the arena of public patronage independently of his aging father. The prominence of his patron saint in the foreground suggests that the altarpiece may have possibly been the first of his own commissions.

Dressed in radiant, crimson robes, two praying angels flank the Virgin's throne. Angels pervaded Franciscan spirituality, as expressed in the writings of Saint Bonaventure and other of the Order's theologians. A medieval Franciscan treatise, still influential in the fifteenth century, described the celebration of Mass as an 'angelic office', in which the friars sang psalms 'devoutly before the angels', who were deemed to be 'present beside them'. The angels in the *Bosco ai Frati Altarpiece* evoked these celestial associations for the Observant Franciscans who celebrated Mass and prayed before it.

Significant differences between the *Bosco ai Frati Altarpiece* and the work that inspired it reveal Angelico's maturation over the course of nearly two decades. Architecture and perspective are assured and convincingly rendered, reflecting the influence of the friar's years in Rome and his exposure to its monuments. The sculptural figures, softly modelled and volumetric compared to those in the *Annalena Altarpiece*, suggest Angelico's response to the somewhat earlier *Saint Lucy Altarpiece*, painted by Domenico Veneziano, who had risen to prominence in the late 1430s and early 1440s, when Angelico was completing his works for San Marco (138). The limpid, subdued colours, especially the pale rose niches of the architecture, also correspond to those of Domenico's altarpiece, although the reverence of the portrayal, epitomized by the Virgin and Child, emerges from Angelico's earlier work. Mary's gaze is mournful and introspective as the infant clings to her. Standing behind them, the angels share their grief. In accord with the spirituality of Saint Francis, who dedicated his Order to Mary, the Observants emphasized her compassion for Jesus that she mercifully extended to all humankind. For Saint Bernardino, the Virgin was 'the mother of all the chosen and all the weary', at once the most humble of women and the Queen of Heaven. Her sorrowful gaze foretells the suffering that she experienced when she saw, as Bernardino wrote, 'her own flesh, with whom she had lived for thirty-three years', dying on the Cross. Displaying the entombed and bleeding Christ as Man of Sorrows, the central predella panel poignantly underscores Jesus's Eucharistic sacrifice.

The predella is unique in Angelico's work. Instead of depicting narratives, the friar portrayed half-length figures enclosed in shell-like niches against a golden ground. Recalling predellas of fourteenth-century Tuscan polyptychs, this archaic format may have been intended to recall the appearance of the church's original altarpiece, now lost. Closest to Christ, Peter and Paul gaze upon him directly, for as martyrs, they empathetically experienced his suffering. Dominic, Jerome and Benedict hold the books of the Orders with which they are associated. Of all the saints in the predella, only Bernardino of Siena regards the worshipper directly. This fervent preacher promoted the reform of the Franciscan Order, including the congregation of Bosco ai Frati. His presence

140
Fra Angelico and assistants, *Mystic Wheel* and *Scenes from the Life of Christ*, from the *Annunciation* to *Christ among the Doctors of the Temple*, detail of *Santissima Annunziata Silver Chest*, begun *c.*1451–2
Tempera and gold on panel; 123 × 123 cm (48½ × 48½ in)
Museo di San Marco, Florence

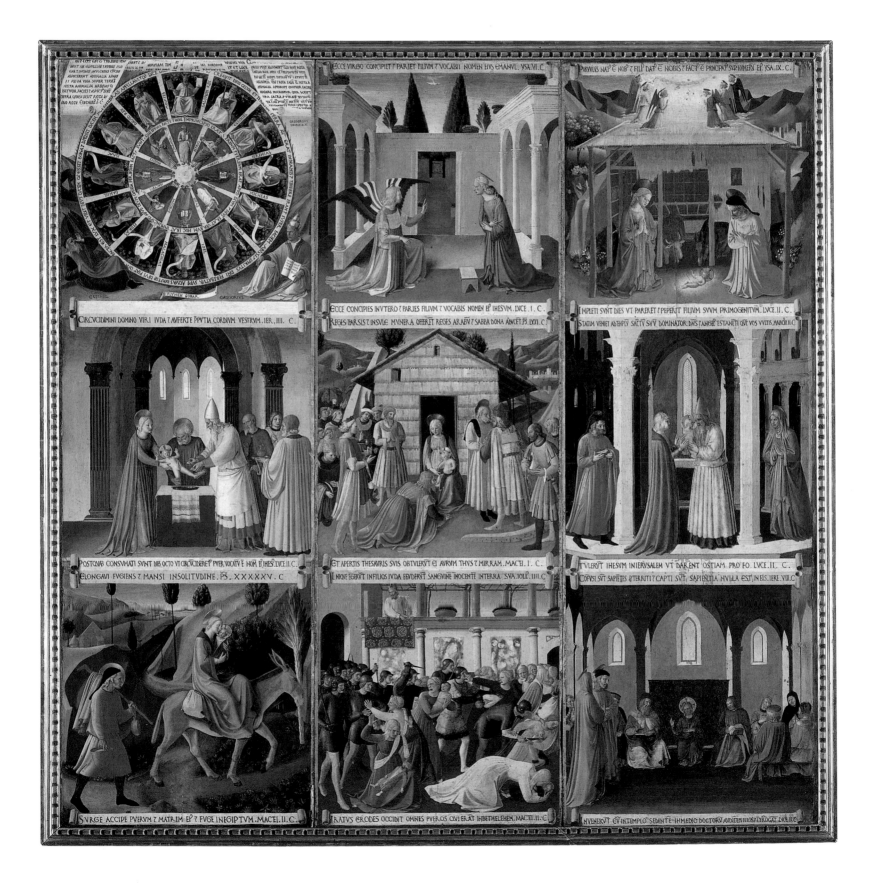

commemorates his role in renewing the Order as well as his devotion to Christ, whose name in Greek (IHS), surrounded by golden rays, he displayed when he preached, as in this depiction. Contemporaries recognized his holiness, for he was canonized only six years after his death.

The altarpiece is among the most moving of any that Angelico painted. The rapport between the Virgin and Child seems suffused with tenderness, evoking their humanity. Instead of emphasizing Mary's role as Queen of Heaven, Angelico portrayed her as mother of humankind. Jesus does not bless the devout or proffer the globe of the universe, as in the *San Marco Altarpiece* (see 84), but seeks the Virgin's protection. The empathy of the Franciscan saints, especially the yearning gaze of Anthony of Padua, conveys the pathos emphasized in accounts of their lives. In the *Bosco ai Frati Altarpiece*, Angelico movingly expressed the compassionate spirituality of the Franciscan Order, which he had interpreted a decade earlier, portraying an anguished Saint Francis kneeling in the *Grand Crucifixion with Saints* (see 95) in San Marco.

A comparison between the *Bosco ai Frati Altarpiece* and the nearly contemporary altarpiece by Fra Filippo Lippi for the Novitiate Chapel in Santa Croce, the Franciscan mother church in Florence, underscores the differences between the two masters (139). Although the Medici commissioned both for Franciscan congregations, each artist approached his subject differently. Fra Filippo enthroned the Virgin and Child within a similar architectural setting, but the elements, painted in sombre grey and dark green, are more muscular and firmly defined. His command of perspective is less assured than Angelico's, for the floor and base of the throne are steeply foreshortened. The anatomy of the figures is massive and sculptural, most evident in the chubby infant, who grasps the Virgin's breast. The sorrowful faces and yearning postures of the saints convey the depths of their inner lives. Fra Filippo introduced a profoundly realistic and emotional conception of the sacred to Florentine painting. Within years, it would replace the idealized paradigms established by Angelico.

Angelico's next commission was for a massive painted cabinet to protect the precious silver votive offerings at Santissima Annunziata, among the most venerable churches in Florence (141, 142, 143). The *Silver Chest* may have been the most visible of the friar's works by virtue of the site for which it was made. Santissima Annunziata was the motherhouse of the Servites (Servants of Mary), founded by Saint Filippo Benizzi (*c*.1233–85), the only religious Order that originated in Florence. For reasons of civic pride, it came to define ideals of piety for its citizens. The sacrality of the church was augmented further when, as legend recounted, an angel completed the fresco of the *Annunciation* (See Chapters One and Two). Servite historians date this miracle to 1252. Almost immediately, the image began performing miracles. By the early fifteenth century, the *Annunciation* had become the centre of a major cult, receiving donations of precious silver. So intense was devotion to this miraculous image that the Chapel of the Annunciation had its own liturgical ceremonies. In the late 1440s, Michelozzo renovated Santissima Annunziata at the behest of Piero de' Medici

141
Fra Angelico and assistants, *Mystic Wheel*, detail of *Santissima Annunziata Silver Chest*, begun *c*.1451–2
Tempera and gold on panel; 40 × 40 cm (15¾ × 15¾ in)
Museo di San Marco, Florence

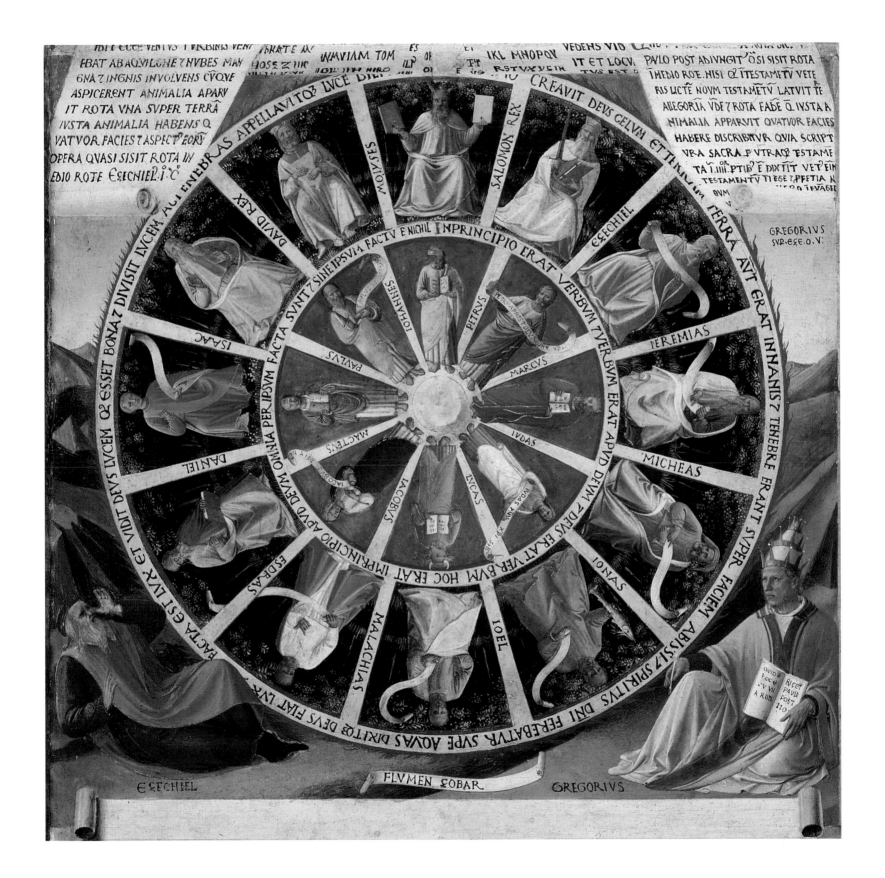

203

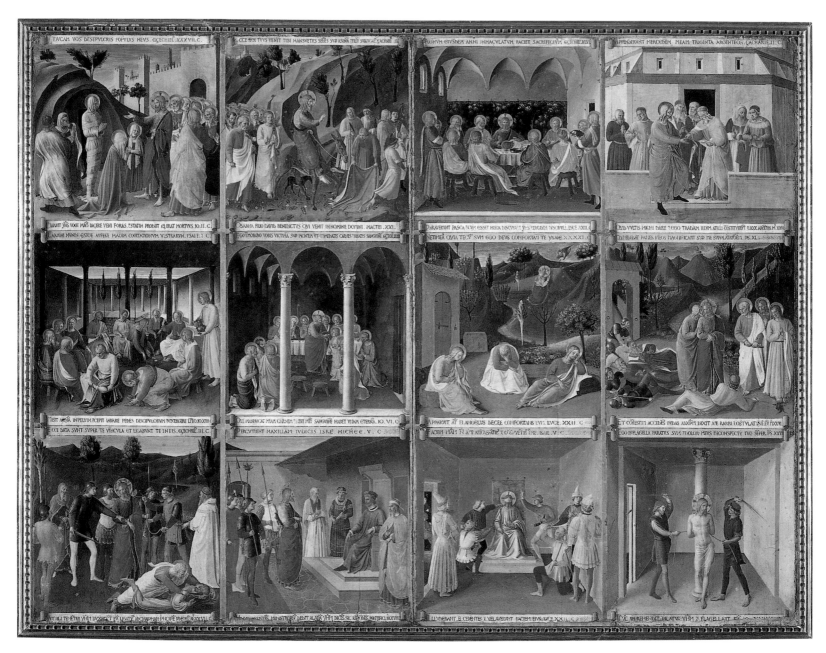

142
Fra Angelico and assistants, *Scenes from the Life of Christ*, from the *Raising of Lazarus* to the *Flagellation of Christ*, detail of *Santissima Annunziata Silver Chest*, begun c.1451–2
Tempera and gold on panel; 123 × 160 cm (48½ × 63 in)
Museo di San Marco, Florence

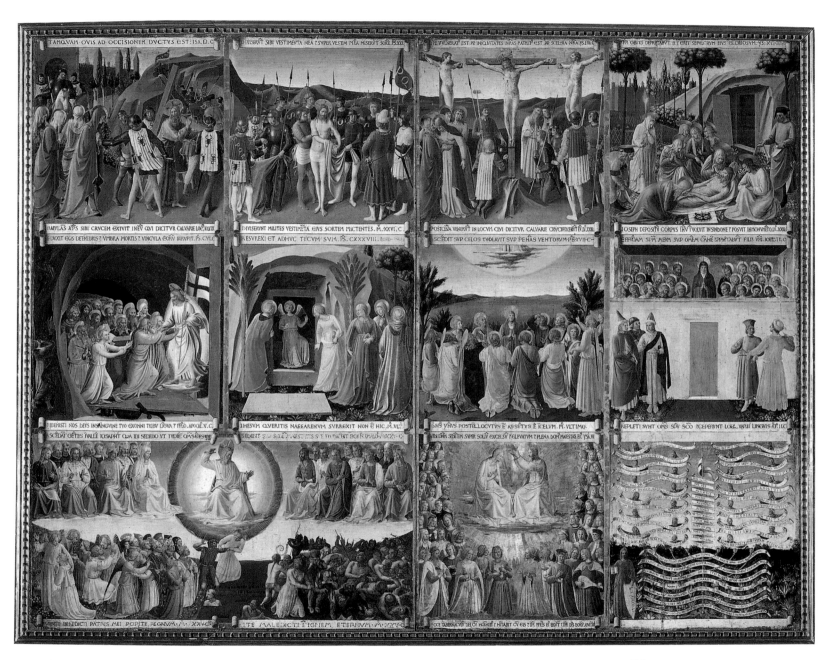

143
Fra Angelico and assistants,
Scenes from the Life of Christ, from
the *Carrying of the Cross* to the
Lex Amoris, detail of *Santissima
Annunziata Silver Chest,* begun
c.1451–2
Tempera and gold on panel;
123 × 160 cm (48½ × 63 in)
Museo di San Marco, Florence

to accommodate the throngs of worshippers who flocked to behold the sacred image. Piero assumed patronage of the *Annunciation*, enshrining it in a costly marble tabernacle in order to enhance his private devotion. To safeguard the silver offerings to the *Annunciation*, he commissioned a wooden cabinet, the moveable shutters of which Angelico painted.

The *Chronicle* of Benedetto Dei (*c*.1460) reported that the friar received the commission from Piero in 1448. However, at that time, Angelico was still in Rome. The cabinet's decoration almost certainly coincided with his return to Fiesole and the completion of Piero's oratory between 1451 and 1452. On 23 October 1451, the bursar of San Domenico paid the considerable sum of two florins on Angelico's behalf for paper to the bookseller Vespasiano da Bisticci, who was Cosimo's own stationer. Angelico may have used the paper to compose and co-ordinate the many episodes of the *Silver Chest*.

Theologically, the *Silver Chest* is perhaps the most intricate of Angelico's paintings. Thirty-five scenes depict the life of Jesus, from the prophecies of his birth to the Last Judgement. Latin texts from the Old and New Testaments are inscribed on scrolls unfurled above and below the episodes. The inscriptions illuminate the meaning of every scene. They followed the fundamental principle of Christian biblical exegesis, inspired by Jesus's own words at the Crucifixion, which he likened to 'Moses lift[ing] up the serpent in the wilderness' (John 3:14). Following Christ's example, theologians from the fourth-century Church Fathers on deemed that the events of the Old Testament foretold and illuminated the New. As Christian exegetes proclaimed, the relationship between the two Testaments was key to unveiling the hidden meaning of Scripture, revealing God's plan for humankind.

This over-arching theme was introduced with the *Mystic Wheel*, the first scene of the *Silver Chest* (141). The *Mystic Wheel* illustrates an apocalyptic prophecy from Ezechiel and its interpretation by the sainted Pope Gregory the Great (reigned 590–604), one of the most esteemed biblical commentators. For Saint Gregory, the prophet's celestial vision of the 'wheel within a wheel' (Ezechiel 1:15–21) prefigured the reciprocity between the two Testaments. He explained how these concentric wheels formed a 'single wheel' so that 'the New Testament is thus the Old'. Angelico included both Ezechiel and Saint Gregory in the mountainous landscape below a fiery wheel. Parallel passages from their writings are inscribed on scrolls floating in the heavens. Prophets, evangelists and the authors of the Epistles are portrayed between the spokes. On the outer wheel, verses from the opening of Genesis (1:1–5) recount how God created the world, dividing dark from light and earth from sky. The inner wheel is inscribed with the introductory verses of John's Gospel: 'In the beginning was the Word, and the Word was with God and the Word was God. He was in the beginning with God; all things were made through him, and without him was not any thing made that was made.'

Throughout the cycle, parallel and prophetic texts amplify the resonance of every scene. In the *Annunciation*, the quotations from the Book of Isaiah and the Gospel of Luke are virtually identical in phrasing, confirming, according to Christian exegesis, that Isaiah's

144
Fra Angelico and assistants, *Annunciation*, detail from *Santissima Annunziata Silver Chest*, begun *c*.1451–2
Tempera and gold on panel;
40 × 40 cm (15¾ × 15¾ in)
Museo di San Marco, Florence

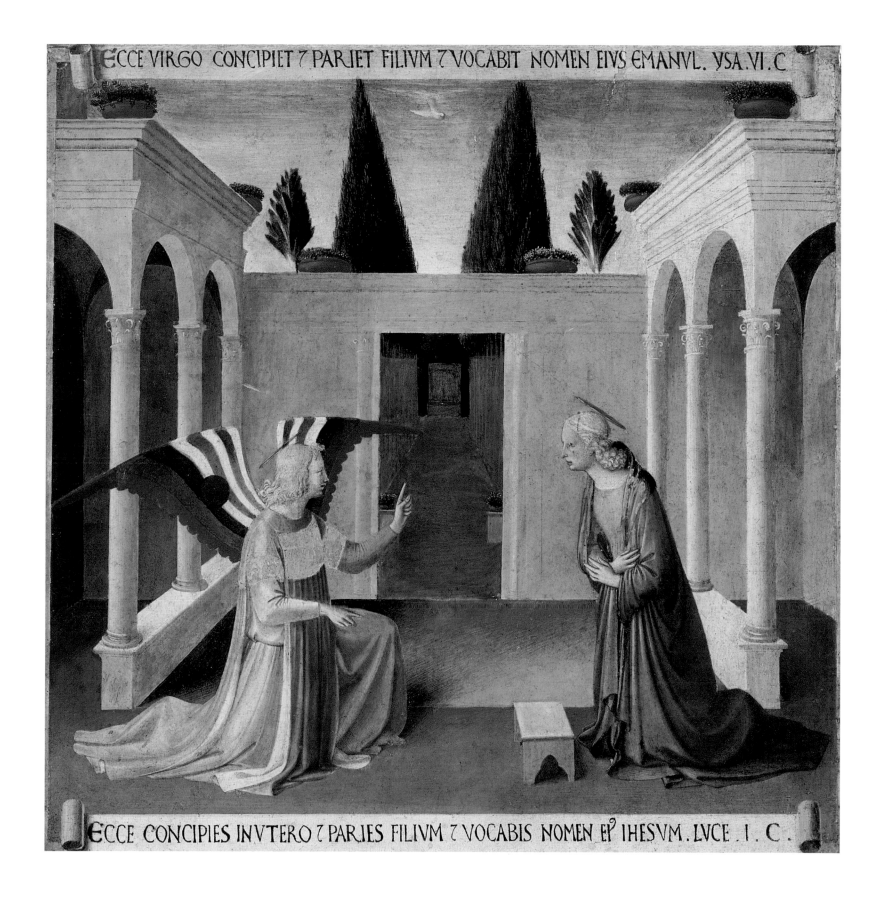

ECCE VIRGO CONCIPIET 7 PARIET FILIVM 7 VOCABIT NOMEN EIVS EMANVL. YSA.VI.C

ECCE CONCIPIES INVTERO 7 PARIES FILIVM 7 VOCABIS NOMEN EI IHESVM .LVCE .I. C .

prophecy was fulfilled through the Incarnation and divinely ordained. Along these lines, the text from Ezechiel (37:12) inscribed above the *Raising of Lazarus* foretells God's resurrection of the dead from their tombs, an allusion to the Last Judgement (142). The scroll above the *Crucifixion* reminded the faithful how 'he was wounded for our iniquities', while the one below, taken from Luke 23:33, recounted how 'they came to the place called Calvary and crucified him' (143). The final scene in the *Silver Chest*, known as the *Lex Amoris* (Law of Love), includes more inscriptions than any other panel. From the heavens to the horizon, Hebrew prophets unfurl billowing scrolls with quotations from their writings and from the liturgy. Seven scrolls defining the seven sacraments of the Church are woven through a golden menorah, symbolic of Judaism, surmounted by the Cross. According to Christian thought, this signified the triumph of Christianity over Judaism. The abundant inscriptions of the cycle proclaim the truth of the quotation from John (1:1–3) in the *Mystic Wheel* that began the cycle. It attests the omnipotence of God and the divine Word that existed 'in the beginning' and, according to Christian thought, was made flesh in Jesus.

As a Dominican, Angelico was steeped thoroughly in the traditions of biblical exegesis. As a consequence, his works were among the most theologically sophisticated of his day. Although the *Silver Chest* has been described as a *summa* of his beliefs on sacred art, his role in proposing the inscriptions and subjects of the *Silver Chest* must not be assumed. The opposite is likely to have been true. Angelico himself did not paint the inscriptions, which are characterized by uneven letters and inconsistent spacing, for his own writing, preserved in notarial documents, is beautifully shaped. They were added later, when all of the scenes were complete. Furthermore, the Servite Order had its own liturgies, beliefs and devotions. They focused on the Passion of Christ and the sorrows of Mary. These themes, represented on the *Silver Chest*, express a Servite sensibility. One of the Order's luminaries, the learned Fra Mariano Salvini (died 1476) may have devised the programme that Angelico followed. Fra Mariano was the vicar of the Annunziata and in charge of the church's renovation and decoration between 1451 and 1452, when the *Silver Chest* was being painted. A fifteenth-century Servite chronicle recorded his 'fame and glory' as a theologian and preacher, while immortalizing his close relationship with Piero de' Medici. Documents attest his personal engagement in all aspects of the church's reconstruction, from raising funds to choosing Michelozzo as architect and augmenting the convent's library. The library's holdings were extensive. They included numerous Bibles, concordances, sermons and accounts of saints' lives, as well as writings by Pope Gregory the Great, whose commentary on Ezechiel inspired the first scene of the *Silver Chest*. They would have provided textual support for the programme of the panels and their inscriptions.

A specific source for the *Silver Chest*, a fourteenth-century *Biblia pauperum* (*Bible of the Poor*), has recently been proposed. 'Bibles of the Poor' were illustrated, medieval manuscripts that glossed and juxtaposed episodes from the Gospels with texts from the Old Testament. Their illustrations encompassed the life of Jesus and included most of the events depicted in the *Silver Chest*. Yet while there are evident similarities between this type of Bible and the *Silver Chest*, their relationship is perhaps more apparent than real. As with the inscriptions on the *Silver Chest*, the juxtaposition of texts in the *Biblia pauperum* was by no means unique. Rather, it emerged from the rich traditions of biblical exegesis established in the early Church and implicit in countless cycles of Christian art as early as Roman catacomb paintings from the first centuries of Christianity. Furthermore, the rudimentary compositions in the *Biblia pauperum*, which are virtually devoid of background or embellishment, bear little resemblance to Angelico's scenes, which are highly illustrative, detailed and populous. Although the *Silver Chest* has been described as 'miniature-like' because the episodes seem relatively diminutive, its conception is monumental. Space flows continuously from scene to scene, conveying the movement of the narrative and uniting the panels in its sweep.

It now is impossible to see the *Silver Chest* as Angelico originally must have imagined it. Within a decade of its creation, Alesso Baldovinetti (1427–99) painted three more scenes for the chest and after 1461 Pietro del Massaio (1420/24–80/96) added six others. Between 1461 and 1463, the shutters were united into a single panel that was raised and lowered by pulleys to facilitate access to the precious silver. In later years, the panel was cut apart, exposing the edges once covered by a frame. Although the original appearance of the work is lost, the integrity of Angelico's conception is still discernible. The narratives alternate between luminous landscapes, as seen in the *Annunciation*, and darkened interiors, as shown by the scenes transpiring in the Temple, where Jesus was circumcised and later preached to the Elders (see 140). The sequence begins with intimate portrayals of Jesus's infancy, as in the *Nativity* (see 140), and concludes with populous images of his public ministry and Passion, as epitomized by the crowds in the *Entry into Jerusalem* (see 142) and *Carrying of the Cross* (see 143).

Each scene is individually framed and lucidly conceived to give primacy to the figures re-enacting the sacred narratives. Events transpire within classicizing architecture or in serene landscapes with atmospheric horizons. Several display Angelico's command of perspective and varied architectural repertoire. The buildings allude to Michelozzo's structures, including the cloister of San Marco (see 93) and the choir of Bosco ai Frati (see 137). Angelico drew further inspiration from Brunelleschi's oratory, then being built for Santa Maria degli Angeli, which became the setting for *Judas Betraying Christ to the Sanhedrin* (see 142). In the outdoor scenes of the Passion of Christ, landscape extends continuously behind the gilt frames (see 143). The recession of the towering trees, which calibrates distance, the lofty horizons, and the exceptional variety in the placement, postures, drapery, gestures and faces of the figures reveal the painter's response to the Ghiberti's *Gates of Paradise* (see 53), completed long before their installation at the Baptistery in 1452. Yet while direct borrowings from Ghiberti may be identified here and there, Angelico rejected the sculptor's multi-episodic narratives to articulate each individual event separately. At the same time, the painted panels comprise a visually unified whole.

Although the themes and settings of the scenes are varied, Angelico united the ensemble with consistently scaled figures, architecture and horizons. The *Annunciation* takes place within a deep, open courtyard framed by twin porticos, inspired by the architecture of the church (144). Quite literally, the Word illuminates the space, as seen in the radiant arcade, suffused with divine light, behind the Virgin. Perhaps in allusion to the miraculous image at the Annunziata or because of the scene's diminutive scale, Angelico did not include the expulsion of Adam and Eve, which appears so prominently in his altarpieces of the Annunciation. He focused instead on the solemn colloquy between the Archangel and Mary, who kneels to accept the will of God. Several scenes, including the *Circumcision* (see 140) and *Christ among the Doctors of the Temple* (see 140), are situated within crystalline architecture inspired by the choirs of Michelozzo's classicizing churches. These dimly lit interiors and receding walls evoke the aura of sacred space and create a convincing illusion of depth. In the *Nativity* (see 140), *Flight into Egypt* (see 140) and *Agony in the Garden* (see 142), shadowed, undulating hills serve as a perfect background for the brilliantly coloured figures re-enacting the pious dramas within them. The continuous landscapes between the *Carrying of the Cross* and the *Lamentation* (see 143) descend in the *Stripping of Christ* and the *Crucifixion* (see 143) to frame the dolorous scenes. In the final scenes (see 143) of the *Last Judgement*, *Coronation of the Virgin* and *Lex Amoris*, the placement of figures against the lofty heavens conveys that earthly time has passed, giving way to the millennium and the realization of Paradise through divine grace.

Although Angelico conceived the compositions for the *Silver Chest*, several critics attribute the painting of only eight or nine scenes to him, all from the infancy of Christ (see 140). They are indeed distinguished by their luminous surfaces, radiant colours, convincing settings and the expressive grace and emotion of the figures. In the *Circumcision*, for example, the volumetric figures and their flowing drapery are modelled in subtly graduated colours with values that reveal a consistent source of light. From the recessed apse to the radiant frames of its windows, glowing with reflected light, the Temple conveys a believable illusion of depth. While the Virgin's serene expression in offering her son is idealized, Angelico's depiction of the lifted head and outstretched arms of Jesus realistically portrays the Moro (startle) reflex seen in newborns. The *Flight into Egypt* reveals the same sensitivity to light, which glows on the back of Joseph's pale saffron garments and glides across the contours of the hills and the misty horizon.

While there are exceptions, such as the *Flagellation of Christ* (see 142) and the *Lamentation* (see 143), several of the later scenes appear inferior in execution. Colours lack the luminosity and subtle range of modelling seen in the early panels. Bright yellows found nowhere else in Angelico's palette appear throughout these later scenes, and surfaces are flat and unmodulated. The proportions of the figures are elongated and their faces are inert. Close scrutiny reveals that some scenes, most notably the *Descent into Limbo* (see 143), have been extensively repainted and their

condition has been compromised, as in the *Last Judgement* (see 143). At the same time, the disparities between the early scenes and most of the later ones indicate that Angelico did not complete the scenes of the *Silver Chest* alone. Some of the figures, most notably those in the *Lex Amoris* (see 143), recall those in choir books from the late 1440s and early 1450s by Zanobi Strozzi, by then a well-established master (145). Others were likely to have been completed later. They include the *Nativity* (see 140), which may have been executed after Angelico's death by Benozzo Gozzoli. In spring 1459, nearly a decade after his departure, Benozzo returned to Florence to paint the famous *Journey of the Magi* in the chapel of the Medici Palace, a commission which Piero de' Medici supervised.

While scholars may concern themselves with the attribution of the panels, the friar's own contemporaries perceived little qualitative distinction between them. Writings of the day praised the *Silver Chest* among the church's 'great treasures' and record how offerings and visits to the Annunziata increased as the 'populace crowded together to see' the scenes. In the eyes of his contemporaries, the *Silver Chest* was among Angelico's most beautiful works. Comprising the most comprehensive narrative of Jesus's life in the friar's art, the scenes are remarkable for the restraint of their drama, the lucidity of their compositions, the continuous space that unites the scenes and the characterization of figures. The *Silver Chest* is not a *summa* of the friar's theology, as some have claimed, but of his art. It is the last painting that can be ascribed with certainty to his final years.

Angelico was still in Fiesole between March and April 1452, when the magistrates of Prato Cathedral tried to persuade him to fresco the high altar chapel. The Cathedral preserved the most sacred relic in the city, the belt given to Saint Thomas by the Virgin as she ascended to heaven. Located 17 kilometres (10.5 miles) from Florence, Prato had engaged many illustrious Florentine artists to adorn the Cathedral. Less than two decades earlier, Donatello and Michelozzo had carved the pulpit from which the precious belt was displayed on special feast days. Well aware of Angelico's renown, the magistrates carefully planned how they would persuade him to accept the commission. They secured the intervention of Antoninus, then archbishop of Florence, to bring him to Prato. Two eminent officials from the city personally accompanied 'the master of painting' from Fiesole to inspect the chapel and discuss the commission. After a visit lasting only a day, he returned to San Domenico, having declined their offer. His reasons can only be surmised. Perhaps he recalled his experience with the magistrates of Orvieto Cathedral, who could not muster sufficient funds to pay him (see Chapter Six). He might well have felt obliged to complete the *Silver Chest* before undertaking another project. Maybe he was unwilling to undertake a project of such magnitude without Benozzo. It is also possible that his health precluded acceptance of this commission. It would have required him to climb the lofty scaffolding of the chapel, which would have been difficult in light of the arthritis that afflicted him. That May, the younger Filippo Lippi, then forty-six years old, agreed to begin the frescos.

146
Domenico Sisto Fiorentino and Ristoro da Campi, Interior of Santa Maria sopra Minerva, Rome, begun 1280 (restored 1848–55 by Girolamo Bianchedi)

147 Opposite, top
Annunciation from Juan de Torquemada, *Meditationes* (published Rome, Ulrich Han, 1467) Hand-coloured woodcut Biblioteca Apostolica Vaticana, Rome

148 Opposite, bottom
Annunciation from Juan de Torquemada, *Meditationes*, MS 973 Pen and ink on parchment Biblioteca Apostolica Vaticana, Rome

Due in part to the insolvency of the magistrates, the chapel was not finished until January 1466. By then, Angelico had been dead for nearly eleven years.

On 2 December 1454, Angelico, along with Filippo Lippi and Domenico Veneziano, was nominated to appraise frescos that Benedetto Bonfigli was painting in the Priors' Palace in Perugia. All three masters had painted works for the city and this honour attests the esteem in which they were held. At the same time, the reference discloses no information about their activity or location. By late summer 1461, when Bonfigli ultimately completed the frescos, only Filippo Lippi was still alive.

Nothing is known about Angelico's whereabouts between April 1452 and 18 February 1455, when an obituary recorded his death in the Dominican convent of Santa Maria sopra Minerva in Rome. The reason for his journey there is unknown. Scholars have suggested that the aged Pope Nicholas V may have summoned him to begin a project, but there is no record in the papal archives of any commission involving Angelico at this time.

Far more intriguing is the possibility that he made his final visit to Rome to work in the convent where he died. By the mid-fifteenth century, Santa Maria sopra Minerva had become the major church of the Dominicans in Rome, housing the tombs of its most eminent cardinals and the Order's renowned mystic, Saint Catherine of Siena (1347–80) (146). Among its greatest benefactors was the Dominican Cardinal Juan de Torquemada, the leading theologian of the papal court from 1439 until his death in 1468 (see Chapter Six). Among his charitable activities, Cardinal Torquemada subsidized the expansion of Santa Maria sopra Minerva, dedicating himself as well to the friars' spiritual and intellectual formation. In 1461, he was entrusted with reforming the convent as an Observant congregation. To this end, he wrote an illustrated devotional guide, known as the *Meditationes* (*Meditations*), which is preserved in several manuscript versions, including one in the Vatican Library. It comprises thirty-four 'contemplations' devoted to biblical themes, from the Creation to the Last Judgement, as well as subjects specific to the Order, such as *Saint Dominic and the Dominican Tree*. The pen-and-ink illustrations in two of the manuscripts portray a Dominican friar as a mediator between image and beholder. Beneath each scene, a commentary written by Torquemada invited the viewer to meditate upon its meaning (148)

Torquemada ensured an audience that extended far beyond the convent walls by issuing the *Meditationes* as a printed book with woodcuts. Ulrich Han, a German printer established in Rome, published it in 1467 (147). As the first illustrated book produced on a printing press in Italy, the *Meditationes* is of exceptional historic importance. Its introduction states that these 'most devout contemplations by the most reverent father', Torquemada, were 'on the walls' in the cloister of the Minerva. The murals were executed in *terra verde*, a green pigment used to simulate the appearance of relief sculpture. Lengthy inscriptions below each scene explicated content and meaning, uniting text and image. Exhorting the beholder to ponder the images, they were intended to shape the spirituality of the friars who passed through the cloister. Numerous

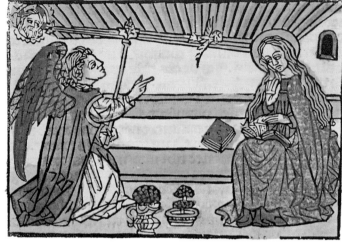

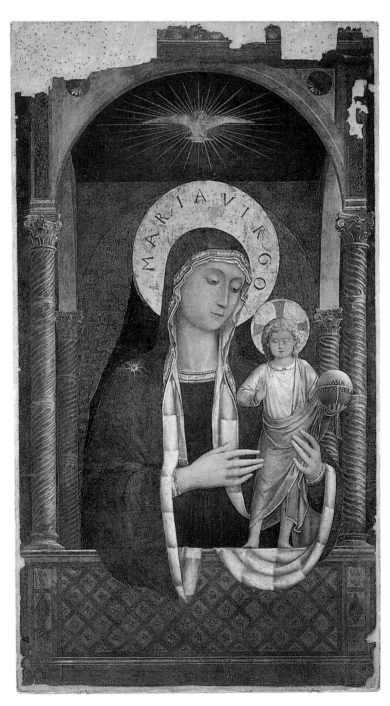

149
Benozzo Gozzoli, *Madonna and Child*,
*c.*1447–8
Tempera on silk (transferred to panel);
254 × 130 cm (100 × 51¼ in)
Santa Maria sopra Minerva, Rome

writers describe 'the most devout contemplations' with their 'most ornate figures', lauding them as 'most beautiful'. Regrettably, the murals were destroyed in the late sixteenth century, when the medieval cloister of the Minerva was rebuilt. While early sources praise the images effusively, they neglect to name the master who created them.

Although the lost frescos have been ascribed to Antoniazzo Romano (*c.*1430–1508/12) and Melozzo da Forlì, masters whose activity was centred in Rome, they also have been attributed to Fra Angelico. It is certain that Torquemada, a Dominican member of the papal court who resided in the Minerva, knew the friar. As has been suggested here, he may even have composed the programme for the Chapel of Nicholas V (see Chapter Six). Yet while it is apparently logical to associate the frescos with Angelico's stay in the Minerva, the claim is difficult to support. The images from the *Meditationes* provide the only evidence for considering this question, but a specific relationship to Angelico's works cannot be pinpointed. And although the manuscripts and woodcuts are presumed to replicate the lost cycle, their illustrations truly do not look alike. This may be demonstrated by a comparison between both versions of the Annunciation (147, 148). Each portrays the scene in an architectural setting, as was conventional, but they differ greatly. The architecture is simplified and incorrectly foreshortened, displaying an elementary command of perspective. Neither displays the rhythmic recession characteristic of Angelico's work.

Similar observations may be made with respect to other scenes. In outdoor depictions such as the *Adoration of the Magi* and *Flight into Egypt*, the landscapes are rudimentary indications of place, with linear hills and horizons. Following tradition in their compositions and iconography, the portrayals in the *Meditationes* are conventional and undistinguished. Instead of confirming that Angelico executed the lost frescos, they fail to establish an attribution to him. It seems more plausible, as has recently been proposed, that the cycle was commissioned in 1461, when Torquemada was charged with reforming the Minerva. Like the didactic paintings in San Marco (see Chapter Five), these images would have shaped the spiritual and moral lives of the friars, although they bear little relationship to the Florentine frescos.

Angelico's reasons for coming to Rome thus remain an enigma. A processional banner in the Minerva and a fresco in the church of Santi Domenico e Sisto were once ascribed to the master, but they have since been recognized as Benozzo Gozzoli's work (149). Given their Dominican patronage, they originally may have been commissioned from Angelico. Indeed, in the final year or so of his life, the severe arthritis that afflicted the friar must have compromised his ability to paint, possibly even precluding it. Is it possible that Torquemada invited him to Rome because his exemplary spirituality, formed in the Observant convent established

by Giovanni Dominici at the beginning of the century, would have inspired the friars of the Minerva? His obituary praises his piety as much as his expertise as a painter, lauding him as 'a man of devout sanctity, and the greatest skill in the art of painting'.

Fra Angelico died in the Minerva on 18 February 1455. Instead of being laid to rest in the cloister, he was accorded the extraordinary honour of burial within the church. The humble friar who had forsaken wealth was laid to rest in a fine marble sepulchre facing the altar of the Chapel of Saint Thomas Aquinas, a most privileged location. (The tomb has since been moved.) Isaia da Pisa (active 1447–64), who carved the tomb of Pope Eugenius IV, portrayed the life-sized effigy (150). The sculptor represented Angelico with his head resting on a cushion and his hands serenely crossed in death. Cherubs in the spandrels of the arch pay homage to the friar. An inscription at the friar's feet proclaims, 'Here lies the painter Friar Giovanni of Florence of the Order of Preachers 14LV [1455]'.

Carved in stone, two epitaphs were affixed to the wall of the chapel. One, written in two rhyming Latin couplets and speaking in the voice of the deceased, was directed to the beholder:

> *Do not praise me because I was, as it were, another Apelles*
> *But because to you, O Christ, I donated all my wealth.*
> *Of my works, some remain on earth; others are in Heaven.*
> *The city that gave me, Giovanni, birth is the flower of Etruria.*
> *MCCCCLV*

The other lamented his passing:

> *Glory, mirror and splendour of painters, Giovanni the*
> *Florentine, is laid in this place.*
> *He was a religious, a friar of the Holy Order of Saint Dominic*
> *And likewise a servant of God.*
> *His disciples, bereft of so great a master, mourn him.*
> *Who could ever find a brush like his again?*
> *Let Fatherland and Order weep for the loss of a supreme master*
> *Of whom there was no equal in the art of painting.*

The epitaphs are ascribed to Fra Domenico di Giovanni da Corella (*c*.1403–83), Vicar General of the Dominicans from 1451 to 1454. His famous poem about churches dedicated to the Virgin, the *Theotokon* (1469), lauded the fame, skill and virtuous nature of the 'Angelic painter (*Angelicus pictor*) named Giovanni'. Within the context of Dominican culture, the description of the friar as 'Angelicus' carried extraordinary resonance. The adjective previously had been applied only to Thomas Aquinas, called the 'Angelic doctor', in allusion to his divinely inspired knowledge. No greater accolade could have been bestowed upon the friar. Within years of his death, the artist known in his lifetime as Fra Giovanni da Fiesole had been immortalized as the angelic friar, Fra Angelico.

150
Isaia da Pisa, *Tomb of Fra Angelico* (detail), after 1455
Marble; life-size
Santa Maria sopra Minerva, Rome

8
Afterlife
The Legacy of Fra Angelico

Unlike many Renaissance artists who faded into obscurity soon after their death, Angelico enjoyed great renown in the years that followed his passing. Establishing the view that has prevailed to this day, the friar was remembered for his piety as much as his art. Well into the sixteenth century, authors of prose and poetry extolled the virtues immortalized by the epitaphs of his tomb. Fra Domenico da Corella's description of the friar as *Angelicus pictor* (1469) was soon evoked by the humanist writer Cristoforo Landino (1424–98) in his commentary (1481) to Dante's *Divine Comedy*. In praising the greatest Florentine artists, Landino proclaimed the painter 'angelic' as well as 'graceful and devout', while lauding his 'supreme expertise'. Writing from the court of Urbino, Giovanni Santi (1430/35–94), a painter himself and the father of Raphael (1483–1520), glorified 'Giovanni of Fiesole' as a 'friar ardent for good' in a poem on the Duke of Urbino. A member of Angelico's own Order, Fra Girolamo Borselli (died 1497), commemorated the painter's angelic spirituality in his biographies of illustrious Dominican men. He immortalized the friar as *beatus* (blessed), a term with specific connotations for Dominicans. In his discourse 'On the perfection of the angels in the Order of Grace and of Glory', Saint Thomas Aquinas declared that beatitude was a state of grace enjoyed by angels, representing 'the ultimate perfection of rational or of intellectual nature' (*Summa theologica* 62:1). For those who led exemplary lives, beatitude represented spiritual perfection that nearly approached sainthood. Interpreted in this light, Borselli's description of the painter as *beatus* implied a most blessed state. In 1517, another Dominican author, Fra Leandro Alberti, acclaimed the friar as 'a man devoted to sanctity'.

Writers were not alone in elevating Angelico to so exalted a spiritual state. In 1499, the painter Fra Bartolommeo (also known as Baccio della Porta) (1472–1517) portrayed him in the heavens among the saints in his monumental fresco of the *Last Judgement* for Santa Maria Nuova, Florence (151). Inspired not only by the apocalyptic preaching of Savonarola (1452–98), but perhaps also by Angelico's transcendent example, the artist took holy orders at San Marco and became known as Fra Bartolommeo. Inhabiting the convent whose walls Angelico had frescoed more than half a century earlier, he established a workshop devoted to the creation of sacred art. Around this time, Luca Signorelli depicted Angelico by his side in the *Preaching of the Antichrist* (see 4, 120) in the Chapel of San Brizio, Orvieto Cathedral, recognizing his predecessor's role in the chapel's conception and commemorating a piety that was widely acknowledged (see Chapter Six). Perhaps most famously, Raphael immortalized the aged friar with prophets, cardinals, saints and the greatest theologians of all time in the *Disputà*, the fresco representing the realm of faith, in the Stanza della Segnatura in the Vatican Palace (see 3, 152). Standing humbly to the side, Angelico is the only painter among them, his eyes lifted to a celestial vision of the enthroned Christ.

Images and writings that celebrated this 'saintly' and 'marvellous master of painting' inspired Giorgio Vasari in 1568, when he composed the second edition of *Le vite de' più eccellenti pittori scultori ed architettori* (*Lives of the Most Illustrious Painters,*

Previous page
Detail of Fra Angelico (fourth from left) among the saints in *Last Judgement* (151)

151
Fra Bartolommeo (modified by Mariotto Albertinelli), *Last Judgement*, 1499
Fresco (detached)
Museo di San Marco, Florence

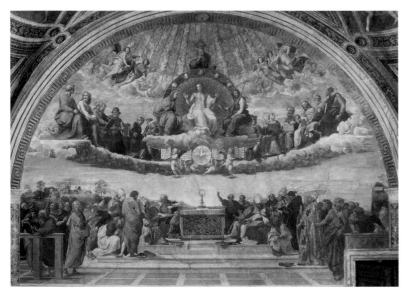

152
Raphael, *Disputà*, 1508–11
Fresco
Stanza della Segnatura, Vatican Palace,
Rome

153 Opposite, top
Franz Pforr, *Raphael, Fra Angelico
and Michelangelo over Rome*, 1810
Pencil on paper; 31.1 × 20 cm
(12¼ × 7⅞ in)
Städelsches Kunstinstitut, Frankfurt
am Main

154 Opposite, bottom
Johann Friedrich Overbeck, *The
Triumph of Religion in the Arts*, 1840
Oil on canvas; 389 × 390 cm
(153⅛ × 153½ in)
Städelsches Kunstinstitut, Frankfurt
am Main

Sculptors and Architects), the most influential history of Italian
art ever written. Invoking for posterity the example of 'this truly
angelic father [who] spent every minute of his life in the service
of God', Vasari believed that 'a talent so extraordinary and so
supreme ... should not descend on any save a man of the most holy
life'. In his evocative account, the works of this 'rare and perfect
talent' seem to have been 'made in Paradise rather than this world',
as if reflecting the virtue of the painter's soul. Celestial imagery
suffuses Vasari's descriptions of the friar's works, whether praising
the Blessed in the *Last Judgement* (see 57), so 'very beautiful
and full of jubilation', or the *Coronation of the Virgin* (see 39) for
San Domenico di Fiesole, whose angels and saints seemed so
exquisite that 'those blessed spirits cannot look otherwise in heaven'.
Such beauty, Vasari believed, appeared 'to be by the hand of
a saint or an angel', explaining why the painter 'was ever called
Fra Giovanni Angelico'.

Vasari's accounts of the friar's personal virtue are equally
compelling. Although some may seem unbelievable to the cynical
reader, they reflect Dominican ideals and, in all likelihood, are true.
The report that he shunned worldly affairs, embraced poverty and
lived chastely accords with the behaviour demanded by the Order's
Constitutions. Vasari's statement that Angelico 'never painted
the Crucifix without tears' or took up 'his brush without saying
a prayer' calls to mind the affective nature of Observant spirituality.
Even Vasari's assertion that Pope Eugenius IV asked the friar to
serve as archbishop of Florence is credible. Several witnesses in the
canonization process of Antoninus (1516–20) confirmed that the
painter humbly declined the honour.

Vasari wrote and revised the *Lives* during a crucial period in
Church history. In 1563, the Council of Trent (1545–63), convened
to reform the Catholic Church, issued its proclamations on sacred
art, emphasizing its role in teaching 'the mysteries of our redemption'
and rejecting all that was 'disorderly' or 'profane'. Acknowledging
the potential of art to provoke 'evil appetites', Vasari, too, rebuked
artists who were disrespectful of 'persons, times and places'
by depicting 'nearly nude' figures in churches. In Angelico, Vasari
found the ideal painter of sacred art, 'in the countenances and
attitudes of [whose] figures one [could] recognize the goodness,
nobility and sincerity of his mind towards the Christian religion'.
The friar's virtue far surpassed that of any artist portrayed in the
Lives, including Fra Filippo Lippi, who seduced a nun in his care,
and Fra Bartolommeo, whose nude *Saint Sebastian* provoked lust
rather than devotion. In Vasari's view Angelico, and Angelico alone,
represented the ideal Christian painter.

Filippo Baldinucci (1624–96) embellished Vasari's moving
portrayal of the friar's life. An artist, historian and connoisseur of
Italian Renaissance art, Baldinucci published *Notizie dei professori
del disegno da Cimabue in quà* (*Notes on Teachers of Drawing
from Cimabue until Now*), a seven-volume history of art in Europe,
in 1686. Citing a chronicle of disputable accuracy, he erroneously
believed that Angelico had become a friar at San Domenico
di Fiesole in 1407. Baldinucci incorrectly presumed that the friar
spent the next decade between Fiesole, Cortona and Perugia until

the Great Schism was resolved. The imagined years of persecution and exile increased the pathos of Angelico's life as recounted by Vasari. Baldinucci's account not only had implications for the dating of Angelico's works, but it also influenced how future generations perceived the friar.

There was little interest in Italian 'primitives' throughout most of the eighteenth century. While the classically inspired art of Raphael, Guido Reni and Annibale Carracci was admired for its suavity and gracefulness, fifteenth-century painting was dismissed for its 'barbarous' medievalism. With the Enlightenment, which emphasized reason and science over faith, the world had become more secular in outlook. Many regarded the Roman Catholic Church as an inconvenient relic of a superstitious and corrupt past. By the late 1700s, regional governments throughout Italy had begun to close religious institutions. In 1808, Napoleon forced the friars of San Domenico di Fiesole to abandon their convent, leaving only a few priests to serve the parish. The following year, the *Coronation of the Virgin* from San Domenico di Fiesole (see 39) was seized for the Louvre. Removed from their original settings and their frames discarded, altarpieces were cut apart. Instead of inspiring faith, they became commodities displayed in museums, galleries and private collections throughout Europe. Within years, this vast dispersion inspired aesthetic and scholarly interest in Italian art, while kindling nostalgia for a lost age of faith. Perhaps more than any other painter, Angelico was deemed to epitomize the spirituality of his era.

Angelico's work was especially esteemed in nineteenth-century Germany, where intellectuals sought to recover the Gothic past and an imagined age of faith. In 1809, several art students from the Vienna Academy departed for Rome, where they formed the Brotherhood of Saint Luke (named after the patron saint of painters), better known as the Nazarenes. They lived communally in the abandoned convent of Sant'Isidoro, hoping to recreate the austere life and purity of artistic expression they ascribed to Angelico. One of the 'brothers', Franz Pforr (1788–1812) imagined the friar in the heavens over Rome between Raphael and Michelangelo, signifying his transcendent faith and parity with the most esteemed masters of Renaissance art (153). Johann Friedrich Overbeck (1789–1869) regarded Angelico as the greatest of artists, praising the purity of 'the soul of the pious [friar from] Fiesole … entirely devoted to heaven', and 'his monastic way of life'. He depicted Angelico in the *Triumph of Religion in the Arts* (154), the composition of which was inspired by Raphael's *Disputà* (152). Here as in his other works, Overbeck contrived a style that flowed 'from feeling and not from acquired skill', like that of 'the seraphic [friar from] Fiesole'.

In nineteenth-century France, Angelico personified the faith of the late Middle Ages and Renaissance that had been lost during the Enlightenment and the French Revolution. One of his most beautiful early paintings, the *Coronation of the Virgin* (see 39), booty from the Napoleonic invasion of Tuscany, had entered the Louvre, where it inspired rhapsodic praise. Although Jean-Baptiste Séroux d'Agincourt (1730–1814), author of a multi-volume history of Italian painting (1811–20), valued the friar's contributions as an artist,

155
Pierre Puvis de Chavannes, *Christian Inspiration*, 1887–8
Oil on paper, mounted on canvas;
105.1 × 129.8 cm (41⅜ × 51⅛ in)
National Museum of American Art,
Smithsonian Institute, Washington, DC

most critics of the day esteemed him more for his piety. In his highly influential book *De la poésie chrétienne* (*On Christian Poetry*) of 1836, Alexis-François Rio (1798–1874) stirringly presented religious sentiment, rather than classicism and naturalism, as the ultimate criterion for judging art. From his perspective, Angelico was the ideal mystic, who 'protected and sanctified his talent in the silence of the cloister', and whose works best expressed the divine. Rio may have inspired the Dominican friar, Henri de Lacordaire (1802–61) to bring a group of artists to Rome, where they lived 'to sanctify themselves' by living and working together. Charles Forbes de Montalembert (1810–70) was among the many critics dedicated to Rio's thought, devoting an entire chapter to the pious friar in his monumental treatise on Catholicism in art and proclaiming him 'the greatest of Christian painters' (1839).

Towards the end of the century, Symbolist groups, including the Nabis and the Rosecrucians, organized themselves as brotherhoods to recreate the monastic ideal that Angelico represented. For Pierre Puvis de Chavannes (1824–98), the hills and convent of Fiesole became the setting for *Christian Inspiration* (1887–8), which portrayed the friar directing his workshop (155). The Symbolists Maurice Denis (1870–1943) and Joséphin (Sâr) Péladan (1858–1918) repeatedly extolled his piety in their writings, and were inspired by the friar, who, in Denis's words, 'heard the call of God with an infinite sweetness'.

To be sure, there were French artists, including Paul Gauguin (1848–1903) and Edgar Degas (1834–1917), who valued Angelico for the beauty of his colour and composition. As did Degas, Édouard Manet (1832–1883) sketched some of his frescos in San Marco, recognizably transforming the portal lunette of *Saint Peter Martyr* into his etching *Silentium* (156, 157). Nonetheless, in France Angelico was viewed and valued primarily as a 'primitive' through the end of the century. In 1899, Ambroise Vollard, remembered today as the dealer of Paul Cézanne and Pablo Picasso, devoted an entire exhibition in his Parisian gallery to Charles Dulac (1882–1953), a recent convert to Catholicism, who was renowned as a 'modern-day Angelico'. In Vollard's words, Dulac recognizably followed 'the example of Fra Angelico' as he made his sacred images while kneeling 'in prayer'.

The situation in England differed from that of Catholic countries. Angelico's works were appreciated for their place in the history of art and their potential for educating the public as well as for their beauty. Translated into English, Rio's book on *The Poetry of Christian Art* (1854) inspired such important writers and collectors as George Darley (1795–1846) and Lord Lindsay (1812–80). Darley, who reviewed *The Poetry of Christian Art*, promoted the study of Old Masters for moral improvement. Enamoured with Angelico's art, he believed that 'a picture by Fra Beato, seen with a fervent spirit of admiration, makes the observer inevitably a *better man*: it raises and purifies his mind'. Lord Lindsay, who wrote *Sketches of the History of Christian Art* (1847) about 'the painting of Christendom', hoped 'to revive the spirit of the past and restore the Arts to a sense of their due vocation' in Victorian England. To that end, Lindsay, who owned a villa in Fiesole near San Domenico,

156
Saint Peter Martyr, 1441–2
Fresco
Cloister, Museo di San Marco,
Florence

157
Edouard Manet, *Silentium*, 1857
Etching on prepared wove paper;
20.2 × 15.1 cm (8 × 6 in) (image)
Bibliothèque Nationale, Paris

158
John Ruskin, *Ancilla Domini* (copied
after the *Annunciation and Adoration
of the Magi* by Fra Angelico), 1845
Illustration from *Modern Painters*,
vol. V (1846); 11.2 × 17 cm
(4⅜ × 6¾ in)

acquired a roundel from the *San Domenico di Fiesole Altarpiece*
(see 164) and commissioned a replica of Angelico's *Coronation
of the Virgin* (see 59) for his private museum.

Prompted by the writings of Darley and Lord Lindsay,
appreciation for Angelico reached its zenith around mid-century.
In 1846, John Ruskin (1819–1900), perhaps the artist's greatest
admirer, published the fifth volume of his influential *Modern
Painters*. He believed that 'only once' had 'the highest beauty' been
attained in art, ascribing this achievement to 'a most holy monk of
Fiesole'. His drawing of the Virgin Annunciate from one of the Santa
Maria Novella reliquaries (see 43), which he described as 'the most
radiant consummation' of the 'pure ideal', served as the frontispiece
(158). In 1848, the Arundel Society was founded to reproduce works
of art, primarily early Italian frescos, through engravings, making
them available to a wider public for the first time. Angelico's frescos
in the Chapel of Nicholas V were the first images that the Society
published, an indication of the friar's popularity. The same year,
seven young artists, William Holman Hunt (1827–1910) and Dante
Gabriel Rossetti (1828–82) among them, formed the Pre-Raphaelite
Brotherhood. Rejecting the constraints of convention, they turned
to nature and studied 'the primitives', including Angelico, whom
they admired for the 'peerless grace and sweetness' of his works.
In 1853, Rossetti portrayed the friar painting the Virgin and Child,
a theme inspired by Vasari (159). In 1860, the National Gallery,
committed to 'instructing the public' in the history of art, acquired
the predella to the *San Domenico di Fiesole Altarpiece* (see 34).
The life-sized figure of the kneeling friar, hands clasped in prayer,
was portrayed among the most renowned Italian painters in the
Albert Memorial in London.

Although antiquarians and writers in Italy had long
esteemed Angelico, his fame escalated in the nineteenth century.
Following Napoleon's fall from power in 1815 and the restoration
of the papacy and convents, many confiscated artistic treasures,
including some of the friar's paintings, were returned. They entered
museums established in the late eighteenth century, prompting
new appreciation of their beauty. Increased nationalism inspired
many intellectuals to study the Florentine Renaissance, whose
magnificence, as they imagined it, contrasted to the political
disorder and religious uncertainty of their own age. Angelico was
key to the age's conception of this lost era of glory. In 1843, a set
of thirty-six engravings reproduced 'the life of Jesus painted by
Fra Giovanni da Fiesole' from his paintings in Florentine museums.
In 1845, the Dominican scholar Vincenzo Marchese immortalized
the friar's life in the monumental *Memorie dei più illustri pittori,
scultori e architetti domenicani* (*Remembrances of the Most
Illustrious Dominican Painters, Sculptors and Architects*). Marchese
identified the friar as the pious founder of 'the mystical school
of painting', centered in Fiesole and at San Marco, and lauded
his art as truly 'celestial'. In 1869, the convent of San Marco officially
opened as the Museo di San Marco, the first European museum
dedicated to a single artist. The public was permitted to enter
the dormitory and experience the transcendent beauty of Angelico's
frescos, praised in reverent reviews and special guidebooks to the

site. Between 1871 and 1875, a statue of Angelico was placed among the greatest Florentines of all time on the new façade of Florence Cathedral. He was the only fifteenth-century painter to be so immortalized.

Perhaps the most crucial event in restoring the artist to living memory was the republication of Vasari's *Lives* (1878–85), annotated with new documents and commentary by the brilliant archivist Gaetano Milanesi. Vasari's account of Angelico, described by Milanesi as 'the most beautiful' of the *Lives*, enhanced the already strong nostalgia for a vanished age of faith as well as renewed belief in the friar's piety. It was in this spirit that Lorenzo Gelati painted *Fra Angelico in the Refectory of San Domenico* (see 1), the image that introduced our book (see Introduction). Its subject is based on Vasari's memorable description of the friar who 'never painted the Crucifix without tears streaming down his cheeks'. Gelati depicted Angelico's own fresco (see 2) in the very convent of Fiesole that Napoleon had forced the Dominicans to abandon. Boarded up for transport, the *Crucifixion* was shipped to the Louvre after being cut from the wall in 1879, an object of art instead of devotion. That same year, the displaced brethren of San Domenico, forced from their convent by Napoleonic law seven decades earlier, were allowed to return.

In 1886, the friars of San Domenico celebrated the first Church feast in honour of 'Beato' (Blessed) Angelico on 18 February, the anniversary of his death. This paraliturgical (non-sacramental) commemoration culminated centuries of veneration that began in the late fifteenth century, when the Dominican Girolamo Borselli praised him as *beatus* (blessed). The friars invoked him as 'beloved Saint, justly named Angelico' ('amabile Santo, giustamente chiamato Angelico'). The liturgy for the feast praised the 'truly divine hand' of this 'dear saint', echoing Vasari's meditation on the *Coronation of the Virgin* that had once adorned the church, a work painted by 'the hand of a saint or an angel'. It included several of Vasari's tales: that Angelico never took up his brush without first offering a prayer; that he wept when he painted the Crucifix; that the only dignity he sought was to escape Hell and seek Paradise. Beseeching the friars of San Domenico as 'beloved brethren' ('amati confratelli'), the liturgy incorporated Vasari's pronouncements on the artist's piety. It exhorted them to live spiritual lives and to 'repeat that God alone is the true object of your heart'. Originating in the convent where Angelico took his vows, the feast anticipated his formal beatification less than a century later, when the Church officially recognized his holiness.

A nuanced and more historical understanding of Angelico's importance to fifteenth-century painting evolved over the course of the twentieth century as the discipline of art history itself matured. Photography replaced memory and the engravings upon which earlier connoisseurs had relied; travel facilitated intensive, on-site study of works by the friar. Art historians distinguished between his paintings and those of his shop, proposing new dates in his chronology. As scholars blurred the distinction between the Middle Ages and Renaissance, they observed the continuity of tradition and innovation in his works. Angelico's sacred themes and mysticism,

159
Dante Gabriel Rossetti, *Fra Angelico Painting*, c.1853
Pen and brown ink and ink wash; 17.8 × 11.4 cm (7 × 4½ in)
Birmingham City Museum and Art Gallery (No. 450.04), Birmingham

160
Mark Rothko, *Untitled*, 1950
Oil on canvas; 188.6 × 101 cm
(74¼ × 39¾ in)
Tate, London

once characterized as medieval, were seen as compatible with the most advanced aspects of Renaissance art.

In 1955 – the quincentenary of Angelico's death – the Dominican historian Stefano Orlandi and the archivist Werner Cohn published documents that presented crucial, new information on the friar (see Introduction). They provided dates for several works and corrected erroneous beliefs about his life, especially regarding the probable time of his birth and religious profession. Their discoveries allowed art historians to reconsider his chronology and to integrate his achievements more fully within the contexts of Florentine painting. That same year, major exhibitions in the Museo di San Marco and the Vatican Palace brought together more than a hundred works by Angelico and his associates from museums all over the world. Drawings, illuminated manuscripts and paintings were displayed in close proximity to his most famous frescos, facilitating comparison, debate and discussion. Given such precious access to his works, scholars gained an unprecedented understanding of his development.

In his address inaugurating the exhibition, Pope Pius XII (reigned 1939–58) praised the friar who 'transformed his art into prayer'. The pontiff charged the Master General of the Dominican Order to promote the Cause (case) for the formal beatification of Angelico. Although belief in the friar's beatitude originated in the late fifteenth century, additional research was required to fully document his Cause. On 3 October 1982, Pope John Paul II (reigned 1978–2005) issued a *motu proprio* (a proclamation 'of his own accord') formally beatifying Angelico. He established the feast of Beato Angelico on 18 February, the day of the friar's death, which the pope described as 'the day of his birth in heaven'. John Paul mandated the celebration of this feast in Santa Maria sopra Minerva and other Dominican congregations. He titled his decree with a quotation that Vasari had ascribed to the artist: 'He whose work is connected to Christ must live ever with Christ.' After reviewing the life of the friar and confirming his piety, the pope concluded that he was 'a man as eminent for his spiritual life as for his art'. Angelico deserved to be called 'Beato' because his art 'still conveyed spiritual and pastoral value for the Christian people'. In 1984, only two years after beatifying him, John Paul further honoured Angelico by proclaiming him universal patron of artists, especially of painters. The pontiff personally celebrated the first votive Mass, exhorting artists to follow the friar's example and take 'Sacred Scripture' as the inspiration for their lives.

In the 1980s, appreciation of Angelico's mastery was further enhanced following the restoration of his frescos in San Marco. For the first time in centuries, the subtle colours and pure expression of these paintings were revealed, inspiring research on their technique and meaning. Uniting science and art, their conservation led to the cleaning of the Chapel of Nicholas V in the Vatican Palace and the Chapel of San Brizio in Orvieto during the 1990s. Yet even before conservators had removed the dirt and candle smoke that obscured the murals, abstract artists had perceived the transcendent colours and inherent spirituality of Angelico's art. In the austerity, subtle yet luminously tinted hues and dry textures that typify the floating rectangular fields of Mark Rothko (1903–70), such as *Untitled* (160),

there are distinct echoes of the frescos in San Marco, which the artist deeply admired. Likewise, the *Projections* of James Turrell (born 1943) from the 1960s, in which the artist eschewed literal representation for the radiance of light projected on white walls. In 1992, Paul Jenkins (born 1923) returned to Florence, where he viewed the cells at San Marco. The prismatic brilliance of the watercolours in his 'Viaggio in Italia' series may record the intensity of his experience (161).

In a secular world, it may be difficult to imagine the profound religious sentiments that Angelico's paintings elicited when they were created more than 500 years ago. Because they are so beautiful, his holy figures have frequently been reproduced, although most people are unaware of the magnificent altarpieces from which they came. For many, his very name has become synonymous with his subject matter. The music-making angels from the *Linaiuoli Tabernacle* (see 64) who evoked the harmonies of Heaven appear ubiquitously on postcards. Splendid angels from the *Coronation of the Virgin* for the hospital church of Santa Maria Nuova (see 59) embellish greeting cards, calendars and souvenirs. Frescos, manuscript pages, predella panels and entire altarpieces can be replicated to order in oil on canvas, materials that the friar never used. One can even drink Frangelico liqueur, allegedly made from a recipe created more than three centuries ago by 'a lone monk in a forest' from hazelnuts and berries. Angelico was a Dominican, yet the brown bottle simulates the Franciscan habit.

But those who pause before his works may imagine the emotions of Renaissance worshippers who were moved as much by the images' meaning as their beauty. As immortalized in his epitaph, Angelico was truly a 'servant of God', whose life was suffused utterly by faith. An innovator who conveyed his Order's visual and spiritual traditions, he conceived of his art as painted preaching. Possessing the sublime gift of piety, Beato Angelico was blessed to express his message of Christian salvation through his exquisite paintings. As the theological subtleties of his work suggest, he may well have been more versed in doctrine than any other artist of his time.

Angelico was a most gifted artist. Uniting tradition with humanist innovation, he reinterpreted sacred themes and endowed them with new resonance. His understanding of perspective, landscape and classicizing architecture reveals a sensibility that few painters of his time possessed. Such works as the *Annalena Altarpiece* (see 67) and *San Marco Altarpiece* (see 84) transformed interpretations of the Virgin and Child, inspiring artists through the end of the century (see 162). Whether embellishing the letters of illuminated manuscripts or painting monumental frescos, Angelico created works of great beauty and poignant expression. His colours are perhaps the most luminous of any Renaissance artist. They include shimmering whites, glowing crimsons that are suffused with light, and radiant blues graduated in saturation from pale azure to deep cerulean. His holy figures convey a range of emotions, from the grief of the swooning Virgin in the *Grand Crucifixion* (see 95) to the jubilation of the dancing angels in the *Last Judgement* (see 57). Although we live in a more secular age, his works still move us by their exquisite beauty and the ardent devotion that they express.

161
Paul Jenkins, *Phenomena Above the Mark*, 1992
Watercolour on paper; 110 × 79 cm (43⅜ × 31⅛ in)
Private collection

162
Workshop of Sandro Botticelli, *Trebbio Altarpiece*, 1495
Tempera on canvas (transferred from panel); 167 × 195 cm (65¾ × 76¾ in)
Accademia, Florence

Appendix

163
Digital reconstruction of the church of San Domenico, showing the positioning of the three altarpieces: *The Virgin and Child with Saints Thomas Aquinas, Barnabus, Dominic and Peter Martyr* (33), *Annunciation* (38) and *Coronation of the Virgin* (39).

164
Digital reconstruction of the *San Domenico di Fiesole Altarpiece* (33, 34)

165
Digital reconstruction of the *San Marco Altarpiece* (84, 85, 86, 87)

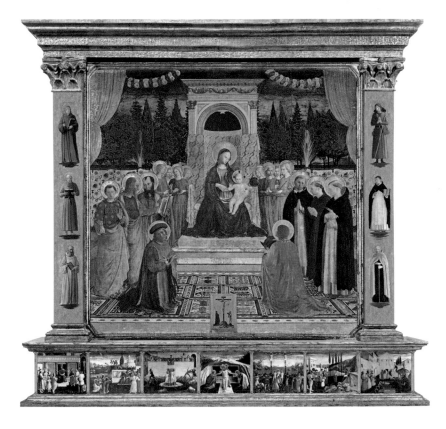

166

Digital reconstruction of predella from unidentified altarpiece, *c.*1425–7

(Left to right) *Saint James Freeing the Magician Hermogenes,* Kimbell Art Museum, Fort Worth; *Naming of John the Baptist,* Museo di San Marco, Florence; *Dormition of the Virgin,* John G. Johnson Collection, Philadelphia Museum of Art, Philadelphia; *Vision of Saint Lucy,* Richard L. Feigen Collection, New York; and *The Meeting of Saints Francis and Dominic,* The Fine Arts Museum of San Francisco, San Francisco

Biographies

Leon Battista Alberti (1404–1472) Architect, painter, sculptor, theorist, priest and papal secretary. Alberti was born in Genoa and educated at the University of Bologna, an experience that laid the foundation for his humanist interests. In 1432, he became secretary to Pope Eugenius IV. In 1434, he visited Florence for the first time and was inspired to write *On Painting* (1435, 1436) in homage to Brunelleschi, Donatello, Ghiberti and Masaccio. This learned manifesto presented his mathematical theory of perspective as well as advice on composition and appropriate subject matter. The *San Marco Altarpiece* may have been the first work to reflect its influence. His treatises *On Sculpture* and *On the Art of Building, Description of the City of Rome* and writings on other themes, from the family to mathematics, attest the extraordinary range of his intellect. Above all, he was an outstanding architect with a profound understanding of classical buildings and proportion. He advised Pope Nicholas V in planning the transformation of papal Rome, although his ambitions were never fully realized before his death in Rome. In Florence, he designed the Palazzo Rucellai and the façade of Santa Maria Novella, and in Mantua, he adapted ancient Roman temple types to Christian needs in the church of Sant'Andrea.

Battista di Biagio Sanguigni (1393–1451) Manuscript illuminator and painter associated with Angelico; formerly known as the Master of 1419 after the Cleveland *Madonna and Child* (dated 1419 by inscription). Although several panel paintings have been ascribed to Battista, documents identify him as a manuscript illuminator. Born in Empoli, he moved to Florence and around 1415, Battista rented a workshop from Santa Maria degli Angeli, near the shop of Lorenzo Monaco. After joining the Compagnia di San Niccolò in Santa Maria del Carmine, he introduced Angelico as a member in 1417. In 1435, he moved near San Domenico di Fiesole, and resided in a house owned by Zanobi Strozzi, who became his student around 1427. He and Zanobi illuminated several miniatures in an antiphonary for the convent of San Gaggio (1435), where Zanobi's sister was a nun. These miniatures and the Cleveland *Madonna and Child* are his only securely dated works.

Benozzo Gozzoli (*c*.1420–1497) Florentine painter who assisted Angelico in Florence (*c*. 1439–44), Orvieto and Rome (1447–9). He also aided Lorenzo Ghiberti and his son in completing the 'Gates of Paradise' (1444–7) before establishing an independent career. His altarpieces, frescos and manuscript illuminations transmitted Angelico's legacy and his own style throughout Umbria, Lazio and Tuscany. Benozzo is famous for his highly realistic portraits and dramatic narratives from the Bible and saints' lives, which are situated within expansive landscapes and inventive, classicizing architecture. He is best known today for his colourful frescos of the *Journey of the Magi* in the chapel of the Palazzo Medici (1459), which include realistic portraits of the Medici and their allies, magnificently garbed figures and exotic animals in a tapestry-like landscape. In his own day, he was renowned for completing the most extensive commission in fresco from the fifteenth century, the multi-episodic Old Testament scenes in the Camposanto, Pisa (1468–84).

Bicci di Lorenzo (1373–1452) Painter, sculptor and architect who belonged to a successful dynasty of Florentine painters that his father, Lorenzo di Bicci, established in the mid-fourteenth century and his son continued. Bicci directed a large and important workshop during a career that lasted more than forty years. From the 1420s through the early 1440s, he was employed by some of the same Florentine churches as Angelico, including Santa Trinita and San Marco as well as Sant'Egidio, where he served as architect, sculptor and painter. He executed numerous works for parish churches outside Florence and began to fresco the choir of San Francesco, Arezzo (*c*.1445–7), a commission which Piero della Francesca completed. Although his paintings transmitted the late Gothic idiom of his training, Bicci responded to innovation and was especially attracted to paintings by Gentile da Fabriano. The number of his commissions demonstrates the popularity and coexistence of a more traditional style alongside the innovations of Masaccio, Gentile and Angelico. He died in Arezzo.

Filippo Brunelleschi (1377–1446) Florentine architect, sculptor and theorist of perspective. Famous for building the dome of Florence Cathedral, Brunelleschi united the principles and forms of Roman buildings with those of the Tuscan Romanesque tradition and theories of mathematical proportion. He was trained as a goldsmith and competed with Lorenzo Ghiberti and other sculptors in 1401 to execute the North Doors of the Baptistery. When Ghiberti was awarded the commission, Brunelleschi departed with Donatello for Rome, where he studied and measured the city's ancient buildings. He incorporated his knowledge of Roman architecture in designing the Foundlings Hospital, San Lorenzo and the Old Sacristy, the oratory of Santa Maria degli Angeli, Santo Spirito and the Pazzi Chapel of Santa Croce. Of all his buildings, the design and construction of the Cathedral's immense octagonal dome, the largest since antiquity, epitomized his genius as an architect and engineer. He resolved seemingly insuperable problems of statics and support while inventing special hoists, pulleys and mechanical devices to facilitate construction. Brunelleschi also was a theorist and practitioner of linear perspective. He may have designed the perspective system of the *Trinity* by Masaccio and is reported to have painted panels that represented the Cathedral piazza and the Piazza della Signoria in perfect perspective.

Donatello (1386/7–1466) Renowned as the greatest sculptor in fifteenth-century Florence. He was a student of Lorenzo Ghiberti, a friend of Filippo Brunelleschi, a collaborator of Michelozzo and the favorite sculptor of Cosimo de' Medici, near whose tomb he is buried. Donatello worked in diverse materials—marble, wood, bronze, and stucco—with unequalled mastery. He introduced new techniques in relief sculpture, reinterpreted classical models with extraordinary imagination, expanded the parameters of narrative, redefined the human figure in a heroic mode and suffused his works with extraordinary physical and psychological presence. His friendship with Filippo Brunelleschi, with whom he traveled to Rome, may have inspired his life-long engagement with antiquity and experiments with perspective. He executed major commissions in Rome (including the *Tabernacle of the Sacrament*), Siena, Venice and Padua, but may be best known for his Florentine works. They include sculpture for the façade of Florence Cathedral, two saints for Orsanmichele, a *Crucifix* for Santa Croce and the nude, bronze *David* for the Palazzo Medici.

Fra Filippo Lippi (*c*.1406–1469) Florentine painter and Carmelite who was a contemporary of Angelico. In 1421, Filippo took his vows as a friar in Santa Maria del Carmine, a vocation that preceded his training as a painter. The experience of watching Masaccio fresco the Brancacci Chapel in the Carmine was fundamental to his artistic formation. He also was influenced by Donatello, as well as the Netherlandish and Venetian painting that he saw in the Veneto in the 1430s, when his earliest works are documented. Filippo became a favourite artist of the Medici in the 1440s and 1450s. He was chosen to fresco the high altar chapel in Prato Cathedral after Angelico declined the commission in 1452. Vasari's reproachful account of his libidinous personality – the friar impregnated a nun, who gave birth to a son, the painter Filippino Lippi – at one time overshadowed appreciation of his art. Yet his brilliant array of colours, sculptural modelling of form, passionately characterized figures and inventive narratives distinguish Filippo Lippi among the best Florentine painters.

Gentile da Fabriano (*c*.1385–1427) The painter best known for the *Adoration of the Magi*. Born in the Marches, Gentile seems to have been trained in Lombardy, where his exquisite style was formed in the court of Giangaleazzo Visconti. By 1408, he was working in Venice, executing

frescos in the Palazzo Ducale, for which he was paid the enormous salary of one ducat a day. After serving as court painter to Pandolfo Malatesta in Brescia, he arrived in Florence in 1419. By that time, Gentile had established himself as one of the greatest masters in Italy. In 1423, he painted the *Adoration of the Magi* for the Strozzi Chapel in Santa Trinita, for which Angelico later executed the *Descent from the Cross*. The opulent colours, sumptuous drapery, softly modelled figures, richly tooled gold embellishments and detailed, naturalistic landscapes were unprecedented in Florentine painting. Completed for a wealthy Florentine family in 1425, the *Quaratesi Altarpiece* inspired Bicci di Lorenzo and others to imitation. By 1427, Pope Martin V had summoned Gentile to Rome, where he began a major fresco cycle in San Giovanni in Laterano, which was unfinished at his death.

Lorenzo Ghiberti (1378–1455)
Florentine sculptor, architect, painter and writer best known for the North Doors and East Doors ('Gates of Paradise') for Florence Baptistery. In 1401, Ghiberti defeated Filippo Brunelleschi and others to win the competition for the North Doors. His gilt bronze panel depicting the *Sacrifice of Isaac* was remarkable for its fluent composition and single-piece casting. The North Doors served as a model for artists through its graceful figures and detailed backgrounds. Ghiberti also cast three larger than life-size statues in bronze for Orsanmichele. He executed the 'Gates of Paradise' between 1425 and 1452, creating dramatic, multi-episodic narratives from the Old Testament in landscape and architectural settings designed in perfect proportion and perspective. He jointly supervised the construction of the Cathedral's dome with Brunelleschi and designed the portal to the Strozzi Chapel in Santa Trinita, for which Gentile da Fabriano and Angelico painted altarpieces. He was a painter as well, providing cartoons for stained-glass windows in Florence Cathedral and preparing drawings for other artists. Near the end of his life, he wrote *The Commentaries*, an autobiography and a history of art from antiquity to his own day.

Lorenzo Monaco (1370/5–*c*.1424/5)
Florentine painter, manuscript illuminator and probable teacher of Fra Angelico, as well as Camaldolese deacon. The painter known as Lorenzo Monaco entered the Camaldolese monastery of Santa Maria degli Angeli in 1390 and was ordained a deacon in 1396. Never taking vows as a priest, he lived outside the monastery walls. By 1401, he had established a successful workshop and scriptorium. His works translated the late Gothic idiom of Agnolo Gaddi, with whom he may have studied, and the graceful rhythms of the sculpture of Lorenzo Ghiberti into luminous colour. His most important painting was the *Coronation of the Virgin* (1414), the execution of which coincided with the probable years of Angelico's training. He began the pinnacles and predella of the altarpiece for the Strozzi Chapel that Angelico completed as the *Descent from the Cross*.

Masaccio (1401–1428)
Considered the founder of fifteenth-century Florentine painting. In a career lasting only a decade before his premature death, Masaccio transformed painting in Florence, where he had settled by 1418. His first surviving work is the *Cascia di Reggello Triptych* (1422). His fresco of the *Trinity* in Santa Maria Novella, remarkable for its classicizing architecture and mathematically constructed perspective, may reflect the intervention of Filippo Brunelleschi. He collaborated with Masolino in three major commissions: the altarpiece of the *Madonna, Child and Saint Anne*, the Brancacci Chapel and a polyptych for Santa Maria Maggiore in Rome, which Masolino completed after Masaccio's death. His rigorously mathematical perspective, expert foreshortening, consistent illumination, solemn narratives, extreme naturalism and evocation of psychological and physical presence were unprecedented in painting. He profoundly influenced Florentine artists, Angelico among them, in the 1420s and 1430s.

Masolino da Panicale (1383/4–*c*.1436)
Painter active in Florence, Hungary, Rome and Lombardy. Masolino seems to have been trained by his father, a specialist in decorative mural painting. He may have been employed in the workshop of Lorenzo Ghiberti around the time that the North Doors were begun. His activity before 1423 is highly problematic. His collaboration with Masaccio on the *Madonna, Child and Saint Anne* and the Brancacci Chapel is likely to have taken place around 1424–5. After spending three years working in Hungary, Masolino resumed his association with Masaccio, completing the *Santa Maria Maggiore Polyptych* after Masaccio's death in Rome. Masolino worked in Umbria and Lombardy in the last years of his life. Although his reputation has suffered by comparison to that of Masaccio, his use of tempera and oil binders as well as oil glazes indicate great technical facility and inventiveness.

Michelozzo di Bartolommeo (1396–1472)
Florentine sculptor, collaborator of Donatello and architect. Michelozzo was an important master whose career intersected with the activity of major Florentine artists. He assisted Lorenzo Ghiberti in executing the Orsanmichele *Saint Matthew* and the North Doors before becoming the partner of Donatello in 1424/5. He collaborated with Donatello on important commissions, including the *Cossa Funerary Monument* in Florence Baptistery and the *Prato Pulpit*, and he supervised the sculptor's workshops. He also was the favourite architect of Cosimo de' Medici, renovating the convents of Bosco ai Frati and San Marco as well as designing the Palazzo Medici and the family villas at Cafaggiolo, Careggi and Trebbio, among other commissions. His structures incorporated classicizing elements with the traditions of Tuscan Romanesque architecture less rigorously than those by Filippo Brunelleschi, whom he replaced as supervisor of construction in Florence Cathedral at the master's death (1446).

Nanni di Banco (*c*.1380/5–1421)
Florentine sculptor. Nanni was the son of a stone-carver employed in the workshop of Florence Cathedral. He studied and collaborated with his father, receiving his first independent commission for the Cathedral façade in 1408. Nanni's classicism was developed in his three statues for Orsanmichele, foremost among them the *Four Crowned Martyrs* (*c*.1416). The studious, archaeological accuracy of these figures, seen in the heavy folds of their togas, drill-carved hair and portrait-like realism of their features, reveals his use of historically appropriate models. His classicizing work and that of Donatello document the importance of Roman examples to Florentine sculpture in the early fifteenth century.

Zanobi Strozzi (1412–1468)
Manuscript illuminator, painter and member of the Florentine Strozzi family. A student of Battista di Biagio Sanguigni, Zanobi lived near the convent of San Domenico, Fiesole, where he may have been associated with the scriptorium, between 1427 and 1445. His independent commissions increased with Angelico's departure for Rome. Zanobi's documented works include paintings for Sant'Egidio (1434) and San Marco (1448), as well as manuscript illuminations for Florence Cathedral (1445, 1446, 1458, 1463) and San Marco (1446, 1454; with Filippo di Matteo Torelli). His works, sometimes confused with those of Domenico di Michelino, are strongly influenced by Angelico.

Chronology

The Life and Art of Fra Angelico

*c.*1390/95
Guido di Piero born.

1417
Joins confraternity of San Niccolò di Bari.

1418
Payment for altarpiece in Santo Stefano al Ponte.

*c.*1418/20
Enters convent of San Domenico, Fiesole.

1423
'Fra Giovanni' is paid for crucifix in Santa Maria Nuova.

1425
Anticipated bequest of Alessandro Rondinelli for an altarpiece for San Lorenzo to be painted by the 'friar from the convent of San Domenico'.

1429
Recorded in San Domenico: partial payment to 'frate Guido' from confraternity of San Francesco for altarpiece in cloister chapel of Santa Croce (48, 49); ten florins owed to San Domenico by convent of San Pietro Martire for its 'painted altarpiece' (45, 46).

1431, 1432, 1433, 1435
Recorded in San Domenico.

1432, 1433
Vicar, San Domenico.

1432
Installation of *Descent from the Cross* in Strozzi Chapel, Santa Trinita (62).

1433
Commission for *Linaiuoli Tabernacle* (63, 64).

1434
Appraises altarpiece for San Niccolò Oltrarno by Bicci di Lorenzo and Stefano d'Andrea.

1435
Consecration of San Domenico, Fiesole.

Three altarpieces for San Domenico (33, 38, 39) painted 'many years earlier'.

Installation of *Linaiuoli Tabernacle* (63, 64).

1436
Payments for *Lamentation over Christ*, dated 1441 (80)

Vicar, San Domenico.

1438
In San Domenico, Cortona.

Portal fresco, San Domenico, Cortona (78).

*c.*1438–43
Directs decoration of San Marco (81–95, 97, 100–11).

1441
Recorded in San Marco.

1445
Signs agreement separating San Marco from San Domenico, Fiesole.

late 1445/early 1446
In Rome with workshop.

1447
Completes 'Chapel of the Pope' in Vatican Palace.

Paints chapel in St Peter's.

Begins New Chapel, Orvieto Cathedral (119–22).

1448
Begins Chapel of Nicholas V, Vatican Palace (123, 126–30).

Santissima Annunziata Silver Chest reportedly commissioned by Piero de' Medici (140–4).

1449
Paid for painting *studiolo* of Nicholas V.

Appraises Zanobi Strozzi's miniatures for San Marco.

1450
Death of Fra Benedetto.

Prior, San Domenico, Fiesole.

1451
Prior, San Domenico, Fiesole.

Negotiations recorded with Fra Giuliano Lapaccini, prior of San Marco.

Obtains two florins-worth of paper from Vespasiano da Bisticci.

1452
In Prato, where refuses commission for high altar chapel in Cathedral.

1454
Nominated, with Fra Filippo Lippi and Domenico Veneziano, as possible appraiser of Benedetto Bonfigli's frescos in Perugia.

1455
Angelico dies on 18 February in Rome.

Buried in the Chapel of Saint Thomas, Santa Maria sopra Minerva, Rome (150).

A Context of Events

1389
Antoninus of Florence born.

Cosimo de' Medici born.

1398
Cennino Cennini writes *Treatise on Painting*.

1401
Masaccio born.

Competition for second doors (North Doors) of Florence Baptistery (24).

1402–3
Lorenzo Ghiberti wins competition for North Doors.

Lorenzo di Niccolò's *Coronation of the Virgin* for San Marco (12).

Donatello and Brunelleschi in Rome.

1405/6
Blessed Giovanni Dominici founds San Domenico, Fiesole.

1409–17
Exile of friars from San Domenico.

1410–28
Sculpture for Orsanmichele by Donatello, Lorenzo Ghiberti (66), and Nanni di Banco (9).

1412
Medici become papal bankers.

Zanobi Strozzi born.

1413–14
Lorenzo Monaco paints *Coronation of the Virgin* (15, 16).

1414–18
Council of Constance.

1416
Piero de' Medici born.

1417
End of Great Schism.

Martin V elected pope. Masaccio in Florence.

1418
Brunelleschi wins competition
for dome of Florence Cathedral (5).

1419
Brunelleschi begins construction
of San Lorenzo (6) and Foundlings
Hospital (52).

1420
Brunelleschi begins dome of Florence
Cathedral.

Blessed Giovanni Dominici dies.

1422
Masaccio's *Cascia di Reggello
Altarpiece* (35).

Brunelleschi begins Old Sacristy
of San Lorenzo.

1422–4
Antoninus is prior of San Domenico,
Fiesole.

1423
Gentile da Fabriano's *Adoration
of the Magi* (29).

1424
Installation of North Doors
of Baptistery (8, 58).

Ghiberti wins competition for East
Doors of Baptistery ('The Gates
of Paradise') (53).

c.1424–5
Lorenzo Monaco dies.

c.1425
Masaccio and Masolino fresco
Brancacci Chapel (30, 37).

Gentile da Fabriano paints *Quaratesi
Altarpiece* (47).

Ghiberti begins 'Gates of Paradise'.

1425–6
Antoninus is prior of San Domenico,
Fiesole.

1427
Masaccio leaves for Rome.

Leonardo Bruni becomes Chancellor
of Florence.

Gentile da Fabriano dies in Rome.

1428
Masaccio dies in Rome.

c.1427/30
Battista di Biagio Sanguigni and
Zanobi Strozzi move near San
Domenico, Fiesole.

1429
Benedetto di Piero, Angelico's brother,
ordained in San Domenico, Fiesole.

Giovanni di Bicci de' Medici dies.

Florence declares war on Lucca.

1430–8
Luca della Robbia's *Singing Gallery* (54).

1431
Council of Basel (1431–49).

Pope Martin V dies.

Eugenius IV elected Pope.

1433
Cosimo de' Medici arrested for treason
and exiled.

Antoninus appointed Vicar General
of Tuscan Observance (1433–46).

Sigismund of Hungary crowned Holy
Roman Emperor in Rome.

Donatello's *Singing Gallery*
(c.1433–9) (55).

1434
Cosimo de' Medici returns from exile
to power.

Expulsion of Palla Strozzi.

1435
Leon Battista Alberti writes treatise
On Painting.

Consecration of San Domenico,
Fiesole.

1436
Completion of Brunelleschi's dome.

Consecration of Florence Cathedral.

Eugenius IV gives convent of

San Marco to San Domenico, Fiesole.

1437
First dated work of Fra Filippo Lippi.

late 1437/1438
Reconstruction of San Marco begins.

1438
Bull of Eugenius IV promoting
decoration of San Domenico, Cortona.

Domenico Veneziano's letter to
Piero de' Medici praises Angelico
and Fra Filippo as 'good masters'
with 'much work to do'.

1439
Council of Florence.

Decree of Union unifies Western
and Eastern Churches.

Antoninus appointed prior of San
Domenico, Fiesole, and San Marco.

Domenico Veneziano and Piero della
Francesca paint choir frescos in
Santa Maria Nuova.

1443
Consecration of San Marco.

Eugenius IV returns to Rome.

1444
Death of Bernardino of Siena.

Library of San Marco opens to public.

Jean Fouquet in Rome.

1445
San Marco and San Domenico sign
agreement of separation.

Filarete's *bronze doors* for Old
St Peter's (114).

Donatello's *Tabernacle of the
Sacrament* (115).

Domenico Veneziano's *Saint Lucy
Altarpiece* (138).

Sandro Botticelli born.

1446
Antoninus becomes Archbishop
of Florence.

Brunelleschi dies.

1447
Eugenius IV dies.

Nicholas V elected pope.

1449
Birth of Lorenzo de' Medici.

1450
Papal Jubilee.

Bernardino of Siena canonized.

1452
Frederick III crowned Holy Roman
Emperor in Rome.

'The Gates of Paradise' installed.

Leonardo da Vinci born.

1453
Conquest of Constantinople
by Ottoman Turks.

late 1454/1455
Johannes Gutenberg in Mainz
prints first book, the Bible, with
moveable type.

1455
Death of Nicholas V.

Death of Lorenzo Ghiberti.

Glossary

Altarpiece
A painted or carved representation of Christian subject matter placed on or affixed to the back of an altar to elicit devotion. The themes of altarpieces may relate to the Mass, represent a narrative, or depict the saint or saints to whom the altar is or was dedicated.

Ave Maria
Latin for 'Hail Mary'. As recorded in Luke 1:28, the first two words of the Archangel Gabriel's salutation to the Virgin Mary when he announced that she would bear Jesus, 'the Son of God'; also, the name of the prayer recited in honour of Mary.

Beatification
In the Roman Catholic Church, the stage before **canonization**. Beatification recognizes the exceptional piety of an individual, known as Blessed (in Italian, 'Beato'), but it does not accord him or her the special honour of a feast day with a commemorative Mass.

Canonization
In the Roman Catholic Church, the supreme honour accorded an exceptionally pious individual, making him or her a saint. Saints enter the Church's calendar of holidays by being given a special feast day with a commemorative Mass.

Chapter House
A room or building used as meeting place within a convent or monastery. In Dominican convents, the Chapter House was used for daily meetings of the friars, as a site where business was conducted and as a place where the laity was greeted.

Choir
Part of a church, located near the altar, reserved exclusively for the clergy and for the singing of the service by friars, monks or nuns, and the performance of other ecclesiastical offices.

Choir Screen
Also known as a rood screen. In the Middle Ages and Renaissance, a wall or tall screen of iron or carved wood that separated the **choir** from the **nave**, and the religious community from the laity.

Cloister
The principal courtyard or quadrangle of a **convent** or **monastery**. It is bordered with covered passageways issuing to the main parts of a religious complex, including the church, the **Chapter House**, the dormitory and the refectory.

Confraternity
Organization of lay people who devoted themselves to acts of piety, charity and penance. Originating around 1260 in Italy, confraternities profoundly influenced medieval and Renaissance culture through their religious, civic, social, philanthropic and festive activities, as well as their patronage of art and architecture.

Convent
Residence of a religious community of either sex. In the Middle Ages and Renaissance, convents were the residences of **Mendicant** (begging) **Orders**, such as the Augustinians, Carmelites, Dominicans and Franciscans, who engaged with the world outside their walls through begging and preaching. Their vow of poverty precluded ownership of property.

Corpus Domini
Literally, the 'Body of the Lord'. In the Roman Catholic Church, the Feast of Corpus Domini, the liturgy of which was composed by Saint Thomas Aquinas, commemorates the Real Presence of Jesus in the Eucharist.

Dominican Order
Properly known as the 'Ordinis Praedicatorum', the 'Order of Preachers'. The religious order founded by Saint Dominic (c.1170/5–1221) in 1216 to defend the Church against heresy through preaching and learning. Devoted to the salvation of souls, the Dominicans were mendicants who embraced the apostolic ideal of poverty and preached in towns and cities.

Eucharist
From the Greek word for 'thanksgiving', also known as Communion, the Mass, or the Lord's Supper. The supreme sacrament in the Roman Catholic Church, in which the bread and wine, consecrated by the priest, become the body and blood of Jesus. Jesus instituted the Eucharist at the Last Supper (Matthew 26: 20–9), when he blessed the bread as his 'body' and the wine as his 'blood of the covenant'.

Fresco
From the Italian word for 'fresh'. Painting technique used to adorn walls and ceilings in which ground pigments dissolved in limewater are applied to fresh, or wet, lime plaster, chemically amalgamating with the surface as the pigments dry. Fresco painting was a multi-step process, beginning with small-scale drawings that outlined the composition and placement of figures. Frequently, the artist prepared cartoons (full-scale drawings), which were transferred to the surface by incision or pouncing (pricking the contours and dusting them with a bag filled with charcoal dust). The masonry surface of the wall or ceiling was prepared with a rough layer of plaster on which the artist sketched the setting and figures, using chalk (made from charred branches) or sinoper (red iron oxide). An area of fine, thin layer of plaster, just large enough for a painter to complete in a day, was then laid on top, covering the underdrawing. Using pigments suspended in limewater, the artist painted on top of this layer, using his drawings and the underdrawings of adjacent areas as a guide. The details of many frescos were finished in **tempera**, which was added after the plaster had dried.

Friar
A member of a **Mendicant Order** rather than a monastic one.

Guild
An association of men sharing a common commercial profession. In the Middle Ages and Renaissance, guild members ensured standards of quality and materials, prescribed the duration of an apprentice's training and regulated competition. Although guilds had their own meeting halls and commissioned works of art, a guild is not to be confused with a **confraternity**, which was dedicated to spiritual life rather than commercial interests.

Humanism
From the Latin for 'study of the humanities'. Late medieval or Renaissance intellectual movement devoted to the study, translation and revival of Greek, Latin and Hebrew culture to enrich understanding of Christianity, as well as of the intrinsic intellectual, historical, literary, scientific, mathematical and social merit of classical texts. Humanist culture contrasted dramatically to that of the early medieval world, which shunned the literary and artistic works of pagans (non-Christians).

Jubilee
Also known as Holy Year. Inaugurated by Pope Boniface VIII (reigned 1294–1303) in 1300, the Jubilee was a specially designated year in which the pope issued a complete remission of sins, called a 'plenary indulgence', for penitent pilgrims who travelled to Rome to visit the city's 'Principal Churches'. The Jubilee was celebrated every fifty years until 1475, when the 25-year interval, as observed today, replaced it.

Liturgy
In the Roman Catholic Church, the collected prayers, hymns and rituals for worship. The term generally applies to the celebration of Mass, whose culminating event is the consecration of the **Eucharist**.

Mendicant Order
'Begging' and preaching order that embraced the ideal of absolute poverty. Founded in the thirteenth century, the Dominicans and Franciscans were mendicant orders, rejecting possessions and begging for material sustenance. Following the examples of their founders, mendicant friars originally travelled to preach (in contrast to monks, who lived in seclusion within their monasteries), but they came to settle in towns and cities to address the spiritual needs of the populace. Even then, they did not 'own' their convents, which were under the jurisdiction of local authorities, bishops or the pope.

Missal
One of twelve liturgical books.
It contains the service of the Mass.

Monastery
Residence of an autonomous, enclosed community of monks devoted to spiritual life within its own walls. In the Middle Ages and Renaissance, monasteries followed the Rule established by Saint Benedict of Norcia in the sixth century, which emphasized prayer, contemplation and manual labour.

Monk
A member of a monastic community living in a **monastery**.

Nave
Main, longitudinal space of a church, generally intended for the laity, extending from the church's entrance to the **transept** or **choir**.

Observance
Reform movement among the mendicant orders that began in the third quarter of the fourteenth century. Observant reformers advocated a return and adherence to the strict ideals, especially poverty, embraced by the founders of their orders.

Predella
Platform or pedestal supporting an altarpiece that may be embellished with painted or carved narratives, figures and coats of arms.

Relic
A body part, possession, or object touched by or associated with a saint or a holy person who has been beatified. Relics were believed to have healing or charismatic properties. Smaller relics, such as fragments of the True Cross, were preserved in reliquaries, while larger ones could be entire buildings or sites associated with Jesus, Mary or saints.

Sanctus
Hymn of praise beginning 'Holy, holy, holy, Lord God of Hosts', sung near the end of the Eucharistic preface of the Mass.

Sacristy
Room in a church, generally near the high altar, in which vestments and liturgical vessels are stored. It may be used as a private chapel for worship and burial, as in the Old Sacristy Chapel of Giovanni di Bicci de' Medici in San Lorenzo, or the Strozzi Chapel in Santa Trinita.

Scriptorium
Dedicated room or studio in which manuscripts were written and/or illuminated.

Sinopia
Preparatory underdrawing for a fresco made on the rough plaster surface and executed in sinoper (red iron oxide) or chalk (made from charred branches)

Te Deum laudamus
Latin for 'We praise you, O Lord'. A hymn of praise sung at Matins, the first of eight canonical hours of prayer.

Tempera
From the Italian for 'mingle' or 'temper'. Painting technique in which ground pigments are amalgamated in an emulsion of egg yolk and water. In the Renaissance, tempera was applied with fine brushes to specially prepared wooden panels. Tempera was the most popular medium for panel painting in medieval and Renaissance Italy.

Transept
Transverse arm crossing the **nave** of a church at right angles, separating the **choir** from the **nave**.

Triptych
Altarpiece comprised of three panels.

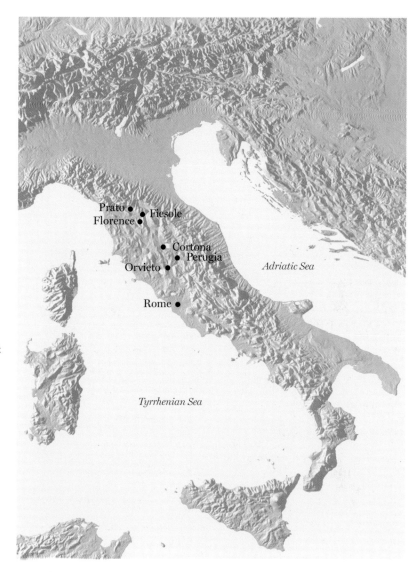

Bibliography

Introduction

Diane Cole Ahl, 'Fra Angelico: A New Chronology for the 1420s', *Zeitschrift für Kunstgeschichte*, 43 (1980), pp. 360–81

—, 'Fra Angelico: A New Chronology for the 1430s', *Zeitschrift für Kunstgeschichte*, 44 (1981), pp. 133–58

Giorgio Bonsanti, *Beato Angelico. Catalogo completo* (Florence, 1998)

Miklòs Boskovits, 'Appunti sull' Angelico', *Paragone*, 27 (1976), pp. 30–54

—, *Un' Adorazione dei magi e gli inizi dell'Angelico* (Bern, 1976)

William Hood, *Fra Angelico at San Marco* (New Haven and London, 1993)

Laurence Kanter and Pia Palladino (eds), with contributions by Magnolia Scudieri, Carl Brandon Strehlke, Victor M. Schmidt, and Anneke de Vries, *Fra Angelico* (exh. cat., New York, 2005)

Dale Kent, *Cosimo de' Medici and the Florentine Renaissance* (New Haven and London, 2000)

Eugenio Marino, *Il Beato Angelico: Saggio sul rapporto persona-opere visive ed opere visive-persona* (Pistoia, 2001)

Stefano Orlandi, *Beato Angelico* (Florence, 1964)

John Pope-Hennessy, *Fra Angelico* (London, 1974)

Postulazione Generale dei Domenicani (ed.), *Beato Angelico. Miscellanea di studi* (Rome, 1984)

Mario Salmi (ed.), *Mostra delle opere del Beato Angelico nel quinto centenario della morte (1455–1955)* (Florence, 1955)

John T. Spike, *Fra Angelico* (New York and London, 1997)

Carl Brandon Strehlke, *Angelico*, Anna Maria Agosti, trans. (Milan, 1998)

Giorgio Vasari, *Lives of the Most Eminent Painters Sculptors and Architects*, Gaston Du C. de Vere, trans. (New York, 1979)

—, *Le vite de' più eccellenti pittori scultori ed architettori scritte da Giorgio Vasari*, Gaetano Milanesi (ed.), (Florence, 1906), vol. II, pp. 505–34

Chapter One

George R. Bent, 'S. Maria degli Angeli and the Arts: Patronage, Production and Practice in a Trecento Florentine Monastery', Ph.D. diss. (Stanford University, Palo Alto, 1988)

Miklòs Boskovits, *Pittura fiorentina alla vigilia del Rinascimento* (Florence, 1984)

Werner Cohn, 'Il Beato Angelico e Battista di Biagio Sanguigni: Nuovi documenti', *Rivista d'arte*, 30 (1955), pp. 207–16

—, 'Nuovi documenti per il Beato Angelico', *Memorie domenicane*, 73 (1956), pp. 218–20

Creighton Gilbert, 'The conversion of Fra Angelico', in *Scritti di storia dell' arte in onore di Roberto Salvini* (Florence, 1984), pp. 281–7

Marvin Eisenberg, *Lorenzo Monaco* (Princeton, 1989)

Laurence Kanter, 'Zanobi Strozzi miniatore and Battista di Biagio Sanguigni', *Arte cristiana*, 90 (2002), pp. 321–31

Laurence Kanter *et al.* (eds), *Painting and Illumination in Early Renaissance Florence 1300-1450* (exh. cat., New York, 1994)

Laurence Kanter and Pia Palladino (eds), *Fra Angelico* (exh. cat., New York, 2005)

Anthony Molho, 'Masaccio's Florence in Perspective: Crisis and Discipline in a Medieval Society', in Diane Cole Ahl (ed.), *The Cambridge Companion to Masaccio* (Cambridge and New York, 2002), pp. 16–39

Stefano Orlandi, 'Beato Angelico – Note cronologiche', *Memorie domenicane*, 72 (1955), pp. 3–37

Gary M. Radke, 'Masaccio's City: Urbanism, Architecture and Sculpture in Early Fifteenth-Century Florence', in Diane Cole Ahl (ed.), *The Cambridge Companion to Masaccio* (Cambridge and New York, 2002), pp. 40–63

Francis Russell, 'An Early Crucifixion by Fra Angelico', *The Burlington Magazine*, 138 (1996), pp. 315–17

Magnolia Scudieri and Giovanna Rasario (eds), *Miniatura del '400 a San Marco dalle suggestioni avignonesi all'ambiente dell'Angelico*, (exh. cat., Florence, 2003)

Carl Brandon Strehlke, 'Fra Angelico Studies', in Laurence Kanter *et al.* (eds), *Painting and Illumination in Early Renaissance Florence 1300–1450* (exh. cat., New York, 1994), pp. 25–42

Stefano Ugo Baldassarri and Arielle Saiber (eds), *Images of Quattrocento Florence. Selected Writings in Literature, History and Art* (New Haven and London, 2000)

Chapter Two

Diane Cole Ahl, 'Fra Angelico: A New Chronology for the 1420s', *Zeitschrift für Kunstgeschichte*, 43 (1980), pp. 360–81

—(ed.), *The Cambridge Companion to Masaccio* (Cambridge and New York, 2002)

Venturino Alce, *Angelicus Pictor. Vita, opere e teologia del Beato Angelico* (Bologna, 1993)

Antoninus of Florence, *Sancti Antonini Summa Theologica* (Verona, 1740)

—, *Opera a ben vivere di Sant'Antonino dell'Ordine dei Predicatori Arcivescovo di Firenze* (Florence, 1923)

William R. Bonniwell, *A History of the Dominican Liturgy* (New York, 1944)

Miklòs Boskovits, 'Appunti sull'Angelico', *Paragone*, 27 (1976), pp. 30–54

Paul Julius Cardile, 'Fra Angelico and His Workshop at San Domenico (1420-1435). The Development of His Style and the Formation of His Workshop', Ph.D. diss. (Yale University, New Haven, 1976)

Tito S. Centi, *Il Beato Angelico – Fra Giovanni da Fiesole* (Bologna, 2003)

Anneke de Vries, 'A Velvet Revolution: Fra Angelico's High Altarpiece for San Domenico in Fiesole', in Laurence Kanter and Pia Palladino (eds), *Fra Angelico* (exh. cat., New York, 2005), pp. 59–63

Lodovico Ferretti, *La chiesa e il convento di San Domenico di Fiesole* (Florence, 1901)

Dillian Gordon, 'Christ Glorified in the Court of Heaven', in *The National Gallery Catalogues. The Fifteenth Century Italian Paintings*, vol. I (London, 2003), pp. 2–25

John Henderson and Paul Joannides, 'A Franciscan Triptych by Fra Angelico', *Arte cristiana*, 79 (1991), pp. 3–6

William A. Hinnebusch, *The History of the Dominican Order* (Staten Island, vol. I 1966; vol. II 1973)

Peter Francis Howard, *Beyond the Written Word: Preaching and Theology in the Florence of Archbishop Antonine, 1427–1459* (Florence, 1995)

Laurence Kanter, 'The High Altarpiece from San Domenico, Fiesole', in Laurence Kanter and Pia Palladino (eds), *Fra Angelico*, (exh. cat., New York, 2005), pp. 64–71

Roberto Lunardi, *Arte e storia in Santa Maria Novella* (Florence, 1983)

Eugenio Marino, *Il Beato Angelico. Saggio sul rapporto persona-opere visive ed opere visive-persona* (Pistoia, 2001)

Stefano Orlandi, *S. Antonino. Studi bibliografici* (Florence, 1960)

Carl Brandon Strehlke, *Angelico*, Anna Maria Agosti, trans. (Milan, 1998)

—, 'Princeton "Penitent Saint Jerome", the Gaddi Family and Early Fra Angelico', *Record of the Art Museum, Princeton University*, 62 (Princeton, 2003), pp. 5–25

—, 'Fra Angelico Studies' and 'Fra Angelico', in Laurence Kanter *et al.*, *Painting and Illumination in Early Renaissance Florence 1300-1450* (exh. cat., New York, 1994), pp. 25–42; 322–48

Chapter Three

Diane Cole Ahl, 'Fra Angelico: A New Chronology for the 1430s', *Zeitschrift für Kunstgeschichte*, 44 (1981), pp. 133–58

Venturino Alce, 'Catalogo delle iscrizioni nelle opere', in Postulazione Generale dei Domenicani (ed.), *Beato Angelico Miscellanea di studi* (Rome, 1984), pp. 375–403

Mary Alexander, 'The sculptural sources of Fra Angelico's *Linaiuoli Tabernacle*', *Zeitschrift für Kunstgeschichte*, 40 (1977), pp. 154–63

Francis Ames-Lewis (ed.), *Cosimo 'il Vecchio' de' Medici, 1389-1464* (Oxford, 1992)

Anna Santagostino Barbone, 'Il Giudizio Universale del Beato Angelico per la chiesa del monastero Camaldolese di S. Maria degli Angeli a Firenze', *Memorie domenicane*, n.s. 2 (1989), pp. 255–78

Darrell D. Davisson, 'The Iconology of the S. Trinita Sacristy: 1418-1435: A Study of the Private and Public Functions of Religious Art in the Early Quattrocento', *Art Bulletin*, 57 (1975), pp. 315–34

Isidoro del Lungo, *Il Regio ospedale di Santa Maria Nuova e i suoi benefattori* (Florence, 1888)

Rembrandt Duits, 'Figured Riches: The Value of Gold Brocades in Fifteenth-Century Florentine Painting', *Journal of the Warburg and Courtauld Institutes*, 62 (1999), pp. 60–92

Elena Giannarelli (ed.), *Cosma e Damiano dall'Oriente a Firenze* (exh. cat., Florence, 2002)

Creighton Gilbert, 'Angelico's Dancers', *Italian Quarterly*, 44 (2000), pp. 165–71

William Hood, *Fra Angelico at San Marco* (New Haven and London, 1993)

Roger Jones, 'Palla Strozzi e la sagrestia di Santa Trinita', *Rivista d'arte*, 37 (1984), pp. 9–106

Laurence Kanter, 'Fra Angelico: A Decade of Transition (1422–32)', and 'Fra Angelico: Artistic Maturity and Late Career (1433–55)', in Laurence Kanter and Pia Palladino (eds), *Fra Angelico*, (exh. cat., New York, 2005), pp. 79–87; 139–54

Dale Kent, *The Rise of the Medici: Faction in Florence, 1426–1434* (Oxford, 1978)

—, *Cosimo de' Medici and the Florentine Renaissance* (New Haven and London, 2000)

Giuseppe Marchini and Emma Micheletti (eds), *La Chiesa di Santa Trinita a Firenze* (Florence, 1987)

Lauro Martines, *Power and Imagination. City-States in Renaissance Italy* (Baltimore, 1988)

Ulrich Middeldorf, 'L'Angelico e la scultura', *Rinascimento*, 6 (1995), pp. 179–94

John T. Paoletti, 'Strategies and structures of Medici artistic patronage in the 15th century', in Francis Ames-Lewis (ed.), *The Early Medici and their Artists* (London, 1995), pp. 19–36

Elizabeth C. Parker, *The Descent from the Cross. Its Relation to the Extra-Liturgical 'Depositio' Drama* (New York and London, 1978)

Giuseppe Richa, *Notizie istoriche delle chiese fiorentine* (Florence, 1757)

Ferdinando Sartini (ed.), *Statuti dell'Arte dei Rigattieri e Linaiuoli di Firenze (1296-1340)* (exh. cat., Florence, 1940)

Magnolia Scudieri and Giovanna Rasario (eds), *Miniatura del 400 a San Marco dalle suggestioni avignonesi all'ambiente dell'Angelico*, (exh. cat., Florence, 2003)

Carl Brandon Strehlke, *Angelico*, Anna Maria Agosti, trans. (Milan, 1998)

Charles L. Stinger, *Humanism and the Church Fathers. Ambrogio Traversari, 1386–1439, and Christian Antiquity in the Italian Renaissance* (Albany, 1977)

Chapter Four

Diane E. Cole [Ahl], 'Fra Angelico – A New Document', *Mitteilungen des Kunsthistorischen Institutes in Florenz*, 21 (1977), pp. 95–100

—, 'Fra Angelico: A New Chronology for the 1430s', *Zeitschrift für Kunstgeschichte*, 44 (1981), pp. 133–58

Venturino Alce, 'Il Beato Angelico a Cortona nel 1438', *Memorie domenicane*, n.s. 13 (1982), pp. 422–50

Daniel Bornstein, 'Pittori sconosciuti e pitture perdute nella Cortona tardo-medievale', *Rivista d'arte*, 42 (1990), pp. 227–44

Georges Didi-Huberman, *Fra Angelico: Dissemblance & Figuration*, Jane Marie Todd, trans. (Chicago, 1995)

Nicola Fruscoloni, 'Giovanni di Tommaso e i suoi quattro testamenti nel XV secolo', *Accademia etrusca di Cortona Annuario*, 21 (1984), pp. 159–74

Philancy N. Holder, *Cortona in Context. The History and Architecture of an Italian Hill Town to the 17th Century* (Clarksville, 1992)

Machtelt Israëls, 'Sassetta, Fra Angelico and their patrons at S. Domenico, Cortona', *The Burlington Magazine*, 145 (2003), pp. 760–76

Anna Maria Maetzke and Nicola Fruscoloni (eds), *Il Polittico di Lorenzo di Niccolò della Chiesa di San Domenico in Cortona dopo il restauro* (exh. cat., Cortona, 1986)

Stefano Orlandi, 'Il convento di S. Domenico di Fiesole dagli inizi alla fondazione del convento di S. Marco', *Memorie domenicane*, 37 (1960), pp. 5–140

Chapter Five

Diane Cole Ahl, *Benozzo Gozzoli* (New Haven and London, 1996)

Giorgio Bonsanti, 'Gli affreschi del Beato Angelico', in *La chiesa e il convento di San Marco a Firenze*, vol. II (Florence, 1990), pp. 108–31

Miklòs Boskovits, 'Arte e formazione religiosa: il caso del Beato Angelico', in *L'uomo di fronte all'arte. Valori estetici e valori etico-religiosi* (Milan, 1986), pp. 153–64

Georges Didi-Huberman, *Fra Angelico. Dissemblance & Figuration*, Jane Marie Todd, trans. (Chicago, 1995)

Dino Dini and Giorgio Bonsanti, 'Fra Angelico e gli affreschi nel convento di San Marco', in Eve Borsook and Fiorella Superbi Gioffredi (eds), *Tecnica e stile: esempi di pittura murale del Rinascimento italiano*, (Cinisello Balsamo, 1986)

Creighton Gilbert, 'The Archbishop on the Painters of Florence, 1450', *Art Bulletin*, 41 (1959), pp. 75–87

Samuel Y. Edgerton, Jr, *Pictures and Punishment. Art and Criminal Prosecution during the Florentine Renaissance* (Ithaca and London, 1985)

William Hood, *Fra Angelico at San Marco* (New Haven and London, 1993)

Dale Kent, *Cosimo de' Medici and the Florentine Renaissance* (New Haven and London, 2000)

Vincenzo Marchese, *Memorie dei più insigni pittori, scultori e architetti domenicani*, 3rd edn (Genoa, 1869)

—, 'Sunto storico del convento di San Marco di Firenze', in *Scritti vari del P. Vincenzo Marchese Domenicano* (Florence, 1855), pp. 33–287

Paolo Morachiello, *Fra Angelico. The San Marco Frescoes*, Eleanor Daunt, trans. (London, 1996)

Raoul Morçay, *St. Antonin: Fondateur du couvent de St. Marc. Archevêque de Florence: 1389-1459* (Tours and Paris, 1914)

Michaela Marek, 'Ordenspolitik und Andacht. Kreuzigungsfresko im Kapitelsaal von San Marco zu Florenz', *Zeitschrift für Kunstgeschichte*, 48 (1985), pp. 451–75

The Nine Ways of Prayer of St Dominic, Simon Tugwell, trans. (Rome, 1982)

Stefano Orlandi, *Beato Angelico* (Florence, 1964)

Pittura di luce. Giovanni di Francesco e l'arte fiorentina di metà Quattrocento (exh. cat., Milan, 1990)

Magnolia Scudieri, 'The Frescoes by Fra Angelico at San Marco', in Laurence Kanter and Pia Palladino (eds), *Fra Angelico* (exh. cat., New York, 2005), pp. 177–89

Thomas Aquinas, *Summa theologiae* (Cambridge and New York, 1964–)

—, *Summa theologica*, Fathers of the English Dominican Province, trans. (New York, 1947–8)

Crispino Valenziano, *Via Pulchritudinis. Teologia sponsale del Beato Angelico* (Rome, 1988)

Chapter Six

Diane Cole Ahl, *Benozzo Gozzoli* (New Haven and London, 1996)

Franco Bonatti and Antonio Manfredi (eds), *Niccolò V nel sesto centenario della nascita. Atti del Convegno Internazionale di Studi* (Vatican City, 2000)

Andrea de Marchi, 'Per la cronologia dell'Angelico: il trittico di Perugia', *Prospettiva*, 42 (1985), pp. 53–7

Marcello Fagiolo and Maria Luisa Madonna (eds), *La Storia dei Giubilei, vol. 2: 1450-1575* (exh. cat., Florence, 1998)

Vittoria Garibaldi (ed.), *Beato Angelico e Benozzo Gozzoli. Artisti del Rinascimento a Perugia* (exh. cat., Cinisello Balsamo, 1998)

Creighton Gilbert, 'Fra Angelico's Fresco Cycles in Rome: Their Number and Dates', *Zeitschrift für Kunstgeschichte*, 38 (1975), pp. 245–65

—, *How Fra Angelico & Signorelli Saw the End of the World* (University Park, 2003)

Anthony Grafton, *Leon Battista Alberti. Master Builder of the Italian Renaissance* (Cambridge MA, 2000)

Thomas Izbicki, *Protector of the Faith: Cardinal Johannes de Turrecremata and the Defense of the Institutional Church* (Washington, DC, 1981)

Sara Nair James, *Signorelli and Fra Angelico at Orvieto. Liturgy, Poetry and a Vision of the End-time* (Aldershot, 2003)

Eugène Müntz, *Les Arts à la cour des papes pendant le XVe et le XVIe siècle* (Paris, 1878)

Stefano Orlandi, *Beato Angelico* (Florence, 1964)

Steffi Roettgen, *Italian Frescoes. The Flowering of the Renaissance, 1470-1510*, Russell Stockman, trans. (New York, 1996)

Kevin Salatino, 'Fra Angelico and the Chapel of Nicholas V: Art, Rhetoric and Decorum in Quattrocento Rome', Ph.D. diss. (University of Pennsylvania, Philadelphia, 1992)

Carl Brandon Strehlke, 'Fra Angelico: A Florentine Painter in "Roma Felix"', in Laurence Kanter and Pia Palladino (eds), *Fra Angelico* (exh. cat., New York, 2005), pp. 203–13

Charles L. Stinger, *The Renaissance in Rome* (Bloomington, 1998)

Giusi Testa (ed.), *La Cappella Nova o di San Brizio nel Duomo di Orvieto*,

(exh. cat., Milan, 1996)

Bruno Toscano and Giovanna Capitelli (eds), *Benozzo Gozzoli allievo a Roma, maestro in Umbria* (exh. cat., Cinisello Balsamo, 2002)

Innocenzo Venchi, Renate Colella, Arnold Nesselrath, Carlo Giantomassi and Donatella Zari, *Fra Angelico and the Chapel of Nicholas V* (exh. cat., Vatican City, 1999)

Vespasiano da Bisticci, *The Vespasiano Memoirs. Lives of Illustrious Men of the XVth Century*, George and Emily Waters, trans. (Toronto, 1997)

Carroll W. Westfall, *In This Most Perfect Paradise: Alberti, Nicholas V, and the Invention of Conscious Urban Planning in Rome, 1447–1455* (University Park, 1974)

Anne Winston-Allen, *Stories of the Rose. The Making of the Rosary in the Middle Ages* (University Park, 1997)

Chapter Seven

Venturino Alce, 'Catalogo delle iscrizioni nelle opere', in Postulazione Generale dei Domenicani (ed), *Beato Angelico. Miscellanea di Studi* (Rome, 1984), pp. 392–8

Eugenio Casalini, 'L'Angelico e la cateratta per l'Armadio degli Argenti alla SS. Annunziata di Firenze', *Commentari*, 14 (1963), pp. 104–24

—, *Michelozzo di Bartolommeo e l'Annunziata di Firenze* (Florence, 1995)

Gerardo di Simone, 'Le *Meditationes* del cardinal Torquemada e il ciclo perduto nel chiostro di Santa Maria sopra Minerva', *Ricerche di storia dell'arte*, 76 (2002), pp. 41–87

Georges Didi-Huberman, 'L'Armadio degli Argenti: Beato Angelico', *FMR*, 14 (1995), pp. 33–68

Angi L. Elsea, 'Juan de Torquemada's *Meditationes* in the First Cloister of Santa Maria sopra Minerva: A Reconstruction of Fifteenth-Century Devotional Experience', Ph.D. diss. (Emory University, Atlanta GA, 2003)

Lodovico Ferretti, 'Intorno alla tomba del Beato Angelico alla Minerva', in *Atti del Congresso nazionale di studi romani* (Rome, 1929), pp. 560–4

Creighton Gilbert, *Lex Amoris. La legge dell'amore nell'interpretazione di Fra Angelico* (Florence, 2004)

Paolo I. Menichini, *Vita quotidiana e storia della SS. Annunziata di Firenze nella prima metà del Quattrocento* (Florence, 2004)

Stefano Orlandi, *Beato Angelico* (Florence, 1964)

Giancarlo Palmerio and Gabriella Villetti, *Storia edilizia di Santa Maria sopra Minerva in Roma, 1275–1870* (Rome, 1989)

Crispin Robinson, 'Cosimo de' Medici and the Observant Franciscans at Bosco ai Frati', in Francis Ames-Lewis (ed.), *Cosimo 'il Vecchio' de' Medici, 1389–1464* (Oxford, 1992), pp. 181–94

Magnolia Scudieri, 'I Corali di Zanobi Strozzi e Filippo di Matteo Torelli per il convento di San Marco', in Magnolia Scudieri and Giovanna Rasario (eds), *Miniatura del '400 a San Marco dalle suggestioni avignonesi all'ambiente dell'Angelico* (exh. cat., Florence, 2003), pp. 168–84

Aristide M. Serra, 'Memoria di Fra Paolo Attavanti (1440–1499)', *Studi storico dell'ordine dei servi di Maria*, 21 (1971), pp. 47–89

Crispino Valenziano, *Via Pulchritudinis: teologia sponsale del Beato Angelico* (Rome, 1988)

Afterlife

Diane Cole Ahl, '"Sia di mano di un santo o d'un angelo": Vasari's Life of Angelico', in Anne B. Barriault *et al.* (eds), *Reading Vasari* (London, 2005), pp. 119–31

Keith Andrews, *The Nazarenes. A Brotherhood of German Painters in Rome* (Oxford, 1964)

Susanna Avery-Quash, 'The Growth of Interest in Early Italian Painting in Britain', in Dillian Gordon (ed.), *National Gallery Catalogues. The Fifteenth Century Italian Paintings*, vol. I (London, 2003), pp. xxv–xliv

Quentin Bell, *Victorian Artists* (Cambridge MA, 1967)

Congregatio Sacrorum Rituum (ed.), *Ordinis Praedicatorum Concessionis missae et officii in honorem servi Dei Ioannis de Faesulis O.P. qui vulgo dicitur 'Beatus Angelicus' (†1455)* (Rome, 1960)

Robyn Cooper, 'The Growth of Interest in Early Italian Painting in Britain: George Darley and the Athenaeum, 1834–1846', *Journal of the Warburg and Courtauld Institutes*, 43 (1980), pp. 201–20

Nancy Davenport, 'The Revival of Fra Angelico and Matthias Grünewald in Nineteenth-Century French Religious Art', *Nineteenth-Century French Studies*, 27 (1998–9), pp. 157–99

Lodovico Ferretti, *La Chiesa e il convento di San Domenico di Fiesole* (Florence, 1901)

Mitchell B. Frank, *German Romantic Painting Redefined: Nazarene Tradition and the Narratives of Romanticism* (Aldershot, 2001)

Christopher Lloyd, 'Manet and Fra Angelico', *Source: Notes in the History of Art*, 7 (1988), pp. 20–4

Laura Morowitz and William Vaughan (eds), *Artistic Brotherhoods in the Nineteenth Century* (Aldershot, 2000)

Adriana Cartotti Oddasso, 'Iconografia del Beato Angelico', *Memorie domenicane*, 41 (1965), pp. 113–19

Postulazione Generale dei Domenicani (ed.), *Beato Angelico: Miscellanea di studi* (Rome, 1984)

Alexis-François Rio, *De la poésie chrétienne* (Paris, 1836)

—, *De l'art chrétien* (Paris, 1861)

Steffi Roettgen, *Italian Frescoes: The Early Renaissance 1400–1470*, Russell Stockman, trans. (New York, 1996)

John Ruskin, *Modern Painters*, David Barrie (ed.), (New York, 1987)

Carl Brandon Strehlke, 'Carpentry and Connoisseurship: The Disassembly of Altarpieces and the Rise of Interest in Early Italian Art', in Clay Dean (ed.), *Rediscovering Fra Angelico. A Fragmentary History* (exh. cat., New Haven, 2001), pp. 41–58

Virginia Surtees, *The Paintings and Drawings of Dante Gabriel Rossetti (1828–1882). A Catalogue Raisonné* (Oxford, 1971)

Caterina Bon Valsassina, 'Il Purismo religioso e Beato Angelico', in Vittoria Garibaldi (ed.), *Beato Angelico e Benozzo Gozzoli. Artisti del Rinascimento a Perugia* (Cinisello Balsamo, 1998), pp. 93–101

Giorgio Vasari, *Le vite de' più eccellenti pittori scultori ed architettori scritte da Giorgio Vasari*, Gaetano Milanesi (ed.), (Florence, 1906), vol. II, pp. 505–34

Aidan Weston-Lewis (ed.), *'A Poet in Paradise'. Lord Lindsay and Christian Art* (Edinburgh, 2000)

Index

Acknowledgements

Picture credits

Dedicated to Arthur and Barbara Rothkopf for their leadership, support and friendship

There is a vast, rich literature on Fra Angelico that has informed my understanding of the artist immeasurably. Of necessity, the Bibliography is highly selective and cannot begin to encompass the numerous publications that I consulted in writing this book. It does, however, indicate many studies that were crucial to my discussion. In addition to acknowledging these texts, I wish to express my gratitude to the scholars, colleagues and conservators who generously shared their expertise and offered assistance. They include Cristina Acidini, Catarina Arcangeli, the late Umberto Baldini, Paul Barolsky, Giorgio Bonsanti, Miklòs Boskovits, Paola Bracco, Jean Cadogan, the late Ellen Callmann, Keith Christiansen, Gino Corti, Cecilia Frosinini, Creighton Gilbert, Dillian Gordon, the late Frederick Hartt, the late Father William Hinnebusch, William Hood, Sara Nair James, the late and dearly missed Andrew Ladis, the late Ulrich Middeldorf, Lew Minter, Arnold Nesselrath, Anna Padoa Rizzo, John Paoletti, Gary Radke, Kevin Salatino, Magnolia Scudieri, Carl Strehlke and Giusi Testa. Barbara Wisch provided valuable insight and editorial acumen throughout the writing of the text. My editors at Phaidon, especially David Anfam and Helen Miles, saw this book to its completion. I am thankful to the Fulbright Scholarship Program, the Institute for Advanced Study in Princeton, the Kunsthistorisches Institut in Florenz (Max-Planck-Institut), the National Endowment for the Humanities, the Renaissance Society of America and the Advanced Research Committee of Lafayette College for subsidizing my research and travel. Finally, I am grateful to my family and friends for their support over these many years.